DRAMA TRAUMA

In this engaging cross-disciplinary study, Timothy Murray examines the artistic struggle over traumatic fantasies of race, gender, sexuality, and power. Establishing a retrospective dialogue between past and present, stage and video, Murray links the impact of trauma on recent political projects in performance and video with the specters of difference haunting Shakespeare's plays.

Drama Trauma blends notions of psychoanalysis and poststructuralism to analyze the 'perpetual menace' of psycho-social trauma. Murray relates the specters of stage to the phantoms of video by offering perceptive accounts of melancholy, skepticism, masquerade, display, censorship, and difference. Focusing on visual and narrative struggles over the materialization and domestication of fantasy, Murray provides close readings of Shakespearean drama, contemporary plays by women, African-American performance, and feminist intervention in video, performance, and installation. Providing an affirmative account of the residues of drama, the book reads installations by Mary Kelly and Dawn DeDeaux, plays by Ntozake Shange, Holly Hughes, Rochelle Owens, Adrienne Kennedy, Marsha Norman, and Amiri Baraka, performances by Robbie McCauley, Jordan, Orlan, Carmelita Tropicana, as well as *King Lear*, *Othello*, *Romeo and Juliet*, and *All's Well That Ends Well* on stage, film, and television.

Drama Trauma is an essential volume for students of Shakespeare, women's studies, African-American studies, cultural studies, performance, television, and video.

Timothy Murray is Professor of English at Cornell University. A former editor of *Theatre Journal*, he is author of *Theatrical Legitimation: Allegories of Genius in Seventeenth-century England and France* (1987), *Like a Film: Ideological Fantasy on Screen, Camera, and Canvas* (1993), *Mimesis, Masochism, and Mime: The Politics of Theatricality in Contemporary French Thought* (1997), and co-editor, with Alan K. Smith, of *Repossessions: Psychoanalysis and the Phantasms of Early Modern Culture* (1997).

DRAMA TRAUMA

Specters of race and sexuality in
performance, video, and art

Timothy Murray

London and New York

First published 1997
by Routledge
11 New Fetter Lane, London EC4P 4EE

Simultaneously published in the USA and Canada
by Routledge
29 West 35th Street, New York, NY 10001

© 1997 Timothy Murray

Typeset in Palatino by Keystroke, Jacaranda Lodge, Wolverhampton
Printed and bound in Great Britain by Biddles Ltd, Guildford and King's Lynn

British Library Cataloguing in Publication Data
A catalogue record for this book is available from the British Library

Library of Congress Cataloging in Publication Data
Murray, Timothy.
Drama trauma : specters of race & sexuality in performance, video
& art / Tim Murray.
p. cm.
Includes bibliographical references and index.
ISBN 0–415–15788–9 (alk. paper) — ISBN 0–415–15789–7 (alk.
paper)
1. American drama—20th century—History and criticism. 2. Social problems
in literature. 3. Literature and society—United States—History—20th century.
4. Shakespeare, William, 1564–1616—Knowledge—Psychology. 5. Performing
arts—United States—History—20th century. 6. Difference (Psychology) in
literature. 7. Drama—Psychological aspects. 8. Race in literature. 9. Sex in
literature. I. Title.
PS338.S63M86 1997
792'.0973—dc21 97–6184
CIP

ISBN 0–415–15788–9 (hbk)
ISBN 0–415–15789–7 (pbk)

For JEAN-FRANÇOIS LYOTARD
a shaper of figure, form, and tim(e)

CONTENTS

vii

CONTENTS

CONTENTS

Part IV Televisual fear

ILLUSTRATIONS

ACKNOWLEDGMENTS

I number not my borrowings, but I weigh them. And if I would have made their number to prevail, I would have had twice as many. They are all, or almost all, of so famous and ancient names, that me thinks they sufficiently name themselves without mee.

<div align="right">Michel de Montaigne</div>

So many borrowings shape this book that their memory threatens to remain unspoken. Yet certain key voices resonate throughout these pages with such timber that they need be named. I dedicate this volume to Jean-François Lyotard. I have never adequately thanked him for the lasting weight of his intellectual beneficence whose many imprints are scattered throughout these pages. I am equally grateful to Stephen Orgel and Janet Adelman who, at crucial stages in my early training, sensitized me to the timber of Shakespearean verse and vision. My writings on Shakespeare testify to their names and hopefully wander not too far from their aims.

More recent debts are far too many to be sufficiently remembered. Foremost is the intellectual friendship of those most present throughout the many stages of this book: Herbert Blau, Mitchell Greenberg, Neil Saccamano, Elin Diamond, Chris Pye, and Tom Conley. These writings have profited from many Cornell collaborations in the study of performance, Renaissance studies, visual culture, and psychoanalysis for which I thank David Bathrick, Naoki Sakai, Mary Jacobus, Phil Lewis, Werner Goehner, Biddy Martin, Biodun Jeyifo, Brett de Bary, Scott McMillin, Shelley Wong, Reeve Parker, Walter Cohen, Barry Maxwell, Marilyn Rivchin, Rebecca Egger, Tejumola Olaniyan, Timothy Billings, Burl Barr, Dan Brayton, and Wendy Walters. In the wings stand many players who lent their figures recently and in the past to the many chapters that follow: Sue-Ellen Case, Billy Flesch, Kathleen Woodward, Maureen Turim, Sharon Willis, Kim Benston, Julia Lupton, Richard Burt, Julianna Schiesari, Maria Minich Brewer, Juliet MacCannell, David Rodowick, Paul

Sandro, Georges Van Den Abbeele, Stephen Greenblatt, Enoch Brater, Dan Brewer, Skip Gates, David McDonald, and Christian Jouhaud.

The idea for this project was first sprung in conversation with Janice Price of Routledge, now too many years ago. Since then Talia Rodgers has graciously, and all too patiently, endured it with enthusiasm, while the traumas of its production have been borne so well by Sophie Powell, Jason Arthur, Diane Stafford, and Philip Parr. Hope Mandeville may not realize how much I appreciate the space she created for my work on this book; thanks as well to her unselfish colleagues of the Cornell English Department: Marianne Marsh, Lisa Melton, Vicky Brevetti, Darlene Flint, Robin Doxtater, and Suzanne Sager. I am also grateful to the many artists and photographers who have permitted the use of their work, in particular Mary Kelly, Ray Barrie, Kelly Barrie, Dawn DeDeaux, and, most particularly, Derek Jarman, whose boundless generosity I will not fail to remember.

Then there are those upon whom this book has weighed the most heavily. Not to be forgotten is my ever so patient son, Erin, whom I recently overheard ask his sister for help with an afterschool snack "since Daddy will be too busy in his books". As for Ashley, her fascination with the materials of this book has impressed me throughout its making, from her horrified observation that my Shakespeare students didn't seem to know the gory details of Duncan's death as well as she to her demand this very morning that I subject her ten-year-old psyche to the hyper-violence of Baz Luhrmann's *Romeo and Juliet* – as she puts it, if she knows the trauma of *Macbeth* she can certainly handle the corpses of Hollywood's bullet-filled love story. No one carries the specters of *Drama Trauma* more fully than their mother, Renate Ferro, who has listened attentively to its many soundbites while going about the business of providing the material and emotional comforts for its penning, always making the most prescient suggestions for its reframings. Finally, I wish to close as I opened by extending thanks to someone whose selfless contributions to the quality of my life can never fully be acknowledged. So, thanks, Scooch, for working so hard over the years to provide me with a comfortable environment in which to live and work, not to mention those times when a break for lunch added renewed force to the writing to come.

Earlier versions have been published of Chapter Three in Richard Trexler, ed., *Persons in Groups: Social Behavior as Identity Formation in Medieval and Renaissance Europe*, Binghamton, N.Y.: Medieval and Renaissance Texts and Studies, 1985; and in G. Douglas Atkins and David Bergeron, eds., *Shakespeare and Deconstruction*, New York and Bern: Peter Lang, 1988; Chapter Five in *Theatre Journal* 35, 3 (October 1983); Chapter Six in Enoch Brater, ed., *Feminine Focus: The New Women Playwrights*, New York and

Oxford: Oxford University Press, 1989; Chapter Seven in *Modern Drama* 28, 1 (March 1985) and in Henry Louis Gates, Jr., ed., *Reading Black, Reading Feminist: A Critical Anthology*, New York: Meridian, 1990; Chapter Eight in *Discourse* 16, 3 (Spring 1994); Chapter Ten in *Discourse* 9 (Spring/Summer 1987) and in Richard Burt, ed., *The Administration of Aesthetics: Censorship, Political Criticism, and the Public Sphere*, Minneapolis: University of Minnesota Press, 1994; Chapter Eleven in *Camera Obscura* 32 (September–January 1993–94). My thanks to the publishers for permission to reprint these materials. Although extensive efforts have been made to contact the copyright holders of images reproduced in this book, the author and publisher apologize in advance for any unintentional omission or neglect and will be pleased to insert the appropriate acknowledgment in any subsequent edition of this book.

1

INTRODUCTION
Performing trauma: the scare
of academic cool

I saw *Romeo and Juliet* with a friend of mine, and he was like,
"Forget Shakespeare! This movie is so cool, you shouldn't
even mention him. It'll keep people away." And I want people
to know this movie has nothing to do with anything scary or
academic or boring.

Claire Danes

Claire Danes here refers to the surprise teenage film success of the 1996–97
season, *William Shakespeare's Romeo and Juliet* (1996), directed by Baz
Luhrmann and costarring herself and Leonardo DiCaprio. This film not
only captured top honors at the American box office during its first
weekend of release but did so without an overwhelming number of adult
ticket holders. Danes is certainly correct in her assessment that
Luhrmann's fast-paced film, the first major remake of *Romeo and Juliet*
since Zeffirelli's 1968 classic, is anything but boring. Set in the excessive
postcapitalist wasteland of Verona Beach (shot in Mexico City), this film of
quick cuts and rock video inserts features a black Prince Escalus who
roams through the air in a legion of fighter helicopters trying without
success to keep a lid on the excessive violence and performative erotics of
tough Generation-X street warriors. The boys in this hood speak dialogue
in Shakespearean verse as they drop acid, cruise the avenues in sleek
designer coupes, and revel in the pyrotechnic blasts of beautifully crafted
automatic weapons. This is a culture of violent addiction whose virtual
speed and commodity excess outpace the capacity of its warring capitalist
patrons, Montague and Capulet, to control and dominate its libidinal
productions. As a consequence, the split order of patriarchy is so over-
whelmed by the unified drives of love and death that the two fathers
perform little more at film's end but the flaccid numbness of their confu-
sion. The dialectical corollary is the angry, final speech of black Escalus
who deprecates himself "for winking at your discords" (V.iii.294). This
loud display of screaming rage assails the battered spectator with yet
another example of the historical linkage of fascism and male hysteria.[1]

1

Perhaps the sole exception to this picture's libidinal overkill is provided by the televisual mechanism that strategically frames the diegesis in tabloid flashback: the numerous scenes of eroticism, violence, and death are rescripted for profitable broadcast by the television newsreader whose monotone reportage brilliantly opens and closes the film. Arrivals at the Capulets' masquerade ball are greeted by live television announcers as we've come to expect from *E* and *Entertainment Tonight* on the evening of the Academy Awards. Similarly, the jump cut transitions and violent events at the outset of the film are accompanied by the interpellation of sounds familiar to viewers of *Hard Copy* and its lesser clones. Indeed, the carefully crafted competition between television and cinema, here underwritten by the hybrid media conglomerate, Twentieth Century Fox, might easily encourage the young spectators to forget Shakespeare for Murdoch – from whom Capulet and Montague could learn a few good lessons about empires, their nations, and their narrations (not to mention the economics of male hysteria). While traditional viewers of this cinematic adaptation of Shakespeare may bemoan the tackiness of such televisual inserts, readers of this book will hopefully come to appreciate their disorienting effects as exemplary of the "tele-visions" common to theatre, film, video, and installation art. That is, if Luhrmann's televisual cuts do anything but pander to a young audience more accustomed to the visceral form of television than to the poetic structure of Shakespearean drama, they may be said to exemplify, much like Holbein's anamorphosis, Vermeer's camera obscura, or Shakespeare's stained mirrors and floating daggers, the performative role of the apparatus and its theatrical exaggeration of the fluid referents of performance. In a fascinating way, televisual reference functions in Luhrmann's film as the destabilizing mechanism of irony and hyperbole for which rhetoric and perspective were the playful engines on the Renaissance stage.

While Danes's film might be more playful than boring, it still has everything to do with what is scary and academic. What verges on the scary and, I dare say, even on the academic is how the film enters more or less into dialogue with Shakespeare's script to represent celluloid specters of the hybrid economies of race and sexuality that have remained deeply traumatic to Shakespeare's viewers over the ages. In a rather academic assessment of *Romeo and Juliet*, in Chapter Four, I discuss the sadomasochistic fright of the play's deadly sex which is framed, as Juliet puts it, by the disturbing maxim, "My only love sprung from my only hate" (I.v.138),[2] the handle, I might add, which Twentieth Century Fox chose as the lead-in title of its official *Romeo and Juliet* World Wide Web site. The depth of Juliet's love is equally disturbing to Danes who reveals that she undertook her part for the film while enveloped in the melancholic haze of a traumatic break-up (at about age sixteen): "I told Baz Luhrmann that I didn't know how I was going to get through all of

Juliet's ecstatic speeches about being in love. I was hurting so much" (cited by Hobson 1996). As Louis B. Hobson of the *Calgary Sun* suggests, Danes's young love affair and subsequent breakup positioned her right alongside Juliet as "the poster girl for teen angst and melancholy." What makes the story of sexuality particularly traumatic in this film and else-where, I hope to show below, is how it displays to its teenage viewers and seasoned adult audience more than it reveals about its angst, incertitudes, and enigmas. Perhaps this is why, rather than weep at Romeo's rather conventional suicide, the young girl sitting next to me caustically urged Juliet to pick up the gleaming pistol Romeo left behind to "go ahead and kill yourself already."

This enigmatic trauma of sexuality is doubled with the scary mixture of race in Luhrmann's film whose multicultural cast is both exceptionally performative and traditionally subservient, unusually assertive and ulti-mately dead. The supporting roles of Mercutio and Tybalt are played with stylistic flair by Harold Perrineau and John Leguizamo. Viewers are teased by the extravagant performance of the dreadlocked Perrineau who, poured into a tight costume of skimpy white drag, struts his black body in a dazzling performance of campy burlesque, one confusingly tantalizing to the young heterosexual audiences who fill the screen and theatres with cross-identificatory delight. This is a racialized performance whose sexual ambiguity and cinematic precedent are nothing but scary in the best and the worst terms. As for the best terms, a nonacademic friend couldn't help but notice that this campy performance by Mercutio, shown to be relished by Romeo, marks the subsequent interactions between Romeo and Mercutio as exceptionally homoerotic ones. His observation receives literary support by Jonathan Goldberg who argues, in "Romeo and Juliet's *Open Rs*" (1994), that Mercutio signifies the imprint of the play's sexual field in sodomy and forbidden desire.[3] As for the worst terms, it is not evident from the film that the director has adequately contemplated, not to mention theorized, the political ramifications of his staging of the black Mercutio in drag. Thinking of Mercutio's complicated straddling of white/black, queer/straight, high/low cultures, I cannot help but recall Jackie Goldsby's constestatory questions about the analogical straddling of cultures in *Paris is Burning*: "when is borrowing not appropriation, and/or when does appropriation become co-optation?" (Goldsby 1993: 112). Similarly enigmatic is the exaggeratedly stylized, Chicano portrayal of Tybalt, played by the well-known performance artist Leguizamo who no doubt brings to Luhrmann's screen the composite Latino specter of his previous appearances as the sensitive drag queen in *To Wong Foo, Thanks for Everything, Julie Newmar* (1995) and the sadomasochistic sex offender in *Whispers in the Dark* (1992). Leguizamo's own award-winning perfor-mance piece, *Spic-O-Rama* (1992), also could be said to lend a counter parodic phantom to Luhrmann's film at numerous points, from Tybalt's

exaggerated machismo to the loud sitcom-like shouting of the Chicana nurse (played by the British actress, Miriam Margoyles) whose loud cries for "Whooooliet" echo throughout the Capulet mansion. Particularly symptomatic is how the film's conflictual positioning of multicultural subject positions recasts the specificities of material and literary culture in the illusive and conflictual specters of race. Moreover, race is levelled out, in this context, in its broadest terms as the corporate fantasy of a televisual multination, one celebrated anew through the digitized cool of interactive webs and CD-Roms.[4]

What's finally cool, so suggests the extensive, and almost immediate, World Wide Web reception of Luhrmann's *Romeo and Juliet*, is not only the film but its many allusions to the multimedia apparatuses that help to shape its representations in and out of the theatre: cinema, television, and digital spectacle. Whether discussed on E-online, on the Twentieth Century Fox website, or on the *Romeo and Juliet* link from *Shakespeare's Diary* (a segment of the electronic soap opera, *Hollywood 101*) all of these media seem obsessed by the spectacular elements of representation, then and now: cross-dressing, teen sex and/or primal scenes, the death of Shakespeare's authorship, and the commodity status of the Shakespearean text. Put another way, *William Shakespeare's Romeo and Juliet* has everything to do with what is scary in the most serious of academic senses: the spectacle's traumatic mixture of subject matter, subjectivity, and the institutional and discursive devices of its ambivalent performativity.

This is what I gleaned in leaving the screening of Luhrmann's film surrounded by dozens of boisterous teens who were clearly excited yet not totally convinced by their popular culture encounter with Shakespeare. I sensed that the extremely performative event of this screening had everything to do with my steadfast commitment to putting together a book that would foreground the cultural manifestations of trauma in its various theatrical guises in theory and in early modern and contemporary performance, television, video, and installation art. Something like the cultural hybridity and unfathomable energetics of this event lie behind my efforts to bring critical readings of Shakespeare into dialogue with feminist, lesbian, and African-American performance, to conflate the purposeful gaze of live theatre and installation with the distracted glance of television and video, to confront the confident materiality of cultural criticism with the haunting specters of psychoanalytic fantasy and the destabilizing theatricality of poststructural philosophy, and, finally, to dwell on the extent to which such passings backward and forward in history, from matter to simulacrum, within and between race and sexuality, give rise to a cultural excitation that is as enigmatic as it is sexual, as ambivalent as it is racial.

My hope is that this book is not boring but still both scary and

academic, hopefully even cool. Cool, at least, in the sense evoked by Jean Laplanche in writing of a new sense of sublimation, one conjoined with traumatophilia:

> You have to think of sublimation in a less transformational and so-called mathematical way than Freud thought of it, which is of inhibited and desexualised drives and so on. We must try to think of sublimation as new sexuality; it is something new, maybe coming from the message, from the work itself. It is a kind of new excitation, new trauma coming from the sublimated activity itself, and through this new trauma comes new energy. I try to connect the idea of sublimation with the idea of research or trauma, and I coined the idea of traumatophilia.
>
> (Laplanche 1992a: 32)

Traumatophilia is a strangely appropriate term for the critical project of this book. Its many chapters on seemingly disparate performative materials from stage, television, video, and museum examine the tangential folds of materiality and affect in a less transformational and so-called mathematical way by theatricalizing those complex textures and resonant spaces comprising the enigmatic discourses of race and sexuality. In this sense of traumatophilia, it conjoins the idea of research and trauma, it blends the sense of what's scary and academic.[5]

FORGET SHAKESPEARE?

"Forget Shakespeare! This movie is so cool, you shouldn't even mention him. It'll keep people away." Were we to believe the teenage friend of Claire Danes, the traumatic antithesis to "cool" is Shakespeare, or the memory of his proper name. Of course, it is the wish to forget the proper name and the attendant obscurity of its reading, the desire to efface the tag of identity with all of its historical and cultural baggage, that Shakespeare formulates so elegantly in *Romeo and Juliet*:

> By a name
> I know not how to tell thee who I am.
> My name, dear saint, is hateful to myself,
> Because it is an enemy to thee;
> Had I it written, I would tear the word.
> (II.ii.53–57)

One name that is frequently so torn on the sadomasochistic stage of hate and love is that of Shakespeare himself. Even the director, Luhrmann, feels compelled to confess that "I hated Shakespeare when I was a kid . . . I was like, 'this is impenetrable'" (cited by Slotek 1996). When the name is hateful for its obscurity, it often represents the kind of self-centered

5

empowerment of authorship so frequently identified with Shakespeare. Think of something like Peter Greenaway's "cross-identification" between Prospero, Gielgud, and Shakespeare in *Prospero's Books*, the kind of composite of literary identity whose buttress of ontological authority and cultural privilege sustains the most sophisticated pedagogies in English literature and theatre.[6] At other times, the name is truly hateful to the Other, "to thee," as the symbolic carrier of the civilizing tradition whose global cultural supremacy has left nary a native shell uncooked. What remains complicated is how successfully the promulgation as well as the seduction of this cultural machinery named Shakespeare has been interiorized with deep ambivalence, in love and hate, as a consequential part of the subjects wishing so desperately to reject it. This proper name Shakespeare, the signifier of so much more than a folio of 1623, has been assumed as natural dress or false masquerade by even its most radically distant bearers, to the extent that the symbolic name becomes culturally requisite to the ambivalent host, yet "hateful to myself."[7]

So lies the fluid frontier of drama trauma traversed by the experimental pioneer of contemporary African-American letters and performance, Ntozake Shange. In a long and telling autobiographical passage, Shange dwells on her ambivalent relation to the Black and Latin Shakespeare Company's 1980 production of *Coriolanus*:

> i had & still grapple with the idea of classics in the lives & arts of third world people. we have so much to do, so much to unearth abt our varied realities/ on what grounds do we spend our talents, hundreds of thousands of dollars, unknown quantities of time, to recreate experiences that are not our own? does a colonial relationship to a culture/ in this case Anglo-Saxon imperialism/ produce a symbiotic relationship or a parasitic one? if we perform the classics/ giving our culture some leeway in an adaptation/ which is the parasite? why aren't the talents & perspectives of contemporary third world artists touted in the same grand fashion successful revivals of dead white artists are? all these things bothered me during the second act of *Coriolanus* but not so much that i wazn't moved to tears simply by the overwhelming power of the company/ i loved looking at them/ hearing them. i waz thoroughly committed to seeing more black, latin & asian artists addressing issues of the world. one thing that doing classics allows us/ that is such a relief/ is to do an evening of dialogue without having to restrict ourselves to the pains and myopia of racism in America. the power of white folks as we know it poses no boundaries in *Coriolanus* or *Julius Caesar*. they are not in it and hold no power – what escapism. the failure of the black & latin Shakespeare company is directly related to the actual power of white folks & the impotence that that sort of

power brings. this impotence is an inability on the part of white audiences, critics, academicians & their specific mythologies of white supremacy to identify with black and latin characters and to accept black & latin actors as nobility. for in our hemisphere race & class are implacably engaged & it is a duel to the death. it resulted in the death of the black and latin Shakespeare company.

<div align="right">(Shange 1984: 35)</div>

Shange understands the remembrance of Shakespeare for black and Latin participants to be a deeply ambivalent one of symbiosis and parasitism. Ironically, Shakespearean dialogue between actors and viewers of color is said to result in the forgetting, the suspension of disbelief, of the memories and machineries of white supremacy, at least those particular to the pains and myopia of racism in America. Yet, she insists that there remains something noble in performing Shakespeare whose inheritance on the American stage is itself worth a fight to the death. The inheritance concerns the rights of identification and the related threat of impotence to a dominant culture sustained by the mystique of fetishism and the disavowal of empowering difference, "the actual power of white folks & the impotence that that sort of power brings." Precisely these deeply structural conditions of psyche and socius, of race and class, are inscribed, I will suggest in the chapters that follow, in the texts of Shakespeare themselves and seep into the contemporary artistic tradition which sometimes would rather operate solely on its own terms. It is the ghostly legacy of these historical texts layered with contrasting racial and sexual machineries of the power of knowledge and its fetishistic props that positions the rights over their staging and interpretation as worthy of just such a fight over the hold of cultural hegemony.

Performance has served as a traditional means of confronting hegemony with the specter of its own vicissitudes. It was performance art, for instance, that became the lightning rod of the 1990 debate over the National Endowment for the Arts. That was when the Director of the NEA, John Frohnmayer (under the guidance of Senator Jesse Helms), disregarded the recommendations for grants made by the peer review panel on performance and defunded projects by four artists, Karen Finley, John Fleck, Holly Hughes, and Tim Miller, all on the same grounds of "obscenity." Reduced to the common denominator of obscenity were these artists' differing commentaries on sexual difference and preference, racism, misogyny, homophobia, and the AIDS crisis. Left unspoken by Frohnmayer and the male Washington establishment supporting his controversial decision was the extent to which the discourse of such different proposals did share a praxis which was much more powerful than something called "obscenity." They performed and demystified patriarchy's fear of its own shaky determination by difference and its

vicissitudes of sexuality, race, identity, love, and, death.[8] Such fear, its negation, and its rage against the expression of its own inscription in the tear of difference has fueled the antitheatrical drive since its inception in Plato. The critics of the Renaissance theatre, to cite a well-documented example, feared the consequences of the dramatic art of imitation and its dangerous instruction in performance or counterfeit. Consider John Northbrook's emphatic argument against theatricality's threat to the state: "If you will learne howe to bee false and deceyve your husbandes, or husbandes their wyves . . . howe to beguyle, how to betraye, to flatter, lye, sweare . . . to disobey and rebell against princes . . . shall not you learne, then, at such enterludes how to practise them" (cited by Chambers 1923: IV, 198–99). This is, of course, the very charge made against Desdemona by Brabantio who warns Othello to "Look to her, Moor . . . She has deceiv'd her father, and may thee" (I.iii.292–93). *Othello* is one play, moreover, that intermixes the differences of race and sexuality as the specters of performance. It would be no stretch to suggest that Brabantio's countryman must be tempted by play's end to attribute her own deception to the theatrical lessons she learned from her Moorish husband. As I discuss in Chapter Four, it is Othello who relies on the prowess of his storytelling to enamor his Venetian hosts with the forceful power of his conquests on which these masters depend. Conversely, the tearfully performative response of Desdemona to the stories of Othello's "disastrous chances" incites his love for her greedy ear that so devours up his discourse.

When the scene of spectacle shifts from England to America, performance is valued as the mechanism of survival and cultural adaptation for the African-American kin of Othello whose identity has always been mediated by the specters of slavery. In "Performance Practice as a Site of Opposition," bell hooks writes that

> All performance practice has, for African-Americans, been central to the process of decolonisation in white supremacist capitalist patriarchy. From times of slavery to the present day, the act of claiming voice, of asserting both one's right to speak as well as saying what one wants to say, has been a challenge to those forms of domestic colonisation that seek to over-determine the speech of those who are exploited and/or oppressed. Performance was important because it created a cultural context where one could transgress the boundaries of accepted speech, both in relationship to the dominant white culture, and to the decorum of African-American cultural mores.
>
> (hooks 1995: 212)

Performance works in this sense to recite or resignify or recolonize the codes that define race in relation to the dominance of white culture. It works to inhabit or mime the production of force whose performative

practice is understood by Judith Butler to result in "a process of material-ization that stabilizes over time to produce the effect of boundary, fixity, and surface we call matter" (Butler 1993: 9). It is in this sense, moreover, that performance can be said to allow for the preservation of race as a theatricalized figure of what Butler, Anthony Appiah, Paul Gilroy, and others recognize as "an effect of the history of racism, that its boundaries and meanings are constructed over time not only in the service of racism, but also in the service of the contestation of racism" (Butler 1993: 18). This is the noble duel to the death produced every time the Black and Latin Shakespeare Company took to the stage.[9]

"I KNOW WHAT YOU MEAN, I CAN'T FIND MINE EITHER"

Whether race is understood as the realist term of biological difference, as the founding narration of imperial nation, or as the discursive effect of the history of racism, it remains, as Henry Louis Gates, Jr. suggests, "the ultimate trope of difference because it is so arbitrary in its application" (Gates 1985: 5) and, I would add, so phantasmic in its cultural roots. This is why I place so much emphasis throughout this book on the ambivalence of cultural internationalization and its psychic corollaries. In the African-American tradition, for instance, performance has served the function of preserving difference while also facilitating cultural assimilation. Particularly fascinating are what Gilroy terms the "residual habits" of such performativity:

> The living, non-traditional tradition of black vernacular self-fashioning, culture-making, play and antiphonic communal conversation is complex and complicated by its historic relationship to the covert public worlds of a subaltern modernity. The slaves, like many other conquered and colonised peoples, were gradually and not always reluctantly drawn into the world that their owners defined and regulated by more than merely coercive means. As they internalised the new languages, causal and purposive understand-ings, spiritual codes, spatial and temporal perceptions upon which their survival was conditional, as well as the orientation towards nature and the natural world that their masters and mistresses required, they did not necessarily abandon the alternative non-European habits that were condensed into living memories of an alternative history and social life. Indeed, these residual habits were often reproduced in customary form even when their earlier "traditional" meanings had been forgotten, were changed or no longer immediately relevant.
>
> (Gilroy 1995: 13–14)

A compelling aspect of cultural internalization, on which I reflect throughout this book, is the means by which our customs, costumes, and habits of identification, whether of race or sexuality or something in between, are so frequently informed by the residual specters of forgetting. I am continually struck by the frequency with which the plays, performances, and videos that are cited in this book are haunted and disjointed by the residual effects of waking dreams, encrypted memories, willed forgettings, and ghostly phantoms. I enter into dialogue below with many compatible theorizations to account for such spectral affect. Foremost is the theory of melancholic "cryptation" and the attendant "phantoms" and cross-generational hauntings developed by Nicolas Abraham and Maria Torok. But also crucial, especially as an after-effect of *Romeo and Juliet*, are Herbert Blau's theatrical "ghostings," Jacques Derrida's "spectralpoetics," Jean-François Lyotard's "libidinal intensities," Jacques Lacan's "Real," as well as J.-B. Pontalis's "oenirical perceptions" that haunt the subject so frequently enthralled by the state of the waking dream.

Equally important to my reflections on the bedeviling residue of cultural disavowal is the framework sustaining Butler's notion of "phantasmatic identification" through which "certain exclusions and foreclosures institute the subject and persist as the permanent or consti-tutive specter of its own destabilization" (Butler 1993: 116). Butler's sense of fantasy is derived from the early Laplanche and Pontalis for whom fantasy is the dramatic scene of unrecoverable loss through which the subject is dispersed between the autoerotic pull of need and desire, positioning the subject itself, *in fantasy*, as both object and desire.[10] As for the "originary" cause of dispersion, the subject comes to recognize its phantasmic constitution only retrospectively in relation to later over-determined crises, whose intensities mark and exceed the possibility of primal fantasy which had remained buried alive during its middle passage. As Pontalis rephrases fantasy in *Perdre de vue*, "we don't have memories *of* childhood but only memories *on* our childhood, which don't arise out of the past but are formed on the run [*sur le tard*]; our memory is a retroactive fiction, retroactively anticipatory, which belongs with no need of sanction to the realm of *Fantasy*" (Pontalis 1988: 289). Being so scripted *in* fantasy, my readings that follow are particularly indebted to Laplanche's later elaboration of trauma as the effect/affect of the signifier that "may be *designified*, or lose what it signifies, without thereby losing its power to signify *to*" (Laplanche 1989: 45). A notion developed in *Problématiques, New Foundations for Psychoanalysis*, and the essays collected by Fletcher and Stanton in *Seduction, Translation, Drives*, "the enigmatic signifier" signifies *to* the child without its sender(s) or addressee knowing necessarily *what* it signifies but only that it signifies.[11] The scene to which my subtitle refers as the "specter of sexuality," which

Laplanche understands as primal seduction, is this "sexual enigma" confronting the infant with the traumatic nuance of all that is particularly dramatic or performative, from "the parental world, a whisper, a secret, an aside, a reticence – in brief, something which is supposed to be hidden behind appearance, from a realist, materialist perspective" (Laplanche 1980: 106). Being the forceful seduction of a word, a gesture, an embrace, and even a glance, such an enigma is performative as well as linguistic, visual as well as textual.

To Laplanche the most striking enigma is the performative distinguishing men and women. Itself a problematic marker of origin in the wake of the critique of the heterosexual paradigm by Butler, Biddy Martin, Trevor Hope, and so many others, this distinction is qualified by Laplanche in an important way that informs my insistence that we bridge the gap between materialist and psychoanalytic assumptions about trauma and its representation:

> Freud posits explicitly that the masculine–feminine distinction is not simply one of sexual difference, as always assumed, but also the most general distinction, *habitus*, social functions, modes of dress or comportment, in brief, the most general distinction between what, from a particular perspective, one calls "genre."
>
> (Laplanche 1980:107)

Such an enigmatic nuance of "genre" in the composite sense of style and aesthetics, what Claire Danes might call "academic cool," is identified by Laplanche as the very kernel of the traumatic. It is crucial to understand, moreover, that trauma here has everything to do with the reluctance of Claire Danes to associate the cinematic "cool" with "anything scary or academic or boring." For what makes the signifier so enigmatic is not only the refusal of its sender to unpack its meaning but, indeed, the inability of the sender herself to provide an adequate account of the performance of her seduction. "The one who sends the enigmatic message is unconscious of the whole meaning; that is," adds Laplanche, "part of the meaning comes from his unconscious sexual wishes" (Laplanche 1992c: 58). Or, put in the discourse of "cool" employed by Claire Danes and her buddies from *William Shakespeare's Romeo and Juliet*, the enigmatic signifier is, like, impenetrable.

Exemplary of "the enigmatic signifier," this popular dramatic pause, "like," gestures to analogy while emptying it out (signifying *to* without necessarily signifying *what*). In my previous book, *Like a Film* (1993), I reflect on many cultural and theoretical examples of such a reversal and destabilization of analogy by the very tropes of analogy on which we've come to depend to fill in the traumatic holes caused by gaps in the Real. But it was initially while working on some of the chapters in this book that I realized the importance of standing back from my fascination

11

with theatricality to pursue the common phantasmic analogy, "like a film." I then shifted my focus to craft a book around this phrase whose theorizations of identification and cultural difference provide a properly phantasmic foundation for *Drama Trauma*, here concerned more specifically with the dis-plays of performance. So it is in the sense of the enigmatic status of the performative that I introduce the notion of "drama trauma," a concept calling forth "the human capacity (of course initially, but not uniquely, by the infant)," Laplanche writes, "to continually create, touching the origin, the sexual from all sorts of external disturbances, from the *new* of which traumatism represents the most dramatic paradigm" (Laplanche 1980: 111). The enigma thus dramatically signifies *to* trauma continually from without and within, from infancy to adulthood.[12]

When considered in relation to performance, the many theorizations of traumatic ghosting from which my analyses derive are fascinating primarily because they exemplify the extent to which the terms of theory remain to be dependent on the spectral nature of the *mise en scène* they articulate. This is one reason why I follow the common lead of the many differing theoreticians so important to this book, from Lyotard, Cixous, Foucault, and Derrida, to Laplanche, Deleuze, Lacan, and Kristeva, in grounding my sense of "drama trauma" in the specificities yielded by the work of close reading.[13] So it went in *Like a Film*, when I found myself turning not so much to Abraham and Torok but to Julie Dash's film, *Daughters of the Dust* (1991), to lay the introductory groundwork for my interest in the cultural duplicities wrought by the discourse of incorporation. I find myself returning here again to the differing ways in which Yellow Mary and Nana Peazant encase their memories in order to protect and preserve their contrasting subjective and cultural positions. Still intriguing is how Yellow Mary calls upon the protective envelope of memory to reject her historical acculturation by the Eurocentric mainstream. She boasts at having "put all bad memories in that case and locked them dead. I didn't want them inside of me. Don't let nobody in that case or out of the case tell me who I am." The film's matriarch, Nana Peazant, presents a contrasting view of the enigmatic procedures of incorporation through which memories, good and bad, continue to speak even when encased as if dead. She knowingly instructs her offspring about her respect for the longevity and psychic independence of incorporated material: "never forget who we are and how we've come – we carry these memories inside of us; we don't even know where the recollections come from." A similar paradox regarding the conflictual specters of identification is voiced by the African-American performer, Robbie McCauley, in her performance piece, *Indian Blood*. McCauley laments her identification with the theatrical matriarchs, Medea, Antigone, and Medusa, by speaking of the "unrighteous fantasy" of

having "to be like them." What distances McCauley from the Occidental tradition of analogy she knows so well is that "Electra knows no rage like what I know." Yet what aligns these two forceful female performers is Electra's vast knowledge of "unrighteous fantasy" itself, of her conflicted identification with the cultural codes confining her.[14]

Ntozake Shange, too, has been the controversial subject of similar "unrighteous fantasy," caught within the codes and traditions she critiques and emulates, "afflicted," she writes, "with the kinds of insecurities & delusions only available to those who learned themselves thru the traumas of racism. what is fascinating is the multiplicity of individual responses to this kind of oppression" (Shange 1984: 24). Gates cites Shange as one of the female African-American writers whose insistent feminism has led her to be (mis)identified by African-American critics as a black male basher "accused of calculated complicity with white racists" (1992a: 75). Ironically, her personal attraction to photographic images of black men has left her subject to a similar, although more ambivalent charge, voiced this time by a white feminist interested in the taboo couplings of race and sexuality. At issue is Shange's penning of a laudatory Foreword to the American edition of Robert Mapplethorpe's controversial *Black Book* (1986).

Shange is not the least bit apologetic for promoting Mapplethorpe's book of nude black male bodies:

> I was drawn immediately to the pungency and clarity of form in his photographs. I love photographs; I even wrote a play called *A Photograph: Lovers-in-Motion*; a love story, a brutal love story, a war of sex and aesthetics. So when I was offered the opportunity to write something/anything about Robert Mapplethorpe's work, I was terribly enthusiastic. Black men, black and white prints of said black men, overshadow other obsessions.
>
> (Shange 1986: np)

In a reading of this Foreword, Jane Gaines raises the question of the extent of Shange's complicity in the fetishization of the black male for which Mapplethorpe has been subject to violent critique. One passage in particular catches Gaines's eye:

> Robert Mapplethorpe and I finally met in Houston. We flipped through the photographs looking for former lovers we knew were somewhere in the book. I said, "I can't seem to find him now, but I know he's there somewhere." Robert lifted his head slightly with a telling half smile: "I know what you mean, I can't find mine either." We liked each other and understood passion and good form are a constant gratification.
>
> (Shange 1986: np)

Gaines expresses concern that this search for the memory or the picture of love shared by the white man and the black female might be taken literally by readers as an invitation to view the pictures "like soft-core porn," an invitation authorized by the colonialist nostalgia for the black male body. In referring to the historical fetishization of this body, Gaines cites an essay penned by Kobena Mercer, and then nuanced by him and Isaac Julien for its disavowal of the fantasies of homosexual desire, that criticizes Mapplethorpe's formalist photographs of nude black men for mimicking his white culture's obsession with the black man's organ. As Mercer and Julien succinctly summarize the argument:

> The black subject is objectified into Otherness as the size of the penis signifies a threat to the secure identity of the white male ego and the position of power which whiteness entails in colonial discourse. Yet, the threatening phobic object is "contained," after all this is only a photograph on a two-dimensional plane; thus the white male viewer is returned to his safe place of identification and mastery but at the same time has been able to indulge in that commonplace fixation with black male sexuality as something "dangerous," something Other.
>
> (Mercer and Julien 1994: 194)

What is fascinating, I wish to suggest, about the imaginary search for former lovers shared by Shange and Mapplethorpe is how its unrighteous fantasy, its mixed specters of race and sexuality, unsettles the safety of any one "commonplace." For as Shange describes her rendezvous with Mapplethorpe, it was marked more by the traumatophilia of fantasy and loss than by the safe place of identity and mastery.

> I said, "I can't seem to find him now, but I know he's there somewhere." Robert lifted his head slightly with a telling half smile: "I know what you mean, I can't find mine either." We liked each other and understood passion and good form are a constant gratification.
>
> (Shange 1986: np)

Shange's open confession attests to the kind of new excitation, new energy, and new trauma deriving from the sublimated activity of photography ("good form") which Laplanche terms, traumatophilia. Differentiating, moreover, between the camera's fixating gaze and the desire of her glance, "he's there somewhere," Shange situates her passion in terms of the fantasy and excitation of loss – what Barthes calls the *punctum* and its Medusa-effect or what Lacan calls the scopic arrestation of "being-photographed"[15] – rather than the certainty of lack and the inhibition of its rigid photographic fetish. This obscure knowledge of the desirous "there" ("good form" in its purest philosophical sense) is something that resonates, in the words of Christopher Pye, "directly with

14

a domain beyond the symbolic register and the lack which ostensibly structures it" (Pye 1997: 17). This obscure "there," the jointure of photographic space and sexual loss, here precedes and exceeds for Shange the constancy of symbolic representation, its identity, mastery, and fetishism. At frequent intervals in the pages that follow, I will stress the enigmatic role of the deictic, in this case, "he's there somewhere," as the energetic pointer of unrighteous and traumatic fantasy. Whether figured as a deictic, a bad joke, a televisual glance, a missing person, or a linguistic gap, loss stands out in this book, in sharp contrast to phobic lack and the related place of identification and mastery, as the performative figure of trauma whose retrospective manifestation is both external and internal, spatial and temporal. I also will have occasion to dwell on examples similar to that of the grinning Mapplethorpe who too turns aside from the comfort of fetishism and its disavowal to acknowledge the ironical constancy of loss: "I know what you mean, I can't find mine either."[16] They can't find theirs, but they know them to be there; they understand passion and form as the gratifying carriers of the specters of loss that sustain the fantasy of seduction and its retrospective trauma. Put otherwise, in a formula I will restate in different ways throughout the book, loss, in contrast to lack, continually haunts the symbolic certainty of representation. *Loss functions as the death drive of implosive designation whose enigmatic dynamism is to be performed and enjoyed, not be contained and feared, as the stuff of seduction.*[17]

TELEVISUAL FEAR

Of equal importance to the project of this book is Shange's linkage of passion and form. Precisely how form operates as the aesthetic vessel of enigma plays perhaps the most fundamental role in determining the artistic and political viability of any artistic performance. Reflecting on the transformational intensities of form, Jean-François Lyotard found himself

> tempted to say, in spite of my interest in politics, that the best, the most radical critical activity bears on the formal, the most directly plastic aspect of painting, photography or the film, and not so much on the *signified*, be it social or anything else, of the object it is concerned with . . . it does not deal with the *signifieds* of things, but with their plastic organization, their signifying organization. It shows that the problem is not so much that of knowing what a given discourse says, but rather how it is disposed.
>
> (Lyotard 1984b: 28–29)

Evaluation of the racial politics of Shange's collaboration with Mapplethorpe has been gauged, for instance, by the disposition of photographic

form – as a rigid machinery of fetishism or as a fluid "genre" of seduction. Similar considerations of how discourse is organized and disposed pervade the analysis of performance and its plastic organization. In stark contrast to Shange, McCauley, and other multimedia performers such as Marina Abramovic and Ping Chong, whose interdisciplinary sensibilities make them so cognizant of the mediating contingencies of plasticity, many of the most passionate proponents of performance tend to couch their arguments in an almost metaphysical discourse whose anti-spectral and counter-televisual terms run contrary, I will suggest, to the most radical forms or "genres" of display and performance.

The discourse to which I refer runs the gamut from Shakespeare to feminist performance. In rehearsing a few prominent examples, I hope to foreground the terms of the analysis of form that are crucial to understanding any dramatization of trauma and its many signifying organizations. The first comes from a somewhat surprising source, the sophisticated feminist and dramatist, Hélène Cixous, who contrasts the depth of Shakespearean character with the flatness of television:

> That is theatre or theatricality. It is obviously – I am not going to say "the other scene" – what makes that a character becomes, *is*, worthy of theatre. For me the supreme example is Shakespeare. All of Shakespeare's characters are like that, every one of them is already his own little theatre. Every one of them gets up on his own stage. Every one of Shakespeare's individuals has his little kingdom, his micro-kingdom. We could say that each inhabitant (let us not say character) of Shakespeare is exceptional; he is rich, he effects us, he fascinates us, he is not a person without a kingdom whom we may cross in the street. There are many people without a kingdom. It must be said that if we put those in the theatre, the theatre fades away. At least, in the theatre the way I see and like it, because there is also a flat theatre. There are many false scenes, those of television, for example – which bring us nothing, because they have no inner universe and because they do not produce a sign.
>
> (Cixous 1997: 34–35)

While Cixous treads on the uncanny territory of "the other scene," she hesitates to align theatricality with the unconscious and chooses instead to identify the worth of theatre with the richness of the inner kingdom or the sovereign dignity of character. To do so, she contrasts theatrical depth, or Shakespearean character, with television's flatness and its many false scenes. But precisely the many false scenes and flat looks of Shakespearean theatre are those that touch to the core of this book. Attentiveness to the "crossed logic" of male outburst in *King Lear* or the "gastness" of an eye in *Othello* necessitates an analytical emphasis on the "nothing" made traumatic precisely because the show of its enigmatic

16

sign does not produce a "thing." Just such a demonstration of the fickle flatness of the signifier turns my analyses away from overemphasis on the psychological depth of character or the symbolism of micro-kingdoms and sociocultural meaning toward stress on the frequent false scenes and contradictory procedures of imaging that shape and lend form to the identifications, incorporations, and resistances of "genre."[18] Theatricality, in this sense, displays less of character and more of what Foucault, following Deleuze, calls "incorporeal materiality:"

> the expanding domain of intangible objects that must be integrated into our thought; we must articulate a philosophy of the phantasm that cannot be reduced to a primordial fact through the intermediary of perception or an image, but that arises between surfaces . . . in the temporal oscillation that always makes it precede and follow itself.
>
> (Foucault 1997: 218)

I will argue at different points in this book, moreover, that the representational model of such temporal oscillation of what is between surface, of what is flat on flat, can be found in the televisual and its theorization. Whether in foregrounding the false scenes and ideologies of the camera obscura, in presenting casually seductive procedures of viewing whose "looks" vary so dramatically from the scopophiliac gaze, or in challenging the presence of the stage with the iterative feedback of video and the 2-D sequencing of digitality, television and its electronic and theoretical variants here provide the retrospective machinery for analyzing theatrical structures and representations whose "flatness," whose "nothingness," so troubled the historical characters of depth and kingdom.

It goes without saying that such a defense of televisual delay and its flat excitations cuts against the grain of performance study. Perhaps the most characteristic, and, in my mind, most troubling assumption about theatricality pertains to the ideology of presence pervading the discourse of performance. The privileging of presence is particularly problematic when offered as the epistemological groundwork of otherwise admirable criticism that promotes the radicality of representation. Such a cautionary note is voiced by Peggy Phelan in her discussion of the realism of presence in *Unmarked: The Politics of Performance*:

> Performance implicates the real through the presence of living bodies. In performance art spectatorship there is an element of consumption: there are no left-overs, the gazing spectator must try to take everything in. Without a copy, live performance plunges into visibility – in a maniacally charged present – and disappears into memory, into the realm of invisibility and the unconscious where it eludes regulation and control.
>
> (Phelan 1993: 148)

In the context of the radicality of performance, Phelan challenges the equation of realism and presence in a way that clearly distinguishes performance from representation, visibility from invisibility, the live from the copy, and the gaze from the glance. As the supporting ground of such a conventional dialectic, the "real" here remains to be a category seemingly undisturbed on any level by the contingencies of mimesis and representation.[19] Such a feminist valorization of presence, especially when deployed by materialist feminists, remains curiously indifferent, Phelan warns, to its endorsement of the phallologocentric tradition which has been critiqued so thoroughly by poststructuralism, from Irigaray and Kristeva to Derrida and Deleuze. As Phelan also implies, "presence" also sustains the "gazing" machineries of perspective and their attendant ideologies of the visible and the consensual. Fortified by the technology of the bachelor machine, these suturing mechanisms of perspective and pluralism prop up the idealization of the homogeneous Subject.[20] These are the same ideologies that find themselves subject, as I argue below, to extensive critique by feminist and African-American performance, as well as dis-played on stage by Shakespeare and demystified on page by other such astute feminist readers of performance as Josette Féral, Elin Diamond, Erik MacDonald, and Anne Pellegrini.[21] Unqualified investment in a politics of "the real," which is generally characteristic of recent work in American cultural studies and materialist criticism,[22] runs directly counter to the spectral irreality of the differing representations of race and sexuality in the performances, texts, and images I read.

Although an account such as Phelan's bears the admirable motivation of the political reconfiguration of the institutional and discursive conditions that structure regulatory norms, it fails, at least as I read it, to take the additional critical step recommended by Biddy Martin of "reconfiguring interiorities, and, in particular, distributions of power, autonomy, attachment, and vulnerability" (Martin 1994: 106). Even though Phelan understands the life of performance to be extended by memory on the quivering terrain of the unconscious, what is invisible and unconscious is said curiously to elude regulation and control. What I hope will become clear by the end of this book is how extensively such memorialized or incorporated material remains embedded in the phantasmic vicissitudes of regulation and control, whether through the sadomasochistic censorship of the Super-Ego and the Ego-Ideal or through the telepathic machinations of encrypted memories and ghostly phantoms. Put otherwise, trauma as well as its aggressive regulation occurs from within as well as without, and is thus as ephemeral as it is material . . . being always already the retrospective supplement of seduction. As discussed in Chapter Ten, reconfiguration of regulatory norms involves not so much the censorial device of regulation itself as

the determination of which psychic and aesthetic principles governing regulation can be understood to contribute to productive social effects.

A corollary spin on the discourse of the real is a prevalent tendency to cast aspirations on particular forms of electronic representation as being counterproductive to the cultural contributions of performance. Consider Paul Gilroy's insistence on the distinction between "real time live" performance and the "unavoidable sense of loss" brought about by cinema, video, and visuality. Gilroy makes this distinction in relation to what he sees as the conflict between itinerant cultures and procedures of commodification. In practical terms, this results in a clash between black vernacular experiments with mixed-media and those caving into the "regulators of the aesthetic and technical codes that define theatre, music, dance and performance art based on the visual" (Gilroy 1995: 30). These regulators are insensitive to "a cultural style that reacts against the capital and labour intensive world of film which has been moved into the centre of our reckoning by the triumphs of the black independent sector in this country and abroad" (Gilroy 1995: 32). Just what should we make of these kinds of terms marshaled to demystify the color of commodification? To what extent do these examples exhibit, on the one hand, the tendency to associate the "real time live" with what eludes regulation, and on the other hand, the proclivity to demonize the cultural force of not only cinema in particular but "the visual" in general?

When performance work passes into the frontier where visuality dominates, Gilroy argues, "it withdraws much of its energy and its authority from the intimacy and indubitably moral force of real time and face-to-face interaction between performer and crowd" (Gilroy 1995: 31). This moral force, to be fair, has as much to do with the diminution of the "active witnessing" of live audiences as it reflects the strangely anti-visual undercurrent of Gilroy's discourse. But this reader is struck by the vehemence of Gilroy's almost Puritan association of morality with the live that seems to deny to the visual an enabling psycho-political force of its own, one deriving from the traumatophilia which is generated by the new excitation of sublimation itself. How can Gilroy so readily distinguish the morality of his real time from the hyperreality, say, of what Pontalis calls *"the visual:"* that which breaks its bonds with the visible world to bring into vision what escapes sight, those phantoms of trauma that always pack more intensity than can be had in the moral real (Pontalis 1990: 39)? Equally questionable is how such moral investiture of live spectating results in the rather impetuous endowment of "liveness" with criticality while continuing to subscribe to the "active" machineries of the gaze and its salvational difference from the mechanism of the televisual look and glance.

Parts Three and Four of *Drama Trauma* clarify how televisual "passivity" is endowed, as Shange might put it, with the knowing

satisfaction of libidinal seduction: "we flipped through the photographs looking for former lovers we knew were somewhere in the book." Finally, I wonder whether Gilroy's ethical investiture of the "live" might not result in something of a pernicious foreclosure of the value of critical performativity exemplary of the sort of televisual–cinematic viewing or dramatic–theoretical reading in which this book's artist–theoreticians engage. If "immediacy and proximity re-emerge as ethically charged features of social interaction," where does that leave the scary or academic or boring phantoms of Shakespeare? Have we come to such a moment of cultural crisis that we need to declare the hyperreal activities of critical reading and imagistic viewing as so uncool, so unethically laden, that we shouldn't value their practice? The texts and performances considered below suggest just the opposite, that close reading and its theorization lie at the core of the ethical and its enactment.

My hope, then, is to reflect on the many "genres" of practice and theory from which new critical energy comes from the traumatic seductions of the enigmatic signifier and its phantoms, whether this occurs awake or asleep, live or on tape. By focusing on artistic representations of the particularly charged tropes of race and sexuality at play, I hope to pause in critical reflection on these fluid categories whose specters are rendered tangential by colonial culture but which remain nevertheless as traumatically differend to it as they are empirically different from each other. These creative practitioners of the differend, from Shakespeare to Shange, recognize in their performance of spectral representation that, as Lyotard explains the differend, "what remains to be phrased exceeds what they can presently phrase, and that they must be allowed to institute idioms which do not yet exist" (Lyotard 1988: 13). It is in this sense, finally, that *Drama Trauma* very much shares Paul Gilroy's broader vision of a performance culture "propagated by unpredictable means in non-linear patterns," one whose "promiscuity is the key principle of its continuance" (Gilroy 1995: 15–16).

WHAT LURKS AHEAD

The chapters that follow very much reflect the non-linear incursions of theory and political performance that have altered our understanding of dramatic "genre" over more than the past decade. The idea for something like this book first crystallized following my term as editor of *Theatre Journal* (1984–87) when I sensed the importance of stretching the genres as we knew them to include the exciting sensibilities of post-structural theory, women's writing and feminist theory, the expanding corpus of African-American drama, as well as the influential revision of Shakespeare in the 1960s and 1970s by such directors and cineastes as Liz White, Carmelo Bene, Daniel Mesguich, Peter Zadek, Grigori Kozintsev,

and Peter Brook. On the heels of my first book, *Theatrical Legitimation* (1987), a deconstruction of the hegemonic structures of representation dominating seventeenth-century representation in England and France (the allegory of genius, the antitheatrical prejudice, the perspectival visibility of phallocentrism, the authority of literary and sociological institution, and the fetishized representation of female and racial Others), I had planned to write something of a companion book for theatre studies concerning the theme of *Machines of Visible Discourse*. Three chapters included in this book, Chapters Three on *Othello*, Five on *Getting Out*, and Seven on African-American drama, were to have provided the historical and conceptual framework of such an analysis of the theatrical machinery of hegemony. To a certain degree, the original project was marked by a polemical esprit of resistance to the academic establishment which today seems less imperative than does the reflective mood of critical intervention driving this book (the 1980s controversy over the introduction of "theory" to the hallways of academia and the pages of *Theatre Journal* seems almost anachronistic from this vantage point).[23] Informed by so much new interdisciplinary and multicultural work in performance, film, video, art, and theory that was just coming together back then, as well as by *Like a Film*'s theoretical groundwork on the vicissitudes of melancholy and identification, I now reflect not merely on the frail hegemony of genres of visibility but on the ambivalences and internal stains of their appropriations-in-difference. By here intermixing essays on the old and the new, some freshly written, some recently revised, and others bearing the historical imprint of their previous publication, I hope to create a reading environment of retrospective reflection whose promiscuous provocations, enigmas, and inconstancies attest to the force of re-reading which is always more seductive, more intense, and more enigmatic than it can ever have been the first time around.

Part One reflects on the transformation of genre and gender wrought by Shakespearean specters of linguistic play, vision gone awry, and well-seeming form. The common thread of this section is my claim that ideology works in Shakespeare not as the false consciousness of the burgeoning capitalistic age but rather as the complex strata of fantasy construction. Ideology presents Shakespeare's spectator with the vision of a doubled phantasmatic screen of both the pleasure of illusions and the fetishistic preservation of the residues of trauma. Chapters Two and Three develop the role played by genre in framing this screen of Shakespearean tragedy, in recovering and classifying past thoughts and virtues. Departing from Stanley Cavell's provocative thesis that "the form of tragedy is the public form of the life of skepticism with respect to other minds," these chapters question how tragedy provides an account of the knowledge of the Other, whether internal or external, whether sexual or racial. Chapter Two considers how different blends of social representation,

from storytelling and history in *Othello* and *Hamlet* to sovereignty, misogyny, and anamorphosis in *King Lear*, confound the epistemological promise of the certainty of knowing with the aphasia of trauma and the gore of state. But in contrast to the endings of *Othello* and *Hamlet* which are fixated on the paralyzing imagery of melancholic horror, *King Lear*, I suggest, turns to narrative and "feeling sight" as a means of confronting characters and spectators with the energetic vision, or traumatophilia, of the poisons of the play. By emphasizing the anamorphic captivation of the stained stone and the enigmatic deictic of Lear's "look there, look there," my reading shifts the balance of knowledge away from the dramatic conventions of memory, custom, and verisimilitude toward the new excitation of affect.[24] Chapter Three pauses to reflect on marginal generic structures in more detail and, to a certain extent, in more conventional terms. Relating the marginality of the Moor in *Othello* to the linguistic seductions of Desdemona, I reflect on the play's flaunting of the "antitheatrical" assumptions which its characters demystify. As for the character most exemplary of the disproportions of this play, I propose that we look to the marginal character whom Cixous might appreciate as being the most televisual one, Bianca, whose depth runs only as deep as her ability to change face, to practice "hypocracie." Finally, Chapter Four returns us to the primal scene of academic cool and its digital maxim, "my only love sprung from my only hate." In a reading of *Romeo and Juliet* today inflected otherwise by the cast of the televisual specters of Baz Luhrmann, I consider how Shakespeare's characters bring to the spontaneous stage of seduction and desire the bejeweled residues of racial and sexual difference that reveal the "ends" of representation: not simply the energetic speed of seduction and desire but also the fetishistic ghostings of the law and the specters of injunction which also return with ghostly consequence in the later plays by Shakespeare. Crucial to this account is consideration of differing theories of "spectralpoetics" or the spectralization of trauma spun by Jacques Derrida, Julia Kristeva, and Herbert Blau.

Part Two considers two contrasting projects that exemplify the rise of women's theatre in the 1980s. Chapter Five examines the machinery of visibility that subjects and subjugates women in Marsha Norman's prize-winning play, *Getting Out*. Reflecting Foucault's theory of the visual machinery of power, the play exemplifies how the performance of knowledge and judgment of an institutional body – whether penal or academic – is relational to the force of performance, to the ability of performance to delimit interpretation to the scene of its own codes of judgmental power. Norman's infusion of female humor into this panoptic stage results, I add, in the counter-display of an energetically theatrical intensity, in the sense of Lyotard, whose sounds and gestures overwhelm the panoptical genre with the monstrous enigma of seductive invocation. In contrast to Norman's emphasis on the visual effects of staging, Rochelle Owens's

word-play, *Chucky's Hunch*, repositions the *mise en scène* of fantasy on the narrative stage of the epistle. Chapter Six examines the single-character play in which Chucky reads to the audience a bizarre series of moody letters addressed but never sent to his former wife. Establishing a dialogue between performance and literary precedents from Proust, Poe, Shelley, and Bellow, Owens turns the tides on the tradition of the fictional epistle that has functioned historically to ensconce its female characters in the Law-of-the-Father and the discourse of the lack. Informed by the work of Barthes, de Man, Heath, and Cixous, this chapter details how Owens foregrounds the traumatic, maddening dilemmas of reading whose oral rehearsal of primal seduction produce the rhetorical effects of resonant perlocutionary responses to Chucky's sick phantasm of fissured subjectivity.

Part Three, "Color adjustments," puns on the title of Marlon Riggs's critique of television's historical effacement of race in order to reflect on the emphasis of African-American performance, and particularly feminist performance, on the techni-colors of difference. Chapter Seven dwells on the struggle of this performance over the technological means of the materialization and domestication of fantasy. Framed by the tenor of Heidegger's view of the "world picture," I reflect on this drama's resistance to the mechanizations of the bachelor machine, the camera's fortification through mechanical reproduction of man's position "as the representative of that which is." The dramas of Elaine Jackson, Adrienne Kennedy, Amiri Baraka, and Ntozake Shange collate the material of film, photography, and theatre to produce a screen of struggle whose crucial activity deflects any hegemonic vision of human agency through the release of fantasy's many representatives. In contrast to the "ideology of the visible" of the bachelor machine, these plays aspire to Fanon's "combat breathing" whose redemption, retrieval, and reclamation of the literary page, dramatic space, and cinematic screen underscore the struggle over previously colonized lives and limbs. Chapter Eight underscores the autobiographical urgency of Robbie McCauley's theatrical raising of the specters of unrighteous fantasy. This is a performer marked not only by her difference from Electra but by the mixed blood, *métissage*, of her African-American, Native-American heritage. *Indian Blood*, a mixed-media piece of performance, blues, food, slides, and video attests to the unrighteous specter of McCauley's African-American grandfather who fought against her own people in the Indian Wars and of her father who was haunted in word and deed by his internal colonization of Oedipal trauma and (white) male hysteria. For her part, McCauley resorts to the dissonant gestus of "combat breathing," that same performative call back by which Jackson, Kennedy, Baraka, and Shange define themselves while confronting their white spectators with the traumas of habitus, social function, and the supplement of differa(n)ce.

Part Four concludes the book by returning to the scene of technological crime, "Televisual fear." It expands the technological context of a claim I made earlier as the grounding thesis of *Like a Film*: that the cinematic apparatus, now understood to include digital capture and televisual creation, has invaded the theory and practice of culture as a mode of morphing the disparate "psychopolitical" fabrics of cultural production, psychoanalysis, and politically marked subject positions. Chapter Nine considers the 1980 BBC production of *All's Well that Ends Well* by Elijah Moshinsky and Jonathan Miller. Comparing the broken perspectival suture and diffracted vision of television with the fetishistic constructions of visibility and depth, the chapter plots the production's complementary staging of the play's destabilization of patriarchal marriage. Here I capitalize on the analogy of soap opera (television at its flattest?) and Shakespearean comedy to reflect on the subversiveness of the televisual "look." Such a "look" involves the performative procedures through which spectators are caught off guard by the spectacle's traumatic imprint on them.[25] Especially crucial is Moshinsky's citation of Vermeer and his televisual adaptation of the visual and ideological codes of the camera obscura through which Helena and her vision functions as the concave screen joining the doubled feelings of need and desire, of demand for corporeal contact and the lack of its sustenance. Chapter Ten was written in dialogue with recent debates over artistic censorship. I recall the censorial structures framing all communication to suggest, as I mention above, that the issue is not the evil of regulation itself, but the need to embrace principles governing regulation which can have productive social effects. These principles, moreover, always bear the traces of the differences enacted by visual immigration and its supplementary libidinal and material vanishings. This chapter playfully compares the media coverage of the 1986 unveiling of the renovated Statue of Liberty with the censorship of female and lesbian performances by the Louvre and the National Endowment for the Arts. In relation to the lesbian spectacles of Holly Hughes and the performative habits of the punk icon, Jordan, I argue that television provides a theoretical model of technological oscillation that dispels the reality of televisual commodification and subjugation.

"Televisual fear" finally acquires titular force in the concluding chapter, "Televisual Fears and Warrior Myths: Mary Kelly meets Dawn DeDeaux." Here the argument dwells on the historical levellings of the distinctions of race, class, and sexuality which critics skeptical of television and psychoanalysis claim to be the typical result of these practices (readers may already have recognized my appropriation of the phrase, "televisual fear," from Joan Copjec's "Introduction" to Jacques Lacan's *Television* (1990)). As readers of *Drama Trauma* by now will have come to expect, I dispute that assumption in turning to both television and

psychoanalysis for a comparative approach to the differing artistic projects of Mary Kelly and Dawn DeDeaux. While Kelly's conceptual concern with sequence, visualization, fetishism, and display reflects her extensive involvement in the feminist appropriation of Lacanian psychoanalysis and her early training in avant-garde film, DeDeaux's focus on materials of power and oppression stems from her interactive work in documentary video and her resistance to television's supposed impact on black youth culture. This chapter provides close readings of Kelly's 1992b art installation on the Gulf War, *Gloria Patri*, and DeDeaux's 1992–93 mixed-media, interactive video installation, *Soul Shadows: Urban Warrior Myths*. While stressing their differing sensitivities to representations of race, sexuality, and culture, I argue that the uncanny commonalities of their work also erode the unproductive political split now plaguing the study of performance, video, art, and culture. This is the gulf separating theoretical practitioners of psycho-philosophical approaches to representation from materialist proponents of social, racial, and gender analyses of culture and power. In the process, I reflect on how these projects represent the colonized subject's "ambivalence of mastery," in the sense of Homi Bhabha, and what Stuart Hall calls the diasporic "inheritances" in which artistic legacies of incorporated fantasy are forged.

I conclude the final chapter of *Drama Trauma* by considering how DeDeaux's experimentation with video transfer and sequencing seems to bring to life the haunting words of Antonioni's 1970 prediction of video's "possibility of producing a different impact on matter, the possibility of being more violent than even the matter one treats" (cited by Bellour 1990: 190). In the context of this Introduction's emphasis on traumatophilia and its performative corollaries, I wonder what Antonioni would make of the hypertelevisuality of the film with which I began, *William Shakespeare's Romeo and Juliet*. There is no doubt that this film is more viscerally violent than even the matter it treats. But when it comes to describing the impact of its digital modelings of Shakespeare, television, addiction, and the hybrid commodity cultures of race and sexuality, perhaps he would rely on the simpler discourse of teen culture. Perhaps he would suggest that this mixed bag of an energetic film, much like the hybrid drama of this traumatic book, is ultimately more scary or academic than the genres of cool *to* which it signifies, as like "this is impenetrable."

NOTES

1 This linkage is analyzed in detail by Klaus Theweleit in *Male Fantasies* (1987).

2 All citations of Shakespeare are from *The Riverside Shakespeare*, ed. G. Blakemore Evans (1974).

3 Equally fascinating is how Luhrmann stages Mercutio's iteration of his dying curse, "A plague a' both your houses" (III.i.99–100) in such a way to

dramatize the centrality of his character and its previous staging by Carmelo Bene. Gilles Deleuze describes Bene's dramatization of Mercutio as the "amputation" of the character, Romeo: "If you amputate [subtract] Romeo, you will witness an astonishing development, the development of Mercutio who was only a virtuality in the play by Shakespeare. In Shakespeare, Mercutio dies quickly. But, in Bene, he does not want to die, he cannot die, he does not manage to die since he will become the subject of the new play" (Deleuze 1997: 239).

4 The ambivalent and unsatisfactory representation of race and multiculturality of this film has everything to do with how culture, and Hollywood culture in particular, is situated within the conflictual fantasy of what I'll be calling the specters of race. In many respects, Luhrmann's film is indicative of the broad genre of white-authored masculine films analyzed so perceptively by Sharon Willis (1993: 67) as those that "understand masculinity as racialized, and that understand their own context as multicultural." In her essay on Quentin Tarantino, Willis acknowledges the imperfections of these films while insisting on the significance of their viewing:

> Such an equation emerges at a moment when the dominant white culture might begin to take seriously the ongoing historical conversations with African-American cultural production that have always been centrally structuring to its very fabric. Tarantino's ahistorical reading of these conversations is deeply fetishistic. But another reading, one that respects history, might ask what US culture would look like without this conversation, saturated with struggle though it has been. Critically analyzing and contesting the work that acknowledges the conversation may be our best way of owning up to the ways in which we don't own culture, but it owns us, in the sense that we are claimed by it. Tarantino's films offer something different; the symptoms they display signal certain shifts in the terrain of racialized representation. And this bears watching, since it watches us.

5 Regarding the blending of research and trauma, see the collection of essays compiled by Caruth (1995).

6 Of *Prospero's Books*, Greenaway writes, "In this script it is intended that there should be much deliberate cross-identification between Prospero, Shakespeare and Gielgud. At times they are indivisibly one person" (Greenaway 1991: 9). See my analysis of this "cross-identification" in "You Are How You Read: Baroque Chao-Errancy in Greenaway and Deleuze" (1997a).

7 I develop this point, particularly in relation to Shakespeare, in *Like a Film* (1993: 1–21; 101–23). Anne Cheng provides a thoughtful reflection on the melancholic nature of such ambivalence in her essay, "The Melancholy of Race" (1997).

8 In "Money Talks, Again," Phelan (1991) provides an excellent overview of the issues surrounding this NEA controversy.

9 Although the artifacts analyzed in this book tend to privilege African-American discourse as the privileged or originary site of American racialization, Chapter Eight on Robbie McCauley emphasizes how deeply African-American identity is embedded in a complex multicultural topography of its own, one which has become more pronounced in recent years, and one which has led us to theorize race through the differential lenses of multiculturalism. I agree with Cheng (1997), moreover, that particularly

fraught identifications of African-American culture provide an appropriate bedrock for consideration of other US multicultural formations of racialization and resistance, such as the Black and Latin Shakespeare Company.

10 See their essay "Fantasy and the Origins of Sexuality" (Laplanche and Pontalis 1986).

11 Fletcher (1992) provides a very helpful overview of the place of the enigmatic signifier in Laplanche's theory of the unconscious.

12 In his exceptional book, *Stages of Terror* (1991: 15), Anthony Kubiak distinguishes his notion of theatrical "terror," derived most specifically from Lacan, from trauma theory. Yet his description of trauma as taking place within a "scene" of performance very much resembles the dramatization of trauma as understood by Laplanche to occur in the "scene of fantasy:"

> We cannot, therefore, think of thought, of dream, or of mythic-memory and their associated traumas as phenomena that occur "within" a performative context. Rather the performative itself is the necessity through which something like the myth-as-seduction scene and its ensuing trauma come into being. Freud seems, at some subliminal level at least, to presuppose this; although he never uses theatre as a *paradigm*, he develops his theory of sexuality and trauma along theatrical lines when he "metaphorically" places such phenomena as memory or dream within a preexisting and essentially performative context – a "scene" or *theatre* that is "always already" there to receive it.

13 I note Jean-François Lyotard's respectful formulation: "I imagine there will always be a difference between artists and theorists, but that is rather a good thing, for theorists have everything to learn from the artists, even if the latter won't do what the former expect . . . ; so much the better in fact, for theorists need to be practically criticized by the works that disturb them" (Lyotard 1984a).

14 Writing on the video works of Pranja Paramita Parasher and Pratibha Parmar, Amy Villarejo (1996: 160) makes a similar point about the "retrospective hallucinations" of postcolonial video: "From within the dizzying effects of transnationality and the international division of labor, postcolonial video seeks to dismantle the representation of ethnographies or heroic portraits, by providing counter-histories in the form of contradictory forces which shape diasporic experience."

15 See Barthes (1981) and Lacan (1978). I elaborate on their photographic terms in "Photo-Medusa: Roland Barthes Incorporated" (1993: 65–97). See also my discussion of the extension of Mapplethorpe's black visions by Thierry Kuntzel's projects in video, in "*Et in Arcadia Video*: Poussin' the Image of Culture with Marin and Kuntzel" (1997c).

16 For broad and helpful discussions of fetishism's ambivalent role in art, see Apter (1991), Bhabha (1994), and Mulvey (1996).

17 Mapplethorpe's rejoinder, "I know what you mean, I can't find mine either," also adds to the traumatic effect of Shange's expression of his book's seduction – it's almost as if this text were scripted by Laplanche to illustrate his theory of the retrospective impact of seduction, that "it takes at least two traumatisms to make one" (Laplanche 1980: 202).

18 More attentiveness to the scene of Freud may even have led Cixous to the point stressed by Greenberg (forthcoming) that Freud and Rosolato understand the Ego as "the projection of a surface."

19 Directly counter to such feminist valorization of the real is Elin Diamond's welcome book, *Unmasking Mimesis: Essays on Feminism and Theater* (1997), whose Introduction boldly refutes the embrace of mimetic realism by feminist critics of the theatre. As I document in *Mimesis, Masochism, and Mime: The Politics of Theatricality in Contemporary French Thought* (1997b), the French poststructural tradition has dwelled seriously on the vicissitudes of mimetic realism.

20 In striking contrast are the artists and writers included in the catalogue, *Inside the Visible, in, of, and from the Feminine: An Elliptical Traverse of 20th Century Art*, edited by M. Catherine de Zegher (1996), who challenge the hegemony of "the gaze" by, on the one hand, referring to postLacanian theories of the screen (see also Murray 1993: 43–49), and by exploring the psycho-political vicissitudes of visibility, on the other. In the words of one of its artist–theorists, Bracha Lichtenberg Ettinger,

> The concepts of *matrixial* gaze and screen, with the aid of which I propose to explore artwork and processes of art making, enable us to conceive of and perceive links connecting artist, viewer, and artwork. I term *metramorphosis* specific routes of passability and transmissibility, transitivity, temporary conductivity and transference between various psychic strata, between subject and several other subjects, and between subjects and composite, hybrid objects – routes through which "woman" that is not the preserve of women alone is inscribed in a subsymbolic web, knitted just-in-to the edges of the symbolic universe that cannot appropriate her by its preestablished signifiers.
>
> (Ettinger 1996: 93)

21 See Féral (1997), Diamond (1997), MacDonald (1993), and Pellegrini (1996), as well as Benston's fine overview of performance as supplement in "Being-There: Performance as Mise-en-Scène, Abscene, Obscene, and Other Scene" (1992).

22 I elaborate on this point in "The Mise-en-Scene of the Cultural," my Introduction to *Mimesis, Masochism, and Mime* (1997b).

23 See Sue-Ellen Case's brief account of the battle over theory in her Introduction to *Performing Feminisms: Feminist Critical Theory and Theatre* (1990: 1–3), the collection of feminist essays published in *Theatre Journal* during our combined six years as its editors.

24 As a way of illustrating the critical contrast I here invoke, I refer readers to the different sociological, philosophical and psychoanalytical approaches to the representation of authority shown, say, by the work of Weimann (1992; 1996); Marin (1988); and Rose (1996).

25 Students of Lacan should not be thrown off here by my use of "look;" whereas Lacan would use the term "gaze" for a similar procedure, television theory contrasts the solicitous "look" from the spectatorial fixation of the cinematic "gaze."

Part I

SOUNDING SILENCE IN SHAKESPEARE

2

GETTING STONED
Psychoanalysis and the epistemology of tragedy in Shakespeare

What might it mean to speak of an ontology of stone in Shakespeare? Stanley Cavell suggests one approach in his substantial chapter on *Othello* in *The Claim of Reason: Wittgenstein, Skepticism, and Tragedy*:

> So they are there, on their bridal and death sheets. A statue, a stone, is something whose existence is fundamentally open to the ocular proof. A human being is not. The two bodies lying together form an emblem of this fact, the truth of skepticism.
>
> (Cavell 1979: 496)

This description of the memorable tableau of *Othello*'s final act serves as a conceit of Cavell's substantial elaboration on the argument of his earlier well-known essay about the failure to acknowledge love in *King Lear*. In reading *Othello* and *King Lear*, Cavell equates tragedy with the hermeneutic problem of skepticism – the inability of characters, especially Othello himself, to inhabit and be inhabited by the Other, to know or be known by the Other. "Tragedy," he writes, "is the place we are not allowed to escape the consequences, or price, of this cover: that the failure to acknowledge a best case of the other is a denial of that other, presaging the death of the other, say by stoning, or by hanging" (Cavell 1979: 493). Stones and statues represent in Cavell's discourse both the objects of representation and the crisis of subjectivity inherent to tragedy – left to their own devices, subjects will inevitably be blinded by their narcissistic quests for ontological certainty. In the process of dramatic identification, the hermeneutic failure of characters is said to be doubled by the mimetic response of spectators. When acknowledging such failure, the Shakespearean spectator is faced with but one consequence: "the death of our capacity to acknowledge as such, the turning of our hearts to stone, or their bursting" (Cavell 1979: 493). The occasion of tragedy might be described, then, as a ritual . . . of getting stoned.

I jump right into Cavell's extremely abstract relation of stones and statues with a dual purpose. In recommending his substantial essay on *Othello* as one of the best essays written about the play, I wish to take

issue with its assumptions regarding dramatic mimesis. This essay is motivated by an almost blinding focus on the humanistic experience of fiction, one either bursting our hearts or turning them to stone. While Cavell's reading of tragedy as skepticism has brilliant implications for an understanding of early modern empiricism, it leaves untroubled the attendant conception that knowledge in drama is produced foremost by the spectator's unmediated experience of the sentiments of characters themselves. Put otherwise, this character-based theory of tragedy rests uncomfortably on the phenomenological premise that what we see is what we (should) get.

But when the philosophical discussion of tragedy becomes divorced from the broad range of discourse that frames characters and philosophers, it becomes difficult to determine the extent of theatre's relation to skepticism, that is to say theatre's staging of the failure of self or the hollow hopefulness of subjectivity. Regarding the philosophical enterprise, Maurice Merleau-Ponty warns, in *Le Visible et l'invisible* (1964: 21), that the skeptical reasons one might have for assuming the "uncertainty" of existence always rely on an assumption that one already knows what it is to exist (what it is to see and what it is to be seen). Similar caution might be exercised in relation to a critical fixation on the "mental" failures of individual characters when such a focus takes for granted the psycho-political elements that lend worth, on the one hand, to the desire for knowledge and, on the other hand, to the institutional forces of government, society, and aesthetics that seek to delimit representation, that aim to determine, in the mystifying jargon of Bosnia or Desert Storm, our "need to know."[1]

This chapter will consider how different discursive blends of social representation, from storytelling and history in *Othello* and *Hamlet* to sovereignty and misogyny in *King Lear*, envelop any promise of the certainty of knowing in the trauma of needing that confounds discourse and its practice, whether public or private. The only thing that Shakespearean tragedy consistently represents as certain, I will suggest, is its characters' need to fill the aphasia of trauma with the enigmatic stuffing of word and image. As a result, so Lacan and Laplanche would say, the stuff or "thing" of tragic dialogue signifies *to* its spectator without the spectator knowing exactly *what* it signifies.[2] The spectator leaves tragedy armed not so much with the truth of skepticism as with the enigma of the signifier gesturing so frantically to the trauma of fantasy, to the hole in the Real.

Shakespearean tragedy demonstrates how the varying force and fluctuating charge of such designation lends to tragic drama a particularly psycho-political or ideological magnetism. Hailing, summoning, or beckoning the spectator as if a phantom hallucination, the energy of tragedy situates the core of social order not on the epistemological

bedrock of the certainty of signification or on its frightful lack which can be disavowed and overcome, but on an emotive stage that forcefully performs and designates signification as the halting enunciation of the trauma of loss.[3] Loss, in contrast to lack, haunts the certainty of representation as the continual force-field of implosive designation whose trauma is not to be overcome. It is in this context that readers of Shakespeare will benefit from considering the charge of ideology, its magnetism and its aim. On the stage of tragic drama, the charge of ideology is thus to shore up loss with the symbolic illusion of a choice of optical proof between governance and chaos, between knowing and needing. Ideology in Shakespeare is not so much the false consciousness of the burgeoning capitalistic age, whose birth so many Marxist critics wish to attribute to Shakespeare and his contemporaries. Rather, it is the more subtle and sublime "thing" which Slavoj Žižek describes as the belief supporting the fantasy that regulates social reality:

> ideology is not a dreamlike illusion that we build to escape the insupportable reality-construction which serves as a support for our "reality" itself: an "illusion" which structures our effective, real social relations and thereby masks some insupportable kernel (conceptualized by Ernesto Laclau and Chantal Mouffe as "antagonism:" a traumatic social division which cannot be symbolized). The function of ideology is not to offer us a point of escape from our Reality but to offer us the social reality itself as an escape from some traumatic, real kernel.
>
> (Žižek 1989a: 45)[4]

I will argue here in relation to *Othello, Hamlet,* and *King Lear,* and again in Chapter Three on *Othello* and in Chapter Four on *Romeo and Juliet* that ideology works in Shakespeare as the complex strata of fantasy construction that provides the spectator with a doubled phantasmatic screen of both the pleasure of illusions and the fetishistic preservation of the residues of trauma. These tragedies offer to their spectators the social reality of the containment, as Iago would say, of "gastly eyes" that falsely promises an escape from the traumatic, real kernel of gender, racial, and sexual difference. Put simply, ideology provides the spectator with only the gastly illusion of a choice between statues and stones.

NARRATIVE TRANSFERENCE, HYPERBOLIZED MATTER

A turbulent coalescence of knowing and needing is nowhere more apparent in Shakespearean tragedy than at the very end of *Othello* when the spectators are confronted by the pathos of mass murder and the threat of social mayhem. If we go one step beyond the tragic loading of Othello's

bed, past that horrific scene of blood and breathlessness which Cavell relates to the paradox of statues and stones, we find that Shakespeare's play ends not with the immediate spectacle of the poisoned sight of death (and thus the cathartic "closure" of Shakespearean tragedy) but with the determination by Lodovico that future evaluation of the spectacle will be limited on a "need to know" basis:

> O Spartan dog,
> More fell than anguish, hunger, or the sea!
> Look on the tragic loading of this bed;
> This is thy work. The object poisons sight,
> Let it be hid. Gratiano, keep the house,
> And seize upon the fortunes of the Moor,
> For they succeed on you. To you, Lord Governor,
> Remains the censure of this hellish villain,
> The time, the place, the torture. O, enforce it!
> Myself will straight aboard, and to the state
> This heavy act with heavy heart relate.
>
> (V.ii.361–65)[5]

Othello ends with a promise to relate tragic acts to the traumas of the heart. But the conditions of such a relation – not the relation itself – are what determine the extent to which Lodovico's audience will leave the theatre with a sense, so to speak, that no stone has been left unturned. Lodovico begins by highlighting the tragic gesture of designation that has haunted the fantasy of spectatorship ever since Iago's "Hah? I like not that" beckoned the paranoia of the hapless Othello in III.iii.34. By the end of the play, the disturbing evidence of "that" becomes the tragic sight of "this": "Look on the tragic loading of this bed; This is thy work." However, Lodovico promises to soften the enigmatic blow of designation by transforming through narration the traumatic object that so poisons sight. What will count in the official version of events, so Lodovico suggests, is not the hidden dramatic object itself, or even the thoughtful subject so witnessing it, but the stabilizing promise of its censorship, the verisimilar relation of official "state" text to the censored image of heavy act.

A likely result of such promised narration can be gleaned from one Renaissance account of historical narrative which Shakespeare cites in *The Tempest*. In "Of the Canniballes," translated by Florio in 1603, Montaigne challenges any popular assumptions regarding the realism of the Renaissance genre of travel or conquest narration. Concerning such narrative accounts as Lodovico's promised narration of the heavy sights of Cypress, Montaigne notes:

> Subtile people may indeed marke more curiously, and observe things more exactly, but they amplifie and glose them: and the

better to perswade, and make their interpretations of more validitie, they cannot chuse but somewhat alter the storie. They never represent things truly, but fashion and maske them according to the visage they saw them in; and to purchase credit to their judgement, and draw you on to beleeve them, they commonly adorne, enlarge, yea, and hyperbolize the matter.

(Montaigne 1893: 93)

With the fashion of ornamentation adorning the visage of an engaging storyteller, the activity of narration places such historical narrators as Lodovico in an untenable position. For, as Montaigne says, "they cannot chuse but somewhat alter the storie." Adornment, hyperbole, and enlargement are the very tropes of excess and displacement that align such storytelling more with the excessive virtuality of theatricality than with the realism of truth. Hyperbole, for instance, is one trope singled out by the Abbé d'Aubignac as particularly appropriate for theatre "where everything must appear larger than life and where there is but enchantment and illusion" (d'Aubignac 1927: 353).[6] What theatricality and narrative adornment have in common, argues d'Aubignac, is the antagonistic ability of hyperbole to "carry the imagination farther" (d'Aubignac 1927: 353) than does the word's own meaning. The implication, then, is that theatrical rhetoric functions first and foremost as the stimulant of virtual fantasy effects rather than as a producer of dependable meaning. The promise of rhetorical excess for neo-classical theatre, to bring d'Aubignac's terms now to bear on *Othello*, was that its power and delight hung in the balance of the ideological fragility of virtuality, not in the moral certainty of poisoned sight. For the dramatic illusions of amplification and its maskings were contingent on their theatrical ephemerality as the perfect mirror images of a state apparatus whose ill-formed parts and poisoned sights threatened to break out against the censorship of illusion at any moment.

While Cavell might ascribe such fateful amplification to the tragedy of skepticism, to the pitiful failure of our "need to know," a different reading of Montaigne's passage might place more emphasis on the universal process of needing (in the sense of desiring or wanting) than on the individual's failure to know. What distinguishes these two positions – knowing and needing – is the difference between the failure of *the individual* to "acknowledge" the truth of narrative and the representational force of *narrative* to perform, to designate, truth as need. Let me rephrase this sentence which is crucial to my argument: while the crisis of knowledge involves the failure of a character like Othello to see someone like Desdemona correctly, the requirements of narration, from censorship to amplification, exceed the bounds and limits of the abilities of such a character as Lodovico to separate what he needs from what he

knows in telling the story. In other words, what confuses these two positions – knowing and needing – is not the failure of *the individual* to "acknowledge" the truth of narrative but the representational force of *narrative*, or textuality *per se*, to perform need as the excessive loss of truth.

The rhetorical performance of need is nowhere more apparent than in Lodovico's alliteration of grief at the conclusion of *Othello*: "this heavy act with heavy heart relate." This emotive, mournful display of narrative foregrounds how analytical efforts and/or failures to read, to understand, to interpret broader textual structures and strata stand fraught in relation to the stabilizing procedures of censorship, on one hand, and the excessive spillage of loss, on the other. Can the precariousness of verisimilar proofs overcome the trauma of the affective relations of loss and their supplemental censorship? As shrouded in the heavy garment of Lodovico's grief and loss of sight, the conditions of cathartic narration in *Othello* appear to remain contingent on the ephemerality of a grotesquely awkward theatrical apparatus whose censored specters haunt the collectivity of rational self and rationalized state.

In the following reflections on similar relations of verisimilar narration to dramatic representation in *Hamlet* and *King Lear*, I am interested in considering those moments when accounts of crises, or the promise of such narration, conclude or even drive dramatic action, thus setting in motion the process of "drama trauma." By this, I mean the way plays set in motion – overtly or covertly – dramatic re-vision or re-figuration through the frames of traumatic narration. I will have occasion here to develop this point in terms of the inabilities of the detached and judging observers *Hamlet* and *King Lear*, most notably patriarchs and sovereigns, to escape the effects of their own hopes and desires for the outcome of their deliberations. Judgment is here a two-way relay in which the boundaries of subject and object always overlap.

Harry Berger attributes this slippage between subject and object on the Shakespearean stage to the frequency of procedures akin to "psychoanalytic transference" through which "speakers as characters are the effects rather than the causes of their language or interpretation" (Berger 1989: 813). Freud's concept of transference denotes the process of psychoanalytical exchange between analyst and analysand that results in a reshaping of past desires into an altered reality of present narration, one that has bearing on the future. Different from, but engaged in the patient's initial manifestations of desire, narrative transference actualizes the past of the speaker through representation to the newly desired listener. But since the ego of the psychoanalytical subject, or, I might add, the historical narrator, is no longer identical with the presence which is speaking, "all of the patient's symptoms," writes Freud, "have abandoned their original meaning and have taken on a new sense which

lies in relation to the transference" (Freud 1953–74: XIV, 444). Lacan goes one crucial step farther than Freud by attributing hermeneutic confusion to the entire scene of the subject's constitution in desire, that is, to both transference and countertransference, or the passions, anxieties, and projections of the analyst as well as of the analysand (Lacan 1966: 215–26).

The dilemma of interpretation that the dynamic of transference poses has provoked recent narrative theorists to discuss this psychoanalytical process as a possible model of text and reading, one especially well suited to the dilemmas of historical narration.[7] Narrative transference can be understood to generate the sort of disjunction of trauma and content, designation and signification, performed by Lodovico and endemic to a wide variety of Shakespeare plays. In these instances, the condition of "getting stoned" is less likely to represent the hermeneutic failure of skepticism, resulting in "the turning of our hearts to stone, or their bursting," than the hallucinatory fantasies haunting tragedy and the apparatus of state judgment it serves.

NATION AND NARRATION

The case of *Othello* might already have brought to mind the conclusion of *Hamlet*. The play ends with the order of Fortinbras:

> four captains
> Bear Hamlet like a soldier to the stage,
> For he was likely, had he been put on,
> To have prov'd most royal; and for his passage,
> The soldiers' music and the rite of war
> Speak loudly for him.
> Take up the bodies. Such a sight as this
> Becomes the field, but here shows much amiss.
> (V.ii.395–401)

The conclusion of *Hamlet* is quite similar to that of *Othello* in wanting (desiring/failing) to reorder, or to block out, the sight of death. Also like Lodovico in *Othello*, Fortinbras here relegates his description of the heap of bodies to the enigmatic signifier, "*this*," in a way that suggests that visual censorship is most effective when its object is relegated to the obscure status of the deictic. In this instance, the deictic positions the spectators directly within the field of visual fantasy without providing them with the anchor of objectivity for reflexion. "Such a sight as this" orients the spectators to what Laplanche understands as the analogical condition inherent to fantasy in which a signifier signifies *to* someone without its addressee knowing necessarily *what* it signifies (Laplanche 1989: 45). In being signified to, the spectators are thus a traumatic effect of signification rather than the cause of its meaning.

This distinction is crucial to an analysis of the role of Fortinbras as the manipulating agent of deixis. Consider how Fortinbras's order, that the spectacle of death be rearranged, follows his assertion of his sovereign right to receive a narrative account of the sorrowful events of Denmark:

> Let us haste to hear it;
> And call the noblest to the audience.
> For me, with sorrow I embrace my fortune.
> I have some rights, of memory in this kingdom,
> Which now to claim my vantage doth invite me.
> (V.ii.386–90)

This passage raises the specter of a whole (g)host of questions concerning the ideological valence of the play. How might we understand Fortinbras's rights of memory in relation to his practice of aesthetic blockage? Does the right of vantage derive necessarily from the loss of sight or "vantage point"? If so, what might this disjunction tell us about the conclusion of *Hamlet*, not to mention tragedy *per se* in which the righting of perspective is so much an issue?

If "*Hamlet* ends with a strong sense of purgation," as asserts Frank Kermode (1974: 1140) among others, this is accomplished by a not inconsequential switch of Hamlet in *rigor mortis* for a promise of the rigorous narration of "memory." Shakespeare ends the play not by focusing on sight amiss but by transferring the scene of representation from the spectacle of loss to a ceremony of legal narration, for whose audience the "noblest" will be summoned. In ordering the corpse of Hamlet to be borne "like a soldier to the stage" and in decreeing that the ceremony "speak loudly *for* him" (my emphasis), Fortinbras assumes the burdens of Denmark's history. In this instance the staged re-presentation of "memory in this kingdom" should be effective enough to transfer the pity and fear of Hamlet's tragedy into the cathartic fortune of Norway's victory, allowing him "now to claim my vantage." This switch of narrative for death mask makes one wonder, then, whether the funereal spectacle of narration – that is, the relation of deadly conquest to its displaced representation in national story and theatricalized image – doesn't stand forth as the fictional bedrock, the monumental tomb, of nation.[8]

Yet the fortune claimed by Fortinbras, like that transferred to Gratiano at the end of *Othello*, must be recognized as a dangerously melancholic one. For the rights "of memory in this kingdom" are embraced only through the enigmatic effects of the incorporation of "sorrow." Norway appears to be able to gain his vantage not by speaking for himself but by inhabiting the "vantage" of the blocked sight of whatever it is that has been lost. Put simply, his position is more affected by trauma than caused by any "vantage" of the language or interpretation of history. The French

psychoanalyst, Nicolas Abraham (1988) has gone so far as to suggest that Fortinbras himself is haunted by the phantom of his own father who haunts the text as the ghost of Hamlet's true father. According to this reading, the ghostly phantoms of incorporation speak loudly for Fortinbras just as the ghost of the father haunts Hamlet throughout to shake the promise of sovereign legacy and institutional stability.

What is especially interesting about Fortinbras's attempt to correct the tragedy of Hamlet, moreover, is how he differs from Lodovico by identifying a legitimate role for the deadly deictic that situates the force of designation within the split field of ideological magnetism to which I refer above. "Such a sight as this / Becomes the field, but here shows much amiss." While the force of "such a sight as this" becomes the battle-field where sight, power, and phallic lack are the conventional operators of symbolic struggle, the enigmatic signifier, "this," can perform only as a marker of loss and disturbance in the censored show of courtly aesthetics. By naming the act of censorship as "a miss'ed encounter," moreover, Fortinbras puts the deictic into circulation as if a phantom hallucination that haunts the cultural order and designates the trauma and loss exceeding the narrative of history.[9] To return to a point made earlier, loss, in contrast to lack, here haunts the symbolic certainty of representation as the continual force-field of implosive designation whose Real melancholic fantasy cannot be overcome.

THE GOR'D STATE SUSTAIN

King Lear may provide the most exemplary Shakespearean case of this melancholic relation of nation and narration. Following in the path of Shakespeare's earlier characters, Fortinbras and Lodovico, Albany responds to the carnage at the end of *King Lear* by commanding that the spectacle of tragedy be regulated in proper perspective. Regarding the heap of death represented by the lifeless Cordelia and Lear, Albany takes on the charge of mourning:

> Bear them from hence. Our present business
> Is general woe. [*To Kent and Edgar*] Friends of my
> soul, you twain
> Rule in this realm, and the gor'd state sustain.
> (V.iii.318–21)

What distinguishes the decree of Albany from those of Fortinbras and Lodovico is its unhesitant inclusion of gore as the stuff of state. Whether "hardened rheum from the eyes," "a triangular piece of land," or "blood shed in carnage" (OED), the "gore" of *King Lear* is incorporated by Albany as the viscous fabric of rule. As I will argue in the remainder of this chapter, moreover, Albany presents "the gor'd state" as the realm's

ontological condition to be sustained quite differently from the "poisoned sight" or "show amiss" that has been blocked, hidden, and censored by other narratives sanctioned by the Shakespearean state. For Albany's incorporation of gore as the trope of state is emblematic of the point I wish to stress about *King Lear*, that the conceits of perspective and narration in the play are *fundamentally* distinct in texture and tone from those on which I've touched up to this point. While the title, "King Leer," indirectly pathologizes sovereign perspective as the residue of the voyeuristic gaze, the play more directly confronts the beholders with demystifying reminders of the visual horrors of spectacle and their retrospective telling. Very near the conclusion of the play, Kent and Edgar inquire: "Is this the promis'd end? / Or image of that horror?" (V.iii.265–66). They hint to the audience that any promise of a conclusion does not necessitate a blockage of sight or an end to the trauma of representation, but rather foregrounds the hyperbolic matter of the supplemental image of horror. These lines echo, of course, Edmund's earlier reference to the ghostly hallucinations haunting his attempt at narration. He heightens the rhetorical thrust of his empirical account of Edgar's revolt when he reports to Gloucester: "I have told you what I have seen and heard; but faintly, / nothing like the image and horror of it" (I.ii.174–75). *King Lear*, I will argue, is distinctly different from *Othello* and *Hamlet* in providing a means for understanding tragedy as a fertile field of hallucinations whose specters convolute the empirical as well as ideological relation of seeming and seeing, of statues and stones.

King Lear is fascinating not only for its fixation on the horrors of imagery, its theatricalization of "drama trauma" (and the play is replete with such trauma), but for its concluding attempt, unparalleled in Shakespearean tragedy, to turn to narrative as a means of confronting characters and spectators alike with the unblocked sight of the poisons of the play. You might recall the amazing transformation of Edmund, who knows only too well the powers of the letter, when he begs Edgar to complete the woeful tale of their father who "with his bleeding rings, / Their precious stones new lost" (V.iii.190–91). In contrast to Albany's plea for narrational blockage, "If there be more, more woeful, hold it in, / For I am almost ready to dissolve, / Hearing of this" (V.iii.203–04), Edmund urges his disguised brother to continue the report: "This speech of yours hath mov'd me, / And shall perchance do good: but speak you on, / You look as you had something more to say" (V.iii.200–02). What Edmund then hears is an account of the crushing blow dealt his father by Kent's hyperbolic tale of equally horrific proportion:

> threw [him] on my father,
> Told the most piteous tale of Lear and him
> That ever ear received, which in recounting

His grief grew puissant and the strings of life
Began to crack.

(V.iii.214–18)

These examples of characters desirous of the uncensored relation of heart-rending accounts, characters possessing first-hand knowledge of the horrific effects of language, stand out in vivid contrast to the examples from Shakespeare which I have discussed thus far. Even more important in *Lear*, I want to suggest, is the epistemological shift that accompanies its multiple references to the structure of narrational transference. Edgar ends *King Lear* by shifting the balance between "knowing" and "needing" away from the dramatic conventions of memory, custom, and verisimilitude, toward the side of affect: "Speak what we feel, not what we ought to say" (V.iii.325). In this play, the notion of "seeing feelingly" might be said to expand the limits of knowledge beyond the realm of political vantage, beyond the horizons of tragedy's skepticism.

Although *expansion* can be isolated as the trope of *King Lear*'s epistemological promise, which I will soon discuss, it may appear at first sight to exemplify the image of horror in *King Lear*. It is, for example, the faulty expansion of Gloucester's family that fuels the script of the raunchy humor opening the play. In a tone of locker-room humor, Gloucester boasts to Kent that "Though this knave came something saucily / to the world before he was sent for, yet was his / mother fair, there was good sport at his making, and the whoreson must be acknowledg'd" (I.i.21–24). At the outset of scene one, moreover, the issue of the legitimate marital expansion of Lear's family and kingdom, by inference, augments the tensions wrought by Lear's expansion of the authority of his daughters. This authority could be acquired, of course, only by the daughters' voicing of expansive narratives adorned by hyperbolic matter flattering to the Law-of-the-Father. Goneril's hyperbolic emphasis on limitless love is exemplary in this regard: "I love you more than [words] can wield the matter, / Dearer than eyesight, space, and liberty" (I.i.55–56). Finally, the play's most pitiful crisis that catalyzes Lear's ghastly decline stems from the horrific expanse of Cordelia's "nothing."

Lear's response to the threat of the enigmatic "Nothing" is quick to the point, grounded in the containment of his challenged perspective: "Hence, and avoid my sight!" (I.i.124). In similarly ordering Kent "Out of my sight" (I.i.157), he reiterates the equation, which is so common to Shakespearean tragedy, of sovereign authority with the containment of visual purity and clarity. This is the equation that even Kent affirms, in his response to Lear's rash expulsion of Cordelia: "See better, Lear, and let me still remain / The true blank of thine eye" (I.i.158–59). I need not rehearse the commonplace reading that these relations of vision and authority, what Lear calls "the marks of sovereignty, / Knowledge,

and reason" (I.iv.232–33), are fundamental to any discussion of the epistemology of *King Lear*. For they obviously foreshadow the play's complex development of the matters of "blindness and insight" which have dominated philosophical discussions of the play. But what still merits further analysis is the relation of royal perspective in *King Lear* to the shifting, psycho-political conditions of empire and empiricism, nation and narration.

Lear's quick turn to sight as the crutch of his authority provides but one example of how extensively absolute perspective functioned in the Renaissance as a symbolic and defensive figure of mental insight or visual penetration. So exclaims York in *Richard II*, "Yet looks he like a king! Behold, his eye, / As bright as is the eagle's lightens forth / Controlling majesty" (III.iii.68–70). Similar references to the piercing gaze of vision as a trope of the watchful Law-of-the-Father not only typified representations of the mental capacity of the Renaissance sovereign, but emblematized the universal practice of political cunning and deceit. "How far your eyes may pierce I cannot tell" (I.iv.345) is how *King Lear*'s Albany expresses his frustrated attempts to match the cunning perspective of his wife, Goneril. Similarly, Lear taunts Gloucester to "Get thee glass eyes, / And like the scurvy politician, seem / To see the things thou dost not" (IV.vi.170–72). Might not this passage, which seems to contradict Lear's quick turn to vision early in the play, warrant a further probe of the empirical, which is also to say, the ideological relation of seeing and seeming, of stones and statues?

Recalling the shifting relations of vision and narrative concluding *Othello* and *Hamlet*, I could begin by noting how the maintenance of the fiction of kingly perspective in *Lear* appears to be grounded in the complex operation of blockage or repression, the distancing or disavowal of sovereignty from the kingdom's enigmatic "faults." The extent of this fetishistic disavowal, "yes, there are flaws, but nevertheless . . . ," can be summed up rather quickly by tracing the frequent tendency of characters to fill up their horrific sense of faults with the consoling stuff of image and word. Remember how almost to the character, the crisis of the play is regarded as one of faulty perspective or judgment? I refer not merely to the hermeneutic faults of individual characters, whether Lear's tragic misreading of Cordelia's "nothing," or Gloucester's similar miscalculation of Edgar's loyalty, but to the play's more general references to faulty perspective.

"These late eclipses in the sun and moon portend no good to us" (I.ii.103–04). Were we to take Gloucester's lead in Act I, scene two, all such faults can be attributed to an eclipse of the sun, that is, to nature's subversion of perspective in which "machinations, hollowness, treachery, and all ruinous disorders / follow us disquietly to our graves" (I.ii.113–14). Gloucester's reference to the eclipse of the sun equates, of course, the sun's

darkened vision with the unnatural break of lineage by his "son." This conflation of the eclipse of vision and the "darker purposes" of lineage endows the middle section of *King Lear* with its dramatically furious landscape. Shakespeare follows the Gentleman's prescient description of the disorienting storm, "impetuous blasts with eyeless rage" (III.i.8), with Lear's loud fulminations against the stormy eclipse of nature: "rage, blow! / You cataracts and hurricanoes" (III.ii.1–2). Both of these stormy references attribute the darkening and blockage of vision to the wanton humors of nature. Rage and impetuosity, not simply the cruel foot of Cornwall, are what out the vile jelly in so profoundly goring the bright luster of Britain.

Equally fascinating is how the staging of Lear's stormy disorientation is framed by Kent's troubled query opening Act III, "Who's there, besides foul weather?" (III.i.1). This seemingly innocuous question, clearly positioned by the playwright to orient the spectators to the storm at hand, is almost uncanny by introducing the natural fury of this scene in terms similar to those marking the ontological crises of tragedy in *Othello* and *Hamlet*. Isn't it difficult not to hear in Kent's words the pulsating echo of Barnardo's "Who's there?," the question that opens *Hamlet* to launch the melancholic humors haunting the citizens and spectators of Denmark? In the context of this chapter, moreover, "Who's there, besides foul weather?" can be read as establishing a double metonymic link, on the one hand, between the blinding fury of foul weather and the play's frightful questioning of identity, and, on the other hand, between the certainty of natural reference, "foul weather," and the enigma of reference itself, marked this time by the deictic, "there."[10] Especially when considered in relation to *King Lear*'s textual variants, "What's here beside" (Q1) and "What's there, besides" (Q2), this passage positions Act III in view of the enigma of identity faced by the viewing subjects poised between those pivotal referents of "who/what" and "there/here" (*fort/da*) that figure in both Freud and Heidegger's attempts to theorize the subject's spatial relation to self and thing. While Heidegger understands the phenomenological solution to skepticism to lie on the fault line of "Being-there" (*Dasein*),[11] Freud understands the child's spool game of *fort/da* to be pivotal to the child's symbolic compensation for the trauma of maternal loss. As we have seen with the endings of *Othello* and *Hamlet*, attempts to reconfigure the trauma of mourning invariably inscribe the fissures of (maternal) loss in the narrative fabric of the (patriarchal) symbolic state. Speaking of the role played by *fort/da* in *Hamlet*, Julia Reinhard Lupton and Kenneth Reinhard helpfully describe such an inscription of loss in tragedy as both a "projective displacement" and a "retroactive translation:"

The "undiscovered country," like the "dark continent" of feminine sexuality for Freud, figures maternal absence through a projective

43

displacement; maternal loss, however, returns as the ghostly father and his law of lack. On the one hand, paternal law is always faulted by the maternal absence it effaces; on the other hand, that law is the means not simply of representing but also of constituting the mother for the child. The relation between mother and father and their metonymic signifiers breast and phallus is not one of antithesis or opposition, but rather of retroactive translation, a translation effected by the work of mourning.

<div align="right">(Lupton and Reinhard 1993: 28)[12]</div>

Retroactive translation, it could be said, is the mournful activity demanded of characters and viewers when the source of trauma in Shakespearean tragedy is relegated to the deictic fault line of this/that and here/there. On this fault line, moreover, the question of identity is enveloped in, or stands beside, the foulness of the state of "whether" or those differentially intermixed folds of gender, family, and state.

In a strange way, Gloucester's pun on eclipsed suns/sons functions as something of a retroactive translation of the fault line of maternal loss quivering since the opening moments of the play. The playful anxiety of Gloucester's opening joke about Edmund's lack of a proper mother, "Do you smell a fault?" (I.i.16), surfaces with seriousness in Act I, scene two, with Gloucester's projective displacement of his guilty engendering on to the unnaturalness of Edgar's guilt: "O villain, villain! . . . Abhorred villain! unnatural, detested, brutish / villain!" (I.ii.75–77). Lear later picks up this theme of illegitimacy by calling Goneril a "degenerate bastard" (I.iv.254) and, then, by threatening Regan similarly: "If thou shouldst not be glad, / I would divorce me from thy [mother's] tomb, / Sepulchring an adult'ress" (II.iv.130–32). One could even go so far as to read Lear's conflation of maternal loss, unnatural lineage, and disrupted patriarchy into the innocent Cordelia's earlier retort to her sisters, "And like a sister am most loath to call / Your faults what they are named" (I.i.270–71).

By turning so rashly to the loathsomeness of the maternal fault, none of these anxious and ambiguous lines tends to translate sovereign patriarchy itself as the source of faulty perspective in the play. Neither the projective structure of perspective nor the symbolic Law-of-the-Father is the focus of much intense reflection in *King Lear* as the source of the characters' faults. Rather, the cue of what Edmund terms "villainous melancholy" (I.ii.135) is related throughout the play to a masochistic source other than patriarchy. Speaking of his father's blindness, Edgar claims to Edmund that "The dark and vicious place where thee he got / Cost him his eyes" (V.iii.173–74). Edgar lays blame on the castrating female and her "dark and vicious place" as the source of his father's anguished eyelessness. And Lear, in the depths of his mental free-for-all in Act IV, anxiously reveals a similar figure as the repressed origin of all of his troubles: "Down from the waist they are Centaurs, / Though

women all above; / But to the girdle do the gods inherit, / Beneath is all the fiends': there's hell, there's darkness, / There is the sulphurous pit, burning, scalding, / Stench, consumption. Fie, fie, fie! pah, pah!" (IV.vi.124–29).[13] This extremely troubled, not to mention troubling, displacement of Lear's mental failure on to the unseen sites of woman is, I should add, a sickening elaboration of his earlier lament about Goneril, "O most small fault, / How ugly didst thou in Cordelia show! / Which, like an engine, wrench'd my frame of nature / From the fix'd place" (I.iv.266–68). Lear's subsequent curse only makes doubly clear his sense of what it is that has rendered his perspectival frame so out of joint:

> Hear, Nature, hear, dear goddess, hear!
> Suspend thy purpose, if thou didst intend
> To make this creature fruitful.
> Into her womb convey sterility,
> Dry up in her the organs of increase,
> And from her derogate body never spring
> A babe to honor her.
>
> (I.iv.275–281)

In sum, it ends up being the invisible fault of woman, the castrating lechery of the mother, and the malignant fruit of her loins that stand out in *King Lear* as the displaced figures of patriarchy's broken visions and failed sights.[14] Or, to speak in Lear's own figural language: "O how this mother swells up toward my heart! / [*Hysterica*] *passio*, down, thou climbing sorrow, / Thy element's below" (II.iv.56–58).[15] Just as Lupton and Reinhard suggest, the stuff of maternal loss here returns with a melancholic vengeance in the figure of the ghostly father and his law of lack.

The swelling of maternal loss is illustrated in Shakespeare by innumerable examples of male authority quaking hysterically in the presence of representational conditions gone awry. The quaking begins in *King Lear*, of course, with the voicing of Cordelia's nothing, which then catalyzes an entire series of representational crises attempting to fill in the stuff of loss with the law of lack. At different moments in the play, woman is described as the embodiment of the dissolution of both male will and sovereign reason. Responding to Goneril's lecherous letter in Act IV, Edgar utters the most telling apostrophe of the play: "O indistinguish'd space of woman's will" (IV.vi.271). Woman's will inverts the logical and rational conditions of visibility upon which both the state and the critical tradition count for their stability and governance. The threat of woman, then, is not necessarily that she may possess a will, but that it is indistinguishable and unreadable when made manifest as the fault line of loss, the figure of an O, or, conversely as the Fool taunts Lear, "an O / without a figure" (I.iv.191–92).[16]

This indecipherability infects the methods of presentation as well as those of reception. One of Goneril's parting lines to Regan, "That eye that told you so look'd but a-squint" (V.iii.72) suggests how severely the codes of trust and honor have been turned a-squint ever since the revelation of Lear's "darker purpose" set in motion the "glib and oily art / To speak and purpose not" (I.i.224–25). In *King Lear*, moreover, disguised and disguising looks are hardly limited in practice to the two evil sisters. On the male side, we have the examples of Kent and Edgar who successfully counter their rejection by the Father by adopting the disguises of the cultural, if not the epistemological other, the beggar and the madman. The inconstant Edmund also always already stands in the wings as does his incompetent go-between or shadow, Oswald. And, speaking of shadows, it is not too far into the play when the Fool's crossed logic – arguably the most dependable form of reasoning in the play – begins to be ventriloquized by Lear's own crazed staging of the phantom trial.

It is in this context of crossed logic that the male outbursts in *King Lear* may be understood diagnostically as symptomatic of more than misogyny – although I certainly don't mean to diminish the weight of the negative representation of woman in this play (not to mention the historical blindness of the critical tradition to Renaissance misogyny). As deep symptoms of cultural despair, these melancholic outbursts may point to the natural faults of method – both sovereign method and the critical methodology nurtured by it – that become projected, condensed, and displaced on to hysterical figures of the organs of increase. Not even a king can be expected to read correctly the expressions of another's emotions when his own melancholic humors drive, frame, and shape his fearful hearing of them. So it happens, in Act IV, that no one knows the reason for the sudden return home of the King of France. "Something he left imperfect in the state, / which since his coming forth is thought of, which im- / ports to the kingdom so much fear and danger that his / personal return was most requir'd and necessary" (IV.iii.2–6). Even attempts at the retroactive translation of this kingly departure are haunted by the enigmas of the King's frightful start whose cryptic incorporations and imperfect states can be made even more traumatic and dangerous when triggered for the second time by new conditions of the coming forth of fantasy. At stake here, then, is a question of the extent of patriarchy's entrapment in the counter-transferential dynamics of villainous melancholy.

STAINED STONES

The contagion of crazed events in *King Lear* is the focus of Stephen Booth's close philosophical reading of the play. He sees the drama

trauma of *King Lear* to suggest more about epistemological method than anything else. In his words, "puns, synonyms, repetitions, and paired contraries offer potential junctions from which the mind might follow irrelevant, logically random trains of thought... Our minds pass through a maze of doorways to madmen's logic and are repeatedly tempted to demonstrate our own susceptibility to abnormal thinking" (Booth 1983: 36). Yet Booth wishes to downplay the significance of illogical irruptions in *King Lear*, wishing to think that the frame of perspective is adequate enough to embrace them. "The discomfort I have described," he writes, "disturbs our mental equilibrium but – because it is generated in relation to relatively minor particulars... never threatens really to throw our thinking off balance and become a 'problem' for interpreters of the play" (Booth 1983: 52). Taking odds with Booth, I want to insist that it is precisely a confrontation with the play's profusion of "minor particulars" that throws interpreters, both those in and out of the play, permanently off balance, that provokes them to "Speak what we feel, not what we ought to say."

To speak of this point I would like to return to the conclusion of the play, when Kent and Edgar stress the enigmatic condition of what they have seen: "Is this the promis'd end? / Or image of that horror?" (V.iii.265–66). The image to which they respond is, of course, that *pietà*-like figure of Lear holding the dead Cordelia in his arms. I recall this image not simply to provide a statuesque example of what becomes a "problem" for interpreters of the play, but to foreground Lear's speech to which Kent and Edgar respond, the speech in which Lear relates statues and stones:

> O, [you] are men of stones!
> Had I your tongues and eyes, I'ld use them so
> That heaven's vault should crack. She's gone for ever!
> I know when one is dead, and when one lives.
> She's dead as earth. Lend me a looking-glass,
> If that her breath will mist or stain the stone,
> Why then she lives.
>
> (V.iii.258–64)

When Booth focuses on this passage, he does so to stress the alternating sense of the word-play on "stone" which illustrates "one more instance of casual likeness between disparate things" (Booth 1983: 24). Booth explains the relation this way:

> In addition to the ideationally insignificant verbal link between the two uses of the word *stone*, the two unrelated uses of the word sustain the larger pattern of violent alternation between evidence of certain lifelessness and evidence of life: in "you are men of stones"

47

(a conflation of the synonymous assertions "you are men of stone" and "you are stones"), *stone* is emblematic of lifelessness; on the other hand, the same word describes the looking glass on which Lear hopes to register signs of life.

(Booth 1983: 24)

This description of Lear's unfulfilled hope to find life in a stone may sound familiar since it recalls the skeptical paradox of *Othello*, as registered by Stanley Cavell:

So they are there, on their bridal and death sheets. A statue, a stone, is something whose existence is fundamentally open to the ocular proof. A human being is not. The two bodies lying together form an emblem of this fact, the truth of skepticism.

(Cavell 1979: 496)

In view of the philosophical sensitivities of Cavell, the ending of *King Lear* entails a by now familiar choice inscribed in the aesthetics of tragedy: "the turning of our hearts to stone, or their bursting." As Booth sums up the options of *King Lear*, "we are pressed toward, *but not to*, the point of rethinking and justifying our evaluations" (Booth 1983: 53). We, as philosophically skeptical critics, are thus freed of the counter-transferential trauma that demonstrates "our own susceptibility to abnormal thinking."

But what happens to this cathartic distancing of evaluation from the vulnerable space of drama trauma when we apply the critical imperative of Albany, "the gor'd state sustain," to the method of proof most suitable to Lear? It is, of course, an ocular method: "Lend me a looking-glass, / If that her breath will mist the stone, / Why then she lives." A curious angle frames this request for ocular proof. In returning to his custom of perspective, Lear here breaks from tradition by railing against the antiseptic feature of unfeeling sight – "O [you] are men of stones!" Rather than depending on his sovereign insight, "I know when one is dead," Lear cites the advantage of faulty perspective in affirming life, "Lend me a looking-glass." The stones of the King's vision – sovereign perspective – are not what verify Cordelia's life or death; rather, the stain of indirect representation, the mist of the mirror, is what functions as the needy supplement of Lear's certainty.[17]

What is horrific about this mirror image in the shape of an empty O is not so much the pain of death or the nihilism of skepticism that it figures. Rather it can be said to embody, as if in a nightmare, the almost subconscious acknowledgment of the remaining characters – now all male – of the fractured method marked by Lear's dissolution. What begins to unfold at the end of *Lear* is the realization that the blockage of phallic perspective and historical narration will not lead the survivors out of the sulfurous abyss of patriarchal history. Indeed, the conclusion of

King Lear provides some evidence that the survivors have come to terms with the enigmatic presence of woman, and, indeed, have learned to see feelingly by turning in need to what they had spurned as the undistinguished method of woman's will.

SEEING FEELINGLY

Lear's request for a mirror exemplifies this shift. It could be argued that he chooses the mirror for its dependable representation of woman. You may recall the Fool's joke in Act III that "there was never yet fair woman but she made / mouths in a glass" (III.ii.35–36). Still, the mirror is important in *King Lear* not so much for its magical powers over the female object of vision – that is, if alive, Cordelia couldn't resist the mirror – but for establishing the *virtual* conditions of viewing life. It is not so much woman who is represented by the mirror as Lear's "womanly" method which is put into practice by the condition of his seeing Cordelia through a glass darkly. The play here turns aside from the clear lines of critical knowledge to affirm the ultimate reality of "glass-gazing," which is the disrespectful charge Kent had leveled earlier at Oswald for being a mediating go-between. At this end point of the play, Lear's curious perspective is duplicated by the projections of his spectators on and off stage, who also want, or "need," to imagine seeing Cordelia's stain on that stone.[18]

King Lear might be argued to go so far as to endorse almost the entire representational method blocked out by the phallic anxieties of its characters. Take the relation of Lear's closing methods to his charge against Regan in the phantom trial: "here's another, whose warp'd looks proclaim / What store her heart is made on" (III.vi.52–54). It is not only Lear who depends on the shifting vision of "warp'd" or "asquint" looks by the end of the play. One of the most touching moments of Act IV is when Edgar utters the words "O thou side-piercing sight!" (IV.vi.85) to frame the spectator's melancholic vision of the touching exchange between Lear and Gloucester. While the metaphor of piercing sight would normally signify the penetrating vision of Edgar's perspective, it here shows him looking at sight anew, from the side, in a way that establishes a relation between detached insight and vulnerable response, much like the structure of counter-transference common to the theatre of psychoanalysis. This is also the relation described 100 lines later by Edgar as "reason in madness" (IV.vi.175), or as his father says, "I see it feelingly" (IV.vi.149).

The side-vision I have been describing has its corollary in the Renaissance artistic genre of anamorphosis. Such painting portrays a subject which is disfigured geometrically according to the misproportions of two convex mirrors or an extended perspective grid.[19] In Chapman and Shirley's 1639 play *The Tragedy of Chabot* such misproportion is

gendered distinctly as feminine: "As of a Picture wrought to opticke reason, / That to all passers by, seemes as they move / Now woman, now a Monster, now a Divell, / And till you stand, and in a right line view it, / You cannot well judge what the main forme is." And even better known is Shakespeare's description in *Richard II* of such a multiplicity of perspectives "which rightly gaz'd upon / Show nothing but confusion; ey'd awry / Distinguish form" (II.ii.18–20).[20] The source of my epistemological model, then, is the practice of anamorphosis, which distinguishes form only when "ey'd awry."

Perhaps the best-known anamorphic painting is Holbein's *The Ambassadors*, hanging in The National Gallery, London (see Figure 2.1). This sixteenth-century portrait depicts two ambassadors, Jean de Dinteville and Georges de Selve, posing among the products of their cultural and imperial activities. If viewed from a frontal perspective, *The Ambassadors* exemplifies not only the art of portraiture, for which Holbein was renowned, but the desire for wealth and power represented by the portrayal of patronage and accumulation *per se*. This painting is made more fascinating by the monstrous image hovering curiously in the picture's low, frontal plane. When viewed from the side, it appears clearly as the representation of a skull. This perspectival phantasm might be read, then, to suggest that any representation of power, accumulation, or wealth inscribes itself in a drive toward death, toward fragmentation, or even toward split-vision.[21]

In my article "A Marvelous Guide to Anamorphosis," which provides a reading of Perrault's version of *Cinderella*, I discuss the broad literary significance of anamorphosis as a structure whose "collection of oscillating and seemingly contradictory signs" sustains and disquiets a voyeuristic reading of the text (Murray 1976: 1294). In that piece, I focus on fluid linguistic procedures analogous to anamorphosis which are disruptive of the binarisms of structural anthropology and linguistics. In turning, with this aim in mind, to Jacques Lacan's analysis of *The Ambassadors* in *The Four Fundamental Concepts of Psychoanalysis*, I there permit my undiscriminating enthusiasm for the pleasures of the literary text to foreclose a detailed discussion of Lacan's analysis of the procedures of visualization. In contrast, much more recent literary theorizations of anamorphosis in Shakespeare, notably by Christopher Pye and Ned Lukacher, profit from providing a more detailed account of the scopic regime in Lacan. In Pye's subtle book, *The Regal Phantasm: Shakespeare and the Politics of Spectacle* (1990), he aptly summarizes Lacan's reading of Holbein in a manner particularly germane to my preceding discussion of *King Lear*. Pye is particularly taken by Lacan's description of the way Holbein's *vanitas* painting yields its secret – the perspectively elongated image of a skull floating in the foreground – at the moment when the viewers give up on the obscure form, move past the painting, and then

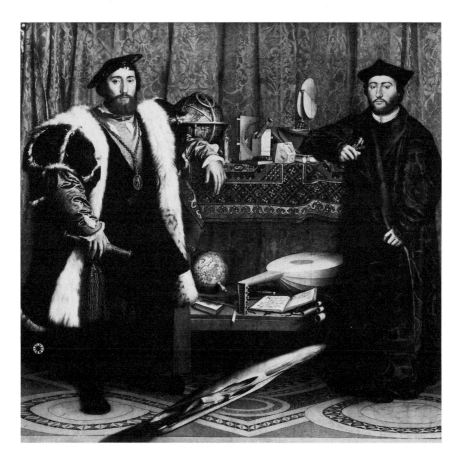

Figure 2.1 Hans Holbein the Younger, *The Ambassadors*, The National Gallery, London, Great Britain (courtesy: Alinari / Art Resource, New York)

catch an oblique glimpse of the skull in passing. The skull represents the subject's nothingness, but it conveys this annihilation specifically in the form of a fatal entrapment within the field of pictorial representation. For it is in this movement of escaping the "fascination of the picture" that beholders find themselves inscribed within it, "literally called into the picture, and represented there as caught" (Pye 1990: 88–92). The anamorphic viewers renew their captivation and loss, then, just in so far as they seek to evade it.

Just such captivation is figured in *King Lear* by that telling metaphor, "seeing feelingly."[22] This dramatic relation also figures centrally in the argument of Ned Lukacher's essay, "Anamorphic Stuff: Shakespeare,

Catharsis, Lacan." Lukacher maintains convincingly that "Shakespeare discovers through anamorphosis an anticathartic aesthetic that insists upon displacing the role of catharsis, upon performing a catharsis of catharsis" (Lukacher 1989: 878).[23] And it is specifically by highlighting the Shakespearean disjunction between the eye and the gaze, between captivation and loss, that Lukacher persuasively analyzes the significance of anamorphosis in Shakespeare, which is "Lacan's figure for the way in which we 'feel' seeing, for the way we feel seeing as an invisible materiality, like feeling the gaze of an other without seeing an other's eyes" (Lukacher 1989: 876).

So it is that I read Lear's dying lines in view of such a methodological shift in which the duplicities of sight sidestep not merely tragedy's catharsis but the horizon of its skepticism. This is the horizon, you will recall from Cavell, in which "the failure to acknowledge a best case of the other is a denial of that other, presaging the death of the other, say by stoning, or by hanging" (Cavell 1979: 493). Lear dies after making one final and moving plea:

> And my poor fool is hang'd! No, no, no life!
> Why should a dog, a horse, a rat, have life,
> And thou no breath at all? Thou'lt come no more,
> Never, never, never, never, never.
> Pray you undo this button. Thank you, sir.
> Do you see this? Look on her! Look her lips,
> Look there, look there!
>
> (V.iii.306–11)

Lear's passing performs the death of sovereignty in soul and method. For his extremely moving, last gesture consists of an unkingly, demonstrative plea to look away from the failing sovereign toward the lifeless body of his daughter. In pointing to Cordelia, he begs us to "look on her" – to see the embodiment of what he previously described as the horrifying specter of female speech and increase, the look of her lips. But he doesn't stop with this specific, anamorphic personification, or fetishization, of female form. Instead he dies with an invested, yet mysterious, deictic appeal to "look there, look there." These are the arresting demonstratives whose mystery has been all but disregarded, blocked out, by Shakespeare's misty-eyed readers touched by the doubled figure of death. Herbert Blau, the director and theoretician who has proven to be most attentive to the force of this gesture, weighs his reading of this moment more on the side of the familiar pathos of drama rather than on the edge of the uncanny bathos of trauma: "It is that dreadful gazing moment where we watch the actors watch what seems so quintessentially painful that it can't be imagined as pain" (Blau 1990: 161). Lear's enigmatic appeal might be said to provide, in this context, the frame of representation for Edgar's closing

promise of narration: "Speak what we feel, not what we ought to say" (V.iii.325).

But what else might we make of Lear's final words that recall while yet so vividly pointing away from the convenient intertextual corollary of that moment in *Oedipus Rex* when Oedipus, the original Son/King, undoes his mother's button to acquire the broach with which he ends his sight of the forbidden body? Lear's last lines clearly appear to speak more than a tired promise to reiterate a cathartic, Oedipal reading in which the pain of castrating blindness counts more than the mother's death, in which stones weigh more than statues. Rather than once more turning blindly away from the forbidden figure, Lear seems to appeal to his audience, to his go-between, to join him in seeing, in acknowledging the captivating enigma of the figure of nothing: "look there, look there." Such a focus on side-vision is lent performative gravity by Peter Brook whose cinematic Lear, as you may not have been able to forget, speaks these lines in traumatic isolation from the other actors with his eyes and his apotropaic finger aimed directly at the camera, as if to stress the beholder's captivation there, there in the look and there in the gesture. Reenacting his imagined representation of Cordelia's living trace on the stone, Lear dies in redirecting our perspective to a side-view of whatever it is that we imagine remains "there" and the fragmented conditions of counter-transference promised by it.[24]

Cavell seems to prefer a more definitive analysis of the traumatic conclusion of this play. His fascinating reading of *King Lear* maintains that Cordelia's death signifies the consequence of what he calls "the avoidance of love" – that "*every* falsehood, every refusal of acknowledgment, will be tracked down" (Cavell 1987: 80). But an epistemological reading of *King Lear* does not seem to me to confirm the knowledge or the acknowledgment of love, at least love in an idealized or Christian sense. Indeed, the dying King's efforts to transfer the phallic gaze or "leer" to the look or reading of what's "there" points the viewer away from the romantic conditions of love as articulated clearly by France in the first scene of the play:

> Is it but this – a tardiness in nature
> Which often leaves the history unspoke
> That it intends to do? My Lord of Burgandy,
> What say you to the lady? Love's not love
> When it is mingled with regards that stands
> Aloof from th' entire point.
>
> (I.i.235–40)

If Lear's closing gesture asks us to do anything, it is to so stand aloof from the entire point, from the ideology of sovereign perspective. Only the shifting relations of such side-vision, not the hallow absorptions of intent

or sentiment, shed light on the psycho-political elements shaping the practice of duty and desire, knowing and needing, in *King Lear*.

Still, I would not want to conclude this chapter without qualifying the gender politics of the literary conditions and empirical structures sustaining and demystifying the promise of counter-method in *King Lear*. It is noteworthy that after all is said and done Cordelia and her sisters die in Shakespeare's account of the history of Lear. While it is bad enough that Goneril and Regan essentially destroy each other over a worthless man, it is noteworthy that Shakespeare, and not Edmund, hangs Cordelia in the prime of her life. We need only recall that the Shakespearean version of the history of *King Lear* departs from Holinshed's *Chronicles*, and even Spenser's *The Fairie Queene*, in not allowing Cordelia to ascend to the throne. Even though she eventually dies in the primary sources from male resentment of her matriarchy, her early death in Shakespeare's play denies her even the opportunity for the manifestation of female rule. What can be said, then, about the conclusion of *King Lear* other than the paradoxical fact that its epistemological promise is itself inscribed in misogynistic paranoia and intertextual blockage? Isn't this an instance when Shakespeare, or, let's just say, Shakespeare's text assumes the position of counter-transference *vis-à-vis* its own characters? Isn't this a case of the text's invested alteration of literary history, where it madly speaks what it feels, but not what it really might have said?

NOTES

1 In more recent essays on *Coriolanus*, *Hamlet*, and *The Winter's Tale*, in *Disowning Knowledge in Six Plays of Shakespeare* (1987), Cavell demonstrates much more fluidity in accounting for the psychoanalytical elements of Shakespearean drama. In my review of *Disowning Knowledge* (1990a), I discuss the book's interesting contributions to the understanding of the psycho-philosophical makeup of early modern masculinity, as well as its shortcomings in failing to profit from feminist reconsiderations of psychological states such as depression and hysteria.

2 See Laplanche's discussion of the "enigmatic signifier" in *New Foundations for Psychoanalysis* (1989: 45).

3 I allude here to the distinction between lack as the condition of the Symbolic and loss as the status of the Real as discussed by Lupton and Reinhard (1993: 177–89).

4 Laclau and Mouffe describe "antagonism" as the fundamental subversion of linguistic confidence: "antagonism constitutes the limits of every objectivity, which is revealed as partial and precarious *objectification*. If language is a system of differences, antagonism is the failure of difference: in that sense, it situates itself within the limits of language and can only exist as the disruption of it – that is, as metaphor. We can thus understand why sociological and historical narratives must interrupt themselves and call upon an 'experience,' transcending their categories, to fill their hiatuses: for every language and every society are constituted as a repression of the consciousness of the

impossibility that penetrates them. Antagonism escapes the possibility of being apprehended through language, since language only exists as an attempt to fix that which antagonism subverts" (Laclau and Mouffe 1985: 125).

5 All citations of Shakespeare are from *The Riverside Shakespeare*, ed. G. Blakemore Evans (1974).

6 In *Theatrical Legitimation* (1987: 157–91), I provide a close reading to the relation of desire and ideology in *La Pratique du théâtre*.

7 For specific discussions of transference and narrative, see Chase (1986); De Certeau (1986: 3–34); Brooks (1984: 216–37); LaCapra, (1985: 72–94); Murray (1987); and, especially, Pontalis (1990).

8 In *The Origin of German Tragic Drama*, Benjamin (1977) foregrounds the important role of melancholy in the baroque production of national narratives. The pivotal role of melancholy as a psycho-political production is one fundamental aspect of the narration of national identity which is left underdeveloped in Bhabha's otherwise thorough collection *Nation and Narration* (1990).

9 Lupton and Reinhard (1993: 196) discuss how trauma is the Lacanian Thing residual to the symbolic that cannot be historicized. In their subtle discussion of the deictic, moreover, they are careful to point out that "the Thing deictically *designates* rather than rhetorically *signifies* the real, and is itself indicated rather than troped in the network of language that preserves the Thing at a distance" (1993: 180). Regarding this distinction between designation and signification, I suggest that Laplanche's notion of the enigmatic signifier collapses it in a helpful fashion.

10 See Lupton and Reinhard's (1993: 179–83) fine reading of the role of the deictic in *Hamlet*.

11 In his subtle book, *Daemonic Figures: Shakespeare and the Question of Conscience* (1994), Lukacher develops this conceptual relation between Shakespeare, Freud, and Heidegger.

12 Lupton and Reinhard refer to Lacan's insistence that the bobbin being thrown back and forth in the *fort/da* game does more than merely symbolize the mother's departure. Rather, Lacan insists that it should be understood as "a small part of the subject that detaches itself from him while still remaining his . . . If it is true that the signifier is the first mark of the subject, how can we fail to recognize here . . . that it is in the object to which the opposition is applied in act, the [bobbin], that we must designate the subject. To this object we will later give the name it bears in the Lacanian geometry – the *petit a*" (Lacan 1978: 62).

13 In "Shakespeare's Nothing," Willbern (1980: 246) notes that "Lear's response to this malignant and demonic image of no-thingness is first rage, then insanity, and then a kind of infancy (*infans*, speechless)."

14 Gohlke (1980: 176) argues that birth itself is displaced here: "the mother's first act of betrayal may be that of giving birth, the violent expulsion of her infant into a hostile environment."

15 Kahn (1982: 38) reads Lear's hysteria as his "galling sense of loss at the deprivation of the mother's presence."

16 In "The Sound of the O in *Othello*," Fineman (1991: 152) associates the sound of the "abject Os" in Othello "with Lacan's *objet a*, that is, what for Lacan is the occasion of desire and the mark of the Real." This provocative kinship of "O" and "a" was noted earlier by Willbern (1980: 250–52).

17 In *The Tain of the Mirror*, Gasche (1986: 238) provides an analysis of the deconstruction of reflection which has striking implications for a reading of

the specular relations of this scene: "In this first step of the deconstruction of reflection and speculation, the mirroring is made excessive in order that it may look through the looking glass toward what makes the speculum possible. To look through the mirror is to look at its reverse side, at the dull side doubling the mirror's specular play, in short, at the *tain* of the mirror . . . Reflection, then, appears to be affected by the infrastructures that make it possible; it appears broached and breached as an inevitably imperfect and limited *Scheinen*." Although Shakespeare stresses more the "stain" than the "tain" of the mirror, the mirror works in *King Lear* to broach and breach both reflection and speculation.

18 Greenblatt (1988: 124) also comments on this point.

19 On the art of anamorphosis, see Baltrusaitis (1969), Leeman, Elfers, and Shuyt (1976). For acute theoretical discussions of anamorphosis and perspectival extensions, see Marin (1995); Lyotard (1971); Bryson (1983); Damisch (1994); Gantheret (1987); and Žižek (1989).

20 On anamorphosis and Richard II, see Pye (1990: 82–105); Lukacher (1989: 863–98); McMillin (1984); Gilman (1978: 94–128); and Lyotard (1971: 376–79). Calderwood (1991) provides a helpful reading of anamorphosis and *A Midsummer Night's Dream*.

21 I discuss the relation of anamorphosis in Holbein's *The Ambassadors* to the psycho-politics of contemporary performance in Chapter Ten.

22 In "Perspectives," Jonathan Goldberg (1988) reflects widely on the tension between anamorphosis and single-point perspective in *King Lear*'s Dover Cliff scene, IV.vi.

23 In "The Caesura of the Speculative," Lacoue-Labarthe (1978: 82) attributes a similar implosion of catharsis to the structure of tragedy itself: "Tragedy, because it is the catharsis of the speculative, reveals disproportion *as* that which secretly animates and constitutes it; tragedy reveals (dis)appropriation." See also Lacoue-Labarthe's "Theatrum Analyticum" (1997) and André Green's introduction to the psychoanalysis of tragedy (1997).

24 Willbern (1980: 246–47) reads this line as Lear's regression into fantasy and final delusion, as his "seeing what is not there."

3

OTHELLO, AN INDEX AND OBSCURE PROLOGUE TO THE HISTORY OF FOUL GENERIC THOUGHTS

In "Shakespeare and the Kinds of Drama," Stephen Orgel analyzes the important role played by genre in the identity formation in Renaissance England. "The genres for such Renaissance critics [as Scaliger and Sidney]," he writes, "were not sets of rules but classifications, ways of organizing our knowledge of the past so that we may understand our relation to it and locate its virtues in ourselves. The ancient world, says Scaliger's *Poetics*, is not a world of monuments. It is real and recoverable, and the process of creation is also a process of re-creation" (Orgel 1979: 115). Orgel's analysis extends the boundaries of an earlier argument made by another astute critic of the Renaissance, Rosalie Colie, in *The Resources of Kind: Genre Theory in the Renaissance* (1973). In the foreword to this influential book, Barbara Lewalski provides a succinct summary of Colie's complex argument regarding the function of genre in the Renaissance: "Miss Colie persuades her audience to acknowledge their constant and inevitable dependence upon genre (kind) for any appre-hension of reality in life as in literature, and then displays how genre functions as a mode of communication – a set of recognized frames and fixes upon the world. In this perspective genre is not only a matter of literary convention . . . but it is also a myth or metaphor for man's vision of truth" (Colie 1973: viii). Generic thought of the Renaissance thus can be understood, following Colie and Orgel, as a method of recovering and classifying past thoughts and virtues – it is a tool for an archeology of knowledge not to be revered as monumental, but to be re-formed, re-cast, and re-created in the text.

Yet we now might want to question the merits of such an archeology: is its knowledge real and recoverable – mimetic – as our Renaissance fore-fathers so wanted to believe, or is it only figurable and representable, always lamenting the process of re-presentation as one prefigured by the limitations of re-creation, as one prefigured by the signs of loss? And what about the relation of gender to genre? Might genre's function as the myth of "man's vision of truth" block out thoughts about the loss of woman?[1]

Thomas Rymer probably would have suggested that these questions pertain not to generic method, the value of genre, but to generic classification, the attribution of genre. In his diatribe against *Othello*, for example, Rymer criticizes Shakespeare for playing free and loose with the generic purity of tragedy. "There is in this Play, some burlesk, some humor, and ramble of Comical Wit, some shew, and some Mimickry to divert the spectators: but the tragical part is, plainly none other, than a Bloody Farce, without salt or savour" (Rymer 1693: 146). Rymer focuses less on the tragic flaw of *the hero* than on the flaws *of the play's action*. He writes that "the foundations of the Play must be concluded to be Monstrous; And the constitution, all over, to be *most rank, Foul disproportion, thoughts unnatural*. Which instead of moving pity, or any passion Tragical and Reasonable, can produce nothing but horror and aversion, and what is odious and grievous to an Audience" (Rymer 1693: 120–21). In Rymer's view, the foundation of *Othello*, the structural core of the play, is an aberration of tragedy because it shows more horror than pity. According to such logic, moreover, this aberration permeates the reception of the play as well as its production. Any performance of *Othello* would enact the re-creation of thoughts unnatural in the minds of the audience.

Rymer's criticism of *Othello* for lacking a therapeutic effect on its audience may say more about certain Renaissance notions of theatre – as a genre – than about this particular play's failure. In the following pages, I wish to consider how a study of *Othello*, in view of genre as well as gender – what I will call "genderic" considerations – shows Rymer's horror and aversion to be endemic to particular Renaissance conceptions of theatre, both as a system of classification and as an epistemological method of pedagogy.

TRAGIC DISSOLUTION

One interesting point of departure may be to dwell for a moment on Rymer's critique of genre in *Othello*. If we look closely at the play for structural flaws, we might begin to understand both the nature of Shakespearean tragedy and how tragedy embodies monstrous codes of male bonding in *Othello*. It is not necessary to probe very deeply into the play to detect flaws of significant proportions. From the outset, characters, actions, and thoughts appear weakened in *Othello* by uncertainties, inconsistencies, and fissures. As opposed to representing social structures and characters marked by traits of wholeness, constancy, and dependability, everything in the play is *already* flawed in and by its representation. Brabantio's fatherhood is already shaken, his daughter's maidenhood is (thought to be) already taken, and Othello's good will is already mistaken – both by his host and by his ancient. Iago is already displaced. Cassio is already victimized. And Othello, Iago, and Cassio are

all (thought to be) already responsible for fouling each other's sheets. What's more, Desdemona is already conniving; the father's house is already unlocked; and the Turks are already threatening the Occidental fatherland. Finally, we cannot forget that when the play opens it is already night, Othello is already black *and* old, while love is already defined as paternal but "caracked." In Iago's introductory words, the tragedy, like flags and signs of love, is already *but a sign*, a figuration of its original representational weakness.[2]

Normative patterns of response to the tragic flaws of *Othello* are also already apparent in Act I. This is where the male characters react to the fragmentation of their society, as Rymer does to the play, with statements of fear and horror. To Brabantio, "this accident is not unlike my dream, / Belief of it oppresses me already" (I.i.142–43).[3] Fear of oppression is something already familiar to Brabantio, something presented to the audience as already known to the dreamstate of fathers. In the patriarchy of Venice, moreover, reason is almost always intermingled with fear. Iago's manipulation of Montano hinges on one statement concerning Cassio: "I fear the trust Othello puts him in, / On some odd time of his infirmity, / Will shake this island" (II.iii.126–28). Iago uses a similar strategy to bait Othello: "Let me be thought too busy in my fears / (As worthy cause I have to fear I am) / And hold her free" (III.iii.253–55). Othello, for his part, succinctly responds in kind, "Fear not my government" (III.iii.256). And, in a significant moment earlier in the play, the Duke of Venice situates governance in the realm of anxiety when he reacts to the "disproportioned" accounts of the Turk by approving the main article "in fearful sense" (I.iii.11–12). Fear rules in *Othello* . . . when the government of Venetian men trembles in its vulnerability.

But the horror of experiencing the frequent and nostalgic signs of paternal dissolution is softened in the play by subsequent disavowals of the tragic source, by displacements of the flaws built into *Othello's* patriarchal structure, and by condensations of worrisome representations into the contained spaces of generic classification.[4] In fraternal conclaves, for example, Brabantio, Othello, Cassio, and Iago all avoid acknowledgment of their own paternal/marital weaknesses by naming their women "whores." In Act I, members of the Venetian Senate identify Othello as far more or far less "fair than black." At the end of the play, moreover, Lodovico opts to displace the visual icon of "tragic loading" with the curtain of decorous, narrative denouement: "The object poisons sight; / Let it be hid . . . / Myself will straight aboard, and to the state / This heavy act with heavy heart relate" (V.ii.364–71). Even the protective codes of reading such heavy narration are spelled out much earlier in the play. During the emergency session of the Venetian Senate, the Senators confidently diminish the cultural threats of the Turk by equating his military aims with their own: "This cannot be / By no essay of reason; 'tis a

pageant / To keep us in false gaze . . . We must not think the Turk is so unskillful / To leave that latest which concerns him first, / Neglecting an attempt of ease and gain / To wake and wage a danger profitless" (I.iii.16–30). The Duke, moreover, performs his threatened authority by making similarly quick and conventional pronouncements on the conflicting reports he receives: "Nay, it is possible enough to judgment. / I do not so secure me in the error" (I.iii.9–10). Whether threatened by Oriental warriors or Occidental women (the forces undermining the security of epic heroism), the Venetian men in *Othello* can be seen again and again to perform their trust in making snap pronouncements that bear the weight of generic classification and nomination.

Linguistic order, definition, and classification may well ease the burden of government in *Othello*, but the patriarchal use of language continues to be compromised by an irrefutable fact. Words always show themselves in this play as but words:

> So let the Turk of Cyprus us beguile,
> We lose it not, so long as we can smile.
> He bears the sentence well that nothing bears
> But the free comfort which from thence he hears;
> But he bears both the sentence and the sorrow
> That, to pay grief, must of poor patience borrow.
> These sentences, to sugar or to gall,
> Being strong on both sides, are equivocal.
> But words are words; I never yet did hear
> That the bruis'd heart was pierced through the [ear].
> I humbly beseech you proceed to th' affairs of state.
> (I.iii.210–20)

As figured by the sentences of Venice, the affairs of state remain just as equivocal as do the sugary sentences of the Turk. Throughout *Othello*, transparent, linguistic infelicity is understood to weaken assertions of authority and order. In Act I, the Duke betrays his own promise to Brabantio that "the bloody book of law / You shall yourself read in the bitter letter / *After your own sense*" (I.iii.67–69, my emphasis). In Act IV, the duped Roderigo finally recovers his wits to reveal the dependable sense of honest Iago's sentences: "I have heard too much; [for] your / words and performances are no kin together" (IV.ii.182–83). Finally, near the close of Act V, as if to sum up the extent of linguistic constancy in Venice, Gratiano laments that "All that is spoke is marr'd" (V.ii.357). Regarding the linguistic practice of patriarchy, we can thus conclude that *Othello* ends as it begins, with pleas for the restoration of the affairs of state, which by their nature fail to hide the tragic loading/lodging of linguistic loss upon which the monuments of fathers, heroes, and hierarchical states already lie.[5]

TRAGIC SKEPTICISM

If the goal of tragedy is to leave its audience with a heavy heart, *Othello* wins the prize. But how does this emotional play address the question of a generic understanding of its heavy acts? How does it frame the interpretation of sorrow, whether from wounds or from words? Up to this point in our discussion, generic consideration of *Othello* suggests that tragedy performs structural flaws inherent in both the signification and the representation of patriarchal power. *Othello* is framed by assertions of power and control that re-create (re-nominate) earlier linguistic and social flaws. These infelicities may well lead contemporary audiences to join Rymer in asking, "what instruction can we make out of this Catastrophe? Or whither must our reflection lead us? Is not this to envenome and sour our spirits, to make us repine and grumble at Providence; and the government of the World?" (Rymer 1693: 141–42). Might not *Othello*'s play on equivocal words be related as much to skepticism as to tragedy?

Rymer's despondent question not only stands out as an example of an early hermeneutic challenge of the play, but prefigures the stimulating generic musings of Stanley Cavell's *The Claim of Reason*. As discussed in the previous chapter, Cavell sees tragedy not simply as the genre defined traditionally in terms of either its flawed action or its heroic flaws, but also as a sign of the aporetical nature of knowledge: "the form of tragedy is the public form of the life of skepticism with respect to other minds" (Cavell 1979: 478). At stake in such a view of tragedy, as Rymer hinted, is the interrelation of dramatic structure and its reception. For both tragic hero and spectator, Cavell suggests, the form of tragedy personifies the epistemological problem of the limits of perception. To what extent does and/or can tragedy provide us "with the knowledge of an Outsider," the spectator's and the hero's Other?

We might answer this question by considering the heroic structures constituting a play like *Othello*. The action of *Othello* can be said to revolve around heroic jockeyings for position within spaces/places of power. Iago, for instance, strives to get Cassio's "place and to plume up my will" (I.iii.393). Throughout Shakespeare's tragedies, such conjunctions of will and possession fuel heroic action which tends to be motivated (at least subliminally) by the forceful penetration and occupation of place and space or the supplementation of unfortified military and vaginal spaces. As suggested by Iago's stress on "my will," occupation and penetration is a singular activity by which tragic heroes act valiantly *alone*, to either the exclusion or expense of other heroes. The phallic drives of the Shakespearean hero, moreover, should not be considered merely as a framework of tragic convention. Cavell aligns them with the archeology of knowledge that motivates the study and performance of genre. Underlying tragic actions and generic claims is the correspondence of

61

heroic, spatial penetration to the assertion of Cartesian subjectivity, "that to know or to be known by another is to penetrate or be penetrated by another, to occupy or be occupied" (Cavell 1979: 470). Here Cavell lends philosophical shape to Rymer's point that both the tragic character and the theatrical beholder should penetrate the Other's space, should come to know the place of the Other mentally as well as physically, and should nurture the Other's acknowledgment and *dependency on* the ontological condition of being seen, seized, and penetrated.

Underlying this tragic self is, to be blunt, the psycho-structure of a patriarchal subjectivity, ideology, and economy whose motivation is the displacement of the Other and the subsequent domination of the Other. Yet, it should be noted that Cavell's fascinating analysis of *Othello* insists that displacement and dominance are represented with equal force as ways of *not knowing* the Other and, conversely, of not allowing the Other to know the self of the tragic hero. *Othello*'s problems of marriage and sexuality, for example, are positioned by Cavell as exemplifying just such crises of epistemology. He suggests that Othello's unwillingness to believe Desdemona, or his desire not to believe her, stems from his refusal to acknowledge her as his partner and from his inability to see her for what she is – which would prevent her from sharing reciprocally in such knowledge of his will. Male domination in *Othello* thus enacts the inability, or at least the refusal, of the hero to acknowledge his relation to (or dependence on?) the Other whom he occupies and dominates. If *Othello* performs the epistemological structure of tragedy – skepticism – it also projects the monstrous consequences of the domineering occupation of space. For the self or the Other, for the hero who will not give up what he cannot have or for the spectator who duplicates the act of (not) having by that of (not) knowing, the most *Othello* promises is tragic death minus catharsis – yet another form of generic impurity. Like the play's language, the force of tragedy in *Othello* is represented to be merely a transparent ideological ruse.

This definition of tragedy as the re-creation of skepticism remains faithful to the history of the generic study of *Othello*. As early as Thomas Rymer, *Othello* has provoked its critics to ponder the purity and the implications of its form as tragedy. Over the years the literary guardians of *Othello* have labored conscientiously to retrieve for the reader the supposed virtues of tragic drama. In fact, the play's tragic structures, whether or not flawed, are so dominant and so self-evident as classifiable thought that the critics' attentive consideration of them has impeded identification and acknowledgment of Other generic structures in Othello. The literary study of *Othello*, I suggest, tends to formalize itself as the reluctance (or conventional inability?) to discuss the many marginal generic structures of the play which I now want to consider.[6] By showing "nothing but horror and aversion, and what is odious and grievous, to

an audience," these structures represent something different from the mimetic recovery of virtue, which mimesis now appears to be a tragic and necessarily phallacious endeavor.

NOT BLACK ENOUGH TO DECIPHER

Consider the status and strategy of the Moor, Othello. Somehow possessing secrets unknown to the civilized courtiers of Venice, Othello charms the Venetians as a marginal man of mystery. It is neither Cassio nor Iago but Othello, in his "unhoused condition," who best comprehends the fortitude of Cyprus. Othello's difference of mind and valor is what makes him strong and useful to the patriarchs of Venice. And more than any other wielder of the Venetian sword, Othello believes that the transparent clarity of his Otherness perfectly represents the figure of his self and his civil stature. "I must be found. / My parts, my title, and my perfect soul / Shall manifest me rightly" (I.ii.30–32). Indeed, what the Venetians recognize as Othello is the sign of his social difference – a sign behind which Othello stands both for recognition and for protection: "Rude am I in my speech, / And little bless'd with the soft phrase of peace" (I.iii.81–82). Although the Moor here assumes "rudeness" as a defensive strategy, he also manipulates the difference of his speech to fascinate his Venetian auditors, to fix their wondrous gaze on his visage and their captive ears on his unbookish, but practiced tales of violent cultural differentiation. By the commencement of the play, Othello's Venetian hosts acknowledge him to be potentially dangerous as "a practicer / Of arts inhibited and out of warrant" (I.ii.78–79).

Othello's depiction as a sort of black magus comes not only from Brabantio.[7] The Moor speaks of himself as a descendant of a line wielding the magic handkerchief handed down by an Egyptian charmer.[8] The power of the handkerchief, like that of Othello's "arts inhibited," lies not in its possession but in its transmission. Othello offers it to Desdemona as a gift, which unknown to her, links her love to the webbing of an absent sibyl. When making the presentation of the potent token, Othello strategically keeps the knowledge of its sorcery to himself. Thus, his first offering to Desdemona, inscribed with invisible magic, confirms Brabantio's charge that the Moor won his daughter by "practices of cunning hell" (I.iii.102). As the play progresses, moreover, Othello's statements enhance his metonymic link to the charmer who "could almost read / The thoughts of people" (III.iv.57–58). Othello believes, as Iago wants him to, that he too can almost read his ancient's thoughts (as well as those of Desdemona, Cassio, and his other intimates): "This honest creature doubtless, / Sees and knows more, much more, than he unfolds" (III.iii.242–43). Othello reveals himself in various ways to be a marginal bearer of the blackest of magic.

Othello's marginality makes him highly attractive to Venice at one moment and extremely dangerous at another. The attraction can be said without too much hesitation to stem from his powers and his charms as a Moor. Based on responses to his powers, Othello's danger to the Venetians seems to be grounded more in his magic as a performer than in his force as soldier. Consider how the threat of Othello's theatricality, especially its threat to a particular woman, dominates the first act of the play. In response to the charge of sorcery, the Moor attributes the source of Desdemona's love to his storytelling which he confesses to have had the effect of a love potion on her. To Brabantio, moreover, Desdemona's seduction can mean only disproportion and thoughts unnatural:

> she, in spite of nature,
> Of years, of country, credit, every thing,
> To fall in love with what she fear'd to look on!
>
> (I.iii.96–98)

Here Brabantio relates his loss of Desdemona to her subliminal over-turning of all civilizing codes, to her confused feminine desire for a black Moor whose appeal seems to lie less in the form of his fearful image than in the subconscious magic of his fantastic tales.[9]

Othello defends himself, however, by recounting the force of Desdemona's own theatrical spectacle:

> These things to hear
> Would Desdemona seriously incline;
> But still the house affairs would draw her [thence],
> Which ever as she could with haste dispatch,
> She'ld come again, and with a greedy ear
> Devour up my discourse. Which I observing,
> Took once a pliant hour, and found good means
> To draw from her a prayer of earnest heart
> That I would all my pilgrimage dilate,
> Whereof by parcels she had something heard,
> But not [intentively]. I did consent,
> And often did beguile her of her tears,
> When I did speak of some distressful stroke
> That my youth suffer'd. My story being done,
> She gave me for my pains a world of [kisses].
> She swore in faith 'twas strange, 'twas passing strange;
> 'Twas pitiful, 'twas wondrous pitiful.
> She wish'd she had not heard it, yet she wish'd
> That heaven had made her such a man. She thank'd me,
> And bade me, if I had a friend that lov'd her,

I should but teach him how to tell my story,
And that would woo her. Upon this hint I spake.
(I.iii.144–65)[10]

In Othello's mind, his story elicits a chain of responses from Desdemona that generates a theatrical performance of its own. The image of Desdemona with her greedy ear entices him into a recitation of the details of his wanderings. The Moor's tale then draws tears from its girlish listener just as a tragedy might. But motivating Desdemona's pity is less her tragic fear of Othello's tale than her contagious desire for his person. Desdemona's subsequent caresses (or Quarto "sighs")[11] bearing both maternal and sexual warmth, along with her wily wish that heaven had made her such a man, comprise Othello's proof that he was not the sole performer on this stage of love. Her husband, her father, and even Iago cite her suddenly inconstant behavior produced by the visions and tales of the Moor as sufficient ocular proof of her feminine capriciousness. Underlying the patriarchal mistrust of Desdemona, moreover, is not only the public belief in her inconstancy as a female, but, perhaps more importantly, the boldness of her own dramatic performance in the wake of Othello's storytelling. The source of male fear, then, might be described as the power of mimesis: the theatrical seduction of Desdemona's own desirous beholders.[12]

Such fear was prevalent in Renaissance England. Theatre, as a generic institution symbolic of beholding and cultural differentiation, was shunned by many thinkers as the source of mimetic, social impurity giving rise to "fears of mixture and disrupted male identity" (Leverenz 1980: 35). Tracts documenting the paternal fear of the public stage describe theatrical beholding in terms virtually synonymous with Brabantio's and Othello's accounts of the visual seduction of Desdemona. To cite one example, William Rankins writes of theatre as a visual

> labyrinth where lodged these monstrous minotaures, had many winds and *turnes fit for a mind* (as they terme it) *Male*content, to walke never content: wherein manie things able to intice a pleasant eye to beholde or an open eare to delight . . . I shall tell you of things *strange* to consider, but more *strange* to behold, no less true than *strange*, yet not so *strange* as damnable.
>
> (Rankins 1587: F3, sig Biv)

What seems strange, turning, and Malecontent to the patriarchs of *Othello* is the seductive operation of spectatorship. The performative result of Desdemona's response to what "'twas strange, 'twas passing strange" is that Othello perceives her as the personification of theatricality:

You did wish that I would make her turn.
Sir, she can turn, and turn; and yet go on

And turn again; and she can weep, sir, weep;
And she's obedient, as you say, obedient;
Very obedient. – Proceed you in your tears. –
Concerning this, sir – O well-painted passion!
(IV.i.252–57)

Desdemona's early visual doting on Othello even turns back on the Moor. His inconstant behavior results from what he sees, blindly or not, as his wife's theatrical feigning. Through his seizure, his impassioned actions, and his erratic turnings, Othello himself personifies the imitation of the theatrical inconstancy he so fears. His loss of self-control in the face of the theatrical Other causes Othello to commit thoughts and deeds exemplifying the antitheatrical fears of dramatic mimesis. His desire for spectacle and the contagion of his beholding result in the dissolution of the self, leadership, and hierarchical status.[13]

The critics of the public stage condemned the generic attraction and imitation of theatrical storytelling for its unconscious force. Stephen Gosson writes that "those impressions of mind are secretly conveyed to the gazers, which the players do counterfeit on the stage . . . the expressing of vice by imitation brings us by the shadows, to the substance of the same" (Gosson 1974: 192–93). William Prynne identifies this mimetic substance as the "execrable precedents of ancient, of moderne Play-poets, and Players witnesse, who have been so deeply plunged in this abominable wickednesse, which my Inke is not black enough to discypher" (Prynne n.d.: 211). To a certain extent, this highly charged metaphor of theatre even envelops references to the feared blackness of *Othello*, as well as to that of "the black and witty" Desdemona.

The horror of *Othello*, in this context, lies not so much in the generic impurity of the tragic hero, or in the play's flawed action and marred language, as in the threat of theatre's societal black death, "by meanes of which," complains Prynne, "both Governours, Government, Religion, and Devotion are brought into contempt" (Prynne n.d.: 124). To reconsider the archeological significance of *Othello* in such a context, I would like to pose the question of what it means for the play's generic structures to be, as Lewalski would have them, "a metaphor for man's vision of truth." Although *The Moor of Venice* concerns man's vision, the play may well hint at the blackness of truth rather than its virtue.[14]

BEGUILING THE THING

The antitheatrical writers thought that theatrical blackness infects morals as well as actions. And because the opponents of theatre considered the morals of women to be the most susceptible to theatrical blemish, writings against the theatre tend to conflate notions of gender with

disciplines of genre. The fundamental antitheatrical argument calls to mind Desdemona's purported inability to shun mimesis:

> those Buxsome and Bountifull Lasses . . . usually were enamoured on the persons of the younger sorts of Actors for the good cloaths they wore upon the Stage, beleeving them realy to be the persons they did only represent.
>
> (Anon, *The Actor's Remonstrance* 1643, 6)

The antitheatrical prejudice held that women were less capable than men of distinguishing between a theatrical sign and its counterfeit signified.[15] To a female beholder, the argument goes, parts and titles manifest their bearers rightly. This antitheatrical assumption also carried archeological valence. Wouldn't women's social conditioning and "subjection to the male conscience" (Dusinberre 1975: 93) necessarily make them susceptible to fictional lords and princes? The antitheatrical certainty regarding women's trust in mimesis stems from the patriarchal training of women to believe in the signs of patriarchy and to live as the signs of men. Women were (and still are, of course) encouraged to efface themselves to enhance the potency of their significational function as mere representations of their men. This adage of woman as a mirror of patriarchy is pronounced clearly by Othello in his plea to the Duke:

> I crave fit disposition for my wife,
> Due reference of place and exhibition,
> With such accommodation and besort
> As levels with her breeding.
>
> (I.iii.236–39)

Much like Caesar in *Antony and Cleopatra*, Othello understands a woman's exhibition to be part and parcel of partriarchal place and breeding. Her disposition signifies the potency of her man's place and exhibition.

Disposition, I might add, here suggests moral comportment as well as social standing. Brabantio's charge that Desdemona has sullied herself by denigrating his name foreshadows the source of jealousy in the play. Cassio's plaint to Desdemona provokes her to perform a name other than that of Othello. She promises to

> perform it
> To the last article. My lord shall never rest,
> I'll watch him tame, and talk him out of patience;
> His bed shall seem a school, his board a shrift;
> I'll intermingle every thing he does
> With Cassio's suit. Therefore be merry, Cassio,
> For thy solicitor shall rather die
> Than give thy cause away.
>
> (III.iii.21–28)

Othello feels that Desdemona's significational switch as Cassio's mouth-piece levels both her breeding and his due reference of place – his bed becomes a school and his board a shrift! Indeed, Desdemona finally comes to know death by talking Othello out of patience. Her method contributes directly to his madness.

Othello's jealousy stems from his failure to accept the fluidity of what we now might call "levelling" signification. Woman is, as Iago would say, but a sign capable of operating simultaneously on multiple levels of representation (including her own). Such inconstant signification levels the mimetic function of a fixed hierarchy of signs. And as both Cassio's and Othello's solicitor, Desdemona begins to fit Iago's description of the deposed Lieutenant: "a slipper and subtle knave, a finder[-out] of occasion; that [has] an eye can stamp and counterfeit advantages, though true advantage never present itself" (II.i.241–44). Such a realistic approach to representation naturally undermines Venetian faith in the rigid order of patriarchal hierarchy in which signs always present their true advantage.

The male anxiety caused by this reality may explain, at least partially, the Renaissance mistrust of female spectatorship, of women's possible acknowledgment of sign systems that demystify patriarchal mimesis. Consider Desdemona's method in receiving Othello's threatening story of the handkerchief. Confronted with Othello's familial memory of the magical webbing, Desdemona first deflects the memory by posing rhetorical questions: "Is't possible?;" "[I' faith]! is't true?" (III.iv.68, 75). She then quickly counters the Moor's passion with a celebrated challenge marking the methodological gap between them: "Why do you speak so startingly and rash?" (III.iv.78). Finally, Desdemona drives her husband mad by countering his demand for optical proof (his mimetic bias) with a peculiar and idiosyncratic turnabout. "This is a trick to put me from my suit" (III.iv.87). Here the handkerchief, like Othello's bed, functions as a double sign of the husband and the lieutenant. Practiced in her method, Desdemona excels at reordering fixed sign systems to realize her personal ambitions.

The text also suggests that Desdemona is not alone in the re-presentation of the mystical webbing. Upon finding the handkerchief, both Emilia and Cassio think first not of keeping it, but of copying the work. The aura of the original webbing is insignificant to those who will use the handkerchief to please their own fancies or to enhance their various assertions of self-discovery. This recognition of the handkerchief as a shifting sign of its various keepers is best expressed by Bianca:

> What did you mean by that same handkerchief you gave me even now? I was a fine fool to take it. I must take out the work? A likely piece of work, that you should find it in your chamber, and know

not who left it there! This is some minx's token, and I must take out
the work?

<div align="right">(IV.i.148–54)</div>

It is hardly insignificant that almost all of the central characters on
Cyprus, except for Othello, read multiple meanings into what the Moor
guards as a singly referential artifact.[16]

The multiple reading of the handkerchief stands out as one of
the many examples of flexible, significational method in *Othello*, of
which Desdemona is the play's high achiever. Throughout the drama,
Desdemona displays an alertness to the play of language by vigilantly
reading and rereading signs, by interpreting events for her own under-
standing and for the calm of her own lodging. In Act III (iv.10), she spars
with the punning clown and counters his nonsense with a demand for the
discovery of meaning: "Can any thing be made of this?" Earlier she
rationally dismisses Othello's emotional "pain upon my forehead" by
explaining, "that's with watching 'twill away again" (III.iii.283–84). The
difference of Othello and Desdemona's reactions to theatrical puzzles,
moreover, is most dramatically displayed in Act IV's bedroom scene. In
response to the Moor's emotional cries of "your mystery, your mystery,"
Desdemona seeks to clarify the import of his declaration: "Upon my knee,
what doth your speech import? / I understand a fury in your words"
(IV.ii.31–32). Desdemona demonstrates her flexibility with language by
recognizing the rhetorical breadth of discourse. She responds to Othello's
speech not only as the carrier of words, but as the performative sign of
the locutor's behavior. While Othello acts out the passion of his lines,
Desdemona tries to reorder his performance by rendering it as a figure of
discourse, as a speech act.

The difference between Othello's and Desdemona's methods may well
constitute the fundamental generic distinction of the play. Whereas
Othello habitually restricts himself to universals and generalizations,
especially in his representations of women, Desdemona fragments and
reorders signification; whereas Othello thinks via magic and passion,
Desdemona is given to argumentative lucidity and logical discourse. Her
balanced use of rhetoric stands out as one of the many examples of
Desdemona's methodological difference from Othello as well as from the
males of Venice who are all too easily prone to fearful proclamation and
hasty nomination.[17]

Still, we need to be more precise about the *genderic* significance of
Desdemona's sensitivity to method. How does her method correspond to
Iago's excellence at significational seeming? Where does Desdemona as a
female worker of words stand in relation to Iago, the character conven-
tionally thought to be wholly responsible for the madness of his superior?
Like the ancient, Desdemona uses words counter to her own meaning,

"I do beguile / The thing I am by seeming otherwise" (II.i.121–22). It can even be suggested that Desdemona out*man*euvers Iago in the manipulation of method for self-discovery. In Act II, scene one, her dramatic seeming packs a strong generic wallop. She humorously dismisses Iago's jokes degrading women by critiquing the judgment behind them. She follows her thrust at Iago, "O heavy ignorance! thou praisest the worst best" (II.i.143–44) with playfully rebellious advice to his wife, "O most lame and impotent conclusion! Do / not learn of him, Emilia, though he be thy husband" (II.i.161–62). In thus differentiating between wives and husbands, Desdemona emphasizes another generic difference in the play. The Moor's wife, however, reclassifies Iago's humorous maxims (a genre of truth) into "old fond paradoxes to make fools / laugh i' th' alehouse" (II.i.138–39). While this testy put-down provides evidence of generic mixture in the play (from tragedy and comedy to maxim and paradoxical proverb), it also suggests the generic implications of the play's archeological methods. Desdemona implies that sexist maxims – and perhaps any generic models framing clearly definable truths – are impotent and archaic, more appropriate for an old man's alehouse than for a theatre sensitive to generic layerings and differences.

Yet, the fraternal bond of the alehouse scores the tragic blow in *Othello*.[18] For it is Desdemona, not Iago, whom Othello suspects of being seemy. As a woman, Desdemona remains especially susceptible to the antitheatrical prejudice against feminine self-fashioning, sexual frankness, and the re-presentation of language. As Iago describes woman, her words and actions are always duplicitous:

> Sir, would she give you so much of her lips
> As of her tongue she oft bestows on me,
> You would have enough.
>
> (II.i.100–02)

> You are pictures out [a' doors],
> Bells in your parlors, wild-cats in your kitchens,
> Saints in your injuries, devils being offended,
> Players in your huswifery, and huswives in your beds.
>
> (II.i.109–12)

Ironically, Desdemona's method enacts Iago's words almost to the letter. In promising Cassio to plea for his suit, she does claim to go to bed for her work, "his bed shall seem a school" (III.iii.24). In the thoughts of Othello, moreover, she plays in her housewifery: "my wife is fair, feeds well, loves company, / Is free of speech, sings, plays, and dances" (III.iii.184–85). Throughout the play's action in Cyprus, Othello readily confuses Desdemona's generic method with his notion of her gender. Whenever she is working, he imagines her to be playing.

70

In her unique attempt to reorder the linguistic play of her house, Desdemona thus frequently commits what her male observers read as the representational actions of a whore. In Act II (iii.252), she mixes the scene of her bed with that of the public hall by appearing in her night clothes to inquire, "What is the matter, dear?" She also can be taken to mimic the working habits of Bianca by leaving her private quarters to seek "where Lieutenant Cassio lies" (III.iv.1–2). Conversely, when Desdemona is not in public quarters, men other than her husband seem to have relatively easy access to her private space. Although her meetings with Iago and Cassio in the private places of the Citadel are innocent enough in the minds of the players, they easily turn abnormal in the eyes of the wedded beholder. Merely the sight of Cassio leaving the privacy of Desdemona's side is enough to spark confused suspicion in the mind of Othello.

Desdemona's genderic fate is to have her "body and beauty," her "well-painted passions," interpreted with suspicion by the cultural codes of man. Her performative behavior meets readily with the same suspicion that theatre's opponents expressed for actors dressed in women's array. In Prynne's words:

> This putting on of woman's array (especially to act a lascivious, amorous, whorish, Love-sicke Play upon the Stage) must needs be sinfull, yea abominable; "because it not onely excites many adulterous filthy lusts, both in the Actors and Spectators; and drawes them on both to contemplate and actuall lewdnesse . . . " but likewise "instigates them to self-pollution . . . and to that unnaturall sodomiticall sinne of uncleanesse."
>
> (Prynne n.d.: 208)

Similarly, to Othello, Desdemona's self-discovery reflects the onset of their self-pollution. "O thou weed!, / Who art so lovely fair and smell'st so sweet, / That the sense aches at thee, would thou hadst never been born!" (IV.ii.67–69). The striking similarity of Othello's quick condemnation of what he beholds as Desdemona's "uncleaneness" to the antitheatrical censure of theatre for being feminine can be understood as providing an historical context for Othello's ready confusion of Desdemona's generic method with his belief in her genderic fickleness. In one of the most shocking moments of the play, Othello spurns Desdemona with the revealing words:

> The fountain from which my current runs
> Or else dries up: to be discarded thence!
> Or keep it as a cistern for foul toads
> To knot and gender in!
>
> (IV.ii.59–62)

Being obsessed with his attraction to Desdemona's gendering, Othello is capable only of foul thoughts in hearing her plea as the "solicitor" of the favors of Cassio.[19]

THE GASTNESS OF HER EYE

Ironically, in her strongest statement of self-defense, Desdemona utters language that almost ensures the possibility of her beholder's confusion of generic method with generic behavior. When relying on her powers of persuasion during the moving bedroom scene with Iago in Act IV, Desdemona states in her defense: "I cannot say 'whore.' / It does abhor me now I speak the word" (IV.ii.161–62). Just as Desdemona saw Othello's passion acted out through his words, her misogynous beholders hear her admit her speech ("ab/hor") to effect the performance of the word ("whore") which she just denied being able to utter.[20] Just such a paradox sustains the horror of *Othello* felt so keenly by Thomas Rymer, who complains that "no woman bred out of a pigsty could talk so meanly" (Rymer 1693: 131).

Such aversion to Desdemona's speech needs to be understood in a broad generic sense – archeologically as well as tragically. Perhaps we should think of Desdemona as a female scapegoat who is sacrificed by an antitheatrical and misogynous society for being a visible woman who exercises the flexible and rational methods which patriarchy fears in the hands of the Other.[21] But, in conclusion, permit me to extend Rymer's plaint of "foul disproportion." Our ways of generic classification can seduce us into critically satisfying assertions like Edward A. Snow's thesis that "the tragedy of the play . . . is the inability of Desdemona to escape or triumph over restraints and Oedipal prohibitions that domesticate women to the conventional order of things" (Snow 1980: 407).[22] Still, any summary of the play's disproportion as the return of woman to the conventional order of things loads the tragedy on only *one* bed, which perspective restricts interpretation of the play only, in Lewalski's terms, to "man's vision of truth."

I would like to suggest that there remains at the conclusion of the play a concealed but more radical woman's vision of things, one maintained by Bianca, the true whore who is missing from the tragic loading of Othello's bed. The traces of this vision derive from Bianca's public disclaimer of the patriarchal social structure (in comparison with Emilia's compromised woman to woman disclaimer, which has made her a feminist hero to some critics). In Act IV, scene one, Bianca refuses to take out Cassio's work in the handkerchief and issues him with what I read as a significant ultimatum – that he visit *her* on *her* terms or have no woman at all. Consider the generic implications of Bianca's threat. She thereby redefines the performance of whoredom (of "gendering") from public

display in the streets to the discovery of her own place and space. Her subjective existence, moreover, is no longer contingent upon her penetration and occupation by phallic heroes. For she loudly pronounces her willingness to live separately, if need be, from the significational and performative space of her white knight Cassio. Bianca stands out as the *only* woman in the play to proclaim openly and publicly that she possesses an identity Other than that wedded to patriarchal beds and the magnetic webbing of heroic representation.[23] As suggested by her easy show of paleness in regarding Cassio's wound, she may even be staged to have relaxed the bold painting of her face, the male sign of her previous public self. The "gastness of her eye" further suggests Bianca's acknowledgment of the horror of phallic aggression in the streets, of which she has been a cheap, whorish victim.

Herein lies the extent of the gender disproportion of *Othello*. Bianca's discovery of a female life "as honest" to her self makes her readily suspicious of performing violence on her male counterpart. Iago is able to capitalize on her new-found feminism by associating "the fruits of whoring" (V.116) with the actor's ability to change faces, to practice "'hypocrisie."[24] Bianca's generic separatism thus doubles the threat to Venice posed by the assumed duplicity of her performative nature. Her assertion and performance of ontological Otherness threatens patriarchy's dependence on her presence as an engine for social definition through generic differentiation.[25] No longer honoring the signs of either whore or virgin, Bianca will not be bought, conquered, or penetrated for some Venetian hero's assertion of self.

But, tragically, Bianca's indifference to man's vision of truth and subjectivity provokes a classical response. The male reaction to Bianca's visibility in Act V displaces her nominally and generically from her rightful home to patriarchy's legal confines. Iago's final command to Bianca, "I charge you go with me" (V.i.120), remains unchallenged and, once again, forces this woman "of life as honest / As you that thus abuse me" (V.i.122–23) to lie in the confining bed of patriarchy.[26] In yet another context, that of the play's critical reception, Shakespeare's literary solicitors tend either to forget Bianca or to cite her skeptically as yet another example of the tragic whore. In essence, it is Bianca who stands out in the play as a marginal index and obscure prologue to the complex history of foul generic thoughts.

NOTES

1 The historical importance of issues concerning "gender and genre" are outlined in Davis (1975). My work on the earliest draft of this chapter, originally composed for the seminar on "Gender and Genre: Feminist Approaches to Shakespearean Roles" at the 1981 Congress of the International Shakespeare Association, Stratford-upon-Avon, was aided by samplings from Lenz,

Greene, and Neely (1980); Schwartz and Kahn (1980); Kahn (1981). Among more recent books on Shakespearean tragedy and gender, I am particularly indebted to material in Neely (1985); Erickson (1985); Belsey (1985); Pye (1990); Adelman (1992); Lupton and Reinhard (1993); and Parker (1996).

2 My understanding of the significational flaws of tragedy and its generic ideology is profoundly indebted to Philippe Lacoue-Labarthe (1978).

3 Unless otherwise noted, all citations of *Othello* are from Evans, ed., *The Riverside Shakespeare* (1974).

4 André Green's book, *The Tragic Effect* (1979), presents an illuminating discussion of the psychoanalytical features of tragedy and how they function Oedipally in *Othello*. In her excellent essay, "Shakespeare and Rhetoric: 'dilation' and 'deletion' in *Othello*," Patricia Parker (1985) discusses how the play is structured around a frustrated narrative of power as knowledge.

5 For a more detailed discussion of male structures in *Othello*, see Neely (1980).

6 This was particularly true in 1981 when I penned the first short version of this chapter for the seminar on "Gender and Genre: Feminist Approaches to Shakespearean Roles" at the 1981 Congress of the International Shakespeare Association, Stratford-upon-Avon.

7 Leslie Fiedler (1972: 139–96) discusses various sorts of black magic in *Othello*. In "Dirty Stills: Arcadian Retrospection, Cinematic Hieroglyphs, and Blackness Run Riot in Olivier's *Othello*," (Murray 1993: 101–23), I discuss the stain of Othello's blackness on Olivier's well-known film, *Othello*, directed by Stuart Burge (1965).

8 Neely's (1980: 228–31) analysis of the handkerchief and its change of keepers is taken a psychic leap farther in Bellamy's (1995) extraordinary essay "Othello's Lost Handkerchief: Where Psychoanalyis Finds Itself."

9 See Stephen Greenblatt's significant essay, "The Improvisation of Power" (1980b).

10 In keeping with the Kernan edition of *Othello* (1963), I purposely alter the *Riverside* version by substituting the Folio "kisses" for the Quarto "sighs." I agree with Greenblatt (1980a: 300) that "the frank eroticism of *kisses* is in keeping with Desdemona's own speeches."

11 I favor "kisses" for reasons that are melodramatic as well as poetic. I am fascinated by the more melodramatic variants in early printed editions of Renaissance plays which seem to belie the tone of many of these editorial projects whose antitheatricality I discuss in *Theatrical Legitimation* (1987).

12 See Newman's (1987a) subtle and extensive discussion of femininity and the monstrous in *Othello*.

13 Fiedler (1972: 150) discusses the incredible turns of *Othello*'s plot and compares our reaction to them to the Moor's contagion of beholding: "the fable of *Othello* is incredible and yet we believe it; the events of *Othello* constitute a 'bloody farce,' and yet we respond to them with the tragic shudder." Also see Pryse (1976).

14 Snow (1980: 387) suggests that the play takes "a certain self-conscious impotent pleasure in demonstrating the moral corruption of its audience and its form."

15 Leverenz (1980) discusses the sexist nature of the antitheatrical response. For a detailed discussion of Renaissance antitheatricality, see Barish (1981).

16 Neely (1980: 229–30) asserts that "after the handkerchief is lost, all of the characters, men and women alike, symbolically misuse and misinterpret it; as a result, all the love relationships in the play are disrupted." While Neely's analysis of the handkerchief contributes to my understanding of the play, I

wish to reconsider the notion of any misinterpretation or misuse of the handkerchief. I would suggest that its multiple uses and interpretations are discovered only after the handkerchief is missed by one character who does not exercise his personal option of interpretation. Instead, Othello sees the handkerchief only as his family *history* would have him see it – as a device to make him miss his Mrs. Also see Kubiak's analysis of the psychoanalytical implications of the handkerchief's place in this family history (Kubiak 1991: 62–63).

17 In a provocative essay on Renaissance genre, "Genus Universum," Michel Beaujour (1980) focuses on two tendencies of generic performance that call to mind the methods of Othello and Desdemona. The mystery of the Moor corresponds in an uncanny way to Beaujour's description of the *genus universum* poet, whose "vision, unimpaired by logical discourse or argumentative lucidity and raised by *furor* to a higher place of intellection, was expressed through the obscure images of myth which he brought to life and perspicuity by means of tropes." Othello, to assert his unique powers of vision, makes frequent allusions to his epic history, magical handkerchief, color, and force. Beaujour would say, no doubt, that the Venetians' fear and horror of both Othello's stories and his cultural Otherness (not to mention his violent actions) can be understood within the broad context of the *genus universum*:

> Attempts to elevate poetry to the status of a *genus universum* were tied to a rhetoric of secrecy, enigma and obscurity, the main figures of which were allegory (taken in a broad sense), mythology, and emblems, considered to be the modern versions of ancient hieroglyphs or ideograms. *Genus universum* brought about a vision of visual figuration and poetic tropes, which more recent oneirocritics still consider to be characteristic of dream work.

In contrast to the "universal genrehood" of Othello, Desdemona subcribes to methods resembling Beaujour's summary of the new rhetoric of the late sixteenth and early seventeenth centuries:

> In the process [of thinking,] memory (the treasure house of eloquence) was deemphasized, while the means of discovering new "things" were developed all beyond those of traditional *Invention*. Memory became the feedback device of discovery itself. The text thus turned into a repository of written traces, a model for future invention, and a regulating system of ulterior additions and modifications to the printed encyclopedia . . . The new Genre was a program for the reader's own dialectical operations (including self-discovery) rather than a *summa* of authoritative data to be memorized and filled into a preexisting structure. Rhetoric, which had been a powerful instrument for social and moral conservatisms, was turned into a machine capable of producing unprecedented idiosyncrasy.

18 Jean-François Lyotard's discussion of the genderic implications of comedy and tragedy, in "One of the Things at Stake in Women's Struggles" (1989: 112), speaks directly to the sexual tragedy of *Othello*:

> One way to separate masculine and feminine . . . virility claims to establish order and femininity is the compulsion to deride order. There is chattering in the gynaeceum and silence among the troops. Contrary to our story, even though comedy may be a masculine genre, it represents the successful strategem of weakness; comedy

makes men laugh like women; the prisoner Rosine makes a fool of Don Bartholo. This is only a momentary concession: Rosine escapes her tutor only to fall under the law of the real master, the Count Almaviva. He who laughs *last*, laughs best: the aimless humour of women will succumb to the learned, socratic, teleological irony of men.

For a more detailed discussion of Lyotard's emphasis on genre and gender, see my chapter "What's Happening?" in *Like a Film* (Murray 1993: 175–206).

19 This confusion of Desdemona's methodological acting with the belief in her whorishness is as much an antitheatrical bias as it is confusion on the part of Othello. As Prynne (n.d.: 145) understood Renaissance theatre it continued to fulfill the classical function of providing an environment for prostitution: "the Play-house and the Stewes were one and the same in ancient times; because after the Playes were ended, the whores who resorted to the playhouses, or were harbored in them, did prostitute themselves under the Theater, unto the lust of others. Whence they derive the Word fornication, seu locis theatralibus [what Othello calls 'gendering']; from Brothels and Playhouses where Whores were kept and prostituted after the Playes were acted."

20 Pryse (1976: 473), as well as Novy (1980).

21 Lacoue-Labarthe (1978: 82) writes that such scapegoatism is endemic to tragedy:

> The tragic fault consists, then, in the religious and sacrificial interpretation of the social ill. The tragic hero is destroyed, as Schelling said, by his wishing to carry out the ritual and by desiring a *"pharmakos"* in order to remove the defilement which he imagines to be sacred. He is destroyed not by directly provoking the chastisement, but by setting loose the old ritual of the scapegoated victim. He is destroyed, in short, by his belief in what Girard calls religious "mechanisms," which are, in fact, with regard to a different concept of religion, "sacrilegious" mechanisms, because they presuppose the transgression of human limits, the appropriation of a divine position (Antigone would be an exemplary case) and of the right to institute difference by oneself (this will be the case of Oedipus just as much as that of Creon, while it is also true that such a reading of tragedy definitively prevents one from conceiving of a "positive" tragic hero). This is why he who desires difference and exclusion excludes himself and undergoes relentlessly, to the point of loss, this unlimited differentiation introduced by the "hyperbologic" in its doubling of the dialectical-sacrificial process, so as to prevent its culmination and paralyze it *from within*. Tragedy, because it is the catharsis of the speculative, reveals disappropriation *as* that which secretly animates and constitutes it; tragedy reveals (dis)appropriation.

Lacoue-Labarthe's reading calls to mind, and, I think, compromises an earlier reading of *Othello* by Kenneth Burke (1964). I discuss the methodological problems of Burke's scapegoat theory in "Kenneth Burke's Logology: A Mock Logomachy" (Murray 1977).

22 See also Fineman's (1991: 143–64) Lacanian reading of the "O" in *Othello* and Greenberg's (1994: 1–32) fascinating analysis of the relation of Oedipality and absolutism in *Othello*.

23 Bianca's difference from Desdemona and Emilia is obvious in light of Carole McKewin's (1980: 128) analysis of the willow-song scene: "Their language is

imbued with frustration and evasion. The conditional mode pervades their syntax: '*Wouldst* thou do such a deed . . . I *might* do't . . . I *should* venture . . . *If* wives do fall' . . . Emilia entertains a dream of power in which women, for a small labor, would own the world and remake the laws. Desdemona turns away from the present to sing of a woman abandoned in the past. What they *would* do, what *had been* is the subject of their talk, not what they *will* do in the face of a terrifying reality."

24 This is Prynne's (n.d.: 158) word for action: "For what else is 'hypocrisie' in the proper signification of the word, 'but the acting of anothers part or person on the Stage:' or what else is an 'hypocrite, in his true etimologie, but a Stage-player, or one who acts anothers part: as sundry Authors and Grammarians teach us.' Hence that common epithite in our Latine Authors: 'Histrionica hypocrisis'.""

25 For forceful discussions of the dialectics of generic politics, see Gayatri Chakravorty Spivak "Explanation and Culture: Marginalia" (1979) and Lyotard "Futilité en révolution" (1977: 157–212).

26 Stephen Greenblatt (1980a: 253) suggests that patriarchal force has wide generic roots – it is endemic not only to tragedy but to theatre: "The theatre is widely perceived in the period as the concrete manifestation of the histri- onic quality of life, and, more specifically, of power – the power of the prince who stands as an actor upon a stage before the eyes of the nation, the power of God who enacts His will in the Theatre of the World. The stage justifies itself against recurrent charges of immorality by invoking this normative function; it is the expression of those rules that govern a properly ordered society and displays visibly the punishment, in laughter and violence, that is meted out upon those who violate the rules. Most playwrights pay at least professional homage to these values; they honor the institutions that enable them to earn their keep and give voice to the ideology that holds together both their 'mystery' and the society at large."

4

"MISSHAPEN CHAOS OF WELL-SEEMING FORMS"

Specters of jointure in *Romeo and Juliet*

The survival of a theatrical work implies that, theatrically, it is saying something about theatre itself, about its essential possibility. And that it does so, theatrically, then, through the play of uniqueness and repetition, by giving rise every time to the chance of an absolutely singular event.

Jacques Derrida, *Psyche*

What distinguishes the performative ethos of the postmodern – in a time of recuperation from the illusions of theatre-as-life – is not only redoubled awareness of what is being restored, but an exponential play around the combinatory sets of stored or past experience which is, since there is utterly no assurance of an uninterrupted present, all we can make of a dubious future.

Herbert Blau, *The Eye of Prey*

Night . . . is, like its opposite the sun, not only half of the real time-space, but an essential part of the proper metaphorical meaning of love. It is not nothingness, non-sense, absurdity. In the polite display of its dark tenderness there is an intense aspiration that is positive for meaning. . . . Let us insist on the nocturnal motion of metaphor and *amor mortis*: it pertains to the irrationality of signs and loving subjects, the irrepresentability on which the renewal of representation depends.

Julia Kristeva, *Tales of Love*[1]

These epigraphs may sound familiar within the intertextual echo-chamber of the subversions of the postmodern. For the postmodern, or as I would rather have it, the poststructural, has indeed resensitized the discourse of theatre studies to the irrepresentable renewal of representation. The jointure of poststructural theory and performance, through their differing rereadings of philosophy and psychoanalysis, has rekindled awareness of the surprising irrationality of signs and lovers, not to mention the death carriage of metaphor and desire. As cautioned

78

time and again by Herbert Blau, who thinks deeply about the critical relation of poststructural theory and performance, such irrationality and irrepresentability have little akin to simplistic notions of nothingness, non-sense, and absurdity; for the renewal of representation stages the intensity of aspiration. Aspiration here calls to mind not simply the longing, aim, or prey of performance, its struggle to appear, but the essential corporeal mechanics of its acting, the breath of its delivery. "In theatre, the body's specific gravity is always there, subject to time, astride of a grave . . . Whatever it contributes, in theory, to the textual dispersal of all forms, the theatre remembers the unstateable undercurrent of play which inevitably makes the actor sweat" (Blau 1982b: 133). For Blau, the actor, the theatre, not to mention the writer, are enveloped in the porous substance at the crepuscular core of things. They are confronted, he might say, by the irrepresentability of their ghostings, those ghostly traces of memory that possess work and haunt performance.

Summoned by the illusive specter of old Hamlet who is recognizable only by the shell of his armor, Blau casts ghosting as the ontology of theatre and its acting. Ghosting is the term he coined for the method employed by his experimental troupe, KRAKEN, to designate, on one hand, the patterns of gesture and speaking which actors carry with them into rehearsal, and on the other hand, "the identifiable structures of reflection, recurrences, clusters of initiatory meaning, the volatility of emerging concepts" (Blau 1982a: 206) that arise from the repetitive improvisations of the collaborative process of rehearsal. Ghosting entails both a stripping off and a taking on from inside and outside those habits and forms that seem always already to have been there. Much like the differing theoretical renewals of poststructuralism, the ghostings of theatre bear consequences that disturb and challenge the certitude of the ontologies of self and institution:

> The ghosting is not only a theatrical process but a self-questioning of the structure within the structure of which the theatre is a part. What seems true in the play of appearances – as most ontological discourse has assured us in our time – is that there is no way in which the thing we want to represent can exist within representation itself, because of the disjuncture between words and things, images and meanings, nomenclature and being – all of which cause us to think that the theatre is the world when it's more like the thought of history. It is, however, a form whose signifying power, like that of language, far exceeds what the world in its seeming opacity offers to be signified. Like Hamlet, we may have the will and means to do it – but do what? That remains to be seen, though its absence may invade us with appalling force, and it is *that* force we are trying to represent in the work.
>
> (Blau 1982a: 199)

Although they probably did not, the writings of Herbert Blau and the specters of his postmodern theatre troupe could have haunted Jacques Derrida when he too turned to Hamlet's ghost to frame his thoughts on the poststructural *Specters of Marx*:

> what distinguishes the specter or the *revenant* from the *spirit*, including the spirit in the sense of the ghost in general, is doubtless a supernatural and paradoxical phenomenality, the furtive and ungraspable visibility of the invisible, or an invisibility of a visible X, that *non-sensuous sensuous* of which *Capital* speaks . . . with regard to a certain exchange-value . . . since we do not see the one who orders "swear," we cannot identify it in all certainty, we must fall back on its voice. The one who says "I am thy Father's Spirit" can only be taken at his word. An essentially blind submission to his secret, to the secret of his origin: this is a first obedience to the injunction.
>
> (Derrida 1994: 7)

The exceptionally forceful specters of injunction, the ghostings of the law, and the porousness of aspiration provide the furtive and ungraspable conditions which Blau, Derrida, and perhaps even Kristeva all recognize as beckoning the renewal of representation in an age in which the exchange-value of aesthetic form is rendered uncertain. But in looking to the future, these writers never allow themselves to forget the forceful legacy of the form of the past. Perhaps the most grossly misunderstood bedrock of poststructuralism is its thoughtful submission to historical injunction. Any renewal of representation will necessarily be accompanied, if not beckoned, by the sights and sounds of the historical specters enveloping it. Perhaps this explains the curious omnipresence of Shakespeare when the works of Blau, Derrida, and Kristeva invoke the specters of performance.

SPIRITS RESORT

Blau refers most consistently to *Hamlet* and *King Lear* in developing his theory of ghosting and its relation to the force of theatrical injunction.[2] It is notable that the specters of an earlier Shakespearean tragedy, *Romeo and Juliet*, have failed to seize the close attention of this theoretician for whom "body's gravity is always there, subject to time, astride of a grave." Few plays represent so eerily the crepuscular core of representation as when Romeo and Juliet lie astride each other's corpse for a final restorative kiss. Few other tragedies imagine more successfully the doubling of deadly expiration and life-giving aspiration that emanates from the faintly warm lips of these adolescents so suddenly certain of their love.

Indeed, the image of the lovers' entwined death may stand out as one of the more memorable icons of Shakespeare, much like the dual deaths of Cordelia and Lear at the end of *King Lear* or the tragic loading of Othello's bed whose poisonous object is ordered hidden by Lodovico at the end of the play.

What seems to have remained indifferent to Blau is less the icon of Romeo and Juliet's tragic end than the many spectralizations of trauma that lend to this final image its haunting quality. A quick gloss of some of the more spectral passages in *Romeo and Juliet* may help to contextualize my reading of the many ghostings that frame its action from beginning to end. I open by citing an example from one of the many scenes of campy humor in which Mercutio mimes the methods of conjuration to summon the spurned lover, Romeo:

> I conjure thee by Rosaline's bright eyes,
> By her high forehead and her scarlet lip,
> By her fine foot, straight leg, and quivering thigh,
> And the demesnes that there adjacent lie,
> That in thy likeness though appear to us.
>
> (II.i.17–21)[3]

The argument of this chapter will soon rest its gaze on the significance of this likeness of Romeo to the fetishistic appearances of conjuration. Although I will not equate him directly with the many part-objects of Rosaline which seem to multiply with their every mention ("bright eyes," "high forehead," "scarlet lip," "fine foot," "straight leg," "quivering thigh," and adjacent "demesnes"), I will have occasion below to analyze his dependence on the spectral machinery of fetishism. For now, suffice it to say that when not himself the specter of quivering conjurations, Romeo opens the play beset by phantoms, revenants, and unknown territories whose figures escape the clarity of his comprehension.[4] Shakespeare's spectators first come to know Romeo as either beset by daybreak's melancholy from unrequited passion, "O heavy lightness, serious vanity, / Misshapen chaos of well-seeming forms, / Feather of lead, bright smoke, cold fire, sick health, / Still-waking sleep" (I.i.169–72), or deeply agitated by the unsettling residue of a prior night's dream:

> my mind misgives
> Some consequence yet hanging in the stars
> Shall bitterly begin his fearful date
> With this night's revels, and expire the term
> Of a despisèd life clos'd in my breast,
> By some vile forfeit of untimely death.
>
> (I.iv.106–11)

The residual effects of such uncomfortable dreams are understood by the French psychoanalyst J.-B. Pontalis (1990: 28–31) to set the stage for the retrospective trauma of future encounters whose intensity is magnified by the "perpetual menace" brought to the scene by the haunted subject. Who can forget, in this oenirical context, Romeo's own frightful conjurations as he looks upon the amorous carrion of his comatose Juliet:

> O my love, my wife,
> Death, that hath sucked the honey of thy breath,
> Hath had no power yet upon thy beauty:
> Thou art not conquered, beauty's ensign yet
> Is crimson in thy lips and in thy cheeks,
> And Death's pale flag is not advancèd there . . .
>
> Ah, dear Juliet,
> Why art thou yet so fair? Shall I believe
> That unsubstantial Death is amorous,
> And that the lean abhorrèd monster keeps
> Thee here in dark to be his paramour?
> For fear of that, I still will stay with thee,
> And never from this palace of dim night
> Depart again. Here, here will I remain
> With worms that are thy chambermaids.
>
> (V.iii.91–109)

The visceral worminess of this scene marks not only the play's conclusion but its imaginings throughout of the transfiguring idealizations of the anthropomorphized corpse. For what Pontalis terms "oenirical perceptions" (1990: 39) Derrida provides the more literary synonym of "spectralpoetics" (Derrida 1994: 45). Imagine what Blau would ask his actress to imagine seeing in Act III as she delivers the Nurse's shaky report of Tybalt's death. This is when the Nurse summons the visualization of the crimson corpse that Juliet handily mistakes for the gruesome figure of her Romeo:

> I saw the wound, I saw it with mine eyes
> (God save the mark!), here on his manly breast:
> A piteous corse, a bloody piteous corse,
> Pale, pale as ashes, all bedaubed in blood,
> All in gore blood; I sounded at the sight.
>
> (III.ii.52–56)

In such imaginings, ghostliness inhabits and interpellates the viewer with the spectral sounds of dreaded death. Just such ghostliness, moreover, is what renders Juliet most fearful of her feigning of death and the paleness of its flag:

How if, when I am laid into the tomb,
I wake before the time that Romeo
Come to redeem me? There's a fearful point!
Shall I not then be stifled in the vault,
To whose foul mouth no healthsome air breathes in,
And there die strangled ere my Romeo comes?
Or if I live, is it not very like
The horrible conceit of death and night,
Together with the terror of the place –
As in a vault, an ancient receptacle,
Where for this many hundred years the bones
Of all my buried ancestors are pack'd,
Where bloody Tybalt, yet but green in earth,
Lies fest'ring in his shroud, where, as they say,
At some hours in the night spirits resort.

(IV.iii.30–44)

Having been wrought into a confounded state by such horrible, yet familiar, imaginings of the stifling vault and its ancestral bones, Juliet is then prompted to swallow the Friar's potion by her sudden spectral vision of her dead cousin in search of bloody vengeance:

O, look! methinks I see my cousin's ghost
Seeking out Romeo, that did spit his body
Upon a rapier's point. Stay, Tybalt, stay!
Romeo, Romeo, Romeo! Here's drink – I drink to thee.

(IV.iii.55–58)

The performative force of such ghosting wreaks the havoc of death all over Shakespeare's stage. Even the Friar bears the mark of the revenant when Romeo names him "my ghostly father" (II.iii.45). *Romeo and Juliet* is a play whose characters rarely think, act, or feel without the threat of someone's ghost rising up to haunt them. As I shall discuss at the conclusion of this chapter, the fertile spectralpoetics of ghosting in Shakespeare's play of 1595 provides a retrospective blueprint for the traumatic theatrical injunctions that will follow in later plays, such as *Hamlet* and *King Lear*, those Shakespearean monuments whose ancestral ghosts most certainly inhabit the poststructural imagination of the likes of Herbert Blau.

CAN YOU READ?

For Julia Kristeva, the author of my opening epigraph from "Romeo and Juliet: the Love–Hate Couple," a chapter in *Tales of Love*, the representational conditions ghosting Shakespeare's two adolescent lovers mirror

the conditions of reading in the poststructural age. The act of reading underscores not only the incompatibility of temporal succession and the instant of love, that double time-structure of fiction theorized so aptly by Gérard Genette,[5] but foregrounds the demiurgical process through which passion actually modifies temporal progression for the loving and reading subject. Being enabled by the unnamable flow of psychic energy, reading, like the love described by Kristeva, can be said to lie somewhere beyond place and temporality (Kristeva 1987: 213). That is, it hovers beyond empirical identification in the murky libidinal territory known for shifting correspondences not for dependable equations. Herbert Blau might say that it there situates theatre . . . at the vanishing point.

Just so in *Romeo and Juliet*, the vicissitudes of reading lead to love as well as to death. On the surface, reading functions as the play's universal metaphor of seduction and melancholy, just as it serves in baroque culture to signify the pensiveness of self and its swing between reason and emotion.[6] In response to the Capulet Servant's query, "I pray, sir, can you read?" Romeo puns on reading as the metaphor of his melancholic self-reflexivity, "Ay, mine own fortune in my misery" (I.ii.56–57). In the next breath, the seduction of reading itself first lures him to exchange with fanciful swiftness his melancholic despair over Rosaline for his love of Juliet. "But I pray, can you read any thing you see?" to which Romeo responds, "Ay, if I know the letters and the language" (I.ii.59–60). It is, of course, then Romeo's recitation of Capulet's party invitation for the illiterate messenger that leads Benvolio to challenge him to "Go thither, and with unattainted eye / Compare [Rosaline's] face with some that I shall show" (I.ii.85–86). Precisely the same prescription of reading provides the occasion for Juliet to draw her eyes from Paris to Romeo:

> *Lady Capulet* What say you? can you love the gentleman?
> This night you shall behold him at our feast;
> Read o'er the volume of young Paris' face,
> And find delight writ there with beauty's pen;
> Examine every married lineament,
> And see how one another lends content;
> And what obscur'd in this fair volume lies
> Find written in the margent of his eyes.
>
> (I.iii.81–87)

The codes of courtly seduction lead their initiates to trust in the veracity of reading, regardless of the nature of the volume bearing the pleasing lines of beauty's pen. Yet, precisely these same seductive conventions of the self-evidence of reading result in the vicissitudes of desire and melancholy that mar the married lineaments of love in *Romeo and Juliet*. Disturbed by the quick alteration of Romeo's melancholic humor early

in the play, the Friar praises the guarded circumspection of Rosaline: "O, she knew well / Thy love did read by rote, that could not spell" (II.iii.87–88). While the Friar himself later depends on the certitude that Romeo will read his letter revealing the falsity of Juliet's final sleep, the missive's failure to arrive at its proper destination leads to the play's tragic conclusion.[7] Reading thus stands out in Shakespeare's play as the libidinal machinery of sudden seduction and missed encounter.

Were Kristeva to summarize the impact of reading in *Romeo and Juliet*, she would likely stress how reading foregrounds the transgression of love as well as its incompatibility with the idealization of law maintained psychically by the Freudian superego and exercised legally by the contract of marriage. Marriage is the symbolic institution which Kristeva describes as the historically and socially determining condition of love's demise and death. Rather than serving as a script of irrepresentable desire, marriage represents the letter of the law of reproduction, production, and the social contract (Kristeva 1983: 264–65). Regarding the psychic illusion sustaining the contract, Kristeva asserts that the couple stands out as a Utopian phantasm of the lost Oedipal paradise in which both male and female hallucinate, although differently, their fusion with the nurturing mother and the ideal father (the latter being a reference, for Kristeva, to Freud's "father of the individual prehistory," what she terms the *"père imaginaire"*) (Kristeva 1983: 281). On one hand, the symbolic couple of *Romeo and Juliet* thus returns by play's end to the ultimate ground of the nurturing mother, which the Friar describes as "The earth that's nature's mother is her tomb; / What is her burying grave, that is her womb" (II.iii.9–10). On the other hand, the story of their woe awaits adjudication by the Prince who functions throughout as something of a *"père imaginaire."*

Finally, Kristeva stresses how the sado-masochism of the love relation is figured doubly in the play by Juliet's poignant phrase, "My only love sprung from my only hate" (I.v.138) and Romeo's odious exclamation, "My name, dear saint, is hateful to myself" (II.ii.55). The love–hate trajectory of this relationship is exemplary, for Kristeva, of the marriage condition in which both partners take on the divided role of both sexes:

> Each acting out both sexes in turn they thus create a foursome [*une machine à quatre*] that feeds on itself through repeated aggression and fusion, castration and gratification, resurrection and death. And who, during moments of passion resort to adjuvants: provisional partners, loved but victimized, whom the monstrous couple pulverizes in its passionate fidelity to itself, sustaining itself with infidelity to others.
>
> (Kristeva 1983: 274–75)

Noteworthy is the fact that the monstrous couple stands juxtaposed in Kristeva's text with her paradoxical idealization of the "pure couple,"

Romeo and Juliet, whom the death shroud of Shakespeare is said to have safeguarded from the pulverizing candor of marriage. As she reads the tale of love in *Romeo and Juliet*, "the story of the famous couple is in fact a tale of the impossible couple: they spend less time loving each other than in preparing themselves to die" (Kristeva 1983: 265).

DEATH'S ACCIDENT

Might we return to the terms opening this chapter to speak this fable otherwise? Could it be said that this couple spends less time preparing for death than inhabiting the ghostliness of love? I make this distinction to recall not only Blau's theory of ghosting, how theatre remembers the spectral undercurrent of play which inevitably makes the actor sweat, but to introduce the argument of Derrida's essay on the play, "Aphorism Accident," in *Psyche: inventions de l'autre* (Derrida 1987).[8] From the perspective of Derrida, the impossibility of the couple stems from their preparations neither for loving nor for dying but for the conjunction of these states in mourning, for loving death. Even in a play so fantastically surrounded by public specters, memories, nightmares, sights, smells, and even tastes of death, these two young lovers guard the absolute singularity of their love for death. As Derrida puts it, "They live *in turn* the death of the other, during a time, the contretemps [accident] of their death. Both are in mourning – and both watch over the death of the other, attend to the death of the other. Double death sentence [double stoppage of death/*double arrêt de mort*]" (Derrida 1992: 524). Whether in love, in death, or in death warrant, the purity of Romeo and Juliet stems from the incomparable status of their impossibility.

Derrida, of course, is not the sole contemporary reader to reflect on Shakespeare's emphasis on such incomparability. A rather brief and casual commentary on the same topic of Romeo and Juliet's incomparable status is penned, for instance, by one of cinema's most poststructural practitioners, Jean-Luc Godard. Indeed, Godard involves a different couple well known to postmodern criticism in an exchange about the doubleness of death in *Romeo and Juliet*. It takes place between Michel and Patricia during the prolonged bedroom scene in *Breathless*.

> Michel: Why don't you want to sleep with me again?
> Patricia: Because I'd like to know. There's something about you . . . that I like but I don't know what. I wish we were Romeo and Juliet.
> Michel: Oh, là, la, what a girlish idea.
> Patricia: You see, you said last night, in the car, you couldn't live without me. But you can. Romeo couldn't live without Juliet. But you can, you can.

Michel: No, I can't live without you.
Patricia: Oh, là, là! Now that's just a boyish idea.
 (quoted in Andrew 1987: 73)

What distinguishes this example is its illustration of the paradoxical
nature of reception's idealization of Shakespeare's perfect couple, one
suggesting not only procedures of reading but gender difference. For
Michel, acquiescence to literary allusion is but an arbitrary means to a
phallic end – he merely wants to have her again and will tell whatever
story comes to mind in order to succeed. The only problem is that he
fails to get the point of literary allusion: he mistakenly conflates Juliet
and Patricia ("I can't live without you"). This constitutes for the playful
Patricia the boyishness of his response to her conditionally analogical
mode of thinking ("I wish we were Romeo and Juliet"). For Patricia,
in contrast, Shakespeare's ideal couple stands out as an exemplar of
epistemological search. However naive she may be, Patricia cites the
couple in reference to her need to know what it is she likes in a man.
Reading for her, or at least her allusion to the public memory of reading,
is an act of reference, not equation, and such reference bears ontological
consequence. Her knowing must be matched by reference to the ghostly
jointure of his being; knowing love must enact the sentence of death.

Very much unlike her partner's tendency to use whatever methods
available to satisfy his drives of conquest, Patricia's playful epistemo-
logical ponderings suggest the sort of adolescent pensiveness which, I
feel, so often distinguishes Juliet from her Romeo.[9] One example from
Shakespeare's text may help illustrate the gender distinction I have in
mind, one that is most often more figural than literal. Romeo responds
to their wedding vows with a frustrated account of his inability to speak
the "imagin'd happiness" they soon will receive as a consequence of
marriage. That is, of course, the *jouissance* which he imagines they will
both experience (simultaneously, no doubt) now that the law of union
sanctions Juliet's shedding of her "vestal livery . . . sick and green"
(II.ii.8). Juliet's rejoinder parallels Patricia's need to relate loving with
knowing, or more precisely, loving with the inability to know:

> Conceit, more rich in matter than in words,
> Brags of his substance, not of ornament;
> They are but beggars that can count their worth,
> But my true love is grown to such excess
> I cannot sum up sum of half my wealth.
>
> (II.vi.30–34)

What remains rich in matter for Juliet is the excess of conceit, or the
aporia of understanding, not merely the adequation of ornament, or
the semiotics of such stuff as green livery or golden worth.[10] Might not
this thoughtful sensitivity to excess also enfold her knowledge of love

in the aporia of death? Isn't the experience of death, and not really that of love, the condition most commented upon by philosophers as what eludes the conceit, summation, and certainty of representation? Conversely, isn't it often the experience of love that opens the way to philosophizing about the phenomenal distance of death? "Methinks I see thee now," says Juliet of Romeo who has descended into the garden following the consummation of their marriage, "thou art so low, / As one dead in the bottom of a tomb. Either my eyesight fails, or thou look'st pale" (III.v.55–57). Perhaps *Romeo and Juliet* might have as much to say about the infelicities of sight and knowledge when faced with the doubled warrant of love and death as it does about the maddening sadness of true adolescent love. Perhaps the truth of method here has less to do with the idealization of love than with the deceit of critical certainty – whose "chopp'd logic" seems to be apprehended more readily by some characters than by others.

IMPOSSIBLE SYNCHRONIZATION

Regardless of how we want to frame purity, what need count, then, is its conditioning by the impossibility of representation. As Derrida asserts in his essay on *Romeo and Juliet*, Shakespeare's text exemplifies the condition of "impossible synchronization." In reflecting on the opportunities provided by accident in the play, both those missed and those gained, Derrida refers not merely to the impossible balance between *signifiant/ signifié, énoncé/énonciation,* inside/outside, self/other, but to the social residues of accident or syncopation itself. So it works, in his reading, that the proper name leaps out of the play as the hero of accident, that which ghosts love, death, and mourning on the scene of interwoven subjective and objective representation, the scene marring the jointure and fissure of social convention and the history of its fictional truths. As he puts it succinctly,

> Romeo and Juliet love each other across their name, despite their name, they die on account of their name, and they live on [survive] in their name. Since there is neither desire, pledge, nor sacred bond (sacramentum) without aphoristic separation, the greatest love springs from the greatest force of dissociation, here what opposes and divides the two families in their name.
>
> (Derrida 1992: 423)

For Derrida, the memorable trait of *Romeo and Juliet* is less its cross-cultural accessibility than the disjointing irony performed by the proper name. What's ironic here is the inadequacy of truistic reading for any comprehension of the incommensurable, perhaps irrepresentable, divisions between names, cultures, genders, and races – *das Geschlecht*.[11]

88

It is within the frame of this paradox of impossible purity that I now wish to return to the issue of the consequence of Kristeva's reading, what some might call its deadly "politics." How might we assess the consequence of "the proper metaphorical meaning of love" here framing the renewal of representation? What is privileged by Kristeva's juxtaposition of the "pure couple" with the monstrous couple's passionate fidelity to itself as sustained by infidelity to its other provisional partners, those loved but pulverized? Might the "impossibility" or the "irrepresent-ability" of true love here designate something like an impossible division between the living metaphor of a speaking, writing, and loving subject (*énoncé*) and the ghostly metonymy of an intersubjective field of reception, inscription, and desire (*énonciation*)? A strong sense of the impossibility of such a properly metaphorical coupling or jointure of the living and the ghostly might be gleaned from an assertion that sets the tone of Kristeva's reading. I am thinking of an aphoristic remark made in passing that positions *Romeo and Juliet* not only within the history of love but within the tradition of its impossible reading. In a confessional moment of exuberant affection for the play, Kristeva notes that "young people the world over, whatever their race, religion, social condition, identify with the adolescents of Verona who mistook love for death" (Kristeva 1983: 266). While such a truism might well serve the needs of a blindly universal psychoanalytical subjectivity, the frame of aphorism itself actually prevents the act of reading, in Derrida's words, "from sharing all of its time with another place of discourse, with another discourse, with the discourse of the other. Impossible synchronization" (Derrida 1992: 418). Put another way, Kristeva's means of articulating her aphoristic claims for a universal reading of *Romeo and Juliet* may well highlight the ghostly folds of the representational difference of fetishism which I understand to haunt the play's discourse of impossibility.[12] In such a case, synchrony marks but the impossible attempt of critical hegemony to mask the traumatic divisions of Shakespearean culture, its reading and its reception.

When the Nurse discovers Romeo hiding in the Friar's cell after his murder of Tybalt, she utters one of my favorite examples of Shakespearean chiasmus whose terms typify the impossible legacy of synchrony which Kristeva wishes to safeguard for the play.

> O, he is even in my mistress' case,
> Just as in her case. O woeful sympathy!
> Piteous predicament! Even so lies she,
> Blubb'ring and weeping, weeping and blubb'ring.
> (III.iii.84–87)

This ill-spoken chiasmus, which has both Romeo and Juliet encased equally in the predicament of sorrow, suggests a kind of balance that

could be argued to sustain the adolescent love of the play. Isn't it just such silly blubb'ring with which young people all over the world might be said to identify in *Romeo and Juliet*? The Nurse acts quickly, however, to assert the impossibility of such poetically adolescent synchrony. "Stand up, stand up," she appeals to Romeo, "stand, and you be a man; / For Juliet's sake, for her sake, rise and stand; / Why should you fall into so deep an O?" (III.iii.88–90). The Nurse denies to the phallic youth the impotence of mourning that debilitates the fallen Juliet. If he follows this logic, he will rise and stand for the sake of supplementing the depth of Juliet's O. Considered philosophically, his potency will be determined by *differance*, by its difference from and deferral of Juliet's lack. Considered psychoanalytically, his rising is contingent on his fetishistic disavowal of the depth of the wound he shares with Juliet: "yes, her weeping is my wound, but nevertheless . . . I will rise and be man."[13]

The irony here is that the Nurse outlines the relations of fetishism dominating the play while actually confusing the imbalance of gender upon which it depends. The play's first description of Romeo comes from Benvolio who posits emotional synchrony as a condition familiar to the "troubled minds" of boys:

> I, measuring his affections by my own,
> Which then most sought where most might not be found,
> Being one too many by my weary self,
> Pursued my humor not pursuing his,
> And gladly shunn'd who gladly fled from me.
>
> (I.i.126–30)

While Romeo and his youthful buddies on the Montague side pine away in melancholic excess, Juliet's father, Capulet, ornaments his trust in her future marriage with the fabric of his untold Oedipal loss: "Earth hath swallowed all my hopes but she; She's the hopeful lady of my earth" (I.ii.14–15). In a world that privileges the initiatory rites of boyish melancholy and the seasoned performance of virile mourning, man's emotional vehicles function as the negative supplement or fetish of the many losses haunting patriarchy.

The regenerate disavowals of mourning and melancholy seem to be rendered illicit and/or life threatening most specifically for women.[14] In sharp contrast to her husband, Lady Capulet makes no mention of the loss from her womb she shares with Capulet. Nor does the Nurse dwell on the death of her daughter, Susan, who "was too good for me" (I.iii.21), and whose passing is marked in time by the life of her charge, Juliet. Upon witnessing the sight of her ashen Juliet, Lady Capulet speaks more the discourse of ghosting than that of melancholy: "O me, this sight of death is as a bell / That warns my old age to a sepulchre" (V.iii.206–07). Such a quick summons of death as the short-circuiting of the prolonged

temporality of melancholy affects Lady Montague as well who is not even given leave to observe the loss of her son, Romeo. This is because grief of her son's exile "hath stopped her breath" (V.iii.211). If women grieve at all on this stage, the attendant danger is their instantaneous death rather than, as Freud would have it, the curative renewal of their Ego damaged by loss of the love object.[15] The minimal extent of woman's right to the customs of mourning is made particularly explicit, moreover, by parental response to Juliet who is "mewed up to her heaviness" (III.iv.11) in response to Romeo's banishment for slaying Tybalt. Capulet and his wife hope to rid their daughter of her feigned woe for Tybalt in order to woo her themselves for a hastily arranged marriage to Paris ("These times of woe afford no times to woo," laments Paris (III.iv.8)). Counseling Juliet against "evermore weeping" for her cousin who suffered a bloody death only earlier that very same day, Lady Capulet insists, "Therefore have done. Some grief shows much of love, / But much of grief shows still some want of wit" (III.v.72–73). Particularly fascinating about this injunction is its replication of the procedures of the supplementation of woman's loss, her "want of wit," with the renewal not of female Ego but of homosocial alliance. The misshapen chaos of impossible synchrony is transformed here again into well-seeming form by the fetishistic logic of phallic disavowal. That is, the deep O of women's loss which threatens the force of patriarchal injunction is transformed consistently in *Romeo and Juliet* into the stabilizing social mechanism of the mournful hope of men.

DARK SEDUCTION

"What happens in all this," Blau might ask, "to the emotion of love itself?" (Blau 1992: 154).

> As it were the debased and rusted counterfeit of the Great Chain of Being, seduction may be thought of as the bejeweled and cynical offering to our capacity for deception, the merest persuasive replica of reciprocal desire . . . But in the flooded circuitries of exchange with not even the remotest electronic measure of a true center of being, it seems natural enough to be carried away by seduction: what happens to love not in the expertise of appearance but at the (purported) end of representation . . . To be carried away from the center of being is what seduction classically is, but it's not only the fire of love which is at stake, its thrills and fevers, the vertiginous speed of love that exhausts itself in a seizure of the heart, but a sort of coronary bypass of language itself, of which seduction appears to be, in the world of simulacra, its terminal collapse.
>
> (Blau 1992: 155)

Might not just the thrill and fever of it all, the vertiginous speed of love, remain to be the beckoning force of *Romeo and Juliet*? Might not the fire of love, rather than the deception of seduction, provide the play's magnetism that joins together, in Kristeva's words, "young people the world over, whatever their race, religion, social condition"? While we might well wish for love to enact "a sort of coronary bypass of language itself," the simulacra of love in *Romeo and Juliet* continue to testify to the forcefulness of what Blau would call the ghostings, but not the bypass of language. The bejeweled residues of cultural and sexual difference which lovers and actors bring to the spontaneous stage of seduction and desire do indeed reveal the "ends" of the representation of desire: not simply the rapid aspiration of sexual attraction but the ghostings of the law and the specters of injunction which also arise with ghostly consequence in later plays by Shakespeare.

Even at the moment of the play's speediest of transformations, when the flooded circuitries of desire transform the object of Romeo's gaze from Rosaline to Juliet, the bejeweled logic of fetishism unfortunately lends a tainted cast to Cupid's fire.

> O she doth teach the torches to burn bright!
> It seems she hangs upon the cheek of night
> As a rich jewel in an Ethiop's ear –
> Beauty too rich for use, for earth too dear:
> So shows a snowy dove trooping with crows,
> As yonder lady o'er her fellows shows.
>
> (I.v.43–49)

Kristeva might cite such a passage as exemplary, to return to my opening epigraph, of the "nocturnal motion of metaphor" that "pertains to the irrationality of signs and of loving subjects" (Kristeva 1983: 271). Although love certainly carries Romeo far away from the center of his being, metaphor here anchors him less in the civil deployment of love's dark tenderness than in the sexual and colonial economy of fetishism haunting so many of Shakespeare's plays, from *Antony and Cleopatra* and *Titus Andronicus* to *Othello* and *The Tempest*. This passage's bejeweled objectification of Juliet pales in comparison to how metaphor inscribes the universality of desire within the psycho-political field of racial mystification. The purity of bright Juliet here hangs on the charged valence of Shakespeare's dependency on reference to the Dark Continent, where the mystery of Juliet's beauty is hinged like a fetish on the ear of the Ethiop and where its purity stands out like a snowy dove trooping with dark crows. The metaphor then shifts terms when later voiced by Juliet who, as the impatient lover of Romeo, summons the aid of strange, black love and then assumes for herself the personification of the dark carrier of passion:

> Come, civil night,
> Thou sober-suited matron all in black,
> And learn me how to lose a winning match,
> Played for a pair of stainless maidenhoods.
> Hood my unmanned blood, bating in my cheeks,
> With thy black mantle, till strange love grow bold,
> Think true love acted simple modesty.
> Come, night, come, Romeo, come, thou day in night,
> For thou wilt lie upon the wings of night,
> Whiter than new snow upon a raven's back.
>
> (III.ii.10–19)

Such poetic doublings of the female erotic object with the dark mysteries of bird, night, and continent elicit their own ghostings in the text of the play. Similar to how the acquired habits of erotic gesture attest to the ghostings of culture which the actress brings with her to the theatre, Juliet here voices the commonly spoken metaphor of the mysteriously seductive woman, an attribute also associated by Mercutio with her cousin, Rosaline: "Alas, poor Romeo, he is already dead, stabb'd with a white / wench's black eye" (II.iv.13–14). While Kristeva does address the role of the Other as abject in the field of love, Shakespeare's means of sustaining the passionate couple through infidelity to the racial Other might point to a difference broader than the merely interior experience of aesthetic or romantic identification. Indeed, it suggests that evocation of the seductive purity of beauty here bears the fetishistic imprint of the containment of threatening racial and gender difference.[16] This is a containment initially theatricalized by drama and later formalized, as illustrated by Kristeva, by the sweeping injunctions of poetics and aesthetics.

SPECTERS OF JOINTURE

Such a lasting division wrought by aesthetics is nowhere more apparent than in the conclusion of *Romeo and Juliet*. Too often cited as a sad paragon of cathartic proportion, as the cleansing resolution of deep social division, the play's ending foregrounds, I wish to suggest, the extent to which the irrepresentable always already conditions the renewal of representation in the disproportionate memory of aesthetics and its history. Two irrepresentable renewals come to mind, both in the guise of an unfulfilled promise. One concerns the promise of art, the other the pledge of justice. Both return us indirectly to the patriarchal specters of Shakespearean injunction that conjure Hamlet and his later kin, Herbert Blau and Jacques Derrida.

First is the promise of Capulet and Montague to supplement the ghostly emptiness of the surviving names of Romeo and Juliet with

the solid value of representation. As if in restitution for the violence to patriarchy wrought by woman's love, Capulet extends to Montague the promise of "jointure:"

> O brother Montague, give me thy hand.
> This is my daughter's jointure, for no more
> Can I demand.
>
> (V.iii.296–98)

In response to Capulet's exchange of his daughter's jointure for the memory of Romeo's proper name, Montague promises the return of something "more," Juliet's statue in pure gold, an aphoristic icon of her "true and faithful" self, a sign that her name remains intact even in death's end. This "jointure" is then doubled in difference by Capulet who promises that "as rich shall Romeo's by his lady's lie" (V.iii.303). Of note here is the reinstatement of aesthetic purity as a rich simulacrum of overdetermined gift-giving and commodity value. While these golden statues signify for Montague and Capulet the "poor sacrifices of our enmity" (V.ii.304), they reinscribe the sacrifice of love in its renewal of the social codes and memories of "jointure" and its aspiring correction of the fissured economics of patriarchy.[17]

In the chapter concluding *The Audience*, "Commodification, Perspective, Community of the Question," Blau notes a curious linkage between the dynamics of commodity fetishism and the universalization of response to the stage. His description of these relations bear a striking resemblance to the spectatorial conditions closing *Romeo and Juliet*:

> What Marx discussed as commodity fetishism applies also to the object of apprehension on a stage. What is invested with empathy in the ordinary theatre experience fuses the passive and the personal. What is signified in the investment is the paradox of the private secreted in public. The real oddity of the audience that is profoundly moved by the charged emotional life onstage is the (dis)unity of the response, which is not at all the ground rhythm of action in a body politic. More likely than not the emotion passes . . . into further silence, distance, and – in the roles we reassume, the jobs we don't like, the masks we wear with each other – the institutional continuity we do not have.
>
> (Blau 1990: 375)

It is precisely the institutional continuity we do not have that is promised at the conclusion of *Romeo and Juliet* by the ghostings of those statues erected in pure gold. The golden statues may signal the injunction of stasis, but there is little in the economy of jointure, here or elsewhere in Shakespeare, to suggest unity in the public response to the charged, concluding tableaux of tragedy. Derrida takes this argument one step

further, in *Specters of Marx*, when he notes the tremendous continuity between the depersonalizing dynamics of commodity fetishism and the specter of gold in Shakespeare. Derrida notes Marx's fascination with the trust of Timon of Athens in the idolatry and fetishism of the cult of money, of gold.

> In question is a spectralizing disincarnation. Apparition of the bodi-less body of money: not the lifeless body or the cadaver, but a life without personal life or individual property . . . One must analyze the proper of property and how the general property (*Eigentum*) of money neutralizes, disincarnates, deprives of its difference all personal property (*Eigentümlichkeit*). The genius of Shakespeare will have understood this phantomalization of property centuries ago and said it better than anyone. The *ingenium* of his paternal geniality serves as reference, guarantee, or confirmation in the polemic, that is, in the ongoing war – on the subject, precisely, of the monetary specter, value, money or its fiduciary sign, gold.
>
> (Derrida 1994: 41–42)

Put otherwise, the phantomalization evoked by the purity of gold in *Romeo and Juliet*, which we now know to have haunted the "spectralizing disincarnations" of *Timon of Athens*, mystifies the conditions of impossible synchronization so prevalent throughout the play. In replacing the singular difference of personal life or individual property with the general promise of jointure, *Romeo and Juliet* extends to its audiences of the past, present, and future an institutional continuity they do not have. Unless, Derrida would add, continuity is itself the institutional disavowal of difference that grounds the accidental aphorism of the play:

> If [*Romeo and Juliet*] has thus been imprinted, superimprinted, on the memory of Europe, text upon text, this is because the anachronous accident comes to illustrate an essential possibility.
>
> . . . The desire of Romeo and Juliet did not encounter the poison, the contretemps [accident] or the detour of the letter by chance. In order for this encounter to take place, there must *already* have been instituted a system of marks (names, hours, maps of places, dates, and supposedly "objective" place-names) to thwart, as it were, the dispersion of interior and heterogeneous durations, to frame, orga-nize, put in order, render possible a rendezvous: in other words, to deny, while taking note of it, non-coincidence, the separation of monads, infinite distance, the disconnection of experiences, the multiplicity of worlds, everything that renders possible contretemps [accident] or the irremediable detour of a letter.
>
> (Derrida 1992: 420)

Just such a concluding promise of impossible synchronization inscribes the play's reassertion of universal aesthetics, the false truth of pure gold, in the rectification of the purity of judgment. This is the promise concluding the play which comes from the mournful mouth of Prince Escalus, the play's *"père imaginaire."*

> A glooming peace this morning with it brings,
> The sun for sorrow will not show his head.
> Go hence to have more talk of these sad things;
> Some shall be pardoned, and some punishèd:
> For never was a story of more woe
> Than this of Juliet and her Romeo.
> (V.iii.305–10)

Here the return of social stability lies, as it always already has been inscribed, in more heavy talk of sad things, in the accidental relativity of purity, in the impossibility of synchronization. Not only is the tale of mourning, its end as well as its recitation, returned once again to the mouth of the princely father, but mourning itself is positioned yet again as the privileged albeit tragic condition of patriarchy. If the story of *more woe* bears any relation to the accident of the proper name, it belongs not to Juliet but to her masculine partner who carries unto his death the marks of the mournful condition he voices earlier in the play:

> This day's black fate on *moe* days doth depend,
> this but begins the *woe* others must end.
> (III.i.119–20, my emphasis)

As echoed by the Prince's concluding aphorism, the story of "more woe" is borne anagramatically by the name of (R)omeo: mo(R)e (w)oe. "Had I it written," Romeo might meant to have told Juliet, "I would tear the word *thus.*" In addition to being "hateful to itself," the patriarchal name is here always mournful only of itself.

It is especially significant, I wish to conclude, that the disjunction of more woe clouds the return and stability of jointure authorized by the death of the proper name. As promised by Escalus, "Some shall be pardoned, and some punishèd." Whose chances are better, Romeo's "ghostly father" or Juliet's blubb'ring Nurse? The Prince's enigmatic promise of the delivery of uneven justice is, finally, what stands out in *Romeo and Juliet* as the unresolved guarantor of jointure, as what could later invoke something like the vengeful specter of old Hamlet. As Derrida writes in *Specters of Marx*:

> If one still translates *Dike* with this work "justice," and if, as Heidegger does, *Dike* is thought on the basis of Being as presence, then it would turn out that "justice" is first of all, and finally, and

especially *properly*, the jointure of the accord: the proper jointure to the other given by one who does not have it. Injustice would be the disjointure or disjoining.

(Derrida 1994: 27)

It is fitting, is it not, that the exact sum or the disproportion of jointure, of justice, of judgment, or of reading, remains unpronounced at the conclusion of this play revered for its timeless story of an impossible couple? Could it be that the ghostly father is already here as always . . . out of joint?

NOTES

1 I rely on my own translation of Kristeva's *Histoires d'amour* (1983) while referring the reader to *Tales of Love* (1987), the English translation by Leon S. Roudiez which sometimes dulls the lyrical fluidity of Kristeva's love stories.

2 For exceptional philosophical and psychoanalytical readings of ghosting in these plays, see Lupton and Reinhard (1993) and Lukacher (1994).

3 All citations of *Romeo and Juliet* are from The New Cambridge Shakespeare edition of *Romeo and Juliet* (1984), edited by G. Blakemore Evans. Although this chapter will not dwell on the importance of Mercutio in the play, I note that Goldberg's "Romeo and Juliet's *Open Rs*" (1994) cites this and other passages relating Mercutio, Rosaline, Romeo, and Juliet to argue persuasively that "the sexual field in which desire operates in the play is the forbidden desire named sodomy." In "One Less Manifesto," moreover, Deleuze (1997: 239) calls attention to the importance of Carmelo Bene's neutralization of Romeo in order to emphasize the development of Mercutio "who was only a virtuality in the play by Shakespeare."

4 Pontalis (1990: 37–44) describes such visual hallucinations as "oenirical perceptions" most often experienced as the residues of bad dreams and encounters.

5 Genette develops the temporal duality between story time and narrative time in the first two chapters of *Narrative Discourse* (1980: 33–112).

6 Following the lead of Walter Benjamin's *The Origin of German Tragic Drama* (1977), Michel Foucault analyzes the significant role played by reading, both the act and the metaphor, in the definition of early modern subjectivity in *The Order of Things* (1970), and Gilles Deleuze *The Fold* (1993).

7 This brings to mind the differing readings by Derrida (1980: 439–549) and Lacan (1966: 11–61) of Poe's story, *The Purloined Letter*.

8 In his 1992 translation of this essay, Nicolas Royle translates Derrida's title, "L'Aphorisme à contretemps" as "Aphorism Countertime." As noted by Derek Attridge in his preface to the English translation of this essay, Derrida's use of *contretemps* plays doubly on "both 'mishap' and 'syncopation,' while the phrase *à contretemps* suggests both 'inopportunely' and, in a musical sense, 'out of time' or 'in counter-time'" (Derrida 1992: 414). While Royle's choice of "countertime" is in keeping with Romeo and Juliet's playful debate about the syncopated sounds of the lark and the nightingale (III.v.1–35), I prefer to translate the title as "Aphorism Accident" to stress the play's emphasis on mishaps and missed encounters. Aside from the title, I will rely on Royle's excellent translation, except where otherwise noted by brackets.

9 In his exceptional essay, "Language and Sexual Difference in *Romeo and Juliet*," Snow presents a detailed case in favor of the ontological depth of Juliet: "Juliet's sensations tend in general to be more 'piercing' and ontologically dangerous than Romeo's. Her imagination inhabits a Blakean universe, where perceptual experience spontaneously invades and emanates from the self ... Even her vision is for her an armed faculty that penetrates the field of perception instead of gazing into it from a wistful distance" (1985: 174).

10 Although Belsey (1993: 138) reads this passage as testimony to the lovers' longing "to make present the unspeakable residue which constitutes desire," I read Juliet's intervention as bearing testimony to the differance of conceit, not its presence.

11 See Derrida's analysis of this concept in "*Geschlecht*: différence sexuelle, différence ontologique" and "La Main de Heidegger (*Geschlecht II*)" (Derrida 1987: 395–452).

12 I note that Callaghan briefly touches on this same passage from Kristeva (1994: 61) in order to introduce her dismissal of psychoanalysis. My aim here, on the contrary, will be to turn the logics of psychoanalysis against this universalizing moment in Kristeva.

13 See also the analysis of "The Sound of O in *Othello*" by Fineman (1991: 143–64).

14 In *Gendering Melancholia* (1992), Schiesari traces how the legitimacy of mourning and melancholia is split along gender lines. In "Translating Montaigne's Crypts: Melancholic Relations and the Sites of Altarbiography" (1991), I offer an affirmative reading of the feminist implications of melancholic incorporation.

15 In his essay distinguishing "Mourning and Melancholy" (1953–74: XIV, 243–58), Freud notes that the most extreme cases of melancholy (he is not referring to the kind of adolescent moping around shared by Romeo and Benvolio at the commencement of the play) can result in suicide most generally following a period of delay. I discuss the relation between mourning, melancholy, and female subjectivity in *Like a Film* (1993: 25–64).

16 In the context of Goldberg's argument cited above, we could also add "sexual difference" here.

17 Snow (1985: 189) notes the failure of the statues to effect such jointure: "The gold statues erected at the end of the play might almost be symbolic realizations of the state Romeo aspires to in death, but they fail utterly to capture Juliet. Though he sees her in the end as a beauty that makes the tomb 'a feasting presence full of light,' she associates herself in death with the sudden illumination of the lightning, that active principle 'which doth cease to be / Ere one can say it lightens'."

Part II

WRITING WOMEN'S VISION

5

PATRIARCHAL PANOPTICISM, OR THE ENIGMA OF A WOMAN'S SMILE

Getting Out in theory

Writing does not come to power. It is there beforehand, it partakes of and is made of it . . . Hence, *struggles* for *powers* set various writings up against one another. Let us not shrug our shoulders too hastily, pretending to believe that war would thus be confined within the field of literati, in the library or in the bookshop . . . But it is true that the political question of literati, of intellectuals in the ideological apparatus, of the places and stockages of writing, of caste-phenomena, of "priests" and the hoarding of codes, of archival matters – that all this should concern us.

> Jacques Derrida, "Scribble (writing-power)"

Theatre places us right at the heart of what is religious-political: in the heart of absence, in negativity, in nihilism as Nietzsche would say, therefore in the question of power. A theory of theatrical signs, a practice of theatrical signs (dramatic text, mise-en-scène, interpretation, architecture) are based on accepting the nihilism inherent in a re-presentation. Not only accepting it: reinforcing it. For the sign, Peirce used to say, is something which stands to somebody for something. To Hide, to Show: that is theatrality. But the modernity of our fin-de-siècle is due to this: there is nothing to be replaced, no lieutenancy is legitimate, or else all are; the replacing – therefore the meaning – is itself only a substitute for displacement . . . Is theatrality thus condemned?

> Jean-François Lyotard, "The Tooth, The Palm"

Getting Out, the 1978, prizewinning play by Marsha Norman, has been acclaimed for its tightly crafted script, in which the contrasting lives of the same white female convict are interwoven on the stage. The audience experiences the first day of Arlene's release from prison, during which time we respond with concern and maybe even trepidation to the simultaneous presence on stage of Arlie, her younger, violent, and

101

self-destructive self who has just spent eight years in prison for the cold-blooded murder of a cabbie. Her prison time is but a minor and relatively static period of Arlie's life which has been replete with prostitution, forgery, and hateful aggression toward her peers. Her crimes are the partial result of a rapist father, a seemingly uncaring mother, and the sometimes imaginative and playful response of a terror-stricken child who must learn to use any means to break out of her familial jail. Our acknowledgment of the flashbacks of Arlie's past is opinionated by our hopes for Arlene's future.

In the short span of the fiction's twenty-four hours, the audience sees Arlene fight off yet another rape, this time by Bennie, her sentimentally confused jailer, yet another confrontation with the uncaring, but present mother, and still another temptation to get out of poverty (but not, of course, out of bondage) by repeating the theatrical rituals of prostitution – Arlene again has the option of working with Carl, her previous pimp/lover. On the bright side, the audience hears her naive but vehement desire to be reunited with her eight-year-old son, Joey (Carl's child whom she has not seen since his birth in prison). The spectators may find themselves siding with her option to join the ex-con upstairs, the tough but respectable cook, Ruby, in a life without further crime. And Christian viewers share Arlene's hopes in her newfound lover, Jesus. In John Simon's opinion, this is "a spiny, realistic play . . . written with such a brisk, fresh, penetrating touch that sordid, brooding things take on the glow of honesty, humanity, very nearly poetry" (Simon 1978: 152).

But what, I want to ask, lies behind such a desire to turn a victim of child abuse and rape into a glowing, poetic figure? Could *Getting Out* be read to portray not only still another victimized woman, but a viciously uncompromising macho theatre? How might *Getting Out* reflect a theatre whose search for new profit-making images delays our admission of the public crimes committed by our playwright fathers, by our own beholding, and by our colleagues' quests for unproblematic and idealistic retorts to real, although violent, challenges of patriarchal ideology and economy? Finally, is theatricality thus condemned? Or, in ironic contrast, might a play like *Getting Out* produce a theatrical substitute for such a sordid world of displaced institutional responsibility?

These questions concerning institutional codes of spectatorship and judgment purposefully limit the following analysis to theoretical and ideological issues which may appear to some readers to represent yet another act of displacement. My discussion of "*Getting Out* in Theory," as well as the analyses of contemporary plays throughout this section, avoids many concerns common to drama criticism: the aesthetics of dramatic poetry, the relative merits of the play and its particular performances, and even any claim of a complete analysis of the plot and characters. Rather than focus on Arlie's obviously perverted delight in violence, for instance,

I choose to highlight how the play self-consciously emphasizes the institutional norms of interpretation that control her deviancy. In confronting such conventions of critical analysis, I necessarily reflect on the economy and ideology of the theatricality inscribed in our social experience. This is how my text may set itself up and against some of the prescribed norms of dramatic analysis and how the two institutions of behavioral and textual control demonstrate their common and natural struggles for power. The evaluation of an aesthetic and/or criminal body depends on the interdependence of interpretational codes and disciplinary forces. Any performance of the knowledge and judgment of an institutional body – be it penal or academic – is relational to the performance's power and force, to its ability to delimit interpretation to the scene of its own codes, to its desire to dominate discourses and actions which are threatening or indifferent to its own bases of judgmental power. As I read *Getting Out*, the play's value lies less in its glow as "honesty, humanity, very nearly poetry" than in its show of institutional conditions of such aesthetic and judgmental figures.

POLITICAL ECONOMIES

In our societies, the systems of punishment are to be situated in a certain "political economy" of the body ... power relations have an immediate hold upon [the body]; they invest it, mark it, train it, torture it, force it to carry out tasks, to perform ceremonies, to emit signs. This political investment of the body is bound up in accordance with reciprocal relations, with its economic use; it is largely as a force of production that the body is invested with relations of power and domination; but, on the other hand, its constitution as labour power is possible only if it is caught up in a system of subjection (in which need is also a political instrument meticulously prepared, calculated and used); the body becomes a useful force only if it is both a productive body and a subjected body.

(Foucault 1977: 25–26)

Getting Out concerns the reciprocal power of interpretative communities. Throughout the play, the audience's opinion of Arlene is influenced strongly by domineering institutional voices and visions. The first act opens with the voice-off of a Warden who introduces the interpretative norms of the play:

The Alabama State Parole Board hereby grants parole to Holsclaw, Arlene, subject having served eight years at Pine Ridge Correctional Institute for the second-degree murder of a cabdriver in conjunction with a filling station robbery involving attempted kidnapping of

103

attendant. Crime occurred during escape from Lakewood State Prison where subject Holsclaw was serving three years for forgery and prostitution. Extensive juvenile records from the state of Kentucky appended hereto. Subject, now considered completely rehabilitated, is returned to Kentucky under interstate parole agreement in consideration of family residence and appropriate support personnel in the area. Subject will remain under the supervision of Kentucky parole officers for a period of five years. Prospects for successful integration into community rated good. Psychological evaluation, institutional history and health records attached in Appendix C, this document.

<div align="right">(Norman 1980: 11)</div>

Holsclaw, Arlene, is first presented to her receptive audience as a success story of "complete rehabilitation." Being a model figure of institutional reform, Arlene represents a judgmental goal for all prisoners (and all spectators): to be "rated good" for the prospect of successful integration into community. This mark of acceptability, this stamp of communal compatibility, first shows Arlene to the audience as a sign of social progress. Her body and mind have been corrected to function as contributive elements in the forces of production. She is released to enter the workplace as a marketable member of society.

Still, Arlene's release from prison does not free her from the system of rating and evaluation which deems her productive. As the offstage voice of the Warden suggests, the primary character of the play is less Arlene who has righted her wrongs by doing institutional time than "subject Holsclaw" – who is subject to the judgment of the Alabama State Parole Board, the supervision of Kentucky parole officers, the evaluation of an institutional shrink, and the unknown contents of her textual self as Subject, Appendix C. Arlene's rating for production is always contingent on her status as Subject, that is, her subjection to (maybe even dependence on) the judgments of absent voices of institutional power.[1] The freedom of her mind and body is relational to social structures and institutions that continue to master them. From the opening of *Getting Out*, Arlene is present(ed) to her audience as a figure of the judgment of an absent voice of institutional power.

Absent voices abound in Norman's play. Preceding each of the two acts, prison loudspeakers blare out the day's orders in a detached drone: "Kitchen workers, all kitchen workers report immediately to the kitchen. Kitchen workers to the kitchen ... do not, repeat, do not, walk on the front lawn today or use the picnic tables" (Norman 1980: 7). "Garden workers will, repeat, will, report for work this afternoon" (Norman 1980: 49). This voice of repetition sets a tone of omnipresence in the theatre and establishes the economic code of the play: "the body becomes a useful

force only if it is both a productive body and a subjected body" (Foucault 1977: 26). Behind the scenes of Norman's theatre, someone is always demanding production and reiterating subjection, always construing orders and making judgments. The offstage placement of this authoritative speech is, moreover, the fundamental element of the economics of the prison. The power of the institution depends on the absence of its source of authority which is doubled by the mechanical simulation of the voice of authority, thus freeing authority from personal accountability.

Authority figures in *Getting Out* tend to be most persuasive when speaking in the voice of someone else. Guard Caldwell, for example, relays the message to Arlie that "Doc says you gotta take the sun today" (Norman 1980: 21). Then, when Arlie responds to an order to eat with "Says who?," Caldwell retorts, "Says me. Says the Warden. Says the Department of Corrections" (Norman 1980: 22). This exemplary enunciation of displaced authority transfers power from the present agent of control to an absent institution of judgment. Even when the Warden shows himself to Arlie, his method of control lies not so much in the performance of physical presence and force as in the representation of inaccessible institutional knowledge:

> Warden: Arlie, you see the other girls on the dorm walking around, free to do whatever they want? If we felt the way you seem to think we do, everyone would be in lockup. When you get out of segregation, you can go to the records office and have your time explained to you.
> Arlie: It won't make no sense.
> Warden: They'll go through it all very slowly ... When you're eligible for parole, how many days of good time you have, how many industrial days you've earned, what constitutes meritorious time ... and how many days you're set back for your write-ups and all your time in segregation.
> Arlie: I don't even remember what I done to git this lockup.
> Warden: Well, I do. And if you ever do it again, or anything like it again, you'll be right back in lockup where you will stay until you forget *how* to do it.
> Arlie: What was it?
> Warden: You just remember what I said.
>
> (Norman 1980: 55)

The Warden tries to conflate the subject's memory of her crime with her memory of both his orders and her unintelligible record. His strategy is to make Arlie dependent on the promise of a simulacrum of clarity – that her time – her being – can be explained to her by the records office. When Arlie objects that "it won't make no sense," the Warden counters her

rebelliousness with a performative assertion of penal mind control: "Just remember what I said." Exactly "what" he said is actually less significant here than Arlie's simple remembrance that the Warden spoke and that some figure of institutional authority will always have the last word. These echoes of voice and the prisoner's remembrance of authoritarian tones are the Warden's most forceful means of exerting his mastery. Authority manifests itself most strongly here in the echoing simulacrum of the absent voice of power.[2]

Still, these echoes have their physical side in which the enigmas of absence acquire the force of visual presence. *Getting Out* materializes its absent voice in visible figures of control. The play's unchanging set provides the audience with a constant vision of both Arlie's prison cell and Arlene's dingy one-room apartment in a rundown section of Louisville. Norman's note to the set designer stresses that "the apartment must seem imprisoned." Indeed it does. Arlene takes no time to deplore the security bars in her apartment window. Bars of any sort in the play evoke Subject Holsclaw, Arlene's memories of entrapment instead of sensations of comfort. The visual carry-over of prison life to personal life serves as a mnemonic device evoking Arlene's indignation at her subjection to past echoes.

This visible presence of both environments in *Getting Out* also reproduces the forceful eyes of surveillance lurking behind Subject Holsclaw's imprisoned mind and spaces. Arlie grows accustomed to and even dependent on the fact that "somebody's sposed to be out there watchin me" (Norman 1980: 65). As her ex-con friend, Ruby, puts it, prison is a place where "no matter how many pictures they stick on the walls or how many dirty movies they show, you still gotta be counted five times a day" (Norman 1980: 59). The eyes of institutional spectators continually probe the protagonist of this play. As a younger girl, not only is she caught stealing by the cops and her school principal, but her murderous prison escape is recorded by the instant eye of television news. Carl, her pimp, and Bennie, her guard, later recall this televised documentation of her criminal history as a means of asserting their voyeuristic complicity in recording her life. They confirm and correct Arlene's version of her flight with their accounts of her actions as seen transformed into a public soap opera by TV. Last, but hardly least, like the vigilant eyes of *Equus*, the gaze of a picture-framed Christ which hangs "on a prominent position of the apartment wall" penetrates Arlene first thing in getting in or out of bed.

Arlene lives in a specular world where she is both under surveillance as an institutional self and, as the preceding example suggests, on stage as a libidinal spectacle. First to her rapist father and uncountable Johns and then to her insatiable, voyeuristic prison guards, Arlie is an image of consumption. Bennie's eyes can't have enough of her – he quits his prison

job to bring Arlene home because, "I been wathcin you eat your dinner for eight years now. I got used to it, you know?" (Norman 1980: 14). And earlier in prison, Guard Caldwell links the vision of Arlie's meals to the sexiness of her body: "Got us a two-way mirror in the shower room. And you don't know which one it is, do you? Yes, ma'am. Eat. We sure do care if you gittin too skinny. Yes, ma'am. We care a hog lickin lot" (Norman 1980: 22). Even her first free morning's glance out her apartment window is greeted with a wolf-whistle by a male worker down below. Arlene's freedom leads her back to the subjection of the familiar sexual gaze that guarded her in prison.

More significant to a discussion of the play's aesthetic ideology, *Getting Out* alludes to the audience's complicity in sexual projection through visual stimulation. When Arlene, for instance, tells Bennie to "turn around then" so she can undress, he turns and the audience alone remains in the privileged position to watch Arlene get "a shabby housecoat from the closet. She puts it on over a towel, buttons it up, then pulls the towel out from under it. This has the look of a prison ritual" (Norman 1980: 42). Here the eyes of the theatre's spectators are confronted with Subject Holsclaw's repetition of the debased ritual of stripping for her guards at Pine Ridge. Theatre here becomes something of a prison; put otherwise, the attractions of the pleasure industry reveal their kinship to the mastery of the penal industry. Institutional voyeurism is . . . institutional voyeurism.

What is more, the scrutinizing eyes of the audience enjoy a privileged perspective of Arlene's inner spaces. A textual note, to cite the most obvious case, emphasizes that the simulacrum of Arlie sometimes appears to Arlene in the apartment, but that "only in the final scene do they acknowledge and appreciate each other's presence" (Norman 1980: 5). Throughout the play, only the audience maintains constant visual contact with both of Arlene's spaces, her cell and her apartment, her despair and her hopes. Through constant surveillance, through the fantasy of control, *Getting Out*'s spectators enjoy all of Arlene's stage history. Critically, the role of the theatre audience might be understood as analogous to the performance of the panoptic gaze, the construct developed by Foucault in *Discipline and Punish* (Foucault 1977: 197–229). This is the model of vision derived from Bentham's prison project, the Panopticon, in which the prisoners are to be isolated in separate cells, all looking out at an inner concentric circle of observation posts. The prisoners, invisible to one another (as are Arlie and Arlene when in their separate spaces on the stage) always can be seen by the guards. The guards, in turn, are constantly present but only partially discernible to the prisoners. As Foucault describes this panopticon, it functions as a specular device for the controlling audience's power and desire, for voyeuristic control and pleasure.

It is extremely difficult and risky to discuss the function of an audience's theatrical gaze, given the fact that it varies from performance to performance and may well differ depending on the viewer's inscription in conditions of gender, race, and class. One need only recall the various critiques of Laura Mulvey's groundbreaking essay on the inscription of the gaze in classical Hollywood film (Mulvey 1989: 14–26) to appreciate the challenge of theorizing audience participation in the theatre.[3] In both the cases of theatre and film, however, helpful groundwork often is laid by the very writers who would be the first to discredit such theorization: the critics. John Simon, for instance, makes an observation about absence in *Getting Out* which provides a convenient frame through which to peek. In praising Norman's interlacing of Arlie and Arlene, Simon points to an even subtler aspect of *Getting Out*. He writes that "still more ingenious, perhaps, than bringing on these two together is the author's strategy of not bringing on at all the heroines' evil and good angels: the cabdriver father who seduced and bullied Arlene . . . and the prison chaplain, who with the help of the Bible and some very shrewd psychology, gave her a new self" (Simon 1978: 152). Simon continues to say that "it is right that extreme badness and goodness should not be shown, only talked about; like a stage in pitch darkness or a spotlight in our eyes, their presence would merely blind us" (Simon 1978: 152). Their actual absence is more the point here. Extreme goodness and badness can only be talked about because they are ideological concepts representing "the imaginary relationships of individuals to their real conditions of existence" (Althusser 1971: 162). It is in keeping with the ideology of Simon's conception of the theatre that the audience of *Getting Out* functions as the representational guardian angel of the patriarchal authorities absent in reality but made present in our beliefs and critical reviews.[4] *Getting Out* allows Simon's spectator to value the displacement of the creator and punishing father by the benevolent witness of the New Testament, the chaplain who strives, just as Simon wants us to hope, for the renewal of this child of God. Through Christian desires to substitute paternal benevolence and forgiveness for legalistic vengeance and violent punishment, the audience of *Getting Out* is offered yet another opportunity in the blinding history of the theatre to act on behalf of the absent father.

The spectators join with the prison guards in experiencing Arlie's religious transformation, which follows the chaplain's departure to a different prison. It all happens in one scene, witnessed only afterwards by the guards and recounted by Arlie for the fetishistic benefit of the audience – not shown on the stage, only talked about. Repeating "Arlie is dead for what she done to me, Arlie is dead an it's God's will" (Norman 1980: 75), the victim stabs herself again and again with a kitchen fork. She provides her witnesses with a Girardian sacrifice whereby they share in her attempt to mutilate her hateful Other, to efface the painful

presence of the Arlie so violated by the punishing stares of her pros-
ecutors. For the spectators, her ineffectual solitary suicide provides an
excuse to transform her physical survival into a symbolic death, "sayin
they's seeing such a change in me" (Norman 1980: 75).[5]

This power to speak transformation, to declare rehabilitation, derives
from the victim's adaptation to the spectator's conditions for survival. It
is indeed "shrewd psychology." For in praising Arlie's spiritual transfor-
mation, the panoptic society can displace its own guilt for contributing to
Arlie's aggressive defensiveness. Just as Arlie charges, the various eyes
replacing those of the absent fathers of the stage choose to ignore her
vulnerable position as a victim of institutional violence. She asks:

> You got eyes or is they broke? You only seein what you feel like
> seein. I git ready to protect myself from a bunch of weirdos and then
> you look . . . You ain't seein when they's leavin packs of cigarettes
> on my bed and then thinking I owe em or somethin . . . You see
> that? No, you only seein me. Well, you don't see shit . . . You ain't
> asked what [Doris] was gonna do to me. Huh? When you gonna ask
> that? You don't give a shit about that cause Doris such a good girl.
> (Norman 1980: 60–61)

The prison guards might not give a shit, but what about playhouse
spectators? The false promise of *Getting Out* for the spectators may allow
them to so displace their own responsibility for this daughter of society
that they need not account for the flaws of the father, of the panoptic
institution, of the very notion of legitimacy sustaining our socio-legal
community.[6] Even Marsha Norman reveals her complicity in this dis-
placement by admitting that Arlie is based on a teenage delinquent who
"was absolutely terrifying. She is now in Federal Prison for murder,
and always was headed that way" (cited by Klemesrud (1979)). The
specifics of this child's tale are irrelevant – the violent kid always already
having been headed that way. Familial and institutional violation and
victimization remain to be ignored in *Getting Out* by the paternalistic
gaze blind to the history of child abuse.

But *Getting Out*, we need to remind ourselves, is a play not only
concerning memories of the father, of violence, and of prison, but offering
hope in an innocent sisterhood, Arlene's promising relationship with
Ruby, who *has got out*. The sensitive spectators, always witnessing both
worlds of Pine Ridge and Louisville, are motivated by pity and fear to
want Arlene to beat the rap and to forget the torturous memory of her
degrading institutionalization. In fact, Ruby could be said to stand in for
these spectators when she urges Arlene neither to "spread your legs
for any shit that's got the ten dollars" (Norman 1980: 73) nor to lend her
body in any way to Bennie for barter in a sexual–economic trade game.
Desiring moral rectitude, we plead for Arlene to spit on the offers of male

protectionism made by both Carl and Bennie, who expect sexual favors in return for their surveillance and aid. By the end of *Getting Out*, we want our visual complicity in the slimy world of paternalistic, capitalistic sexuality to give way to a romantic vision of liberated sisterhood.

LIBIDINAL ECONOMIES

Such a teaching from political economy must be compared to what libidinal economy teaches us: both political and libidinal economy in so much as they shape our modern life, support criticism and the crisis of the theatre . . . Reading Zeami's treatises . . . and at the same time Artaud and Brecht, whose analyses and concurrent failures still dominate today's theatre, I am learning how theatre, put at the place where dis-placement becomes re-placement, where libidinal flux becomes representation, wavers between a semiotics and an economic science . . . However, the semiotics of Zeami seem traversed, sometimes thwarted by a very different drive, a libidinal drive, a search for intensiveness, a desire for potency (isn't it necessary to express *nô* as potency, *Macht*, might, in the Nietzschean sense, in the same sense that Artaud takes *cruauté*?). The name of flower (*fleur*) is given to the search for the energetic intensification of the theatrical apparatus.

<div align="right">(Lyotard 1997a: 283–84)</div>

An energetic reading of *Getting Out* might look to the play's jokes for evidence of the structural devices of theatrical intensity. Two strategies of joke telling emerge in the play. One is what I call the late night talk show method (Johnny Carson in Arlene's time) of frustrated complicity in the panoptic system, the sort of narrative irony used by Arlie to entertain and tease her prison guards. At the beginning of Act II, Arlie does a stand-up routine:

Hey! I know . . . you ain't gotta do no dorm count, I'll just tell you an you jus sit. Huh? You preciate that? Ease them corns you been moanin about . . . yeah . . . OK. Write this down. Startin down by the john on the back side, we got Mary Alice. Sleeps with her pillow stuffed in her mouth. Says her mom says it'd keep her from grindin down her teeth or somethin. She be suckin that pillow like she gettin paid for it. Next, it's Betty the Frog. Got her legs all opened out like some fuckin . . . (*Makes croaking noises*) Then it's Doris eatin pork rinds. Thinks somebody gonna grab em outta her mouth if she eats em during the day. Doris ain't dumb. She fat, but she ain't dumb. Hey! You notice how many girls is fat here? Then it be Rhonda, snorin, Marvene, wheezin and Suzanne, coughin.

<div align="right">(Norman 1980: 51)</div>

The weary reportage, which might be performed in Carsonesque dead-pan, tries to make a joke out of the mental and physical savagery of prison life. But this kind of comedy has a sour taste. Instead of critiquing the penal system, the joke only accentuates the reality of penal cruelty and society's perverse need to capitalize on the victims of reform through laughter.[7]

Juxtaposed with the Carson technique is a more aggressive, potentially revolutionary strategy of joking which is directed at the controlling eyes of the stage. Bennie and Arlene, for example, flaunt civil authority by hitting a no-littering sign "square in the middle with a tomato;" Arlie feeds her forceful father a toothpaste sandwich, a kind of childlike death gift; and Ruby, fed up with the routine of cooking and the repetition of filling the same orders coming from outside her prisonlike kitchen, threatens that "some day . . . I'm gonna hear 'tossed salad' an I'm gonna do jus that. Toss out a tomato, toss out a head a' lettuce, toss out a big ol carrot" (Norman 1980: 60). This joking threat to throw the mythically big carrots of freedom back at their authoritarian source lingers throughout the play.

More importantly, the joke coexists as the structural frame of *Getting Out* with Appendix C, the penal history of Arlie. The play opens and closes with scenes of Arlie retelling jokes from an earlier time of seemingly innocent sisterhood with her younger sibling June. As *Getting Out* begins, the audience joins Arlie in uncomfortable laughter over

> this little kid, this creepy little fucker next door. Had glasses an somethin wrong with his foot. I don't know, seven, maybe. Anyhow, ever time his daddy went fishin, he'd bring this kid back some frogs. They built this little fence around em in the back yard like they was pets or somethin. An we'd try to go over an see em but he'd start screamin to his mother to come out an git rid of us. Real snotty like. So we got sick of him bein such a goody-goody an one night me an June snuck over there an put all his dumb ol frogs in this sack. You never heared such a fuss. Slimy bastards, frogs. We was plannin to let em go all over the place, but when they jumpin an all, we just figured they was askin for it. So, we taken em out front to the porch an we throwed em one atta time out into the street. Some of em hit cars goin by but most of em just got squashed, you know, runned over? It was great, seein how far we could throw em, over back of our backs an under our legs an God, it was really fun watchin em fly through the air then splat all over somebody's car window or somethin. Then the next day, we was waitin and this little kid comes out in his back yard lookin for his stupid frogs and he don't see any an he gets so crazy, cryin an everything. So me an June goes over an tells him we seen this big mess out in the street,

111

an he goes out an sees all them frogs' legs an bodies an shit all over everywhere, an, man, it was so funny. We bout killed ourselves laughin.

<div style="text-align: right;">(Norman 1980: i)</div>

The tone of this joke stands in comic contrast to the absent Warden's pronouncement of Arlene's successful reintegration into community. But coming at the beginning of the play, the joke may go over the head of the audience. As with any type of uncanny representation, the joke may require repetition to be recognized as presenting forms of control and torment similar to those of the Warden and his sadistic guards. Not until the opening of Act II, then, when the audience hears Arlie jokingly mimic Betty the Frog with more croaking noises, does the corollary of Arlie's animalistic imprisonment and senseless torture begin to surface.

Still, what is exceptional about this joke is not its message but how it differs in tone from Appendix C. Unlike Arlie's penal history, this story of female aggression against the froggy trophies guarded and imprisoned by the little creep and his daddy is humorous in being almost totally absurd. It is senseless. It is . . . a (bad) joke. In contrast with Appendix C, it cannot be deciphered and controlled by the rational norms of panoptic scrutiny. The uncomfortable pleasure (and power) of this joke stems from its production of liberating nonsense and play. From the opening scene, *Getting Out* nurtures subliminal desires for a life different from the standard of "successful integration into community." By laughing at Arlie's memory of her early acts of violence, the audience becomes psychologically complicitous in her anti-institutional behavior and norms.

This is especially evident in light of Freud's discussion of laughter's kinship with repressed sexual and social desires. In *Jokes and Their Relation to the Unconscious*, Freud (1953–74: VIII) relates the force of jokes to the aggression of the joke teller *and* the willingness of the recipient, the third party, to receive the joke through laughter at the expense of the second party, in this case, the creepy kid and his frogs. The joke functions as a release mechanism not only for the teller but for the listener who enters into collusion with the speaker – jokes are effective only if they receive laughter (a kind of subconscious applause). The audience of Arlie's jokes, being in the substantial position of receivership, would be said by Freud to entertain and experience Arlie's inhibitions vicariously. Freud writes that the third person "must be able as a matter of habit to erect in himself the same inhibition which the first person's joke has overcome, so that, as soon as he hears the joke, the readiness for this inhibition will compulsively or automatically awaken" (Freud 1953–74: VIII, 151). And the laughing response of the third person derives, of course, not from his or her acknowledgment of complicity in the joke,

<div style="text-align: center;">112</div>

of understanding *per se*, but from the release and liberation provided by senselessness, by freedom from the responsibility to make meaning and from having to be on guard at all times. Through the structure of jokes, then, the viewer of *Getting Out* joins Arlie in experimentation with the process of laughter, of survival outside or in juxtaposition with the pressures of optical control, meaning, and production. In laughing, the audience frees itself momentarily from the pathos of its own tragic position as controlling voyeur.[8]

Freud is careful to assert, moreover, that the freedom of the joke is different from the free play of non-tendentious jests "serving solely the aim of producing pleasure. Jokes, even if the thought contained in them is non-tendentious and thus only serves theoretical intellectual interests, are in fact never non-tendentious. They pursue [a] second aim: to promote the thought by augmenting it and guarding it against criticism. Here [jokes] are once again expressing their original nature by setting themselves up against an inhibiting and restricting power – which is now the critical judgment" (Freud 1953–74: VIII, 132–33). The freedom of *Getting Out*'s laughter, then, must be understood within the context of its rhetorical force. As Derrida says of writing's struggles for power (Derrida 1979a: 12), the function of the joke is to *set itself up against* the institutional codes inhibiting its freedom of expression.

THE ENIGMATIC SMILE

A laughing struggle for power again occurs at the conclusion of *Getting Out*, as if an unconscious impulse to relive once again the mental struggles of Arlene. In the closing scene, Arlie reminds Arlene of

> that time we playin policeman an June locked me up in Mama's closet an then took off swimmin? An I stood around with them dresses itchin my ears an crashin into that door tryin to git outta there. It was dark in there. So, finally, I went around an peed in all Mama's shoes. But then she come home an tried to git in the closet only June taken the key so she said, "Who's in there?" and I said, "It's me!", and she said, "What you doin in there?" an I started gigglin an she started pullin on the door an yellin, "Arlie, what you doin in there?"
>
> (Norman 1980: 79)

Arlie lets out a big laugh and then both Arlie and Arlene repeat, "Arlie, what you doin in there?" The play closes with Arlene "still smiling and remembering . . . light dims on her fond smile as Arlie laughs once more" (Norman 1980: 79). A smile and a laugh. How might the contrast between these similar but differing gestures be theorized as the play's last word? What might Arlene's smile, a more distanced, perhaps more thoughtful

113

gesture than is a laugh, indicate about her remembrance of the joke, her reading of her life's more preciously personal moments?

Were it possible to consult Arlie's psychological evaluation in Appendix C, it might be appropriate to decipher this joke in terms of Arlie's relation to her Mama, the sexual significance of Arlie's pissing in her Mama's shoes, and the traumatic after-effects of darkness and lockup on Arlie. We might join Arlie's Mama and her many prison shrinks by repeating the question "What you doin in there?" until we receive a satisfactory response accounting for the mixture of narcissism and aggression underlying this complex memory.[9] Yet this sort of evaluation might be the butt of *Getting Out*'s last joke, which may well delight in the violation of interpretational authority. Instead of answering yet another one of Mama's questions, instead of helping Mama to continue to peer through her child's closed doors, Arlie turns to senseless humor for self-protection and creative expression. It is only in this final scene, as Norman's introductory note emphasizes, that Arlie and Arlene "acknowledge and appreciate each other's presence" (Norman 1980: 5). Only in this scene does Arlene enjoy, without feeling tinges of horror, the memory of her former jokes; only in this scene does she receive strength from the resourceful and creative side of her former self, a side which before had been beaten and bruised by the probing voices and critical eyes of authority.

In Arlene's laughing remembrance of her moment in the closet, the text reveals a striking example of what Lyotard calls the energetic theatrical apparatus. *Getting Out* realizes moments in which "the elements of a total 'language' are divided and linked together in order to permit the production of effects of intensity through slight transgressions and the infringement of overlapping units. The signs are no longer looked at in their representative dimensions, they don't even represent the Nothing any more; they do not represent, they permit 'actions,' they operate as the transformers, fueled by natural and social energies in order to produce affects of a very high intensity" (Lyotard 1977: 107). Whereas Arlie's memory had been scrambled by the mediating voices of institutional judgment, Arlene's memory here resounds in the power of her own sardonic smile and personal vision.

Getting Out (in theory) ends with the smiling sign that its spectators might not have to perform a tragedy after all. Arlie's laughter, especially if mimicked by the audience, suggests that while there are limits to patriarchal panopticism, while authorities and audiences can always shit on their visual victims, they can in turn be pissed on in a diffusing manner, in the disguise of a bad joke. The libidinal economy of theatricality thus disfigures, without displacing, the political economics of institutionality. The play's final gesture is not to join Arlene in *Getting Out* with the likes of Johnny Carson but to incite her playhouse spectators to represent the

performance of power in a way different from the exploitational, sexual–commercial world of paternal entertainment. The play, then, could be theorized to close with a seductive smile, asking its audience to join Arlene in her desires to be free of the macho world of control as it intertwines law, sex, and economics, as it prescribes production and subjection.

But is it sufficient to claim that a silent smile energizes Norman's female protagonist? And what happens when the smile and laugh are considered *in view* of their representative dimensions, in relation to *why* the "actions" are performed and to *how* "affects of a very high intensity" might be translated or read?[10] Indeed, might not a feminist reader question the affirmative possibilities of a play whose only liberating action is to offer silence to woman as her empowering voice?

There is no doubt that the ambiguous status of silence has troubled women characters throughout the history of Occidental drama and its Oedipal rereading through psychoanalysis. On the one hand, female silence – a sign and symptom of hysteria – has functioned in the study of literature and the practice of psychoanalysis to empower the male decipherer – the provider of discourse and interpretation – over the dumb subject whose silence cries out as "a speaking symptom, a conversational matter (one connected with sexuality) as well as a symptom of hysterical conversion" (Jacobus 1986: 206). On the other hand, when woman willfully manipulates silence as a political and/or ontological strategy in countering patriarchal discourse, she positions herself, it can be argued, outside of or on the margins of dominant political and cultural institutions. But even in this context, silence might be critiqued for disenfranchising woman, since the dominant institutions have proven themselves capable of functioning without her, that is, capable of enslaving her without her vocal resistance (Berg 1983: 144–45). Thus the seductive strategy of a silent feminist praxis in response to phallologocentric discourse foregrounds difficult theoretical issues which continue to haunt any attempt to provide such a strategy with an affirmative reading. But in acknowledging this problem, to which I return in Chapter Six, I here want to dwell less on the implications of Arlene's hypothetical "silence" and more on the fact of the antagonist's doubled corporeal articulations at the end of the play, the laugh and the smile.

In *The Newly Born Woman*, Catherine Clément (Cixous and Clément 1986: 9–112) foregrounds the role of female laughter as a forceful performative of hysteria. Rather than critique such laughter, Clement analyzes its "hystorical" role as both female self-expression (narcissism) and agonistic articulation (aggression). Aligning itself with the uncanny, the monstrous

> laughter breaks up, breaks out, splashes over: Penthesileia could
> have laughed; instead she killed and ate Achilles. It is the moment

115

at which the woman crosses a dangerous line, the cultural demar-
cation beyond which she will find herself excluded . . . To break up,
to touch the masculine integrity of the body image, is to return to a
stage that is scarcely constituted in human development; it is to
return to the disordered Imaginary of before the mirror stage, of
before the rigid and defensive constitution of subjective armor.

(Cixous and Clément 1986: 33)

But rather than join Clément in positioning the Imaginary simply as a
disordered state prior to the mirror stage, I would rather read it here
in terms of its complicated relation to the invocatory drive, the moment
during the mirror stage when the fragile subject both names the virtual
image for itself and for its parental figures. When invocation is shaped
by laughter directed toward Arlie's inquisitive audience, it works,
in keeping with Clément's interpretation of the laugh as agonistic to
parental, masculinist discourse, to empower her expression and freeze its
authoritarian appropriation. Recalling the effect of Laplanche's enigmatic
signifier, the youngster's invocation induces the adult "to be deviant
and inclined to perform bungled or even symbolic actions because he is
involved in a relationship with his other self, with the other he once was"
(Laplanche 1989: 103).

In a final context, it also could be said that Arlie's disturbing laugh
becomes virtualized in the play's closing image of Arlene. Would it be
overreading the play to suggest that this image calls to mind the phantom
of Medusa with her apotropaic smile? This is the specter feared by the
guardians of patriarchy but embraced by the vision of feminism. In the
words of Hélène Cixous (1981: 255): "you only have to look at the Medusa
straight on to see her. And she's not deadly. She's beautiful and she's
laughing."

NOTES

1 Mitchell Greenberg (1992) argues in *Subjectivity and Subjugation in Seventeenth-century Drama Prose* that the interrelated representation of subjectivity and subjugation has a long and complex history on the stage.
2 Louis Marin (1978: 142), in an analysis of seventeenth-century sovereign power, suggests that the *discourse* of power is the guarantor of force and by which power presents itself as just and true. The essence of power, he adds, is not so much *representation* which might guarantee the presence and absence of delegated authority as it is *simulation* which could be said to sidestep the accountable relation of *signifiant/signifié*. This reading also could be said to set a seventeenth-century precedent for Baudrillard's analysis of the modern political economy of the sign (1972).
3 The extent of this difficulty is also apparent in Herbert Blau's ambitious study, *The Audience* (1990), which would benefit from as much sensitivity to the differences of subject positions as it lends to the significant issues of ontology and psyche.

4 Simon proves to be consistent in this regard. In analyzing the Burge/Olivier film of *Othello*, I critique in *Like a Film* (Murray 1993: 101–23) Simon's (1972) patriarchal and racist vision of *Othello*.

5 Arlie's sacrifice of her double exemplifies the cultural theory of René Girard in *Violence and the Sacred* (1977) and other more recent texts. Girard maintains that the violent sacrifice of the hateful double (a topos exemplified by Cain and Abel and Romulus and Remus) fulfills the mediated desire of the beneficiary of the act, the cultural other, the choric observer. To a certain extent, Girard's theory, reminiscent of Kenneth Burke's earlier stress on dramatic scapegoating (1969: 406–08; 1973: 39–51) is helpful in interpreting *Getting Out*. The guards and the audience – if, and when, the audience can be said to share the guards' perspective in a sutured relation (Heath 1981: 76–112; Silverman 1983: 194–236) – want to observe and participate in the mediated death of Arlie. Her spectators here rest in complicity in the results of the panoptic violence performed on Arlie. On the flip side, *Getting Out* illustrates the ideological foundation and implications of Girard's work which is always poised to discover new evidence for the scapegoat mentality which he says motivates us all. The message of Girard's text comes very close to resembling that of Appendix C, which praises Arlie for her bloody transfiguration because it serves as a stabilizing model for the other prisoners and as a sign of her lobotomized belief in the promise of the New Testament. But while Arlie's example might bolster Girard's case for surrogate victimage and sacrificial substitution, it also reveals the other side of the story: that surrogate victimage here is the result of panoptic manipulations and institutional pressure. Seen from outside the Girardian symbolic structure, Arlie's total sacrifice could be read as scandalous and unnecessary, serving no purpose other than the continuance of patriarchal dominance. *Getting Out*, I believe, asks us to think twice about accepting Girard's visions of sacrificial crisis and resolution. I would suggest that Arlie's self-mutilation is less a testimony of the social safeguard of scapegoating than a tragic reminder of the ill effects of obsessional, panoptic control.

6 Underlying the judicial and penal systems is a belief in the legitimacy of both their means and their ends. Legitimation here encompasses the individual and the institutions serving him/her. In regard to the individual, judicial legitimation safeguards and polices moral integrity, or what Habermas (1975: 95) calls "the internalization of symbolically represented structures of expectation." Habermas suggests that the legitimacy of legal authority rests on the supposition that

> the values and norms in accordance with which motives are formed have an immanent relation to truth. Viewed ontogenetically, this means that motivational development, in Piaget's sense, is tied to a cognitively relevant development of moral consciousness, the stages of which can be reconstructed logically, that is, by concepts of a systematically ordered sequence of norm systems and behavioral controls. To the highest stage of moral consciousness there corresponds a universal morality, which can be traced back to fundamental norms of rational speech. Vis-à-vis competing ethics, universal morality makes a claim not only to *empirical* superiority (based on the ontogenetically observable hierarchy of stages of consciousness), but to *systematic* superiority as well (with reference to the discursive redemption of its claim to validity).
>
> (Habermas 1975: 95)

Getting Out's penal institution works similarly to instill universal morality in its convicts – thereby exercising a show of both empirical and systematic superiority. However, this results in an institution directed less toward the moral improvement of its members than to the enhancement of its own superiority and power. It is this side of socio-legal legitimation "which legitimates the system, power" that Lyotard asks us to ponder in *The Postmodern Condition* (1984a). For a discussion of earlier historical contrasts of theatrical legitimation, see Murray (1987).

7 This kind of amusement, which purports callously to being apolitical, flourishes in the American theatre industry. The tradition of American musicals and light-hearted comedies panders to a standard of apolitical entertainment. Moreover, the economic returns from laughter are so substantial that amusement is too often fused – with little theoretical purpose – into serious drama, film, and video. Horkheimer and Adorno present a compelling critique of the amusement industry which American consumers have ignored for too long:

> The stronger the positions of the cultural industry become, the more summarily it can deal with consumers' needs, producing them, controlling them, disciplining them, and even withdrawing amusement: no limits are set to cultural progress of this kind. But the tendency is immanent in the principle of amusement itself, which is enlightened in a bourgeois sense. If the need for amusement was in large measure the creation of industry, which used the subject as a means of recommending the work to the masses – the oleograph by the dainty morsel it depicted, or the cake mix by a picture of a cake – amusement always reveals the influence of business, the sales talk, the quack's spiel. But the original affinity of business and amusement is shown in the latter's specific significance: to defend society. To be pleased means to say Yes. It is possible only by insulation from the totality of the social process, by desensitization and, from the first, by senselessly sacrificing the inescapable claim of every work, however inane, within its limits to reflect the whole. Pleasure always means not to think about anything, to forget suffering even where it is shown. Basically it is helplessness. It is flight; not, as is asserted, flight from a wretched reality, but from the last remaining thought of resistance. The liberation which amusement promises is freedom from thought and from negation.
>
> (Horkheimer and Adorno 1972: 144)

I should stress that, in the context of their influential critique of the pleasure industry, Horkheimer and Adorno go too far in claiming that pleasure *always* means to forget suffering. Although *Getting Out* plays on the tradition of Carson or Lettermanesque amusement, it develops a strain of laughter which is antithetical to the pleasure industry and which remembers suffering all too well. Below I will analyze the promise of *Getting Out* as the seduction of a bad joke.

8 Lyotard (1977: 115–232) discusses how the strategy of breaking down specular centralization amounts to a theatrical act of revolt, "a kind of lunacy completely other, a violent mobility, a strength of invention not referring to a center." Barthes (1985: 44) understands the mobility of jokes to constitute what he calls "the third meaning:" "the one which appears 'in excess,' as a supplement my imagination cannot quite absorb, a meaning both persistent and fugitive, apparent and evasive." Also claiming that this excess extends

"beyond culture, knowledge," he differs significantly with Lyotard who focuses on the role of jokes and parodies as revolutionary strategies of cultural performance and historical action. I discuss Barthes in greater detail in *Like a Film* (1993: 65–97). For other subtle theoretical extensions of Freud's text on jokes, see Weber (1977 and 1982) and Mehlman (1975).

9 See Rose (1986: 167–97) for a detailed account of the combined role of narcissism and aggression in the Imaginary stage. These combinations she argues constitute the initial nexus of Identification through which the subject knows herself as the split between what she herself once virtually was (primary narcissism) and what she herself virtually would like to be (secondary narcissism). Silverman (1992) and Bersani (1990) develop the representational implications of masochism in quite different directions.

10 A similar question has been posed by Blau (1983: 152, 160): "What I am trying to do is suggest that there is in any performance the universal question, spoken or unspoken, of *what are we performing for?* . . . *What for?* As any good performer knows, that also determines the means." Tejumola Olaniyan turns to this passage to discuss "a ceaselessly self-critical performative identity" at the end of his formidable book, *Scars of Conquest/Masks of Resistance* (1995: 141–42).

6

THE PLAY OF LETTERS
Writing and possession in *Chucky's Hunch*

One of the qualities of artistic writing that is conscious of its enigma, is that it draws every interpretative reading towards that revived enigma, as if into a trap, and that the writing infects the interpretation with the writing-effect from which it emanates: its madness.
Daniel Sibony, "*Hamlet*: A Writing-effect"

A curious and contradictory writing-strategy motivates the "play," *Chucky's Hunch*. Rochelle Owens pens a compelling and disturbing contemporary performance by silencing dramatic dialogue and minimizing theatrical action, those two very tangible attributes of Occidental drama that lend shape to heroic characters and theatre's many primal scenes. Although Chucky himself enunciates the terrors of sexual trauma and what he calls "reptile age fears," his author limits his theatrical properties to the echoed monologue of twelve letters already written to Elly, the second of Chucky's three wives. These epistles are supplemented in performance by two other texts. First, a taped narration of a "primal scene" in which a copulating bestial couple, a snake and a porcupine, devours Chucky's dog in the course of a love ritual. Second, a supplementary epistle from Chucky's Mother to Elly. This letter recalls Elly's earlier "loss" of Chucky's unborn baby, and confirms the death of the dog which Chucky had grown to cherish "just like a little child, my son, and Ma's grandchild" (Owens 1982: 20). Similar accounts of loss doubled by the wounds of representation surface throughout this spoken performance. Reliving the broken memories of the unfulfilled American dream, Chucky's letters recount the disruption of his fragile life brought about not only by the unnatural death of his dog but by an added instance of Oedipal displacement – the erotic love affair of Chucky's eighty-five-year-old mother with the eighty-two-year-old Chester Nickerson. The complex memory of doubled Oedipal threat prompts Chucky to recount his subsequent epic journey into Upstate New York's "forest primeval" to avenge the ritualistic slaughter of Freddy. This scenario is accompanied by other graphically violent tableaux inscribed throughout the play's

primary scene of textuality, the series of Chucky's misogynistic love letters, replete with the best of the epistolary genre's incompatible narrative impulses – vengeance and nostalgia, defiance and desire (Kauffman 1986: 26).

The tableaux of writing – the enunciative acts of writing and reading – constitute the source of this play's primal attraction. But this maddening scene remains for Chucky to be significantly different from earlier exemplars of theatre's enigmatic writing-effects. Deprived of the authorial dignity of a Faust or a Marat, Chucky is never staged in the act of writing the letters. Nor does he share the cunning dialogical strategies of a Hamlet or an Oedipus since his female interlocutor remains absent and silent, as if, as Derrida might say, Chucky's letters never reached their destination, or as if, as Lacan might retort, they were meant to be received back again by the sender "in reverse form" – "in sufferance."[1] Indeed, it is much like the patient limited to verbal abreaction in the analyst's office that Chucky reproduces – this time for his audience – the bizarre combination of familial psycho-sexual encounters and complex oneiric scenarios that find themselves inscribed in the figure of letters to his "lost wonder," to his "ex-"communicant. And even more to the point of evoking Owens's contradictory writing-strategy, it is much like the analyst caught in the maddening throes of counter-transference that the audience, continually assaulted by the repugnant images of Chucky's strongly willed misogyny, must either leave the theatre of analysis or sit back anxiously, helplessly, and ambivalently *wanting* (wishing/lacking) to help Chucky achieve dramatic fulfillment, what he terms as, "a clear and urgent purpose as if I'm going to find something or someone that is necessary to the continuation of my being" (Owens 1982: 25).[2]

Owens's writing-strategy is simultaneously seductive and maddening by continually positioning Chucky's silent and disgusted interlocutors, Elly and the spectatorial recipients of his letters, as the dilemma posed by his narrative presence – whether or not to pledge to filling, which here can only mean "being," Chucky's lack. In the terms posed by *Chucky's Hunch*, this crisis involves not only our interpretative relationship to the history of Western drama, but our position *vis-à-vis* the primal scenes of psycho-sexual narrative *per se*, intertextual fragments ranging in allusion from Oedipus, Hamlet, and Frankenstein to the fictional memories of Proust, Freud, and maybe even Bellow. At stake in viewing, which means reading, *Chucky's Hunch*, is the realistic, yet *un-wanted*, possibility of enunciating the sick phantasm of subjectivity that falls between the fissures of Chucky's epistolary presentations. Still, it is the ideological hollowness of the phantasm itself that Rochelle Owens lays bare through the enigmatic writing-effects of her epistolary drama.

SELF-RESTORATION

Death is a displaced name for a linguistic predicament, and the restoration of mortality by autobiography (the prosopopeia of the voice and the name) deprives and disfigures to the precise extent that it restores. Autobiography veils a defacement of the mind of which it is itself the cause.

(de Man 1984: 81)

Owens's layered text openly stages the spectacle of representation's fissure, its *mise-en-abîme*. This maddening gap is especially apparent in view of the relation of *Chucky's Hunch* to its shifting epistolary conditions, to its inter-texts which become fused as "writing" in Chucky's creative consciousness. Take, for example, the text's enunciative foundation – the melancholic voice of autobiography, replete with poignant reminders of Chucky's rapidly declining condition. His nostalgic recollection of potency, "I used to be able to fuck a lot. . . . I'm going to be fifty soon, and my teeth are rotting away. Heaven help me" (Owens 1982: 13), is echoed in the text by his displaced acknowledgment of intellectual slippage, "Shucks, look what you got me doing – complaining about the conditions of my life. Now don't tell me to see a shrink because I tried it. It didn't work! I know, my perceptions at times are completely messed up" (Owens 1982: 14). This messed-up novelist and unsuccessful artist, now specializing in "bird-feeder constructions," spends most of his epistolary energy laying out his skewed perspective of the conditions of his life. He begins by recounting his coexistence with his eighty-five-year-old mother "in a rotting pre-Revolutionary house in a remote part of upstate New York." Under the roof of their "dilapidated dream house," the feeble mother and her psychotic son are virtually unable to distinguish between material and psychological dissolution resulting partly from age and partly from the haunting phantasm of an absent father:

> The old woman just lies in bed fifteen hours a day. I can't blame her – what the fuck is there to get up for? Last night I got smashed and I was stalking through the old house with a hammer in my hand. The furnace was on the blink and I was trying to fix it but I also knew that old Ma was kinda scared of me. We'd had a fight. She gets mad because she has to help support me on her Social Security checks. She says I'm just like George. You remember who he was – my father! Well you know I never knew my father. He was no good and old American, as Ma says, and I'm an awful lot like him and she sure stresses the word "awful."
>
> (Owens 1982: 12)

A good portion of the narrative of *Chucky's Hunch* is fueled by the writer's autobiographical attempt to right the awful wrongs of memory, whether

122

they be the failings of George the "no good and old American" father or those of Chucky, George's phallic double. Just as Chucky equates the coming of "a new day" with his plans "to renovate this beautiful old church in town," his letters stand forth as a concerted effort to restore his ruined life through the narrative recapitulation of the "bad end" of a "blue-eyed boy." Yet, in *Chucky's Hunch*, the narrative result is itself a dis-figuration. Recalling the character who surfaces most often in Chucky's many allusions to prose fiction, Victor Frankenstein, Chucky is continually frustrated by his multiple attempts to give purpose to his life by recreating existence from the ashes of the past. To cite one of the more obvious examples, the reader need only recall Chucky's anecdote of the sudden failure of his business venture to profit from recycled antiques: "in 1961, I went into the antique business. Yeah, I knew that would make you laugh – but I had a little antique shop – and then everything started to fall apart – I mean the bottom of my life was starting to drop out" (Owens 1982: 14). Chucky's is a narrative in which everything he (re)creates eventually turns on him, from his own entropic image to his epistolary phantasm of the female interlocutor who laughs derisively at everything he recounts.

By the conclusion of his weary tale, following his unsuccessful quest to destroy the "deadly duo" that beheaded his "son," Chucky's narrative displays more of an empty shell of self than any positive substance: "I felt so wrong in the scheme of things . . . I used to wonder why the bloodhounds hadn't picked up my scent. I used to wonder that – but now I know. I'm wasted – and the dogs have given up on me" (Owens 1982: 25–26). So it goes throughout *Chucky's Hunch* that the writer's attempt to account for creative restoration in his life leads inevitably to further mental and, often, physical disfiguration. Chucky's narrative of auto-biographical waste promises substantive renewal only in the future of performance, and then only as the hollow echo of a textual phantom. In Paul de Man's words, "the restoration of mortality by autobiography (the prosopopeia of the voice and the name) deprives and disfigures to the extent that it restores. Autobiography veils a defacement of the mind of which it is itself the cause" (de Man 1984: 81). The exchange of autobiographical restoration for ontological fulfillment leads Chucky headlong down representation's bottomless pit, the catastrophic doubling of life with letter, of subject with object, in which sender and receiver are virtually indistinguishable.

Throughout his letters, Chucky counters his autobiographical reality by remembering his hopes to be recognized as an "immortal artist." His nostalgic missives to Elly recall his earlier sense of artistic purpose. "Somehow I always felt that I deserved a better name than loser in my life. I mean I had more options than you twenty years ago. I was the one with the superior intelligence and the physical strength. I was the artist

and you were just a pretender" (Owens 1982: 19). To be an artist means for Chucky to be a Subject, a master of cultural and sexual superiority whose phantasm of strength will be doubled in the Other as mere copy, pretense, or lack. The artist is a lasting source of potency whose image casts doubt on the authenticity of the Other, whose position in the world necessarily leads to the sort of unequal relation depicted twenty years earlier by Chucky in a self-referential mosaic: "The knight with his lovely lady. He was playing the lute – and she sat there next to him – with an empty smile" (Owens 1982: 14). Whether reminiscent of an illuminated manuscript or the "American Gothic," similar imagistic traces of an empty lady in view of her phallic master appear throughout Chucky's epistles.

> Anyway between the phonies – I repeat the phonies of the art world scene and you [Elly] – it's a wonder that the magic christian ever got out alive!
>
> (Owens 1982: 14)

> Don't put me down, Della. I can still show you a thing or two. The magic christian is still as beautiful as Michelangelo's David.
>
> (Owens 1982: 17)

Elly stands forth textually not only as either a phony or a misguided spectator of Chucky's aesthetic "show" but in relation to the constancy and beauty, indeed, the immortal potency of "the magic christian." In Chucky's letters, the image of his magic christian stands forth lasting and rigid much like the towering figure of Michelangelo's *David* whose self-referentiality eclipses the many Christian icons of the nurturing mother that grace the adjoining galleries of the Accademia. Still, the fact that Chucky's potency must be qualified as being merely aesthetic directs us back to the import of the drama, that it need be understood as a play of letters. Regardless of the immortal potency with which Chucky wishes to fuel the image of the magic christian, its only true position of strength remains to be that of a recycled textual figure. In one context, it recalls Shakespeare's misogynistic references to "marble-constancy" in *Macbeth* and *Antony and Cleopatra* where the traces of potency remain at the end of these plays only as monuments of dissolution and the death drive. In another context, that of Michelangelo's *David*, not to mention his controversial nude sculpture, *Risen Christ*, the image of the magic christian brings to mind the phallic phantasm nurtured by fine art's earliest fixations on the sexuality of Christ. This is the figure carefully traced by Leo Steinberg in *The Sexuality of Christ in Renaissance Art and Modern Oblivion*. Steinberg's study provides a tangible framework for understanding Chucky's trope of the magic christian:

124

As a symbol of postmortem revival, the erection–resurrection equation roots in pre-Christian antiquity: it characterized Osiris, the Egyptian god of the afterlife, represented with his restored member out like a leveled lance. And the ithyphallus as emblem of immortality haunts later Mediterranean mysteries honoring Bacchus. The prevalence of such symbolism accounts perhaps for the readiness with which Christian theology associated the penis in its circumcision with resurrection.

In Western literature, the *locus classicus* for our metaphoric equation is Boccaccio's *Decameron*, the tenth tale of the third day, where the sexual arousal of the anchorite Rustico is announced, with blasphemous irony, as "la resurrezion della carne." The context of the novella makes Boccaccio's wording – the resurrection of the flesh following its mortification – an apt and effective pun. But this same pun, now deeply serious, lurks in the greatest 16th-century representation of the Raising of Lazarus – Sebastiano del Piombo's colossal painting in London, composed with the assistance of Michelangelo: Lazarus' loincloth, which in the preparatory drawing dips unsupported between the thighs, appears in the painting firmly propped from below – a sign of resurgent flesh.

(Steinberg 1983: 86–90)

Resurgent flesh. This is the image that motivates Chucky's writing as well as his art. His turn to the phallic pen in an effort to maintain his fragmented mosaic of self reveals the currency of the magic christian as the echo of a writing-effect. In one letter remarkable for its ugliness, Chucky boasts how his recent sexual exploits lead to his recollection of the earlier eroticism of his ex-wife.

> I still get horny. The other night I took a package of beef kidneys that were supposed to be for the cats, yup, we have two of them running around. I let the kidneys get at room temperature, then I wrapped them in a pair of panties and somehow managed to work myself up into a state of sexual desire – and came into the kidneys. Pretty depraved, right? Do you remember during the fifties you used to wear your dark red lipstick over your lipline, a fat round arc that glistened – you were stacked like a brick shit-house.
>
> (Owens 1982: 15)

The juxtaposition of these two memories highlights the narcissistic depth of Chucky's sexual desires. He transforms all figures of desire into passive, glistening objects awaiting the depraved arrival of his resurgent flesh. The ultimate effect of this transformation is to subject all of his partners of desire, lovers and readers, to Chucky's version of their lack of – and desire for – his potent flesh. The reader thus joins Elly as the

embodiment of Chucky's repeated writing-effect. "But just remember that I was more intelligent than you!" he reminds Elly, "I WAS MORE INTELLIGENT THAN YOU! Boy, I got you worked up. This time I really gotta rise outta you" (Owens 1982: 14). Here, as throughout Chucky's letters to Elly, the image of her rise in reading can be said to function only as the doubled phantasm of Chucky's desire for textual mastery through phallic aggression. Elly's imagined appropriation of this rise is but the personification of Chucky's wish for supreme potency.

Still, personification is, at least in this context, a rhetorical condition that defies fulfillment. By subjecting Elly to his framework of rhetorical selfhood, Chucky not only delimits the potential for any extensive interpersonal communications with his ex-wife but reasserts indirectly her authority to dismiss his conditions of being, to reject his style and method. As a result, Chucky makes himself more a slave to communication with his departed lover than her master in any form.

The inequity of such thwarted power relations demystifies Chucky's textual exploits, which are misogynistic as well as bigoted. Owens's text continually reveals the impotency of his efforts to posit his self-worth in relation to a necessarily inadequate Other. Whereas *Earwax of America's Minorities* is the bizarre and demeaning title he proclaims for his "next book," he dreams up another title in his opening inscription of a letter to Elly:

> How's that for a title of a book I'm going to write? "Dear Lying Eyes." You know the trouble with you is you won't answer any of my letters. What's the matter – are your fingers too greasy to hold a pen? I bet you've become a woman's libber since I went out of your life, Della. But we can always talk about it if you want in some low-down hotel room.
>
> (Owens 1982: 17)

While writing is inevitably linked by Chucky to the release of his magic christian, fucking is related to his own neurotic equation of sexual parity with deceit and "dirty" sex. These problematic relations surface again in the narrative frame with which he announces his book about American life, a book revealing Chucky's deep discomfort with America's many layers of cultural Otherness:

> I'm an artist, remember – an abstract expressionist that is. And you're just a housewife. I have this book that I've been working on a few years now ... It tells the way it is and was – it even goes into the American art world scene and I like to think that it's a metaphor for the American political scene as well. You have to be a hustler to make it big. Hey, have you heard the one about the ethnic who goes to get gas? Ah, you wouldn't get the gist of it – you just wouldn't

get the gist. Speakin' of ethnics – the way these Portuguese here in town treat me when I go to their goddamned one and only bar – you'd think I was the local, I don't know what – pervert! I was talking to Marie the waitress about it the other night. Boy, I'd love to get into a knock-down drag-out fight with her. Prone position – we might really make some sense together.

(Owens 1982: 12)

About the only way for women or "ethnics" to make sense of Chucky is to acknowledge his desire "to make it big" – in the doubled phantasm of the prone/prose position. Still, this desire to effect sexual and racial dominance through epistolary/seminal exchange is ridiculed by Owens's contradictory writing-effect. Chucky's aims are always already derailed by his texts' resistance to making his kind of sense.

Mastery of sense, he tells his addressee from the outset, entails the knowledge of language, the control of nomination:

Dear Della, remember the Christmas when we hitchhiked across the country together? It was in 1958. Dig? And the young trucker asked us if we lived like that – picking up rides across the U.S.A. The joker was amazed, wiped out by our pre-hippy lifestyle. But he didn't know a thing about us because, and I must repeat, because we never told him our names! He who knows my name has power over me! Shit – I never wrote my name big enough for you – you refugee from Brooklyn. Ethnic!

(Owens 1982: 11–12)

Power, in Chucky's mind, derives not only from the paternal or authorial right to confer an offspring's name but from authoritarian knowledge and control over extant names, from the ability to check, verify, and thereby delimit identities (illustrated by the French noun, *contrôle*, referring to the police check of identity papers). While Chucky's name, ironically, is not "big enough" to be possessed by Elly, he has no difficulty endowing her with the nominal identity of division: "Ethnic." Here again, the enactment of power reveals itself as locutionary, as an effect/affect of writing and reading.

OOZING SIGNS, EARLY MEMORIES

In his letters, Chucky makes precise intertextual allusions to his bungled attempts to exercise influence through linguistic manipulation. Paramount is his paradoxical reference to a certain epistolary novel. He tells Elly, "You were just an unformed baby when I met you. I created you – you Frankenstein monster!" (Owens 1982: 16). Much like Victor Frankenstein, Chucky attempts to maintain nominal control over his

127

independent creation long after it has thwarted his uncertain expectations for its existence. He does so through his series of letters to Elly, all of which lapse into frustrated efforts to shackle the interlocutor with excessively demeaning labels: "Ethnic," "Ms. Housewife," "middle-class babe in woods," "bourgeois cunt," "ole rubber hammer," "female spider," "snap-hole," "Mr. Death," and the repeated nomination, "Della-Fella." While Chucky's insistent return to such belittling names reveals his threatened defensiveness in the face of woman, the names themselves reveal the futility of his efforts to tame her with language. Take his equation of "Elly" and "Refugee." If elided to sound like "El-ugee," this would refer easily to Chucky's lamentable autobiography – the one in which he stars through counter-transference as the protagonist, "Mr. Death." Indeed, the threat of the monster of difference, the "refugee," points to the deep significance of the name he repeats most earnestly, "Della-Fella." The OED defines "Dell" as signifying "a deep hole, a pit" or "a deep natural hollow or vale of no great extent, the sides usually clothed with trees or foliage." This vaginal reference is accompanied by a variant definition suggesting the specific identification of "a young girl (of the vagrant class); a wench." "Della," then, functions as a condensed figure of vagina and wench (woman of (lower) class), the kind of figure that Chucky enjoys manipulating. On the face of things, "Fella" seems less easy to explicate. Its sense as "a peasant in Arabic-speaking countries" could well reinforce the class dimensions of Chucky's nominal control. Or it could simply be understood to reinforce Chucky's own castration anxieties by transforming Elly into a "fella." A more obstinate reading, but one that is perhaps more in keeping with the perverse spirit of *Chucky's Hunch*, would pun phonetically on "Fella." In the active world of Chucky's sexual fantasies gone astray, one function of the unequal role of "wench," or "Della," might well be the performance of "Fella-tio." This playfully phallocratic association of "Della" with "Fella" is made even more credible, if not deadly serious, by the text's many references to Elly's sexual threat: "You used to have strong teeth, Della, big like a horse's. I can visualize you with your big teeth, smiling broadly at me, laughing your head off the way you always did whenever you became nervous" (Owens 1982: 17). These threatened, toothy remarks are followed only a few sentences later by the revealing punchline, "Women with their sexual organs are the stronger sex" (Owens 1982: 17).

In *Chucky's Hunch*, even the letter writer's most condensed nominations generate an accumulation of what Lacan anxiously summarizes as "the castrating and devouring, dislocating and astounding effects of feminine activity" (Lacan 1985: 92). Chucky's fears of the castrating woman place him once again in the complex position of being subject or slave to his own masterful phrase. Or as Chucky understands his position, "But then the female spider does devour the male. Right rubber

hammer? How many men have you chewed up, you fat spider?" (Owens 1982: 19). These bestial accusations not only underline Chucky's complex anxiety but seem to answer in the affirmative an earlier, testy question posed by Lacan: "Even given what masochistic perversion owes to masculine invention, is it safe to conclude that the masochism of the woman is a fantasy of the desire of the man?" (Lacan 1985: 92).

If the prior discussion has not allowed us to arrive comfortably at this conclusion, consideration of one more textual detail will clarify Chucky's displacement of his masochistic perversions on to his epistolary Other. In as much as his name-giving and personifications reveal his strong discomfort with the female organ he so desires, his repeated references to his own scarred groin depict Chucky as the bearer of the icon of "the masochism of the woman." Preceding the memorable citation of Chucky's preference for beef kidneys, he elides his memory of Della with another telling remark:

> I want to send you my book because you're in it too. It's about you, Della. The book's about you. Do you remember my old hernia operation? The fissure that I have on my side? It still oozes some-times. My old hernia trouble. It sounds like a song. God what a disgusting mess I yam, I yam.
>
> (Owens 1982: 15)

It is his oozing fissure, his glistening fold, that reveals Chucky to be the ultimate bearer of the sign of the lack. "Is it any wonder that I suffer emotionally as well as sometimes oozing from the fissure in my side from the operation I was forced to have?" (Owens 1982: 19). Even prior to the operation which he claims elsewhere to have desired and which was forbidden at fifteen by his mother's "Jehovah Witness phase," Chucky's herniated condition, not his resurgent flesh, is what caught the "painful" attention of his adolescent peers, "that year when the other boys in the locker room at school found out about my wearing a truss" (Owens 1982: 19). There, in the steamy enclaves of adolescent virility, Chucky existed as the disgraced object of phallic vision and ridicule. For then, as happened later when Chucky witnessed the murder of his dog, his hernia left him "in much too weak a condition to defend myself." So it is that Chucky's letters reveal him to bear the painful memory and oozing sign of the masochistic flesh that he so desperately desires to displace on to the figure of woman.

Chucky's entrapment in this (un)desirable fold is made further evident, on an even grander scale, when his form of discourse – the letter – is placed generically in relation to the epistolary novel. Historically, the epistolary novel casts as its central character the spurned female, whose manipulation of the pen is more often than not a desperate substitution for both her lost father and departed lover (Kauffman 1986:

34). The position of the writer is here one of reflection instead of action, one of hopeful passivity instead of confident aggression. Also in this spirit of the epistolary romance, Chucky's drama of letters is "a slow motion affair" whose stress is placed not so much on captivating events as on the lingering pains of psychological trauma (Altman 1984: 21). As primarily a psychological medium, the love letter reveals more about the frustrated desires of the writer than it possibly could about the wishes of the silent receiver. Roland Barthes describes the situation this way: "to know that one does not write for the other, to know that these things I am going to write will never cause me to be loved by the one I love (the other) . . . that it is precisely *there where you are not* – this is the beginning of writing" (Barthes 1978: 100). It is also precisely there – at the beginning of writing – where the play, *Chucky's Hunch*, opens as well as ends: "What do you think of when you look at the old photographs of us together? Do you feel as though you walked away from a head-on collision? I talk to you – you refuse to understand. I loved the way you moved your body – and not once I have pitched woo with anyone but you, dear" (Owens 1982: 26). A defiant question of understanding, an anxious expression of nostalgic desire, a vengeful hint that Chucky will not stop writing his tiresome letters, these are the narrative elements of epistolary literature that frame *Chucky's Hunch* (Kauffman 1986: 26).

In terms of theatrical representation, the scope of the play remains limited by these narrative demands. The conclusion allows for no more action than is apparent from the outset: "I have an image of you in my mind, poking like a finger under my eyelids. You're standing next to a vase filled with wildflowers. My ego is growing claws that are ready to tear off a piece of whatever I can get them into" (Owens 1982: 26). As each successive citation of the text makes even more apparent, this is a play of the never-ending violence of the phallocratic, I should say, narrative mind.[3] In the tradition of epistolary narratives like Bellow's *Herzog*, Chucky's written outbursts are grounded in complex flashbacks that function as deceptive substitutions for the layers of repression he accumulates throughout a life of childhood trauma and three failed marriages.[4] There is the memory of when "Ma and I did sit down together for a talk about the good old days when I would eat a whole head of lettuce all by myself at the age of twelve. And then the tale about the time a man tried to get into the house when Ma left me there alone. He was a genuine mid-Western pervert who probably wanted to assfuck a young boy and then cut his throat. Ma and I hugged each other real close after that story – we might have our differences but we still don't want any physical harm to come to Chucky" (Owens 1982: 16). Here memories of the "good old days" are interlaced with the safe recollection of a very bad tale. But Chucky reveals the imminent threat of sexual danger by speaking of Ma's concern for his safety. A similar attempt to

displace fear with nostalgia occurs in the flashback to the time "in 1958 when I was interviewed by that young twerp from the Columbia School of Journalism and he suspected that I was of a rebellious nature. And he told me, 'We can't afford to have defiant characters in our midst.' Hey, Della, did you think that I was a defiant character? I was really too much for you, wasn't I? From the very first day that I met you when I told you about my life with my first wife, Hettie, you thought of me as the sonovabitch in your life" (Owens 1982: 15). Typical of Chucky's prose style is the way his flashback to 1958 provokes obscure references to his life with Hettie and to his memory of how Elly responded to this tale. Chucky's own notion of his role in transferring past desires and memories into present text might even be said to stand out as the psycho-analytical key to reading *Chucky's Hunch*. For the most significant aspect of the flashbacks interspersed throughout the play is how they position Chucky as the startled recipient of his own memories, as the confused respondent to his own ugly tales, and even, for the spectator, as the phantasm of the analyst duped by the clouds of his own counter-transference.

Consider the case of an early memory that not only haunts Chucky but stirs the unconscious of his literate spectators. "Sometimes I start thinking of when I was seven years old sitting on my grandmother's porch in Michigan, holding a glass of cold water and a chocolate nut cookie – and then I think of what Ma always says – how did I ever get out of the mid-West alive?" (Owens 1982: 13). Chucky's self-conscious reference to the literary cookie of Proust suggests how the outer shell of his letter to Elly introduces a complex textual *mise-en-abîme* in which intertextuality works both as expression and displacement of earlier misunderstood events. In this particular example, the memorable image of the cookie is more significant to the narrative strategy and writing effect than is the traumatic event signified by its remembrance. The force with which Chucky's recollection of the cookie disrupts the narrative illustrates his tendency to get "sidetracked as usual" whenever discoursing on love and desire. "Oops, there I go again digressing – Ma says that I'm the most digressing person she's ever seen – and she ought to know after all the times we've digressed each other. But you know my story, dear Elly. I could tell Whatsis Face much more easily than I could tell you how women have always lorded it over me" (Owens 1982: 14). By so falling into a digressive tail-spin whenever warming up to the topic of sexual relations, *Chucky's Hunch* may well reveal the duplicitous narrative, not the threatening Other, to be the most effective force in demystifying the masterful illusion of the magic christian. In many ways, Chucky's failure to manipulate textuality recalls the frustrated efforts of Proust's Marcel, the original custodian of the psychoanalytic cookie. As Leo Bersani explains Marcel's dilemma, the power-surge of memory

generated by writing will always disrupt the stable image of a textual self: "Desire makes being problematic; the notion of a coherent and unified self is threatened by the discontinuous, logically incompatible images of a desiring imagination" (Bersani 1976: 84).

PRIMAL DIGRESSIONS

The writing-strategy that most disturbs Chucky, the digression of flashback, is also the literary method with which he is most familiar. It is Chucky's repetition of cookie-triggered memories that juxtaposes the indiscriminate and often senseless trace of the involuntary over the coherency of narrative and self – those cultural simulacra of the magic christian. A poignant example occurs when Chucky acknowledges peering through the gap in his mother's window shade at her amorous tryst with Chester Nickerson. His description, only part of which I cite here, is classic in the digressive way that it moves from an account of his voyeuristic vision and its mixed emotional effect to an involuntary revelation of childhood memories and future fantasies:

> I was stunned! I could hardly believe my own eyes when I saw what went on between them. Ma sucking Chester's soft gray dick until it grew hard and then Ma sitting right smack on Chester's face, pulling at his hands with her arthritic fingers, clutching at his wrists while making low groans in the back of her throat. I admit that though I was jealous at what those two had between them, I was also furious . . . They started to fuck with Ma on the edge of the bed and Chester standing in front of her. By that time the noise of their gasping was beginning to sound terribly loud and scary in my own ears and my anxiety was becoming more than I could bear and all I could think of was a glass of cold water and a chocolate nut cookie and being seven years old again. But then I had an image of burning the house down with them inside.
>
> (Owens 1982: 21)

Flavored by Chucky's confused, Oedipal notion of what it is that he thought he actually saw or heard, his account is disquieting in its emotional fluctuation, from jealousy and fury to fright and anxiety. These emotions, on which I have already touched in summarizing the psychological territory of the epistolary novel, stand out here as the traumatic effects of experiencing the bare sights and especially the undiscriminating sounds of creation/destruction. Doubled by the oral performance of the letters from which they emanate, the sounds of love are lasting in their production of rhetorical effects, in their generation of resonant perlocutionary responses to a fleeting linguistic moment. The end of this attempt to re-collect the senses does little, moreover, to contribute

to the reconstitution of any "notion of a coherent and reconstituted self." Providing neither theatrical catharsis nor psychological resolution, Chucky's textual repetition of this real (or imaginary?) event catalyzes a free-for-all of literary flashback and projection – the senseless *mise-en-abîme* of Proust's cookie on the one hand, the hellish specter of the apocalypse on the other. These almost logically incompatible images of past and future work, in turn, to introduce more a scene of interpretative infelicity than one of narrative coherency. Here, Chucky presents himself, not to mention the recipients of his letter, with the traumatic, indeed maddening, dilemma of reading.

Chucky's posturing throughout his letters is framed by similar scenes of uncanny digression, those which are both comforting and disturbing, those which position Chucky as both their creator and their victim, that is to say, as their writer and their reader. For the spectator, a peculiar feature of *Chucky's Hunch* is how Chucky gathers momentum in writing/reading his tale at the precise moment in the story when he most dissolves as an active, dramatic agent. After he has disappeared into the forest primeval, after the search dogs have given up looking for his ghost, and after his mother has abandoned his memory by joining Chester Nickerson in a carnivalesque scene at a nearby Holiday Inn, we, the audience, continue to hear from Chucky. We continue to receive his account of these final moments when he acknowledges his enslavement in, and thereby subversion of, the narrative polarity of subject/object: "I'm here under the rocks with the bugs – being watched by the dragons and owls of hysterical imagination. Elly, if I've seen a weird thing – I mean something really weird – I might just chalk it up to being loaded or whatever, but if I see the weird thing again and again, well then I possibly might be correct in my perceptions. Right?" (Owens 1982: 25). At issue in *Chucky's Hunch* is how the repeated enunciations of the writer effect a sort of psychoanalytical memory screen through which the text is both written and read, produced and received, first by the author/player and then by the spectator/reader. Throughout the course of the play, it becomes readily apparent that Chucky's tale is one of enslavement in the uncanny scene of libidinal creation.

Let me be more precise. What is repeated throughout this tale is not merely Chucky's belittling epistolary nominations of woman nor simply his unsuccessful attempts to displace the troubling Other with the artistic presence of his magic christian. All of these desperate acts are framed by digressions into a deeper, more problematic oenirical scene, one resonant in Occidental literature since *Oedipus Rex* and *Hamlet*, the complex scene of primal fantasies. This is the scene described by Freud as comprising fantasies in which "the individual reaches beyond his own experience into primaeval experience at points where his own experience has been too rudimentary" (Freud 1953–74: XVI, 371). While Freud initially

understood this to be a scene of multiple fantasies decisive in early life, comprising "the seduction of children, the inflaming of sexual excitement by observing parental intercourse, the threat of castration (or rather castration itself)" (Freud 1953–74: XVI, 371), he later restricted the "primal" to the scene of the child's trauma, actual or imagined, of witnessing parental intercourse. What is consistent throughout Freud's evolving version of the primal is not so much the object of trauma as the (ir)reality of the phantasm itself. Whether actual or imagined, the phantasm is equally traumatic.[5] Taking Freud's point one step further, Ned Lukacher dwells on the interpretive *aporia* subsequently generated by the primal's shifting between the actual and imagined:

> Rather than signifying the child's observation of sexual intercourse, the primal scene comes to signify an ontologically undecidable intertextual event that is situated in the differential space between historical memory and imaginative construction, between archival verification and interpretive free-play ... The primal scene is the figure of an always divided interpretive strategy that points toward the Real in the very act of establishing its inaccessibility; it becomes the name for the dispossessive function of language that constitutes the undisclosed essence of language.
>
> (Lukacher 1986: 24)[6]

Primal confusions of memory and construction, of the real and its literary dispossession, haunt the writer of Chucky's letters. In the wake of his confrontations with the primal, Chucky's individual responses are endemic of a much larger cultural lack displayed by Rochelle Owens, the cureless wound of interpretation as the primal effect of writing.

The most striking example of primal fantasy is when Owens sidesteps her epistolary strategy to present the theatrical audience with the fable (I'm tempted to say, the case history) of the snake and the porcupine. On a formal level, this primordial narrative spoken by a "taped voice resembling that of a news broadcaster" shifts the boundaries of enunciation established by Chucky's letters to Elly. This is a tale presented directly to the audience in the semi-factual voice of documentary (if not clinical) omniscience. But not even the realistic frame of documentary containment diminishes the phantasmic depth of this primal tale:

> The snake and the porcupine had been a couple for five years. Spawned in the woods near Apple Valley, New York, they were a symbiotic entity, cunning, vicious, frightening, above all pragmatic during a killing ... This was an extraordinary pair, intelligent and prospering. During that first incredible encounter, the porcupine had dropped seventeen quills to the earth in fright because she had believed that the snake was going to sting her to death. He wanted

only to touch her where there were no quills, to rub his length along her voluptuous roundness. With inscrutable thoroughness they smelled each other ravenously . . . One of the most dramatic fights they had shared together was when they had seized a large husky and began to chew its head and neck so violently that the victim thrashed about wildly in an effort to escape. After the struggling had ended, the pair spent an hour swallowing their prey. All the while a man watched from a nearby bush, showing curiosity and agitation. When the pair made especially violent movements he dashed away in terror only to return again to peer through the bush at the fascinating spectacle. After the meal the couple did a slipping and skidding and zigzagging dance that slowly progressed into copulation.

<div align="right">(Owens 1982: 18)</div>

While this disembodied narrative accounts for the murder of Chucky's dog, it does more than function as an essential plot device. Addressed to the audience, it serves as an atavistic paradigm of the primal scene and its dangerous repetition. Replayed here are the sights and sounds of the first sexual encounter, in which primeval copulation is always already preceded by Oedipal violence, by the erotic dismemberment of a surprised husky who is represented throughout the play, it should not be forgotten, as the animistic double of Chucky, the voyeuristic son.

To some degree, it could be said that this journalistic representation is made "safe" by the distancing conventions of the news broadcast. Within the framework of journalistic re-presentation, the veracity of the tale stands no longer in doubt. In addition, we need only recall Brecht to understand how the strategy of reportage also aims at diminishing the evocation of pathos in order to stimulate the recipients' contemplation of their alienated reception of the report. How alienation is even conceivable in the face of the primal has been analyzed on a comparable front by Stephen Heath, in terms of the conventions of narrative film: "the narrative plays, that is, on castration known and denied, a movement of difference and the symbolic, the object lost, and the conversion of that movement into the terms of a fixed memory, an invulnerable imaginary, the object – and with it the mastery, the unity of the subject – regained. Like fetishism, narrative film is the structure of a *memory-spectacle*, the perpetual story of a 'one time,' a discovery perpetually remade with safe fictions" (Heath 1981: 154). There is little question that the fable of the snake and the porcupine stands out in *Chucky's Hunch* as a memory-spectacle perpetually available to all takers. Still this memorable spectacle remains safe only if its fiction *can* be separated from the phantasm of imaginative reconstruction through which the recipient becomes husky / Chucky. As elsewhere in *Chucky's Hunch*, the experience of the primal is

presented here to be less the alienation of voyeuristic witnessing and its appropriation than the absorption of the conflicting emotions aroused by forbidden sights. This report of bestial and violent sexuality is said to speak to the deepest phantasms of the viewer, both terrorizing and fascinating him, in the age-old tradition of Teiresias who was punished, so the fable goes, for similarly peering at the copulation of two serpents.

The numbing effect of this universal scenario underscores the conditions of enunciation posed by all narrative accounts presented by Chucky in the guise of the letter. Chucky is said to be entranced, to a similar but perhaps greater degree than his audience, by the spectacle that so horrifies him. Chucky's repetitive and desperate attempts to reconstitute the Subject through his belittling of the symbolic object – the lacking Other – return to him in digressive "sufferance," in reverse form. He performs on stage as the suffering voice projecting letters that are never answered, that is to say, that return, literally or imaginatively, to him to be read. And while the letters may underscore his distance from their subjected recipient, they also guard and reinforce his proximity to and interdependence on the object of his discourse.[7]

This paradox speaks to the scene of dramatic interpretation as well. Even though Chucky is the only character known to have actually possessed or "read" these letters, their status as letters – that is, as texts – leaves them, like the disembodied voice narrating the primal scene, open to reception by all readers, by all viewers. In the words of Barbara Johnson, who comments on the transferential status of Poe's "Purloined Letter," "the letter's destination is wherever it is read: the place it assigns to its reader as his own partiality. Its destination is not a place, decided *a priori* by the sender, because the receiver *is* the sender, and the receiver is whoever receives the letter, including nobody . . . As Lacan shows, the letter's destination is not its literal addressee, nor even whoever possesses it, but whoever is possessed by it" (Johnson 1982a: 502). (Dis)possession by the letter, by the primal scenes of textuality: this is the maddening enigma of the writing effect of Rochelle Owens.

REBIRTH OR LACK?

Their "symbolic" exists, it holds power – we, the sowers of disorder, know it only too well. But we are no way obliged to deposit our lives in their banks of lack, to consider the constitution of the subject in terms of a drama manglingly restaged, to reinstate again and again the religion of the father. Because we don't want that. We don't fawn around the supreme hole. We have no womanly reason to pledge allegiance to the negative.

(Cixous 1981: 255)

When read in the light of this Cixous epigraph, Rochelle Owens's text seems finally to do little more than reiterate the tale of the lack, albeit here a universal condition ironically symbolized by Chucky's oozing groin. Indeed, her text may be said to seduce its readers into the indefensible position of failing to articulate a positive female discourse, one aiming to sidestep "allegiance to the negative." But it is perhaps too easy, so I "want" to argue in closing, to delimit *Chucky's Hunch* to the negative realm of the visible, to the terrain staked out by Chucky, its onstage character. For *Chucky's Hunch* is framed by subtle conditions of reception that shift the focus away from Chucky's vision of history to recall alternate scenes "in-different" to the sustenance of this vision.[8]

First is the text's acknowledgment of the will of the patient, here Chucky or phallologocentrism *per se*, to speak itself into traumatic oblivion. One literary effect of *Chucky's Hunch* is to turn the tides on the tradition of the fictional epistle that has functioned historically to enslave its female characters in the Law-of-the-Father, in the discourse of the lack. Recalling the paradox of a similar epistolary text penned by a woman and cited by Owens, *Frankenstein*, the creator, Chucky, is one who exemplifies the status of the lack, not his uncontrollable creation, Elly.[9] By so restaging the paltry drama of the lack, Owens's play could be argued to do it permanent damage rather than reinstating it. This reversal stands out as a welcome and bold step, especially in the midst of recent American theatre which continues to fawn around the supreme holes of the Shepards and the Mamets, those surprisingly successful dramatists who receive unending praise for reactivating the tiresome search for the lost father.

Second, framing all of Chucky's letters is the figure of silence. It is Elly's silence that so forcefully highlights the narrative failure of Chucky to rewrite the power of the magic christian. It is her silence, perhaps her in-difference to the dilemma of Chucky, not her positive or negative response to it, that provokes so much ire in the man unable to control her through the conventions of dialogue. This is not to say that Owens's text allows Elly, or any recipient of the letter, not to be possessed by Chucky's writing effect. But rather than depict female silence only as a sign of passivity, weakness, and patriarchal exclusion, the play suggests that it may well be a strategy of strength in response to Chucky's ceaseless references to the past failures of his interlocutor. Such a hypothesis calls to mind the argument of Jean-François Lyotard regarding the incommensurability of political discourses. Lyotard chooses the phrase *differend* to signify "the case wherein the plaintiff is divested of the means to argue and becomes on that account a victim . . . A case of *differend* between two parties takes place when the 'regulation' of the conflict that opposes them is done in the idiom of one of the parties while the wrong suffered by the other is not signified in that idiom" (Lyotard 1988: 9). Since dialogue in

the discourse of the plaintiff will only aggravate the injustice, Lyotard recommends the development of new rules of language for the discourse of the differend. His description calls to mind Owens's writing-effect of the silent Elly:

> In the *differend*, something "asks" to be put into phrases, and suffers from the wrong of not being able to be put into phrases right away. This is when the human beings who thought they could use language as an instrument of communication learn through the feeling of pain which accompanies silence (and of pleasure which accompanies the invention of a new idiom), that they are summoned by language, not to augment to their profit the quantity of information communicable through existing idioms, but to recognize that what remains to be phrased exceeds what they can presently phrase, and that they must be allowed to institute idioms which do not yet exist.
>
> (Lyotard 1988: 13)

The solution, according to Lyotard's argument, is one that accompanies "possession" of Chucky's text by Elly, by the audience. "To give the differend its due is to institute new addressees, new addressers, new significations, and new referents in order for the wrong to find an expression and for the plaintiff to cease being a victim. This requires new rules for the formation and linking of phrases. No one doubts that language is capable of admitting these new families of phrases or new genres of discourse. Every wrong ought to be able to be put into phrases. A new competence (or 'prudence') must be found" (Lyotard 1988: 13). It may indeed be idealistic to assume that Elly's silence in *Chucky's Hunch* might be heard positively as the gesture of her own search for discourse. But it can be said, at least, that the play leaves Elly in the position of the differend, reading on her own, determining her own response to textual possession, indeed, to primal discourse *per se*.

Finally, *Chucky's Hunch* contains one example, if only a feeble one, of an attempt to find a new competence in discourse. This would be the sole example in the play of woman-to-woman correspondence represented by the letter from Marge Craydon (Chucky's Ma) to Elly. In terms of plot function, this letter might be explained as filling the gap in correspondence caused by Chucky's sudden disappearance into the forest primeval. But such a reading is negated by the resurfacing of Chucky's voice and letters in the scene immediately following this one. Even in Chucky's absence, his distant voice assumes the resurgent strength of dramatic narration.

To some degree Marge's letter points more to the primal territory of the account of the snake and porcupine than to the political scene of injustice represented by Chucky's reading of his letters. For Marge's letter is

performed by "a very deep woman's voice offstage. Taped" (Owens 1982: 22). So it is that the spectator might want for this letter to suggest a resonant, female "depth" – one that surfaces only temporarily and only in the momentary absence of the pressures of the differend. The content of this letter, while not altogether different in tone from the mixed epistolary emotions of nostalgia and vengeance, differs significantly from Chucky's use of the epistle to exercise nominal control through textual creation. Here, in reporting the disappearance of her son, her offspring, Marge makes reference to her "memories of when I was a young mother-to-be." This letter is striking in its emphasis on the mysteries of childbirth, those resulting in "the miraculous coincidence that my boy and I were born on the same date" (Owens 1982: 23). Even in the letter's more bitter communications, Marge juxtaposes the nurturing codes of maternity with the negative influence of paternity:

> I remember distinctly the desire to have a normal child and so I made sure that as soon as I found out I was pregnant, I would never wear a tight leather belt again that pressed my waist in; now I know, Elly, you always wore tight belts and I'm sure that is why you lost your baby when you were married to Chucky. But these days I think it was definitely a good thing that Chucky never had a child because I'm convinced the reason for his terrible disturbances are due to the bad genes that he inherited from his father George whom I had to leave because I knew that he would be dangerous to Chucky sooner or later.
>
> (Owens 1982: 22–23)

Lamenting her daughter-in-law's maternal failure, Marge here evokes the differend by suggesting that both Elly's silencing of birth and her own flight from marriage were necessary strategies of eluding the violent failures of paternity. In the midst of its most contradictory moments, from Marge's fantasy of joining Chester Nickerson in amorous magazine photos to her defense of prayer in the schools, this letter is resplendent with examples of a woman-to-woman discourse unparalleled in Chucky's letters. To some extent, this gesture made by one woman, a mother, to her daughter-"in-Law" calls to mind Cixous's analysis of the writing-effect of woman:

> Everything will be changed once woman gives woman to the other woman. There is hidden and always ready in woman the source; the locus for the other. The mother, too, is a metaphor. It is necessary and sufficient that the best of herself be given to woman by another woman for her to be able to love herself and return in love the body that was "born" to her . . . The relation to the "mother," in terms of intense pleasure and violence, is curtailed no more than the relation

139

to childhood . . . Text: my body – shot through with streams of song;
I don't mean the overbearing, clutchy "mother" but, rather, what
touches you, the equivoice that affects you, fills your breast with an
urge to come to language and launches your force.

<div align="right">(Cixous 1981: 252)</div>

Clearly Rochelle Owens presents her audience with only a slight degree
of any such feminine force; still, the degree itself could be argued to be
almost inconsequential. For it is the Symbolic value of measure itself, the
Law-of-the-Father, that is here under review. Marked by a tone different
from the "awful" judgment of the "old American father," this marginal
letter, so out of place among Chucky's angry communications, equates
the experience of writing with primal reflections on the female scene of
creation.[10] This is the enigmatic scene that stands aside – in-difference –
from the dangerous inheritances of fathers and their maddening dramas.
This is the scene "of woman's style" that Owens's anxious readers might
want to remember amidst the maddening spectacle of Chucky's phallic
play of letters.

NOTES

1 I refer to the differing readings of Poe's story, *The Purloined Letter*, by Lacan
(1966: 11–61) and Derrida (1980: 439–549). Both of these essays, along with
Barbara Johnson's response (1982a) are reprinted in Muller and Richardson
(1988).

2 On the relation of transference and text, see Chase (1986); de Certeau (1986:
3–34); Brooks (1984: 216–37); LaCapra (1985: 72–94); and Rosolato (1990).

3 Maria Minich Brewer (1984) analyzes the phallocratic structure of narrative,
one grounded in the "desire of power (and power's desire)." The relation of
narrative authority to the art of seduction is the subject of Chambers's *Story
and Situation* (1984).

4 In *Epistolarity*, Altman (1984: 37–41) provides a theoretical account of the role
of the flashback in *Herzog*.

5 In "Fantasy and the Origins of Sexuality," Laplanche and Pontalis (1986)
describe fantasy's indifference to the reality of its representation, as well as
the Subject's ability to be both object and subject of the phantasm, thus
leaving him/her outside of the scene.

6 Warner (1986: 37–111) also provides a helpful account of Freud's theory of the
primal and its relation to literary theory.

7 Derrida (1980: 34) focuses on this paradox in "Envois."

8 Diamond (1985) outlines feminist strategies of theatre in which a reshaped
narrative text "insistently shapes or interrupts the dramatic present and thus
alters audience perspective on the event."

9 Johnson (1982b) dwells on the paradox of "feminine contradiction" in and
around *Frankenstein*.

10 Evoking the paradox of *Chucky's Hunch* – a play starring a man, about the
decline of misogyny, and written by a female author – Johnson contemplates
the implications of the feminine contradiction lying behind the authorship
and content of *Frankenstein*:

It is perhaps because the novel does succeed in conveying the unresolvable contradictions inherent in being female that Shelley himself felt compelled to write a prefatory disclaimer in Mary's name before he could let loose his wife's hideous progeny upon the world ... How is this to be read except as a gesture of repression of the very specificity of the power of feminine contradiction, a gesture reminiscent of Frankenstein's destruction of his nearly-completed female monster? What is being repressed here is the possibility that a woman can write anything that would *not* exhibit "the amiableness of domestic affection," the possibility that for women as well as for men the home can be the very site of the *unheimlich*.

(Johnson 1982b: 9–10)

141

Part III

COLOR ADJUSTMENTS

7

DIFFERA(N)CE

Screening the camera's eye in Afro-American drama

The fundamental event of the modern age is the conquest of the world as picture. The word "picture" [*Bild*] now means the structured image [*Gebild*] that is the creature of man's producing which represents and sets before. In such producing, man contends for the position in which he can be that particular being who gives the measure and draws up the guidelines for everything that is. Because this position secures, organizes, and articulates itself as a world view, the modern relationship to that which is, is one that becomes, in its decisive unfolding, a confrontation of world views ... For the sake of this struggle of world views and in keeping with its meaning, man brings into play his unlimited power for the calculating, planning, and molding of all things.

> Martin Heidegger, "The Age of the World Picture"

A desire for the possibilities of the uncolonized black female body occupies a utopian space; it is the false hope of Sappho Clark's pretend history. Black feminists understood that the struggle would have to take place on the terrain of the previously colonized: the struggle was to be characterized by redemption, retrieval, and reclamation.

> Hazel V. Carby, "'On the Threshold of Woman's Era'"

When framed by Hazel Carby's appeal for the reclamation of usurped female terrain, Martin Heidegger's reflections on technology expose modern productions as both scopic and colonial by nature. In the light of recent feminist discussions of film theory, psychoanalysis, and contemporary art, Heideggers's earlier analyses of questions concerning technology leave contemporary critics (especially those of us inheriting the world view of the "white male") with the burden of acknowledging the ideological weight of our complicity with technological machines of communication. This relation is grounded in what Heidegger depicts as the duofold fiber constituting the contemporary (technological) image

145

as always both a structure of representation and a device or apparatus (tool and *épistémè*) lending itself naturally to colonial struggles for unlimited power and authority. To speak of contemporary artistic performance in view of the technological image is to raise the specter of man bringing "into play [this] unlimited power for the calculating, planning, and molding of all things."

Carby's alternative suggestion that black feminist efforts need "take place on" (re-situate/ re-cite/ re-sight) previously colonized terrain calls to mind collaborative artistic and literary efforts made over the past decade to probe the relation of the technological to gender, race, and representation. Exemplary of this program, to mention some prominent examples, are the 1984–85 exhibition, "Difference: On Representation and Sexuality" at New York's New Museum of Contemporary Art and London's ICA, the Spring–Summer 1989 issue of *Discourse* edited by Trinh T. Minh-ha on "(Un)Naming Culture," the 1989 gay and lesbian conference "How Do I Look?" sponsored by Bad Object Choices, the 1990 exhibition at The New Museum of Contemporary Art, "Out There: Marginalization and Contemporary Culture," the 1990 "Decade Show: Frameworks of Identity in the 1980s," between New York's Museum of Contemporary Hispanic Art, The Studio Museum in Harlem, and The New Museum of Contemporary Art, the 1990–91 Miami University Theory Collective's lecture series, "Questioning Technologies," the 1991 project, "Black Popular Culture" organized by Michelle Wallace for the Dia Center for the Arts, the 1994 Whitney Museum show, *Black Male*, the Fall 1994 issue of *Public Culture*, on "The Black Public Sphere," and Judith Butler and Biddy Martin's Summer–Fall 1994 issue of *diacritics* on the "Critical Crossings" of postcolonial and queer theory.[1] Many striking pieces in these diverse projects re-dress the technological image with the aesthetic and ideological fabrics of confrontational strategy and revolutionary enactment.

While the scope and collaborative nature of these artistic and literary ventures have resulted in wide publicity and critical acclaim, similar individual and isolated representations in the theatre have received far less attention from theorists of gender, race, and representation. Although Lowery Stokes Sims (1988) provides a helpful overview of black American female performance, her focus on visual and performance artists necessarily forecloses any adequate consideration of black female playwrights and theatre works. Even the 1989 special issue of *Performing Arts Journal*, "The Interculturalism Issue," ignores black American theatre's historical contributions to "interculturalism" which is said to hinge on the critique of "questions of autonomy and empowerment" (Chin 1989: 174). But it has been only more recently, in the wake of feminist and queer interest in performance, that the theorization of performativity and "critical crossings" has begun to turn its attention to the

146

groundbreaking reflections on race, sexuality, and technology by African-American playwrights.[2] Especially in contemporary black American drama, the complexity of technological manipulation and subsequent theatrical confrontation has been developed with particular care and theoretical concern. In the serious world of black American theatre, plays layered with mixed-media themes and technologies profoundly demonstrate how the marvelous technicolors of the camera have yet to escape from their white against black fundamentals.

A CAST OF CAMERAS

"A photograph is like a fingerprint / it stays & stays forever / we cd have something forever / just how we want it. give me a camera," boasts the aspiring photographer, Sean, in Ntozake Shange's *a photograph: lovers in motion*, "& i cd get you anything you wanted / breeze / a wad of money / madness / women on back porches kneading bread / stars falling / ice cream & drunks & forever / i cd give you forever in a night sky / michael / i cd give you love / pure & full / in a photograph" (Shange 1981: 77). Sean's unspoken assertion here is that the objects of desire and excess, from money to ice cream, from madness to intoxication, from breeze to eternity, are unrealizable on a stage lying outside of the realm of the camera, outside of the world of the picture. His hopeful and yet clearly desperate position suggests that desire can be permanently fulfilled only as a picture, as a copy, as a supplement. Of course, Sean's repeated insistence on his trust in the essence of pictorial representation ("my photographs are the contours of life unnoticed" (Shange 1981: 93, 108)) is not a new or merely technological belief, but rather one common to the conceptual history of drama. It would not be that difficult to extend Sean's hope in photographic mimesis to the historical depiction of theatre as imitative *pharmakon*, as a curative experience of the world.[3] Yet Shange's essay, "unrecovered losses / black theatre traditions," which serves as the Preface of her collection, *Three Pieces*, directs the audience to suspect the authenticity of any pictorial catharsis in the world of her play "which has no cures for our 'condition' save those we afford ourselves" (Shange 1981: xiv). Even Sean's best photos seem dull and lifeless when compared to the fluid movements of the dancer, Michael, who maintains her own private visions of a fantasy love, of whom "i never even saw a picture / but not far from me never far from me / i've kept a lover who waznt all-american / who didnt believe / wdnt straighten up" (Shange 1981: 63). In the shadow of the now implausible cure of traditional, mimetic notions of theatre and visual arts, Shange displays most effectively the sickly "condition" of hope in an all-American world picture nurtured mainly by the veil of visual presence.

As Heidegger explained as early as 1938 in "The Age of the World

Picture," this is a blighted condition, untreatable by (partially, we now know, because it stems from) Aristotle's notion of mimetic, curative drama:

> With the word "picture" we think first of all of a copy of something. Accordingly, the world picture would be a painting, so to speak, of what is as a whole. But "world picture" means more than this. We mean by it the world itself, the world as such, what is, in its entirety, just as it is normative and binding for us ... Hence world picture, when understood essentially, does not mean a picture of the world but the world conceived and grasped as picture. What is, in its entirety, is now taken in such a way that it first is in being and only is in being to the extent that it is set up by man, who represents and sets forth.
>
> (Heidegger 1977: 129–30)

The stage in this context is not a picture of the world but the world as picture, the world, say, of Sean's *photographic construction* in Shange's play: "i've got it all there in that frame. i gotta whole dynamic of centuries / in a two-dimensional plane" (Shange 1981: 76). What makes modern drama's alliance with the world as picture decisively different from the staged world of Aristotelian poetics is that the technological apparatus of the camera now urges man to fortify through mechanical reproduction his position as "the representative of that which is, in the sense of that which has the character of object ... What is decisive," Heidegger adds, "is that man himself expressly takes up this position as one constituted by himself, that he intentionally maintains it as that taken up by himself, and that he makes it secure as the solid footing for a possible development of humanity" (Heidegger 1977: 132). We need but listen again to the photographer Sean to appreciate how the modern love affair with the camera can turn unformulated desires into formulaic phantasms of creative potency: "i gotta world i'm making in my image / i got something for a change / lil sean david who never got over on nothing but bitches / is building a world in his image" (Shange 1981: 79). The photographic process allows Sean to objectify the world around him, to stabilize the fluid and changeable referents around him, and to arrange the world according "to a point of view which endows it with a recognizable meaning" (Lyotard 1984a: 74). Most significant to Sean is how this imagistic constancy provides the frame for the objectification of his own (masculine) self, the reproduction of "my image" into "his image." Such an object building through the genius of mechanical reproduction allows Sean, as Lyotard puts it, "to arrive easily at the consciousness of his own identity as well as the approval which he thereby receives from others – since such structures of images and sequences constitute a communication code among all of them" (Lyotard 1984a: 74). As Sean

puts it, "i'm a genius for unravelling the mysteries of the darker races" (Shange 1981: 76–77).

Yet Shange's play does not permit Sean to receive easy approval from his interlocutors. Although his female counterpart, Michael, has little difficulty acknowledging Sean's desire to conceive the world as picture, she does not let him forget that his self-esteem as a maker of both pictures and women is always already mediated on the stage of the world by the presence of a technological character, the camera. "You tell em straight out," she taunts Sean, "that you are/ osiris returned & yr camera has been the missing organ in our forsaken land" (Shange 1981: 93). As Michael understands Sean's phallic antidote for the diseased condition of black American culture, hope lies less in the subjective (im)potency of its voyeuristic user than in the idealized character of his camera, his bachelor machine.[4]

Viewers of contemporary black American women's drama are greeted by a domineering cast of cameras posing as the technological hope and strength of their users, who tend unsurprisingly to be male. Sean's camera in *a photograph* performs a role similar to that of Martin's camera in *Toe Jam*, a script written by the sensitive playwright, Elaine Jackson. In this text, the photographic machine provides the material condition for Xenith's misdirected hope that her newly objectified image will launch her black face into fame as "the new look." "I'm gonna get me a real tough photographer," she boasts, "like tough Martin, to get me in all the magazines – make me the 'in' look and . . . these sweet, big, juicy lips will be the new lip-line for 19" (Jackson 1971: 649). To her surprise, however, she finds that her look is not new but has been "made" and objectified many times before by Martin's secretive voyeurism aided and abetted by the masterful eye of his camera. This ideological formation of the camera as phallic voyeur and shaper of the female "look" serving male desire also surfaces in *a photograph* when Sean recounts how he has made pictures ever "since we cd hide neath mary susan's window in the projects & watch her undress" (Shange 1981: 95).[5] In these instances, the fixating camera and the desirous male gaze come together in a performance of masculine entrapment as deeply oppressive as is the racism from which the characters all hope to escape.

This complicity of the controlling male gaze with deeper structures of black oppression also surfaces as the broad subject of Adrienne Kennedy's media play, *An Evening with Dead Essex*. Here, the cast of actors is supplemented by the erect figure of a slide projector, "slightly larger than reality and very black" (Kennedy 1978: 71). But any hope in this larger-than-real black character is diminished by Kennedy's introduction of its projectionist, the only white character in the play who arranges "his slides in the order **He** will use them" (Kennedy 1978: 71). The play itself presents actors in rehearsal who, with the aid of the

manipulative projectionist, reconstruct the photos, stories, and abstract images surrounding and haunting the mind of black Mark Essex. A tragic victim of the sweeping conscription of American blacks in the campaign of genocide against the Vietnamese, Essex safely returns from the war only to be violently massacred by the New Orleans police in retaliation for his crazed, but racially motivated, sniping from a Howard Johnson's rooftop. The play is a subsequent attempt to recount the media's collaboration in creating Mark Essex's picture of the world, "that open American look – I guess innocence is the word." This is a mythical picture positioning black Mark Essex as its always alien spectator. Joining his numerous innocent victims, Essex silently cries out as the bullet-ridden icon of that open American look, the one carefully nurtured for profit by the media's intruding cameras.

The deep threat to black spectators of an overinvested trust in a super-real camera is played out further in Amiri Baraka's play, *The Motion of History*. In this documentation of the history of black oppression, the television camera functions as the compromising device permitting Kenneth Clark, the keeper of white, cultural innocence, to discourse with the black militant, Malcolm X. Later in Baraka's play, Reggie speaks harshly of television's ultimate effect on black revolution: "you fall out in front of that television set like you crazy. TV set say, 'Look into my eyes. Now get up, go climb up on that ledge, now take a giant step . . . Sucker!'" (Baraka 1978a: 108).[6]

What is striking about the overall role of the cast of cameras in these plays is its mesmerizing ability to nurture a hope in the dissemination of a liberating black image while yet, to recall Heidegger's distinction between image and representational function, always operating as a memory device of the ideological heritage of the camera. Consider, for instance, Sean's boast in *a photograph* that "these photographs are for them / they are gonna see our faces / the visage of the sons / the sons who wdnt disappear niggahs who are still alive i'm gonna go ona rampage / a raid on the sleeping settlers / this camera's gonna get em" (Shange 1981: 62). This suggests a revolutionary trust in the camera while at the same time attributing that trust to the tainted memory of the device's past and present as a filial agent of cultural hegemony, recollective also of Baraka's rampaging Red Squad in *S-1*, the one that specializes in raiding sleeping leftists.[7]

THE VEIL OF VISIBLE CONSENSUS: A THEORETICAL INTERLUDE

This blatant identification of camera and Red Squad, particularly worrisome twenty years ago in North America and frightfully repressed today, is laden with a long history of increasingly complex ideological

formations of technological and philosophical structures. The French film theoreticians Marcelin Pleynet, Jean-Louis Baudry, and Jean-Louis Comolli have documented the abstract relationship of the development of the camera with the colonial history of Occidental humanism. Pleynet was first among them to insist that "the film camera is an ideological instrument in its own right, it expresses bourgeois ideology before expressing anything else . . . It produces a directly inherited code of perspective, built on the model of the scientific perspective of the Quatrocento. What needs to be shown is the meticulous way in which the construction of the camera is geared to 'rectify' any anomalies in perspective in order to reproduce in all its authority the visual code laid down by renaissant humanism" (cited by Comolli 1977: 129).[8] Within this context of the humanist tradition, the camera functions as an agent of "the ideology of the visible." This is the social construction and dissemination of the belief that "the human eye is at the center of the system of representation, with that centrality at once excluding any other representative system, assuring the eye's domination over any other organ of the senses and putting the eye in a strictly divine place" (Comolli 1980: 126). The philosophical corollary, of course, is transcendental subjectivity which positions the gazing Subject as the unifying agent. In terms of the relation of theatre and camera, this tradition encourages the spectator, according to Baudry, "to identify himself then less with the represented, the spectacle itself, than with that which puts into play or dramatizes the spectacle; with that which is not visible but which shows, shows in the same movement as he, the spectator, sees – obligating the spectator to see what he sees, that is to say the function assured by the relaying space of the camera" (Baudry 1978: 25).[9] The ideological mechanism at work here is the concretization of the rapport between camera and Subject, the maintenance of a dominant ideology of visibility sustaining the idealization of the representing Subject – the power-laden Subject conceiving and grasping the world as picture.

Although feminist film theory as well as the social history of photography and art stress the many exceptions to any tautological view of the camera, it is clear that strategic attempts to administer such a monocular ideology have indeed reared their ugly heads ever since centralized programs of aesthetics were advanced by the early modern absolutists. In this highly politicized context, the complex relation of camera and transcendental philosophy stands on the horizon of contemporary theatre's casting of the camera as a character of visual knowledge and social advancement.[10] Further reflection on this horizon in terms of its epistemological implications would encourage us to ponder the relation of the ideology of the visible to the ideology of cognitive agreement. This problematic has been the focus of much of Jean-François Lyotard's work in which he analyzes how the mechanical "objects and the thoughts which

originate in scientific knowledge and the capitalist economy convey with them one of the rules which supports their possibility; the rule that there is no reality unless testified by a consensus between partners over a certain knowledge and certain commitments" (Lyotard 1984a: 77).[11] The ideology of consensus operates according to the principle that we can agree on cognitive boundaries allowing us to recognize what lies inside or outside reality. Taking a similar but much more developed position regarding the role of the contemporary media, Oskar Negt and Alexander Kluge argue that "agreement, order, and legitimation" are contingent on "the primacy of the power relations that determine the domain of production" (Negt and Kluge 1988: 73). As protectors and providers of the conditions of humanistic cultural production, the media can be understood to adopt the guise of the "postbourgeois public sphere" which fluctuates "between a façade of legitimation capable of being deployed in diverse ways and being a mechanism for controlling the perception of what is relevant for society" (Negt and Kluge 1988: 66). Or, similarly in view of my attentiveness here to black American drama, this media is also a mechanism for controlling the perception of what is white and what is black.

Thus we enter into the exceptionally complicated situation of contemporary drama operating in the material and cognitive world of the camera and its appropriations by the media. From the horizon of philosophical knowledge stem the mechanisms of control which can no longer be identified as belonging to any one particular site of cultural or social production. On the stage, the ideologies of visibility and consensus can be said to enshroud dramatic characters and the conditions of their representation, from Shange's Michael to Sean's camera, in the web of the hegemonic eye (I). "The problem of theatre," Lyotard suggests, "is no longer posed as a problem of understanding or knowledge, or even of truth, but as a problem of force and power: force of creatures provisionally enslaved on the stage, power of the spectator-director who is master [*metteur en scène . . . metteur en cage*]" (Lyotard 1973: 156). Or, to situate Lyotard's point in a realm even more familiar to North American critical theorists, we need only recall Derrida's frequently cited statement regarding metaphysics and Artaud: "directors or actors, enslaved interpreters . . . more or less directly represent the thought of the 'creator.' Interpretive slaves who faithfully execute the providential designs of the 'master'" (Derrida 1997: 43). Implied by these relations of spectators, authors, and directors is the final link in the hegemonic chain – the operation of dramatic spectatorship which, as I suggest in *Theatrical Legitimation* (1987), is inscribed historically in the tradition of the ideologies of the visible and consensual.[12]

Contemporary theory's understanding of this collusion of vision and consensus by the audience as producer – itself a specialized product of

technological reproduction – is indebted, of course, to the writings of Walter Benjamin. In the early years of the burgeoning film industry, Benjamin insightfully suggested that the film apparatus diminishes "the distinction between criticism and enjoyment by the public." This nurtures the positive force of public consensus at the expense of hierarchically elitist expressions of reception. "Mechanical reproduction of art," he writes, "changes the reaction of the masses toward art . . . With regard to the screen, the critical and the receptive attitudes of the public coincide. The decisive reason for this is that individual reactions are predetermined by the mass audience response they are about to produce, and this is nowhere more pronounced than in the film. The moment these responses become manifest they control each other" (Benjamin 1969: 234). But while Benjamin applauds the value of film's "distracted" spectatorship in contributing to "simultaneous collective experience," Max Horkheimer and Theodor Adorno focus on the false promises of the audience's co-production of predictable forms of numbing entertainment. Through transformation of predetermined mass response into normative products, the culture industry benefits in profit and power from the public's newly acquired authority over technological culture. "This promise held out by the work of art that it will create truth by lending new shape to the conventional social forms is as necessary as it is hypocritical . . . In the culture industry this imitation finally becomes absolute. Having ceased to be anything but style, it reveals the latter's secret: obedience to the social hierarchy . . . Culture as a common denominator already contains in embryo that schematization and process of cataloguing and classification which bring culture within the sphere of administration" (Horkheimer and Adorno 1972: 130–31). Although this hegemony of cultural representation has been shown by media theorists, like Enzensberger (1986) or Negt and Kluge (1988), to be more leaky than air tight, the sustenance and control of the ideologies of consensus and visibility continue to concern those black dramatists who cast the camera in the role of the dominant culture industry.[13]

In all fairness, however, I should point out that theatre practitioners and theoreticians have not absent-mindedly accepted the argument that the veil of the camera's eye enshrouds the enterprise of theatre. Indeed, the predominant critical position has been to emphasize the fundamental difference between the institution of theatre and the entertainment industry most dependent on the apparatus of the camera, film. Even Benjamin was quick to stress "that there is no greater contrast than that of the stage play to the work of art that is completely subject to or, like the film, founded in, mechanical reproduction" (Benjamin 1969: 23). More recently this distinction has been made in regard to two significant, theoretical factors. First, Christian Metz emphasizes that theatre as an empirical activity does not share film's dependence on the camera as a

transcendental Subject. For what defines the scopic specificity of the camera work is the empirical fact of the *absence* of its objects of representation. As seen only on the screen, actors are not physically present in the movie house. Metz understands this absence, moreover, to compound the psychological potency of visual authority and scopic force. He contends that while the spectator's filmic vision in the darkened cinema may be psychologically "collective" it is not always "authorized" and "verifiable" as a shared public activity, thus positioning the filmic institution in the realm of forbidden sight – the primordial ground of the solitude of spectatorial experience (Metz 1977: 61–94).

Toe Jam provides a corollary of how the filmic spectator might remain unknown to the work of art, unknown as the viewer of the sort of libidinal drama revealed by Martin to Xenith, the object of his gaze in *Toe Jam*:

> You didn't know me years ago when I used to watch you and Alice behind your fence when we lived over on Canon Street . . . You didn't know how I used to climb up on the roof of my house just to watch you play in your backyard. You didn't know how I used to stand outside your house just to watch your mother take you to school . . . I got tons of pictures of you that you don't even know I took. It's like I was an undeveloped negative, sweetheart.
>
> (Jackson 1971: 669–70)

In so positioning the spectator as an undeveloped *negative* (as something other than a merely empirically conditioned subject), film has been said to differ from theatre by inscribing itself psychologically as well as sociologically in the undifferentiated (invisible/visible) space of globalizing representation.[14]

In Herbert Blau's opinion, this inscription leads to a second and even more empirically specific difference between film and theatre. "The cinematic institution . . . shifts the locus of vulnerability from the film, the art-object, or the actors in the film (if there are actors) – the image of human agency in the narrative – to its *representatives*" (Blau 1982b: 134). According to this view, film differs from theatre in that it provides a less immediate, perhaps even inauthentic, presentation of human agency. Bodily presence, the fundamental phenomenological attribute of Being-in-the-World, is reduced by film to technological representatives, to undeveloped negatives. "So as regards the power of a disappearing presence," Blau writes concerning the development of our acknowledgment of ideological representations, "the theatre would appear to have the advantage, its very corporeality being the basis of its most powerful illusion, that something is substantially there, the thing itself, even as it vanishes" (Blau 1982b: 132). Whether or not it is always conceived as a picture, the body of the theatre actor is always *there* (*Da-sein*), thus

differentiating itself in presence *and* in absence from its spectatorial Other. It is this presentational fact of the body, the fact of a body that can and does vanish in the sight of the scopic eye, which Blau claims as theatre's contribution to the demystification of hegemonic control. "What the theatre does, then, is to bring into presence what, without theatre, cannot be present" (Blau 1982b: 130).[15] Such a stress on bodily presence, in and of itself, would be argued by some to provide the grounds for renewed hope in a specifically black American theatre, a drama of the presentation of *black* corporeal presence.

From an empirical perspective the arguments of both Metz and Blau concerning theatre's specificity might appear to be convincing and hopeful. They provoke recollection, for example, of the 1970 political tract by Woodie King and Ron Milner, "Evolution of a People's Theatre," which insists that black theatre "go home! If a new black theatre is to be born, sustain itself, and justify its own being, it must go home. Go home psychically, mentally, aesthetically, and, we think, physically" (King and Milner 1971: viii). Yet, the preceding discussion of contemporary black American drama in the eye of the camera advises against positioning theatre in only an empirically privileged position lying outside of the penetrating gaze performed daily by the mechanical productions of film and television. For such legitimation of theatre on empirical grounds can work easily to reinscribe contemporary black drama in the idealism of essence and the ideology of consensus which has enslaved it historically in the image of white culture and pedagogy.[16] Black practitioners of drama caution that the empirical reduction of theatre's polymorphous structures to the primacy of corporeal presence might result in too strong a trust in phenomenological relations. As Baraka's Actor in *The Motion of History* warns us, black skin does not necessarily guarantee a black art free of the hegemonic structures encouraged by the media: "Black Art. (*Glossy eyed, then*) Blacula! Super Fly! The Werewolf from Watts! Starsky and Hutch!" (Baraka 1978a: 98). This is a concern shared by Shange's actor, Alec, in *Spell no. 7*: "i'm not playing the fool or the black buck pimp circus / i'm an actor not a stereotype . . . we arent gonna get anyplace / by doin every bit part for a niggah that someone waves in fronta my face" (Shange 1981: 60). The plays of both Baraka and Shange caution their peers against the pitfalls of corporeal essentialism whose shaky empirical foundations are so easily appropriated and subjugated by hegemonic cultural interests. As Althusser cautions in *For Marx*, "an empiricism of the subject always corresponds to an idealism of the essence (or an empiricism of the essence of the idealism of the subject)" (Althusser 1977: 228).[17]

Oscar Negt and Alexander Kluge relate the culture industry's attraction to the quick fixes of empirical essentialism to its need to keep in check the foundation of fantasy underlying "distracted spectatorship"

and its libidinal manifestations. They argue that "the capacity of fantasy to organize one's own experiences is concealed by the structures of consciousness, attention spans, and stereotypes molded by the culture industry, as well as by the apparent substantiality of everyday experience in its bourgeois definition" (Negt and Kluge 1988: 77). Although they see in fantasy "an unconscious practical criticism of alienation," they stress how the "postbourgeois" culture industry relies on essentializing strategies to numb the cultural Other from the potential of its own phantasmic productions. "In this way," they write, "one of the raw materials of class consciousness, the imaginative faculty grasped as a medium of sensuality and fantasy, remains cut off from the overall social situation and frozen at a lower level of production – that of individuals or of only random cooperation. The higher levels of production in society exclude this raw material. At the same time, industry – in particular the consciousness industry – tries to develop techniques to reincorporate fantasy in domesticated form" (Negt and Kluge 1988: 79). It is this struggle over the materialization and domestication of fantasy in which a number of contemporary black theatre pieces are significantly engaged.

Shange reminds the audience of *Spell no. 7*, for example, that reserves of indigenous fantasy remain available to an oppressed black spectatorship. Subtitled *geechee jibara quik magic trance manual for technologically stressed third world people*, this play echoes the theme of Shange's more explicitly feminist novel, *Sassafrass, Cypress & Indigo*, that fantasy cannot be stolen from those in secure possession of it: "When there is a woman there is magic. If there is a moon falling from her mouth, she is a woman who knows her magic, who can share or not share her powers" (Shange 1982: 3). In both *Spell no. 7* and *a photograph*, Shange focuses on evocations of cultural fantasy in order to reveal both the collusion of theatre and media in exploiting racial "inequality" and in providing means of production which are in-different to the dominant strategies of exploitation. In so doing, Shange joins her many peers in theatre who strive to question the efficacy, not to mention the possibility, of theatre's evasion of the mixture of visual and narrative structures of film and video: the narrative structures with which the contemporary audience is familiar, and the visual codes which offer technical options for staging interpretive re-presentation. In doing so, these plays also question the fundamental epistemological and psychoanalytical criteria said to distinguish theatre so clearly from film.[18] These plays "for technologically stressed third world people" thus aim to refigure the domestication of fantasy in the interests of those artists who want to bring Afro-American cultural production back home for those who can then choose whether or not to share their powers.

FRAMING WORLD VIEWS

Baraka's *The Motion of History* provides us with a striking mixture of dramatic and cinematic vision that unveils different layers of the fantasy material available to indigenous populations. The play opens with the projection of a documentary film on a screen, the only visible object on a blacked-out stage.

> Film of rebellion is playing on screen. Police beating black people savagely. Put all the rebellion films together. One big rebellion film, in all countries the people struggling. Third World struggling against imperialism, colonialism, neocolonialism, hegemonism. In the west, the workers battling police, the oppressed nationalities, black people prominently, getting smashed and bashed but fighting back.
>
> (Baraka 1978a: 21)

This screening of rebellion against the hegemonic backdrop of the age of the world picture establishes the conceptual framework of Baraka's play. Even when the lights go up demystifying the screen as an empty field of technological projection, the dreamlike images of violence and oppression continue to hover over the stage. The screen, always present in this "postbourgeois" *Motion of History*, takes on the character of a cinematic memory, a ghosted memory of corporeal fragility in an age when technology increases both the stakes and potential of hegemony.[19] This memory or vision is reinforced intermittently throughout *The Motion of History* when the screen is filled with films of black people getting smashed and bashed. Through the mixture of film clips and actual dramatic performance of racial and economic rebellions, the play blends corporeal presence and technological image into one representational *cinematic body*, a membrane depicting, to recall Heidegger's words, "a confrontation of world views."

Baraka opens his play with an additional dimension of the screen that intensifies its impact as a cinematic body. During the screening of the film which opens the production, "two men [one white, the other black] come and stick their heads out of two holes in the screen. They barely turn their heads trying to see the films" (Baraka 1978a: 21). Denying the essence of either film or theatre, the play opens by embodying the screen literally with a Janus-like face of black and white. And much like the cinematic visions of repression floating in and out of sight throughout the play, these two actors proceed to move in and off the screen, sometimes playing roles of characters on the stage, sometimes appearing from within the screen or sometimes from its side to comment on the visual rays being projected on both the screen and each other's bodies.

157

It is their differing and sometimes complementary commentary from within their screen, from within the eyes of their cinematic body, that positions Baraka's dramatic image as more than a merely pheno-menological hope or vision, as something more than the aesthetic object of theatrical performance. The coalition of film and theatre – the fusion of technology's representations and drama's human agency – produce a screen of struggle in which the crucial activity is less a controlled vision of human agency than a release of fantasy's many representatives, that is to say, its framings, its readings, its interpretations. Coming from around the side of the screen in Act IV, Baraka's black Janus confirms that his acting constitutes a reading, a reading of the underexposed libidinal structures which struggle against his commodification as a visual product: "the bitterest agony of it like a half moon, half lit, half smart, half slick, half integrated. Where I'm at. Because for everything I carry there is another half to me. My fullest memory from a fullest self. Why? I'm here with you . . . but no, there's something more, I know – " (Baraka 1978a: 80–81). On the stage, positioned behind this half-lit Black Dude, remains the screen's empty hole unable to be lit, to be filled, to be read as anything other than the mechanical frame – the essence – of the Dude's visual slavery.

Baraka's plays framing the representational conditions of slavery – *Slave Ship*, *S-1*, *The Motion of History* – provide his audience with extremely significant images of the domestication of the Afro-American spirit. "An American drama has to deal with America," he writes, "and you cannot deal with America without the question of the Afro-American, you cannot deal with America without the question of slavery, because the country's built on it" (Baraka 1978b: 60). Baraka's cinematic bodies thus provoke their viewers to acknowledge, to read, the structural screens and abstract relations enslaving them in the colonial age of the white against black world picture. And by so screening the camera's controlling eye, Baraka confronts his spectators with the acknowledgment of visibility as ideology. This visibility is not a primary activity but a repre-sentative one within the frame of ideology: "a 'representation' of the imaginary relationship of individuals to their real conditions of existence" (Althusser 1971: 162). Any screening of the ideology of visibility, more-over, goes hand in hand (or eye in eye) with the analysis of its structure and our particular *fictive* relation to it. Baraka's Black Dude insists that "we got to have science, we gotta use science, the entire world is harmo-nized according to laws, laws, internal natural laws. And to change the world we have to understand those laws. You dig?" (Baraka 1978a: 109). This speech echoes, moreover, the warning Althusser makes in "Cremonini, Painter of the Abstract," that we must turn aside from a merely cognitive approach to such laws, "that the freedom of men is not achieved by the complacency of its ideological *recognition*, but by the

knowledge of the laws of their slavery, and that the 'realization' of their concrete individuality is achieved by the analysis and mastery of the abstract relations which govern them" (Althusser 1971: 241).

Baraka's analysis of the abstract relations of slavery – the imaginative field of re-presentation – goes beyond the visual relations and surfaces of the screen. In addition to structuring his play around a mixture of visual strategies, Baraka turns to narrative techniques refined particularly well by the visual media and their Brechtian counterpart on the stage.[20] *The Motion of History* is divided into fifty-one separate and often disconnected scenarios or frames. Each frame depicts an historical event of deep consequence to the motion of black labor history in white America. Although the frames vary in size and thematic depth, none is longer than might be appropriate for a slot, say, on the television news. Reminiscent of the irreverence for temporal order developed by the television news and the alternative tradition of documentary film clips, Baraka's play does not necessarily present its historical frames in chronological sequence. Following the lead of its own Janus-like film body, the same actors and voice-overs jump in and out of differing historical moments, frames, and character roles throughout *The Motion of History*. But unlike the "flow" of television news which softens the hardened edges of docudrama with the enslaving pleasures of commodity fetishism, the stylized form of Baraka's visual and verbal montage asks its spectator to witness how its parts enslaved by difference produce a picture other than the unified black and white photograph of progressive American (commercial) history.[21] It is in this context of the play's relation to the media that we might appreciate its production of a challenging montage of black American history.[22]

For an even more blatant analysis of how montage underlies the strategy of historical narration, we might turn to Adrienne Kennedy's *An Evening with Dead Essex* which revolves around the reconstruction of imagistic fragments of the persona of Mark Essex. The cast's difficult project of sifting randomly through the artifacts of this real character's tragedy expose on stage the false unities and connections underlying the media re-presentation of the history of Mark Essex. The audience joins the actors and taped voice-overs in re-playing again and again the same newspaper accounts and media images of Vietnam, the evening of the death of Essex, and the tragedy of America's myth of unification replete with the assassinations of Malcolm, Martin Luther King, and the Kent State killings. Kennedy's drama performs a coming and going from one contemporary historical moment to another similar to that of the Janus-faced body traversing the frames of *The Motion of History*. But here this switching suggests not merely an irreverence for temporal order but, much more significantly, the portrayal of blacks by the media, particularly by the television news, as social "problems," as "always the exceptions, the cause for concern" (Ellis 1982: 140).

Saying, "let's not get away from the idea of recounting what people said about Essex" (Kennedy 1978: 72), the Director in *An Evening with Dead Essex* inscribes cultural mediation and racial alienation into the fabric of narrative as collage. Underlying this troupe's attempt to arrive through rehearsal (*répétition*) at a reasonably harmonious image of Essex is the play's attentiveness to the deception inherent in the project of such narration. Referring to Richard Nixon's "Peace Is At Hand Speech," the Director ironizes the fallacy of consensus underlying the rehearsal process:

> I want the repetition of the coming of peace, the coming of peace, peace coming of peace. In all that repetition is deception – and Essex was a man sensitive to deception . . . Yes we want that picture ["of Kissinger entering the peace talks again and again"] over and over entering and leaving, entering and leaving the peace talkings with peace at hand – smiling – all this happening around Essex – all appearing deception to him.
>
> (Kennedy 1978: 71–72)

Appearance as deception. This is the fabric of Kennedy's play with its dizzying collage-like effects always standing beside its larger than life black film projector. Framed by an even more dominating screen, "slightly bigger in scale than everything else," this projector emits "razor sharp" images continuously demystified by the fact that they "vary in focus."

Kennedy's play joins Baraka's in reshaping the structures and laws of dramatic focus. We should note that it is conventional for documentary in theatre and film to provide the viewer with a sharp overview of a world picture, an overview closely dependent on the ideology of the visible, that is to say, an overview contingent on the projection of a unified and objective (objectified) historical narrative. When spectators look for razor sharpness in *An Evening with Dead Essex* or *The Motion of History*, however, they will notice that the play lacks a narrator's eye or voice to put its picture into focus. Presenting the spectator with something resisting the transcendental point of view of documentary, *The Motion of History* turns aside from the frames and formulas of black-and-white clarity to enact the energetic friction of differing positions of plot and scenario. Baraka's Black Dude says to his white counterpart: "There's a gap in our dialogue . . . A historical . . . ellipse. Can you fill me in on your whole history? There's something you're missing could put this thing more in focus, more reality to it" (Baraka 1978a: 103). The White Dude then responds with a view of reality as phantasmic as it is realistic: "Neuroses. Immigrant memories. My integration into Amoralca. Ancient hippies. Cultural assassinations. Psychical annihilations. Even the cold trip on the boat through nightmares and fog, carrying a pocketful of cobblestones to

give this here place its alleged character" (Baraka 1978a: 103–04). The structural laws underlying the play's ideological reality are dizzying, just like the temporal flux of the play. The characters' realities are as libidinal as they are historical, calling to mind the laws of condensation, displacement, figuration, and elaboration constituting the economies of representation – whether psychological or material. These are the unpredictable and unframable structures that confront the fiction of a black-and-white world view.[23]

Readers of *The Motion of History* might want me to conclude by commenting on Baraka's eventual collusion in the ideology of consensus sustaining a good number of modern drama's marriages to the media. His play closes, we should not forget, with the hopeful and idealistic evocation of Marxist–Leninist unity: "Forward to the Party . . . Long Live Socialist Revolution!" This ending makes strong gestures toward a trust in the visible and consensual. "I think there's been some work," says Lenny, "trying to unify the Marxist–Leninists, a hell of a lot of struggle's gone on around the correct political line." Yet Richie responds to this statement by reminding Lenny that political coalition is a fragile and dangerous ideological collage: "Yeh, yeh," answers Richie, "but there's some types here we can't agree with thoroughly," to which Lenny replies, "Who agree thoroughly?" (Baraka 1978a: 120). The play's final scene acknowledges the continual production of differing imaginative relations to real conditions which stimulate, unlike slavery's need to obscure, a confrontation of world views.[24] Such a subliminal play of difference here juxtaposes a uniform "world picture" with a conflicting montage of "world-memory." This is the paradoxical condition of contemporary culture championed by Gilles Deleuze in *Cinema 2*:

> a memory for several: the different levels of past no longer related to a single character, a single family, or a single group, but to quite different characters as to unconnected places which make up a world-memory.
>
> (Deleuze 1989: 116–17)

COMBAT BREATH

For Ntozake Shange, this confrontation is just as crucial when staged on the subliminal arenas of art and fantasy as when fought on the more tangible street scenes of political debate. "for too long now," Shange writes of her work as a black "theatre poet," "afro-americans in theatre have been duped by the same artificial aesthetics that plague our white counterparts / "the perfect play," as we know it to be / a truly european framework for european psychology / cannot function efficiently for those of us from this hemisphere" (Shange 1981: ix). Shange's theatre

pieces openly confront the Oedipal master relations of European dramatic form and political content. These are the relations dependent on the intermixed phallologocentric economies of race and gender. In this "truly european framework," the Oedipal tradition's uncompromising investment in castration anxiety is exceeded only by the extent of its ritual sacrifice of the cultural/sexual Other. In *a photograph*, Sean apes this colonial tradition when he projects slides he secretly took of a Muslim woman performing the private rituals of her toiletry.[25] Yet this scene stands in vivid contrast to Michael's earlier dismissal of Sean's phallocentric conflation of artistic production and sexual return, "i dont like thinking that you think yr dick means more to me than yr work" (Shange 1981: 86). For her part, Michael continually berates Sean for turning his back on the cultural aims of her dance work. She dedicates her life to the serious rehearsal and performance of dance to provide a fluid expression of the psycho-economic struggles of "our lives / our grandparents & their uncles / it's how we came to be / by taking our lives seriously / we fight for every breath every goddamn day" (Shange 1981: 80).

"what is fascinating," writes Shange in "unrecovered losses/ black theatre traditions," "is the multiplicity of individual responses" to racial repression (Shange 1981: xv). Differing strategies of confrontation within the realm of technological representation constitute the imaginative pharmakon of the black American reaction both to art-as-technology and art-as-politics. This response faces eye to eye the threats and advantages of technology in the age of the world picture. Shange's essay leaves us with an image of a living, breathing, but always fractured cinematic body – one poised to confront the potential losses of uniform trust in a transcendental eye:

> "combat breathing" is the living response / the drive to reconcile the irreconcilable / the black & white of what we live n where. (unfortunately, this language doesnt allow me to broaden "black" & "white" to figurative terms / which is criminal since the words are so much larger n richer than our culture allows.) i have lived with this for 31 years / as my people have lived with cut-off lives n limbs. the three pieces in this collection are the throes of pain n sensation experienced by my characters responding to the involuntary constrictions n amputations of their humanity / in the context of combat breathing.
>
> (Shange 1981: xiii)[26]

Shange's emphasis on her personal relation to the artistic enterprise introduces a final, if not an essential, aspect of contemporary American black women's writing – that breathing precedes politics.

But isn't this to say that the breath of racial/sexual difference is in itself ideological as a condition and assertion of cultural fantasy? Readers of either Shange's or Kennedy's prose frequently come across statements that re-situate the terrain of the political in these women's writings. At the core of their work lies an animated commitment to an inter-personalized autobiographical friction which they contrast with conventional assumptions about "political action." In Kennedy's words,

Autobiographical work is the only thing that interests me, apparently because that is what I do best. I write about my family. In many ways I would like to break out of that, but I don't know how to break out of it ... I feel overwhelmed by family problems and family realities. I see my writing as being an outlet for inner, psychological confusion and questions stemming from childhood. I don't know any other way. It's really figuring out the "why" of things – that is, if that is even possible. I'm not sure you can figure out the "why" of anything anymore. You try to struggle with the material that is lodged in your unconscious, and try to bring it to the conscious level. You try to remain as honest about that as possible, without fear.

(Kennedy 1977: 42)

Here the enigmatic implosions of autobiography frame (veil) the visible explosions of social struggle. Shange makes a similar point when she speaks up for the "singularity" of black writers. In "takin a solo / a poetic possibility / a poetic imperative," she reinscribes the *political reconstruction* of racial and gender imbalance in the "now," the "moment" of her *poetic construction*:

we assume a musical solo is a personal statement / we think the poet is speakin for the world / there's something wrong there, a writer's first commitment is to the piece itself. how the words fall & leap / or if they dawdle & sit down fannin themselves. writers are dealing with language, not politics. that comes later. so much later. to think abt the politics of a poem before we think abt the poem is to put what is correct before the moment.

(Shange 1984: 31)

While the pragmatic tradition of European political aesthetics might criticize such a position for promoting apolitical formalism (if not a nostalgia for narcissism and its Oedipal frames[27]), the black female playwright would be more inclined to understand it in the agonistic context of being-together-differently. Hers is a living struggle characterized by the moment of redemption, retrieval, and reclamation of the literary page and visual space – a re-citing of her own previously colonized breath. So

stands the dilemma of Ntozake Shange who wants to separate her voice from your expectations about universal political action:

> when i take my voice into a poem or a story / i am trying desperately to give you that / i am not trying to give you a history of my family / the struggle of black people all over the world or the fight goin on upstairs tween susie & matt / i am giving you a moment / like something that isnt coming back / a something particularly itself / like an alto solo in december in nashville in 1937.
>
> (Shange 1984: 32)

Such is the structural paradox of technologically stressed artistic commitment in which writing performs "Differa(n)ce." That to breath is to live, differently; to live is to act, politically; and, yet, to act is to write, momentarily – on the previously colonized familial terrain that always already defers the desperate tone of the solo voice.

But what is this story that remains to be told? As Trinh T. Minh-ha understands it, the story is not that of the European, Oedipal "'story of what has been lost' . . . but the story of that which does not readily lend itself to (demonstrative) narrations or descriptions and continues to mutate with/beyond nomenclature" (Trinh 1989: 116).[28] This is the story of "Differa(n)ce."

NOTES

1 These exhibitions and projects are documented in the following sources: *Difference: On Representation and Sexuality* by Linker (1984b); "Sexuality: Re/Positions" by Kolbowski (1984); *Discourse* (1989); Bad Object Choices, *How Do I Look?* (1991); Ferguson, Gever, Trinh, and West, *Out There: Marginalization and Contemporary Cultures* (1990); *Rethinking Technologies* (1993) edited by Verena Andermatt Conley for the Miami Theory Collective; Wallace's project, *Black Popular Culture* edited by Dent (1992); Golden's *Black Male* (1994).

2 Much of the credit for this new critical attention should be given, I believe, to ten years of effort by the many editors of *Theatre Journal* as well as to the similar persistence of editors of other scholarly journals, such as Kathleen Woodward who foregrounded these issues in the pages of *Discourse* (exemplified by its special Spring 1992 number, edited by Herbert Blau, on *Performance Issue(s)*. Still, recent exciting and welcome collections, such as *Let's Get It On: The Politics of Black Performance*, edited for the ICA by Catherine Ugwu (1995), continue to emphasize conceptual contributions made by African-American performance art at the expense of providing an adequate account of the cross-fertilization between American performance art and African-American theatre.

3 Theatre's curative power as pharmakon underlies the well-known theories of the dramatic scapegoat developed separately by Kenneth Burke (1969, 1973) and Rene Girard (1977 and 1997). However, Jacques Derrida, in "Plato's Pharmacy" (1981: 61–171), analyzes the illusory nature of such a cure, entrapped as it is within the larger world picture of an illusory metaphysics,

which I will discuss below as the ideology of the visible. For a specific discussion of Burke's specific metaphysical entrapment, see Murray (1977), "Kenneth Burke's Logology: A Mock Logomachy."

4 Constance Penley, in "Feminism, Film Theory, and the Bachelor Machines" equates Duchamp's mechanism of "the Bachelor Machine" with the apparatus of film as theorized by Baudry (1978, 1986a, 1986b); Comolli (1977, 1980); and others:

> The bachelor machine is typically a closed, self-sufficient system. Its common themes include frictionless, sometimes perpetual motion, an ideal time and the magical possibility of reversal (the time machine is an exemplary bachelor machine), electrification, voyeurism and masturbatory eroticism, the dream of the mechanical reproduction of art, and artificial birth or reanimation. But no matter how sophisticated the machine becomes, the control over the sum of its parts rests with a knowing producer who therefore submits to a fantasy of closure, perfectibility, and mastery ... For feminists writing about film the question of the fitness of the apparatus metaphor has become a secondary one, that is, whether or not it provides an adequate descriptive model of the way classical film functions on the basis of and for masculine fantasy (most agree that this is largely the case). They have found it more productive to ask whether this description, with its own extreme bacheloresque emphasis on homogeneity and closure, does not itself subscribe to a theoretical systematicity, one that would close off those same questions of sexual difference that it claims are denied or disavowed in the narrative system of classical film.
>
> (Penley 1989: 57–58)

Also see Rose, "The Cinematic Apparatus – Problems in Current Theory" (1986: 199–213) and Copjec, "The Anxiety of the Influencing Machine" (1982).

5 For representative discussions of the cinematic look and sexual politics, see Mulvey, "Visual Pleasure and Narrative Cinema" and "Dialogue with Spectatorship: Barbara Kruger and Victor Burgin" (1989: 14–26; 127–36) and Linker, "Representation and Sexuality" (1984a).

6 For insightful discussions of the false hope in television as a racial consciousness raiser, see Winston (1982); Omi (1989); and Gates (1992b).

7 Baraka's ambivalence about visual empowerment reflects Frantz Fanon's earlier insistence in Black Skin, White Masks (1967) and in "Algeria Unveiled" (1997) that the only visual position available to the colonized subject is a masochistically visual one since the subject position of the colonized is determined from without by the image and fantasy of the white man's eyes. For helpful analyses of the visual implications of these texts, see Bhabha (1989; 1994: 75–84) and Fuss (1994).

8 For elaborations on film's relation to perspectival theory, see Wees (1980) and Daney (1970) where he defines the ideology of the visible.

9 See also Christian Metz's comments on monocular perspective in Le Signifiant imaginaire (1977: 70–71).

10 Penley (1989), Silverman (1988), and de Lauretis (1984, 1987) provide representative feminist critiques of the tautology of the film apparatus. For similar analyses of the omnipotence of the photographic eye and its potential reappropriation, see Lyotard (1973); Mulvey (1989: 127–36); Burgin (1982;

1986); Barthes (1981); Wallis (1984); Krauss (1990); Squiers (1990); and Brettle and Rice (1994).

11 I elaborate on Lyotard's theorization of the visual in *Like a Film* (1993: 175–206), and Turim (1980) discusses the applicability of Lyotard's theories to discussions of the cinematic apparatus.

12 The various levels and nuances of spectatorship provide the subject matter for Blau's fascinating, subtle book, *The Audience* (1990).

13 The extent to which the camera has been reappropriated with success by a *black public sphere* is evident in the many photo essays gracing the special issue of *Public Culture* 7, 1 (Fall 1994) on "The Black Public Sphere" and the Ugwu collection *Let's Get It On* (1995) to which I refer above.

14 Although Deleuze (1989: 224) emphasizes this difference between film and theatre in developing his theory of a "minority cinema," "in order to constitute an assemblage which brings real parties together, in order to make them produce collective utterances as the prefiguration of the people who are missing," he attributes the same possibility of minority representation to the theatre works of Carmelo Bene (Deleuze 1997: 248): "Must it be said, however, that this double principle, of aphasia and obstruction, reveals its relations of power in which each body becomes an obstacle to the body of the other, as each will thwart the will of others? There is something else, different from a play of oppositions, that would return us to the system of power and domination. That is, by constant obstruction, gestures and movements are placed in a state of continuous variation in relation to one another and themselves, just like voices and linguistic elements are sustained in this state of variation." In "You Are How You Read: Baroque Chao-errancy in Greenaway and Deleuze" (Murray 1997a), I develop the implications of Deleuze's theory of minority representation in relation to the dramatic film, *Prospero's Books*.

15 Blau is not alone in arguing for the representational specificity of the dramatic body. Wladimir Krysinski (1982: 35) goes so far as to conclude that "the modern theatre is marked by the predominance of value systems favoring the body and putting it in relief . . . As a theatrical sign liberated from the constraining logos, the body lays the foundation of the symbolic fable." Joseph R. Roach (1989: 101–02) takes this point one step further in arguing that "the history of performance since the eighteenth century is the history of the ever more rigorous subjection of the body to forms of internalized control." See also Erika Fische-Lichte's (1989) overview of her extensive semiotics of the actor's body.

16 One of the methods proposed by James V. Hatch (1989) for ending the academic "apartheid" of black performance studies is for the theatre historian "to first recognize the origin and development of the evolving black character in Western theatre." Hatch calls not only for closer attention to various modes of black cultural performances but, most boldly, for an honest reappraisal of the negative *and* positive ways in which Western theatrical stereotypes might have worked to preserve traces of undocumented varieties of indigenous black European and American performance. Jeyifo (1985) conducts a similarly sensitive reading of African theatre.

17 For an extensive and honest discussion of the dangers of an "essentialist" approach to aesthetic practice, see Spivak (1989a).

18 In the Introduction to *Like a Film* (1993: 1–21), I elaborate on the epistemological and psychoanalytical structures through which the cinematic experience has pervaded contemporary cultural production. See also the special issue of

Theatre Journal 39, 3 (October 1987) on "Film / Theatre" that concerns the formal and structural properties made especially evident by the juxtaposition of the two media.

19 I discuss Blau's notion of ghosting, which he developed with his theatre troupe, KRAKEN, in Chapter Four. About ghosting, Blau writes that

> like music in this sense, like dream, theater is hollow at the core, empty of value, until its signs – body act space gesture color light cadence voice word mask etc. – are retrieved by reflection within a structure of relativity . . . The ghosting is not only a theatrical process but a self-questioning of the structure within the structure of which the theater is a part. What seems true in the play of appearances – as most ontological discourse has assured us in our time – is that there is no way in which the thing we want to represent can exist within representation itself, because of the disjuncture between words and things, images and meanings, nomenclature and being – all of which cause us to think that the theater *is* the world when it's more like the thought of history.
>
> (Blau 1982a: 195–96; 199)

20 In "Lessons from Brecht," Stephen Heath (1974: 111) emphasizes how theatre and film can work together to achieve a Brechtian alienation effect, similar to Baraka's, in which "the aim is no longer to fix the spectator apart as receiver of a representation but to pull the audience into an activity of reading; far from separating the spectator, this is a step towards his inclusion in a process." See also Diamond (1988) "Brechtian Theory / Feminist Theory: Toward a Gestic Feminist Criticism;" Pollock (1988), "Screening the Seventies: Sexuality and Representation in Feminist Practice – a Brechtian Perspective;" and Reinelt (1994) *After Brecht: British Epic Theatre*.

21 Raymond Williams (1975) coined the term "flow" to argue against the understanding of advertising's "interruption" of unitary programs. "Flow" depicts, in contrast, the way that separate television production units – advertisements, serial sequences, announcements, and so on – flow together as a kind of montage of the television "experience." Ellis (1982: 111–26) provides a helpful elaboration and extension of this thesis leading up to his notion that television nurtures a spectatorship of the "glance" as opposed to the "gaze."

22 Although the debate in film theory over montage is too complex to rehearse here, I point to four astute analyses of montage by Ropars-Wuilleumier (1981: 9–124); Heath (1981: 19–112); Kluge (1981–82); and Rodowick (1994: 195–207).

23 On the relation of libidinal economies to political and aesthetic ones, see Lyotard (1973, 1977, 1993, 1997a, 1997b), and from perspectives different from that of Lyotard, see Bersani (1990); Krauss (1993); and Foster (1993).

24 In *Scars of Conquest/ Masks of Resistance*, Olaniyan (1995) maps out such a confrontation of world views in African, African-American, and Caribbean drama.

25 In "Black Looks," Roach and Felix (1989) investigate black artistic experiments aiming to turn the tables on the dominant male gaze by developing different "multifaceted" black "looks" for and by women.

26 "Combat breathing" is the term coined by Frantz Fanon to signify the ongoing struggle against colonization, a practice exemplified by the revolutionary activity of women in the Algerian resistance movement (Fanon 1997).

27 On the Freudian notion of narcissism and its phallocratic entrapment of

woman, see Irigaray (1985a); Kristeva; (1982); Silverman (1988); and Murray (1993).

28 In the words of Gates (1985: 12), "black writing, and especially the language of the slave [enslaved woman?], served not to obliterate the difference of race; rather, the inscription of the black voice in Western literatures has preserved those very cultural differences to be repeated, imitated, and revised in a separate Western literary tradition, a tradition of black difference." On the difference of black autobiography *per se*, see Rosenblatt (1980).

8

IN EXILE AT HOME
Tornado breath and unrighteous fantasy in Robbie McCauley's *Indian Blood*

Inherent in the ideology of race, gender, and class that informs the primal scene of translation is the notion that full humanity is not attainable without eloquence. To speak ordinarily is to remain part beast, to be a kind of monster. Only eloquence can produce a purely human form, a fully human speech, that is, the form and speech of a European male aristocracy that struggles to circulate eloquence only within its own race, gender, and class.

<div align="right">Eric Cheyfitz, The Poetics of Imperialism</div>

Differences do not only exist between outsider and insider – two entities – they are also at work within the outsider or the insider – a single entity.

<div align="right">Trinh T. Minh-ha, When the Moon Waxes Red</div>

Remaining then within the system(s) of representation negotiated by internal colonization . . . the postcolonial negotiates with the structures of violence and violation that have produced her.

<div align="right">Gayatri Chakravorty Spivak, "Who Claims Alterity?"</div>

A reading of "The Hunt" by Mahasweta Devi provides the subaltern, literary context for Gayatri Chakravorty Spivak's comments on feminist negotiations of internal colonization. The central character of the story, Mary Oraon, is the descendant of indigenous tribals converted to Christianity by foreign missionaries. The many transfigurations of the postcolonial status of Mary's race, class, and gender are prefigured by the circumstances of her conception. Her white planter father raped her tribal mother before leaving India for Australia. Devi's story documents the subsequent negotiations of this woman marked in so many ways by the internal colonization of her mixed blood. At issue for Spivak is how a character like Mary negotiates and puts into question "the new culturalist alibi, insisting on the continuity of a native tradition untouched by a Westernization whose failures it can help to cover" (Spivak 1989b: 281).

<div align="center">169</div>

The complexities, ambiguities, and contradictions of such a negotiation also constitute the dramatic core of Robbie McCauley's engaging performance, *Indian Blood* – the wrenching life story of her own mixed blood. The performance enacts in movement, sound, and image the fissures and grafts of the African-American heritage. One side of McCauley's family is shown to be nurtured by the deepest of tribal roots – not only African but American. Her father's mother's grandmother had Indian blood, "they said she was half-Indian, everybody down the line was half-Indian."[1] Just this mixture, this "half-ness," is the source of the performer's cultural pride and personal anguish. While recounting how "they used to tell me I had Indian Blood . . . when they wanted to tell you you was pretty," McCauley portrays her sorrow over her grandfather's betrayal of their bloodlines. As a member of the black American Tenth Cavalry, Twenty-Fourth Infantry, he fought against his ancestors in the Spanish–American War. "It was my job to kill the Indians," she recalls him saying. For his execution of this job, he is praised in his retirement papers as a loyal soldier to be imitated by "all red-blooded men that have the interest of their country, all men themselves and their families at heart." Complicating even further the mixed bloodtypes of McCauley's performance is her acknowledgment of how the other side of her family bears the physical marks of subjection and subjugation to the imperial imperative. "Everybody in my mother's family was half-white," a condition bitterly dismissed by McCauley as "nothin' but some rape." Of course, this qualifier, this particular "nothin' but," reads as agonistic and derisive. For "nothin' but" the colonial parameters of cultural rape, those "structures of violence and violation that have produced her," are what permeate McCauley's theatrical methods and accounts of the paradoxical divisions lying deep within her American ancestry. Similarly, in relation to a nativist perspective, this captivating performance is adorned with layered narratives and mixed-media imagery that demystify any essential "purity" of McCauley's African heritage. Hers is an enigmatic story of the miscegenist complexities of the African-American legacy.

TORNADO BREATH

Hers is a writing of "mixed-blood," of "*métissage*," what Françoise Lionnet terms the strategy of "half-breeds" and female writers of color. *Métissage* reflects the cultural mixtures resulting from neocolonial encounters on small Caribbean nations, as on her homeland of Mauritius. While the notion remains to be culturally specific, it also carries the critical legacy of its Greek homonym, *métis*. Lionnet elaborates on three aspects of this legacy that she aligns with the critical operations of *métissage*.

1 Being the allegorical figure of a cunning intelligence, like that of Odysseus, *métis* "opposes transparency and the metaphysics of identity" (Lionnet 1989: 14).

2 As a form of *techne*, it spans a number of practical levels but can never be limited to "a single, identifiable system of diametric dichotomies" (Lionnet 1989: 14).

3 Being the proper name of the wife of Zeus whom he swallowed prior to the birth of Athena, *Métis* is the sign of patriarchy's rapid appropriation of the powers of female transformation (some might even say, a sign of the penning of this very chapter), thereby signifying the dominance of paternal authority and the need for its continual resistance.

To survive the cultural and masculinist traditions never really her own, the female writer must quilt together the scraps of her cultural legacy to form something resembling a viable whole. "Viable," asserts Lionnet, "in that it calls for the use of a multiplicity of elements that can allow the writer to assume the past (the literary tradition) as past and therefore to reintegrate it into a radically different present" (Lionnet 1989: 213).[2]

Robbie McCauley's theatrical journey moves back and forth between the past of enslavement and the emergent present of feminist, African-American performance. As McCauley presents it, this is no simple, nostalgic excursion celebrating or lamenting the arrival or passing of cultural essence. For hers is a deeply pensive account of the ambivalences and violations of identification,[3] especially those scripted on to the cultural scene of "passing" itself, the scene of mixed blood.[4] It is one where daughters, not fathers, cultivate the foods of ritual and the moods of mourning, more for the African-American family than for the patriarchal state (in stark contrast to the Shakespearean legacy of state-sponsored mourning which I discuss in Chapter Four). In line with the feminist tradition of African-American performance, for instance, McCauley puts "food at the center of everything" in *Indian Blood*.[5] Greeting her uncertain spectators as they enter the theatre, she snacks and prepares a tray of fruits which she soon offers them during a lull in the opening moments of her charged, dramatic performance. "So much comes out of my mouth," she jokes, "I like to have something come in." The spectators later learn that McCauley's female relatives turned to cooking to ease tension and to provide them with "something to bargain with on the road." Food served these women as material for their *métissage*: "a lot of liberal time both men and women swallowed a lot . . . people knew how to live like that back then with a lid on. I decided not to talk at all unless I had the floor so to speak. I'd go to a secret garden like people have." For the young Robbie McCauley, *métis* amounted to consuming the food of language and holding it, preserving it, in the space of a secret garden. An autism

that could only have been futile, or "mental," to her aunts was a strategy of containment and preservation to the guardian of this secret garden.

Just such a fluid economy between interior and exterior, incorporation and expiration, self and other marks the ambivalence and promise of *Indian Blood*'s response to the phantoms maintained by the past and reshaped in the present. A good deal of the punch of *Indian Blood* comes from its attentiveness to the difficulty of verbal delivery and the syncopated tones of its politically resonant *techne*. Aligning her technique directly with the trends of performance so powerfully embraced by Adrienne Kennedy and Ntozake Shange,[6] McCauley shows herself to be enveloped in her cultural milieu of speaking, singing, miming, and moving to the choric beats of the blues and jazz performed by the trio of musicians surrounding her.

It was to sound this enlivening dissonance that McCauley initially turned to experimental theatre writing in the seventies.

> I started to pull out the little notes and journal pieces that I'd started writing to myself, meeting other poets in New York, listening to Allen Ginsberg, groups like The Last Poets, and cross-culture people who were doing all kinds of experimentation – poetry coming out of music, poetry coming out of blues and jazz – and I found that the writing I was doing was connected with what I was hearing. In the early eighties I actually started to work with a group of musicians. This began when I met Ed Montgomery, who I am now married to. And this is the story: He came to one of my shows and afterward came up to me saying, "I'm writing a political musical."
>
> (Cited by Rivchin 1990: 61)

While *Indian Blood* connects McCauley in body and voice with the clarinet and sax of Ed Montgomery and the guitar and percussion of Martin Aubert, its most notable collaborators are McCauley and the female piano player, April, who frequently joins in performance by sounding call and response. Early in *Indian Blood*, April helps set the tone of the piece by initiating a refrain resounding silently throughout the drama: "racism is based on class, is class bias, is caste biased, is class biased, is class, is class, is class." Indeed, the pulse of this textual bit and the beat of its drama are so forcefully rhythmic that, like the blues and jazz of the past, they challenge the cultural violence of imperial narrative which is crafted in an alien kind of eloquence, voiced in a poetic measure not their own. To sustain a dissonant gestus, the performers adopt strategies resembling the "radical marronage" characterizing the liminal practice of the Harlem Renaissance. These are the rhetorical strategies of hybridity, deformation, masking, and inversion derived from the guerrilla warfare of the maroon communities of runaway slaves and fugitives who survived perilously "on the frontiers or margins of *all* American promise, profit, and modes

172

of production" (Baker 1987: 77). Out of the dissonance of McCauley's agonistic creations thus comes a radical blend of blues, jazz, and poetic presentation, one which uplifts and sustains an emergent multicultural discourse.

Enlivening McCauley's pastiche of historical evidence and family account, of stubborn survival and mixed blood, the dramatic mixtures of sound and vibration duplicate a combined breath of past and present in *Indian Blood*. The mixed breath of subjection, endurance, and contestation resists the systems of power subjecting the African-American, female performer to the burdens of submissive eloquence. In response to the memory of her aunts' efforts "to make me say the right thing because if you say the wrong thing you could get your ass killed" ("Don't say it like that, Honey," taunts April from the piano in the background), McCauley moves from mike to mike simulating "soprano voices to drown out the late night danger." This rush of voice, gesture, and movement assaults the audience with a performative force analogous on stage to that of her father's tales at home: "heavy breathing, quick breath, just like my father, that's my father telling war stories in the background about 1971." Whether in war stories or late night dangers, the specter of struggle seems always to inhabit the diaphragmatic regions of its African-American carriers. Care is exercised by these performers, however, not to shy away from the disturbing powers of quick breath. For their danger contains the drive, energy, and empowerment of lasting duration.

Performers and actors may well recognize this diaphragmatic empowerment in terms of Hollis Huston's insightful conceptualization of "the gest of breath." In reflecting on the phenomenological gap between an actor's performance and thought, Huston distinguishes the passive and active phases of voice. On the passive side is the breath of expiration whose entropic condition is best regulated by rules of conditioning and presentation. On the active side remains *inspiration* that turns the potential energy at the top of a breath (at the moment of tension between the diaphragm and stretched tissues) into the kinetic energy of expiration. Huston would say that inspiration, the gest of breath, is one of the lasting agents that provides quick breath with an eloquence of its own. "Beneath the convoluted surface of art (peaked as it is by athletic emergencies) there are constant rhythms which can perform without needing to, and to which the forms of all performances recur. If we confuse the rhythm of the diaphragm with the expression so often imposed on that rhythm, we can never know its eloquence, an eloquence that is mute because always lent to what the breath contains. Only when that single action is captured – stopped, enclosed – in a gest (lost, no longer present) can we read the writing in the breath" (Huston 1984: 205). To read the writing of cultural resistance in the gest of breath, might not

this open the way to a productive reception of the forceful expressions of African-American performance?

In *Indian Blood*, the audience hears Daddy's quick, labored breath as the uncanny echo of an earlier account of his combat with a racist filling-station attendant.

> Daddy's breath turned into a tornado. I couldn't tell which way the breath was going. The white dude kept sayin nigga, nigga, nigga, nigga, nigga, and I closed my eyes. I don't know what happened. It was very fast. It was very private. I don't know what kind of deal they made. Mother never kept still. I looked up the dude was gettin' up off the ground, got us our gas, didn't do the windshield. Daddy said, "Yes, sir." It was about a mile down the road before he lit a cigarette.

Tornado breath for inspiration; cigarette smoke for expiration. The call and response of the performative, not merely the content of the narrative, are what so powerfully link the struggles of African-American performance to the empowerment of the gest of breath. No matter how it surfaces, this gest is very resourceful in grounding its subjects in the constant rhythms and empowering interpellations of its call and response.[7]

To emphasize a point made in the preceding chapter, this is precisely how Ntozake Shange describes her work's debt to Frantz Fanon's enlivening concept of "combat breathing:"

> "combat breathing" is the living response / the drive to reconcile the irreconcilable / the black & white of what we live n where . . . the throes of pain n sensation experienced by characters responding to the involuntary constrictions n amputations of their humanity / in the context of combat breathing.
>
> <div align="right">(Shange 1981: xiii)</div>

As a drama of "combat breathing," Robbie McCauley's *Indian Blood* reflects passionately on the drive to reconcile the irreconcilable or what Jean-François Lyotard calls the differend nurtured by the institutions of Eurocentrism. On one side stand the terms and laws of forced reconciliation on which justice depends: "a case of differend between two parties takes place when the 'regulation' of the conflict that opposes them is done in the idiom of one of the parties while the wrong suffered by the other is not signified in that idiom" (Lyotard 1988: 9). On the other lie the reproachful silence and new idioms of the victim sustained by the (in)dignities of "combat breathing," victims who are summoned by language "to recognize that what remains to be phrased exceeds what they can presently phrase, and that they must be allowed to institute idioms which do not yet exist" (Lyotard 1988: 13). While attesting to

the enslavement of enforced language, the differend also provides a mechanism through which the constant rhythms of inspiration come to fruition in emergent idioms of comfortable eloquence and political empowerment. The creative tension of just such a differend sustains the labored breath that punctuates the visceral performance of *Indian Blood*.[8]

UNRIGHTEOUS FANTASY

As a theatre piece, McCauley's story stands firmly within the alien dramatic trajectory of the Occidental, Oedipal trauma. With only minimal focus on the mother, *Indian Blood* recounts the painful mournings of a daughter tormented by her love and identification with "the strong, gentle presence" of a military father whose love ran as deep as his brutality struck hard. Theirs was a love firmly etched "in the contradictions in my life." Few spectators will forget McCauley's beautiful, serene description of the daughter's private moment with the proud father who has just revealed the secret details of his violent struggle with a racist gas-station attendant: "That night I do remember dead in the night everybody else asleep, Daddy smoked a lot, I lit his cigarettes, and we saw an amazing forest fire." Just as memorable as this secretly shared, incestuous moment is its performative contrast with the daughter's subsequent account of the explosive patriarch.

> Do you think I do not understand the other father parts . . . I understand why he pushed me down the stairs with a Bible in his hand like a half-assed fascist, like a calvinist . . . I know he fought their wars. And when he came home, beat us up, beat us up with his thoughts, beat us up with his words, beat us up with his fists.

Her reflections come to terms with a father whose fascistic and fetishistic posture reflects his complex entrapment in the adverse sociocultural conditions of his racialized gender. Sustained by the subliminal mechanics of internal colonization, he habitually blocks out, through the disavowals of verbal abuse and violent behavior, the psycho-cultural infelicities of the heritage he could have called his own. Although his daughter credits him with her drive to judge the world with an unflagging commitment "to fix it," she portrays him as intoxicated by the socially determined distortions of male fantasy:

> Seems like my father was always in somebody's army, navy, air force, national guard. In the Navy, he longed to be a policeman. He loved uniforms and other male pathologies. He liked his cigarettes raw and whiskey straight in a shot glass. He wanted a Cadillac more than anything else in the world.

Yes, very much like his dramatic forefather, Oedipus, not to mention his twentieth-century brethren of fascism, he was sheltered by the pathologies of male eloquence – physical, verbal, and symbolic – from confronting the violent traces of his own mixed blood.[9] For those same phallic props that lent him constancy without are precisely what tormented him and continue to haunt his lineage from within.

Yet the psychic procedures of fantasy are recast by McCauley as a maneuver of summoning what remains to be phrased, as a strategy of performing the retrospective construction of text and image that disturbs the ontology of essence.[10] "They said in the middle passage we lost the name . . . our holocaust is our history . . . these confessions are becoming like a mourning for the lost, for the lost, for the lost connections." Being the lost Thing, the names, the connections will be regained only through the reconstitutions typical of mourning and melancholy in which revital-ized identity comes at a certain cost to the prior interior masquerade of self-sufficiency. For any mournful reconnection to the lost name may be possible only through the vicissitudes of what Nicolas Abraham and Maria Torok term "melancholic cryptation." This is the melancholic procedure of harboring a "phantom" in a "secret crypt" as a means of censoring the inconsolability of loss, "of dispensing with the painful procedures of psychic reorganization" (Abraham and Torok 1987: 266).[11] What they call "cryptation" is the condition of not being able to do other-wise than deny the loss by burying it alive as a ghostly hallucination, a phantom, an "intrapsychic secret." Such a phantom is said by Abraham and Torok to be a fantasy formation notable, and here lies the specter of the middle passage, for serving as a means of communication from the unconscious of the parent to that of the infant. But even if the subject and her performance can be thought capable of carrying the phantoms of her ancestors (a truly bizarre hypothesis), she cannot acknowledge the lost connections, so insist Abraham and Torok, except in relation to the unsettling representations that link them to what is more familiar, from without.[12]

This traumatic mixture of projection and introjection is particularly notable in *Indian Blood* as the "half-remembrances" of a girl close to death who hears the familiar sounds of her father's raging voice. But this time, the tornado breath is half-remembered to have been directed outward, not inward, at indifferent hospital workers accustomed to leaving the children of color for last, for dead. On an even broader scale, the wounds of cultural difference work throughout *Indian Blood* to disturb the reconstructions of mourning itself. Twice McCauley performs in front of reproductions of newspaper accounts of her lost father and grand-father. Even in a performance replete with resentment for the patriarch, the loss of having missed her father's passing is what impresses the performer as she faces the phantom slide of his fading obituary. "I wish

I coulda seen him. I would have given anything if I coulda seen him one more time." But just what this sight would have accomplished is rendered uncertain by the conclusion of *Indian Blood*. It is to see her grandfather one more time that McCauley closes her show with an account of how he even "shot the Indians as they were coming back over the border from Canada." In view of her own ability to quiet the paternal phantoms who will not lie still, McCauley ends her performance on a note of the incompletion of its aggressive mourning. "Somebody asked me, should I stir my fathers in their graves? I can't believe they're resting yet."

When *Indian Blood* is not a disturbing specter of male fantasy and its ambivalent passing, it remains a mat(t)er of family blood and internal colonization "in a world turning backwards."[13] This is a world driven by the imperatives of fantasy, those necessary productions of retrospective texts and images.[14] These attest to the differences of strategy, of *métis*, at work from inside the oppressed family of color as well as from without. McCauley notes, for instance, how the different familial responses to racism, from apology to accusation, tend to bear the marks of gender and its incommensurable differences: "my mother who spoke in italics, 'all white people aren't bad;' and Daddy who spoke in capital letters said 'a cracker don't have to act like a cracker'." Even though the white agent of colonial doom remains constant throughout, the scene of reconstitution generates a differend within. But to what end? Will the bolder, male voice of accusation necessarily prevail over the quieter, reflective discrimination of female apology? The case is not so clear in the performance environment of Robbie McCauley.

In this world of *métissage*, the apparent masculine strength of accusation seems to lack the clarity of female perception, since the men "who fought their wars . . . tend to think in circles and women tend to think straight ahead. But I will not let my arrogance about the blood . . . obscure my perception of the government." The forward thought of the female movement, if I hear McCauley clearly, thus challenges the return to the same of male identity, its military loyalty, and its hermeneutic circle. "If you ask a Negro where she's been," to call on a phrase of Maya Angelou, "she'll tell you where she's going."[15] Knowing full well the violations and dangers of the past, the African-American woman directs attention to its refiguration in the future. The forward direction of the mournful confessions of *Indian Blood* are thus what map the uncharted fissures of gender difference and its enigmatic performatives.[16]

Indian Blood is a piece in which the feminist artist most assuredly counts for something, delivers something – always already in relation to her arrogance about the blood. And this is the arrogance that makes for divided loyalties in the drama of Robbie McCauley. Consider the cries of the ancestors, the phantom voices within which seemingly call for

revenge of an evil yet to be acknowledged: "Sometimes I feel like I've been kidnapped, feel like I am rolling to the side of my bed, feel like my ancestors are calling me – they tell me that I have Indian blood." While McCauley uses the stage "as a weapon to revenge her father's death," she acknowledges her place in the enigmatic line of drama's tragic hero-ines, "Medea, Antigone, and Electra." Like the troubled women before her, McCauley frequently calls on the specters of the mother to ward off the patriarchal evil about her. Like her mother and aunts before her, she habitually responds to life's inequities by returning to the strategies of cunning, guile, and subterfuge which have been quietly perfected in the domestic sphere.[17] She proudly tells about the time that her grand-mother woke up in the middle of the night to the sight of the KKK outside her window. To ease tension and subvert the surprise, Grandma tells her husband to pack up the car so they could go to town for her aching tooth. McCauley herself admits to a similar practice of adding to language, of signifying, as a means of producing something from a foundation of destructive anger.[18] In the space of a dramatic pause, she asks her audience, "Everybody OK? Um, it's hard not to go off on things like I'm talking about so I like to keep telling stories."

These are stories of the harsh realities of the female response to the displacements of their cultural identity. Theirs is the story of the death of the grandmother's family due to the flu epidemic and how she was then "placed" by church people, the same ones who taught her to read, with the white Colonel, the same one who sanctioned her marriage to his black valet. Theirs is the account of the mother's defensiveness to her daughter's psychotherapy, "She said, 'Girl are you crazy? What did he say about me? It was a woman,' I said, 'and it wasn't about you, it was about me'." To which April adds the source of the mother's frustration, "mother slammed on those brakes so hard: 'Girl, this is America . . . I may not have been a producer of any security, but I sure as hell raised you'." Theirs are the accounts of the confusions of American identity with their mixed-blood heritage, "how they always told the story about when you've got background and dignity and self-respect and upbringing and official papers, it can keep your ass from gettin' killed."

Within this same ambivalent context of the accounts of her peoples' survival in a country they so proudly called their own, Robbie McCauley also challenges the stories of *métissage*. She openly laments her placement in the literary traditions of the past. She bemoans her identification with her literary mothers, Medea, Antigone, and Electra, in terms of the "unrighteous fantasy" of having "to be like them." This strong ambiva-lence positions Robbie McCauley as a daughter of Jocasta performing in a radically different, dramatic present.[19] As she puts it bluntly, "Electra knows no rage like what I know." But what Electra did know was the power of "unrighteous fantasy," of masochistic identification with the

cultural codes confining her. Electra and her sisters stood enclosed in the alienating conventions of patriarchal, literary construction, much like the modern fantasy figure described by McCauley.

> I remember my hair flowing in the breeze like an American gothic movie. It was the cover for the real fantasy. We are in exile yet we are home. We don't speak any more of longing for freedom, we are afraid we won't be heard. We are in exile and yet we are home. We carry the history on our shoulders, thousands of us, and we meet each other in this wilderness and nod our rhythms . . . nod our rhythms.

Like those heroines of gothic film, the daughters of *Indian Blood* bear the silent burdens of the family secrets they work so diligently to disclose. Like those unforgettable gothic women, their home is the large and forbidding wilderness of exile, of alienation, of the differend. And, yet, very much unlike those paranoid figures of 1940s film, these contemporary African-American daughters turn to *métissage*, the mixed blood of cultural violations, for the forceful sustenance of combat breath. Resisting the fantasy effect of gothic paralysis, they rely on the differend of feminist performance for the nod of their rhythms.[20]

THE SIGH OF A LONG SCREAM

To Robbie McCauley, performativity of the differend is a matter of revealing and thereby contesting the stronghold of imperialist signs by giving new sound to the constant rhythms, constrictions, and amputations of her peoples of mixed blood.

> everything reminds me of apartheid in America. I remember the colored and white signs. I was too young to be born into that. Somebody said in North Carolina they have Indian signs on their bathroom doors and stuff. The Mormon Church has a long history of apartheid against black people. But recently they have this thing about the Indians being their brown brothers that they were supposed to come over here and meet. I don't know, it could be like the Catholics fronting for the European settler: colonialists in the fourteenth, fifteenth, sixteenth and seventeenth centuries. I don't know. I don't know, it could be like the Calvinists fronting for the Dutch and the Anglicans fronting for the British in South Africa or it could be like the Zionists fronting for the US in Palestine. I don't know. They say the Mormons are the largest growing church in the country. And they say it is one of the largest corporations in the country. I know that one-fourth of all the energy resources of this country are on Indian land. In fact, this is all Indian land.

To this complex assertion of theological righteousness fronting for the cracks and fissures of European authority, April raises the stakes of the capital. In an assertive rejoinder to Robbie's mixture of private memories and public histories, April clarifies the unholy agenda of the colonial claim: "Indian land and African slave labor are the foundation and the basis for the rise of capitalism and the Industrial Revolution in the United States and Europe." The rhetoric and eloquence of metaphysical essence are reduced by April to the brutal logic of plunder and slavery, not to mention the insidious mystifications of commodity fetishism.

A similar mixture of class history, public memory, and private fantasy is projected visually throughout the performance of *Indian Blood*. Upon entering the theatre, the audience is faced with three large images (sometimes four, depending on the performance venue) projected across screens spanning the back wall. As a prelude to the performance, the screens are covered with markings of script, suggesting that their texts, if deciphered properly, contain the story of anyone – the stuff of universal (some might say, humanist) drama. But when the performance begins, the figure of anyone takes on the specific dimensions of the incommensurable and the differend. Denotative script becomes connotative imagery as clashing visuals transform the space into a memory theatre of McCauley's family photos, group shots of Indians, black cavalrymen, slave ships and black prisoners, black marchers and riot police, hooded Klansmen, black revolutionaries, newsprint obituaries of father and grandfather, and even *Ebony*'s cover proclaiming "The Black Woman of the 80s." Portraying the tragedies of African-American history and the traces of the artist's familial memories, these projections lend visual body to McCauley's public memories and private fantasies. As powerful technological displays, they appropriate the pedagogical mechanisms of photography and documentary to face the audience with a look back on its own diverse psycho-historical self. Somewhere, sometime, the viewers of *Indian Blood* find themselves faced with the visual and auditory phantoms of their own mixed, cultural, and technological pasts.

McCauley is also joined in performance by a pair of black-and-white video monitors generally portraying her as a "talking head" who lectures on the revisionist history of Occidental imperialism (Figure 8.1). "Everyone knows," proclaims the headstrong teacher, "there is a not-so-secret war to annihilate the Indians . . . history books have screwed people up . . . a not-so-secret war in South America today is a continuation of the annihilation of the Indians . . . history has so much nuh, uh, uh, in it." These illuminations of the black teacher getting it right lend somewhat of a surreal cast and accusatory tone to their televisual medium. As analyzed in *Color Adjustments* (1991), the video documentary by Marlon T. Riggs, television has its own pernicious history of manipulating color to achieve the imperialist ends of captivating, not liberating, the African-

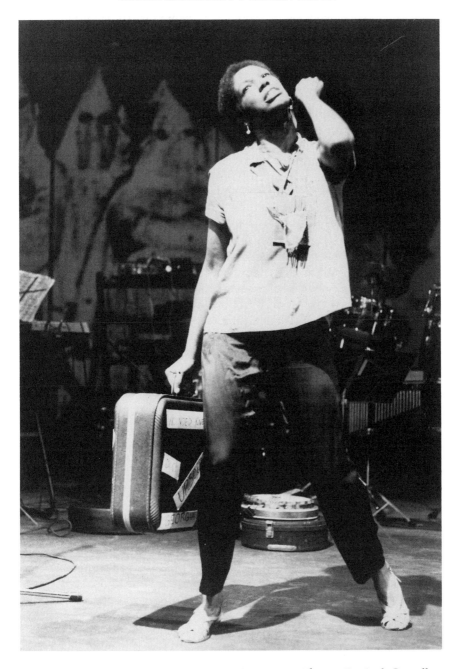

Figure 8.1 Robbie McCauley, *Indian Blood*, American Theatre Festival, Cornell University, Ithaca, New York, September 1989 (courtesy: Department of Theatre, Film, and Dance, Cornell University)

American viewer. McCauley snips apart the colored sutures of television that so frequently transform the nodding rhythms of the resisting subject into the placid image of a historical object. This becomes especially evident in an early sequence of the performance when the video shifts momentarily from history lesson to self-portrait. It is through the mediation of video that the talking head of Robbie relates the story of her father's inspired tornado breath at the gas station. Throughout the course of this segment, the performer, McCauley, mimes the tense narrative with contorted limbs and pained expression. It is almost as if the nodding rhythms of the performer's body are mapped on to the graphic screen as an overwhelming palimpsest, as an emotive display exceeding the regulatory grids and delimiting conventions of documentary story and video image.[21]

Especially fascinating is how this juxtaposition of talking head and performative body works to demystify the kind of impossible suturing of pedagogical object and performative subject that constitutes the narrational thread of the modern, imperial nation. Homi K. Bhabha argues, in an exceptionally pertinent analysis, "DissemiNation: Time, Narrative, and the Margins of the Modern Nation," that the narrative position of the "national subject" is ambivalent due to its doubled derivation. It stems from the continual, accumulative temporality of the pedagogical, on the one hand, and the repetitious recursive strategy of the performative, on the other.

> The people are not simply historical events or parts of a patriotic body politic. They are also a complex rhetorical strategy of social reference where the claim to be representative provokes a crisis within the process of signification and discursive address. We then have a contested cultural territory where the people must be thought in a double-time; the people are the historical "objects" of a nationalist pedagogy, giving the discourse an authority that is based on the pregiven or constituted historical origin or event; the people are also the "subjects" of a process of signification that must erase any prior or originary presence of the nation-people to demonstrate the prodigious, living principle of the people as that continual process by which the national life is redeemed and signified as a repeating and reproductive process. The scraps, patches, and rags of daily life must be repeatedly turned into the signs of a national culture, while the very act of the narrative performance interpellates a growing circle of national subjects.
>
> (Bhabha 1990: 297)

In McCauley's performance, the interpellation of subjects of mixed blood and gender continually disrupts, while still relying on, an accumulative pedagogy. But on this stage, pregiven authorities and origins make room

for the scraps and patches of a prodigious *métissage* in motion. While debunking the innocent purity of imperial culture and native traditions, McCauley openly reflects on the delicate fabric and densely mixed blood of an expanding American peoples.

McCauley sums up the paradox of her performative pedagogy by recounting a painful encounter she shared with her friend, the novelist and performer, Jessica Haggedorn. Discussing the turmoil in the Philippines following the Spanish–American War, Jessica adds a chapter to the already tragic story of her friend's mixed blood. McCauley's Filipina friend, Jessica, tells her that it was the regiment of Robbie's grandfather, the 24th Infantry, that went to the Philippines to help crush the Independence rebellion of Aguinaldo. In response to this new infusion of her ancestor's spilled blood, Robbie joins Jessica in nodding their newfound rhythms.

> And when she told me that, I said, "Oh, no." She said, "But we betray each other all the time." And then we said, "Maybe you just have to," and then we said, "Oh no you don't." And then we just both sighed like a long scream.

In the broadest context of its knowing resistance to internal colonization, *Indian Blood* presents a quiltwork made from the performative oscillations of backward and forward motion. While acknowledging the vicissitudes of mourning that so stir fathers in their graves, *Indian Blood* embraces the prospects of an emergent culture of empowering multiples. It calls upon the tradition praised by McCauley of "the first democratic cross-cultural communal" established in the interior of South Carolina when Indian and African slaves sabotaged the "first settlement in this country" by the Spanish of Santo Domingo. Deriving strength from its oscillations, the "multi-"culture emerging from the performatives of *Indian Blood* remains, like its author, always already humbled by the tenuous fragility of its stitchery and the lasting durability of its rhythms.[22]

NOTES

1 Quotations of *Indian Blood* are taken here and throughout from my transcriptions of a videotape directed by Marilyn Rivchin of the performance at "An American Festival," Cornell University Center for Theatre Arts, September 1989.

2 Lionnet (1989: 18) is quick to add that such a legacy will include both male and female writers. In justifying her opening chapters on Augustine and Nietzsche, she stresses that "my point is not to use them as male paradigms or antimodels to be criticized and refuted: I want to examine how dimensions of their work that might be called feminine tend to be either ignored or coded in reference to a more "masculine" and hierarchical framework, even though these texts explicitly reject the possibility of such unproblematic appropriation by critics blind to the biases of their own disciplines and unreceptive to

the subversive rhetorical features of language." In the reading of *Indian Blood*, to follow, I reflect on how McCauley similarly calls upon, interpellates, many terms of European, male theory in ways that stage a dialogue between the subversive rhetorical features of both sets of text, performance, and theory.

3 The notion of the violation of identification is a Lacanian one, stemming from the originary moment of identification in which the infant facing the mirror identifies with an image more corporeally complete than itself. The taking in, or incorporation, of this image, this Other, can be said "to violate" the self in the sense that the subject first recognizes itself in relation to an image that alienates it and thus confronts or aggresses it. The subject is constituted by its "splitting" in the face of its loss of the ideal ego and knows itself only in relation to what it "would like to be." For a superb summary of the procedures of identification, see Rose (1986: 167–97). Most pertinent to the issues of this essay are Diamond's discussion of identification in the theatre, "The Violence of 'We:' Politicizing Identification" (1992), Homi K. Bhabha's thoughtful essay on how identification always leaves the colonial subject "overdetermined from without" (Bhabha 1989: 131–48), and my discussion of "mimesis, masochism, and mime" (Murray 1997b: 1–33).

4 Mullen (1994), Smith (1994), and Butler (1993: 167–85) provide excellent essays on the fluid dynamics of passing in narrative and cinema.

5 See Lowery Stokes Sims's (1988) discussion of consumption in the performance art of Kaylynn Sullivan.

6 On the work of Kennedy and Shange, see Chapter Seven, as well as Richards (1983); Geis (1989); and Cronacher (1992).

7 See Spillers (1987) on the interpellative power of the female, African-American performative. Butler (1990a), Forte (1990), Fusco (1995), and hooks (1995) analyze different ways in which the performative functions as an empowering device of feminist performance art.

8 This is very much akin to what Derrida understands to be the power of translation, the transformation of deadening idioms into new phrases and aims. "Absolute heterogeneity, signaled by the 'outside itself' which extends beyond or on this side of sense, must still be translated, anasemically, into the 'in itself'" (Derrida 1979b: 23).

9 McCauley's linkage of her father's fascist temperament to uniforms and other male pathologies calls to mind the analysis of very similar relations by Klaus Theweleit in *Male Fantasies* (1987). Michael McMillan (1995: 207) cites such pathology as another instance of "internal colonization": "A further turn of the screw of oppression comes with the black male subjectively internalising and incorporating aspects of the dominant definition of masculinity to contest the conditions of dependency and powerlessness. Many of the assumptions about black sexuality emanate from a view of the black family as deviant, dysfunctional, disorganised and pathological: a family that fails to socialise their offspring into correct societal norms."

10 On fantasy as a retrospective articulation of an earlier unacknowledged trauma, see Laplanche and Pontalis (1986).

11 I provide more detailed discussions of Abraham and Torok's "cryptation" and its potential relation to literary and film theory in *Like a Film* (1993: 25–64) and in "Translating Montaigne's Crypts" (1991).

12 See Freud's essay, "Mourning and Melancholy" (1953–74: XIV, 239–58). It should be noted that many African-American theoreticians are hesitant to endorse psychoanalysis, especially the theory of mourning and melancholy, as a helpful method of studying African-American culture (see, for instance,

Hortense Spillers's complex analysis of the African-American woman's relation to the Lacanian symbolic (1987), as well as Michele Wallace (1990) and Adrian Piper (1990)). A compelling feature of *Indian Blood*, however, is that it asks the viewer to understand the dynamics of mourning and melancholy in terms of the complex psycho-political structuration of the African-American experience of loss. In the "Introduction" to *Like a Film* (1993: 1–21), I elaborate on a similar point in relation to the discourse of incorporation in Julie Dash's film, *Daughters of the Dust* (1991).

13 Reflecting on the irresistible draw of the family hearth, Herbert Blau (1992: 137) states that "where politics draws upon the personal, the emotions are almost inescapably derived with ambivalent feelings and unpurged vestiges of the psychological framework of the oedipal family romance. No matter what we do with behavior – mask it, frame it, freeze it, laminate it with ritual borrowings, or deconstruct it in theory as the mask of logocentrism – the oedipal vocabulary of emotions is, as we know, not easily displaced." It is fair to say that a position such as Blau's strikes a controversial chord in black cultural theory. Strong opposition to "the discourse of race as community, as family," comes from Paul Gilroy who argues, in "It's a Family Affair" (1992: 312–13), that "spreading the Oedipal narrative around a bit can probably produce some interesting effects, but this bears repeating: the trope of the family is central to the means whereby the crisis we are living – of black social and political life – gets represented as a crisis of black masculinity. That trope of the family is there, also, in the way conflict, within and between our communities, gets resolved through the mystic reconstruction of the ideal heterosexual family." In an essay concluding the conference collection, *Black Popular Culture* (Dent 1992), which contains Gilroy's text (a collection, by the way, whose focus on popular music and mainstream film virtually ignores the contributions of public performance art to black popular culture), Michele Wallace responds to the imperative of the Oedipal dilemma:

> One of the goals of this conference was to achieve a gender balance in which the black feminist voice would be at least as strong as the male voice, but that didn't quite come off. Usefully, Lisa Kennedy suggested the discussion had gotten bogged down in Oedipal reenactments and that such reenactments were characteristic in African-American discourse. Paul Gilroy went on to rebuke African-American theorists for their presumably wrongheaded preoccupation with the family paradigm. But I don't think we have a chance of comprehending our own irrationality outside of the framework of the family romance.
>
> (Wallace 1992: 345)

14 I refer to the definition of fantasy by Laplanche and Pontalis (1986).

15 Cited by Lionnet (1989: 131). I have taken the liberty of altering Angelou's pronouns from masculine, "If you ask a Negro where he's been, he'll tell you where he's going," to feminine in order better to contextualize her phrase in relation to the gender distinctions made by McCauley, not to mention in terms of Angelou's own citation of the phrase to illustrate her grandmother's cunning use of language.

16 Isn't this what situates *Indian Blood* firmly on the agonistic stage of the "minor" theatre lauded by Gilles Deleuze? Doesn't this theatre subtract from "the stable elements of power that will release a new potentiality of theatre, an always unbalanced, non-representative force" (Deleuze 1997: 242)?

185

Deductive, sure; non-representative, just as surely, no. While certainly un-balanced, the force of McCauley's performative stands in direct relation to its representativity.

17 In "Desire in Narrative" (1984: 157), Teresa de Lauretis calls for a reconsider-ation of the cunning and guile of classical tragic heroines, like the Sphinx, the Medusa, and the daughters of Jocasta which lead to "an interruption of the triple track by which narrative, meaning, and pleasure are constructed from [Oedipus'] point of view."

18 I am alluding, of course, to the notion of "signifying" developed so lucidly by Gates in *The Signifying Monkey* (1988).

19 "The daughters of Jocasta" puns on the title of Christiane Olivier's controver-sial book, *Les Enfants de Jocaste* (1980), which dwells on the feminine trajectory of the Oedipal line, "le different oedipien, origine de tous les differends." In *Like a Film* (1993: 25–64), I discuss the relation of such a differend to different post-Lacanian theories of feminine narcissism.

20 In *The Desire to Desire* (1987:123–54), Mary Ann Doane summarizes the conditions of female paralysis in the gothic novel and critiques their broad insertion into gothic film.

21 See Trinh T. Minh-ha's perceptive analysis of the codes of documentary throughout *When the Moon Waxes Red* (1991).

22 Ironically, the same narrative irresolutions I am praising provided John Howell with material for his negative *Artforum* review of the 1987 perfor-mance of *Indian Blood* at The Kitchen: "The lack of overall organization was perhaps a reflection of the piece's thematic failure to bring its provocative subtext to some sort of climactic conclusion: How would McCauley reconcile her emotional pride in her admirable heritage with her intellectual rejection of their unwavering armed commitment to a political system that McCauley finds unjust and corrupt? . . . The untangling of the personal and the political is one of the great American mythic struggles, and while McCauley was certainly on the mark in her material, *Indian Blood* seemed too anemic to become the all-out political tonic it purported to be." Put another way, Howell's review provides a fitting summary of McCauley's acknowledgment of the enigmas of an emerging culture. For it is against the great American mythic struggle that McCauley so valiantly struggles to rid her Indian blood of its anemic pale.

Part IV

TELEVISUAL FEAR

9

CAMERA OBSCURA IDEOLOGICA

From Vermeer to video in *All's Well That Ends Well*

Because soap opera is a highly segmented structure whose essential fracture of narrative produces a dispersed subjectivity, it is perfectly suited to the type of distracted viewing which characterizes television as an institution. As John Ellis points out, television is a medium which "engages the *look* and the *glance* rather than the gaze."

<div align="right">

Sandy Flitterman-Lewis, "All's Well That Doesn't End:
Soap Operas and the Marriage Motif"

</div>

These multiple positions and points of view are often regulated by an implicit hierarchy that privileges certain positions over others. This can be seen as a strategy of containment, as minority positions or deviations from the mainstream are introduced but are framed and held in place by more familiar, conventional representations. John Fiske and John Hartley describe television's cultural mediation as working to *claw back* any subject to a central focus by referring the subject at hand to familiar modes of understanding.

<div align="right">

Mimi White, "Ideological Analysis and Television"

</div>

Together with White's remarks on televisual "claw back," Flitterman-Lewis's reference to *All's Well That Ends Well* provides a fitting way to introduce this chapter on televised Shakespeare. For these epigraphs concerning the popular romance with televisual drama set the stage for a perceptive approach to Shakespearean criticism. This becomes especially apparent when the same epigraphs are recast with somewhat different wording. Were "television" replaced by the phrase, "Shakespearean comedy," the affirmative passage from Flitterman-Lewis would read:

Because soap opera is a highly segmented structure whose essential fracture of narrative produces a dispersed subjectivity, it is perfectly suited to the type of distracted viewing which characterizes Shakespearean comedy as an institution. As John Ellis points out,

Shakespearean comedy is a medium which "engages the *look* and the *glance* rather than the gaze."

Sporting the same minor substitution of "Shakespearean comedy" for "television," the more critical quotation from White would read:

These multiple positions and points of view are often regulated by an implicit hierarchy that privileges certain positions over others. This can be seen as a strategy of containment, as minority positions or deviations from the mainstream are introduced but are framed and held in place by more familiar, conventional representations. John Fiske and John Hartley describe Shakespearean comedy's cultural mediation as working to *claw back* any subject to a central focus by referring the subject at hand to familiar modes of understanding.

While these substitutions might well seem gratuitous, I make them to introduce significant critical strategies shared by the ideological work of television and Shakespeare. In terms of script and performance, it would not be difficult to make a case for many stylistic similarities of televised soap opera and Shakespearean comedy that confront viewers with narrative and formal strategies of segmentation, dispersion, and distraction. A brief summary of common traits might focus, for instance, on how both genres produce multiple perspectives through a barrage of intertextual citation. While televised soaps depend on the viewers' participation in story lines running throughout the history of the series as well as frequent cross-references to other series by the same production company or network (whose deeper references often stem from events televised in past seasons), Shakespeare's comedies weave a web of allusions to themselves as well as to a multitude of historical and contemporary texts which often confound the viewer's ability "to fix" the plot in any one temporally bound narrative or free the viewers from any obligation to do so (indeed, Elizabethan theatre often willingly advertised its revision and renewal of well-known plots and plays).[1] Both genres also deviate from the narrative continuity and visual suture which is the theoretical hallmark of classical film. They highlight segmented and undeveloped scenes as well as "problem" characters who vanish as quickly as they appear. And both genres nurture what Rick Altman calls a strategic "discursiveness," that is, an acknowledgment of the viewer, if not a direct address to the audience which dispels voyeurism and the cinematic gaze (Altman 1986: 50). They both could be said ultimately to engage the "look" and the "glance" rather than the "gaze."[2] That is, they share performative procedures through which the spectators are caught off-guard, or rendered self-conscious, by the spectacle's disempowering "imprint" upon them.

190

INVERSION WITH A DIFFERENCE

Particularly fascinating is how Shakespeare's comedies frequently depict marriage as a disruptive institution. Such a representation of matrimony as an unstable institution is also suggested by Flitterman-Lewis to be perversely favored by television:

> where classical Hollywood cinema almost always leads to marriage (the formation of the couple being seen as synonymous with resolution), marriage in most television narrative forms (especially in soap operas and prime-time dramas) is a major mode of complication, a site of disruption rather than resolution. The unstable, reversible, and circular movement of this type of program thus frustrates our desire for closure, for it embeds interruption into the very heart of the discursive structure.
>
> (Flitterman-Lewis 1987: 193)

Although many Shakespearean comedies end with marriages that allow for the ceremonial resolution of familial tensions, some of the more interesting ones position marriage as a site of dramatic disruption.[3] In *All's Well That Ends Well*, the nuptial bonds divorce a son from his mother and a prince from his fatherland. Marriage stands out as such a disruptive force in *The Taming of the Shrew* that scriptwriters for the 1980s comedy, *Moonlighting*, chose to adapt it to foreground the lasting tensions between the series' protagonists, Maddie and David.[4] To some degree, it is true that these same dramas, *The Taming of the Shrew* and *All's Well That Ends Well*, close by reaffirming patriarchal hierarchies. Through such closure they may seem to confirm the opinion of Jonathan Miller, producer of the BBC / Time-Life televised *Shakespeare Plays*, that Shakespeare turns to comedy to achieve "his highest and most serious purposes" of bringing together "the higher and more exalted themes of reconciliation, harmony, and peace on earth – as far as is possible, the idea of heaven" (Hallinan 1981: 141). But it could be argued, just as easily, that the comic disruption of marriage by the female appropriation of male aggression and sexual fantasy is so extensive as to invoke a lasting challenge to any ultimate gestures of narrative closure, phallic confidence, and even metaphysical harmony. Such a paradox underlies Janet Adelman's thoughtful suggestion that the dissonance between Helena's various roles in *All's Well That Ends Well* seems "less the sign of an idealized union of love and chastity than the sign of a deep anxiety about female power" (Adelman 1992: 86). While Adelman argues that "marriage has become for Shakespeare literally the end of comedy," she frames her claim around the tenuousness of comic results in Shakespeare's more lighthearted plays: "the defensive measures they must undertake to enable marriage remain more striking than the marriages they achieve" (Adelman 1992: 79). Particularly problematic to

191

Adelman is the tendency of these comedies to build the foundation of matrimony of a past history of sexual deceit and manipulation: "insofar as the bed tricks betray the desires of the male protagonists in curing them, they tend to become less a vehicle for the working out of impediments to marriage than a forced and conspicuous emblem for what needs working out" (Adelman 1992: 77–78).

My contention is that Shakespearean comedy joins soap opera in capitalizing on the instability of exalted patriarchal themes like marriage, reconciliation, harmony, and peace on earth. It is within the narrative context of dramatizing the frailty of marriage, "what needs working out," that soap opera and Shakespearean comedy share a significant, doubled ideological practice: the representation of subversive women who destabilize the patriarchal institution of marriage and the extensive subversiveness of just such a representation. Both genres excel in developing active, female characters who turn the patriarchal law and the phallocratic gaze against themselves. On the one hand, following the argument of Flitterman-Lewis, they periodically foreground "the very act of looking itself, the undeniable fact of watching the woman as spectacle in a virtual performance of sexual transgression and excess" (Flitterman-Lewis 1988: 124). On the other hand, their representations of the feminine are said by Flitterman-Lewis to be much more "subtle and diffuse" through which traces of the performance apparatus surface to disrupt momentarily the flow of pleasure (Flitterman-Lewis 1988: 124). Yet, many critics offer a more skeptical analysis of the promise of televised dispersion, especially when it is inscribed in the eruption of the phallic gaze. These readers would take the lead of Mimi White who puts more pressure on how subversion provides the historical frame of the video text. From this perspective, video dispersion is a matter less of "resistance to" and more of "containment in" the familiar, conventional representations of the medium. It merely provides a mechanism for directors and producers to contain unruly women in conventional roles. As Jonathan Miller describes the gender boundaries of his productions of Shakespearean comedy on television, "throughout these comic plays, Shakespeare's heroines are teachers ... The mysterious thing is that in many of Shakespeare's plays the woman only becomes a teacher when ... she's masquerading as a man" (Hallinan 1981: 141). Here Miller seems to cherish the Shakespearean "mystery" that woman is most likely to succeed only when contained in the strictures of patriarchal authority. But his emphasis on masquerade could point just as easily to film theory's parodic appropriation of the 1929 assessment of the analyst Joan Riviere that female masquerade is as much a woman's appropriation of masculine authority as an example of its "claw back:" "womanliness therefore could be assumed and worn as a mask, both to hide the possession of masculinity and to avert the reprisals expected if

she was found to possess it" (Riviere 1986: 38). In "Joan Riviere and the Masquerade," Stephen Heath cites the example of Marlene Dietrich as one classical figure who subversively appropriates masquerade to her own female ends: "Dietrich gives the masquerade in excess and so *proffers* the masquerade, take it or leave it, holding and flaunting the male gaze; not a defense against but a derision of masculinity" (Heath 1986: 57).[5] Could it be that precisely the critical instability generated by masquerade itself – the imbalance lent to the critic by masquerade's oscillation between defense and derision – is what renders the institutions of patriarchy equally unstable?

Two feminist essays from the same issue of *Shakespeare Quarterly* (Spring 1987) articulate a similar disagreement about the significance of minority representations in Shakespeare. In "Cultural Confusion and Shakespeare's Learned Heroines: 'These Are Old Paradoxes'," Lisa Jardine shares White's skeptical view of the significance of patriarchal representations of sexual difference. Discussing Helena, in *All's Well That Ends Well*, Jardine writes:

> The "knowing" woman is only precariously a force for moral good. Lurking behind that moral front is the female sensuality which is readily released into potential for harm (specifically, harm to men). In acting out the atonement of pilgrimage and the fairy-tale "restoration to favor" of the solving of the riddle (bed trick, ring game, and all), Helena is made a kind of wish-fulfillment solution to the paradox of the two-faced learned lady – a reconciliation of the opposed figurings of the educated woman as both symbol of civilization and social stability, and "impudent" (a sexually disruptive force for social disorder).
>
> (Jardine 1987: 12)

This position understands impudence as merely confirming negative patriarchal portrayals of the Renaissance woman. In contrast, Karen Newman's essay on *The Merchant of Venice* suggests that impudence itself can be situated culturally and historically to look back in the face of the beholder. "To read Portia's transgression as subversive risks," she suggests, "the theoretical accusation that the power finally depends on a reversal, on occupying the position of the Big Man, thereby preserving the oppositions that ground gender hierarchy. From such a perspective, all resistance is always already contained, dissipated, recuperated finally to the *status quo*" (Newman 1987b: 31). Newman counters this position by reflecting on the deconstructive resonance of gender *difference* itself:

> But *Derrida's* deconstruction of such inversion, unlike many of its ahistorical and ultimately conservative applications, recognizes that particular strategies, languages, rhetorics, even behaviors, receive

meaning only in sequences of differences ... I have therefore argued that the *Merchant of Venice* interrogates the Elizabethan sex/gender system and resists the "traffic in women," because in early modern England a woman occupying the position of a Big Man, or a lawyer in a Renaissance Venetian courtroom, or the lord of Belmont, is not the same as a man doing so. For a woman, such behavior is a form of simulation, a confusion that elides the conventional poles of sexual difference by denaturalizing gender-coded behaviors; such simulation perverts authorized systems of gender and power. It is inversion with a difference.

(Newman 1987b: 32–33)

While not denying the facility with which patriarchy can usurp resistant women, I share Newman's concern to note specific instances of drama's "inversion with a difference" in characters, as well as in aesthetic form. Such considerations motivate this chapter's shift of focus from my earlier concern with the absorptive silences of Shakespearean tragedy and stage to consideration of the distracting visions shared by Shakespearean comedy and television.

By considering the playful visuals of the *All's Well That Ends Well* directed by Elijah Moshinsky and produced by Jonathan Miller (1980), one of the better BBC productions of Shakespeare, I will dwell in this chapter on the critical inversions of Shakespeare on video. While the critical timidity and generally weak performance values of the BBC productions of Shakespeare prevent me from making claims for their overall success, my hope is that the critical framework of this reading of the televised version of *All's Well That Ends Well* will lead to greater appreciation of the potential interfacings of video and Shakespeare. For much like the Widow of *All's Well*, who ends up profiting from her sponsorship of Helena's lusty conterfeit, the conventions of Shakespearean performance and criticism can benefit from further attentiveness to the shifts and inversions of the televisual apparatus. To recall the "teletheory" of Gregory Ulmer (1989), such an inversion might enact change not merely on the level of technology but, more significantly, on the levels of institutional practices and critical assumptions. That is, it might contribute to how we "see" the text of Shakespeare as something renewed "with a difference."

IDEOLOGY OF THE VISIBLE

It is difficult to assess the difference made by Moshinsky's *All's Well That Ends Well* without first situating it in view of its producer's overall aesthetic. Jonathan Miller's BBC productions are marked by a carefully designed approach to the adaptation of dramatic *mise en scène* for

television. "I think that as soon as you put Shakespeare on that box where, as you say, people are accustomed to seeing naturalistic events represented, you are more or less obliged to present the thing as naturally as you can" (Hallinan 1981: 134). But when Miller elaborates on the parameters of such naturalism, he refers more to the higher codes of art history than the lower conventions of video verité.

> Well, if you're going to recreate a play from the remote past, you have to have some sort of documentary source in order to supply you with images. Pictures of the period are the best documentary source to go by in order to come up with something which convincingly recreates the world that Shakespeare or any writer of his period is actually referring to. As a director, then, one has to spend as much time moving around art galleries and collecting picture postcards as one does in reading texts. It's simply one of the sources of inspiration. It's the director's job, apart from working with actors and getting subtle and energetic performances out of them, to act as the chairman of a history faculty and of an art-history faculty.
>
> (Hallinan 1981: 137)

Miller's sense of visual naturalism thus stems from his habits as a collector of picture postcards and commander of the forces of high and academic culture. His many productions, from *The Taming of the Shrew* to *Antony and Cleopatra*, are designed around series of carefully blocked and constructed tableaux modelled after well-known classical paintings. This strategy complicates the already delicate transfer of Shakespearean text from theatrical stage to video performance by adding a third dimension, the codes of art history. From the opening shots in Moshinsky's *All's Well That Ends Well*, (Figure 9.1) for instance, learned viewers recognize motifs of interiors, lighting, and subject matter common to the style of Dutch baroque painting. These viewers are likely to note the features of Pieter de Hooch's *Interior with Woman Drinking with Two Men* or the composite style and subject matter of Emmanuel de Witte's *Interior with a Harpsichord* and Johannes Vermeer's *The Music Lesson*.

Miller appears to have confidence in mixing not only the disciplinary conventions of art history, dramatic literature, and theatre but the historical demarcations of history itself. For *Antony and Cleopatra*, for example, he relied, rather unsuccessfully, on Veronese's Mannerist paintings to provide the baroque design concept for *Antony and Cleopatra*'s Renaissance view of the classical Roman–Egyptian world.[6] Even his more satisfactory placement of *All's Well That Ends Well* in the visual framework of the Dutch baroque remains equally arbitrary for a French–Florentine play composed from fables dating from the sixteenth century at the very latest. I stress the extensiveness of Miller's disciplinary hybrids, however,

195

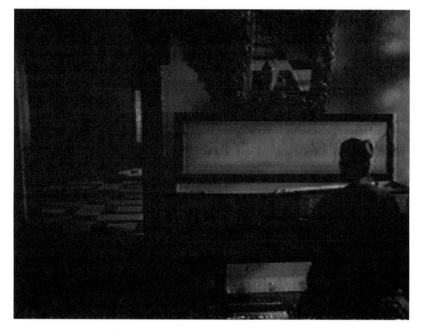

Figure 9.1 Elijah Moshinsky, Angela Down plays Helena at the harpsichord in Elijah Moshinksy's *All's Well That Ends Well* (courtesy: British Broadcasting Corporation)

not to argue for their inversions, nor for what they suggest about the fluidity of disciplinary and historical conventions, but to stress Jonathan Miller's bold confidence in the visual harmony of their staining acts. "In *The Taming of the Shrew*, for example, I used ordinary rectangular rooms where the space is quite readily 'readable.' There is a readily intelligent perspective, a vanishing point which is quite clearly visible" (Hallinan 1981: 138). Indeed, Miller often introduced the television runs of his tapes by expressing his sincere belief that the plays can be represented as readable with minimal or even no significant distortion or loss in their transfer from text to edited script, from script to visual conception, and from visual to video reproduction.

At stake in Miller's project, then, is his confidence in "a readily intelligent perspective," a notion very similar to what visual theoreticians term the cinematic endorsement of the "ideology of the visible." This is a trust in the camera's ability to carry on the symbolic tradition of classical or "monocular" perspective as outlined by Panofsky in *Perspective as Symbolic Form* (1991).[7] This same trust, it should be noted, is constantly under assault by the production codes of television. The conventional wisdom of television production prescribes the use of three cameras – one for the entire *mise en scène* and two for close ups – to cinema's more

traditional use of one. The result is the sort of broken perspectival suture and diffracted vision that presents the "visual" as something constructed rather than natural (this code suits, of course, the "distracted" habits of televisual viewing).[8] But even though monocularity is assaulted by the production codes of television, it is safeguarded by Moshinsky's loyalty to cinematic value. "I deliberately move away from this basic method. All the scenes are done with one camera; you stop, reposition the camera and shoot again; that's how movies are done" (Hallinan 1981: 130). By putting all of his focus on the one camera, and stressing none of the subsequent constructions of cinematic montage, Moshinsky clearly inscribes his production within the ideology of the visible. His loyalty to the single camera also sustains certain conservative values of dramatic production, those based on the faithful mimesis and ordering of text through dramatic representation. In this context, critics evaluating the BBC *All's Well* are faced with a complexly ideological dilemma: whether the *All's Well* video enhances or disfigures a belief in monocular visual convention as a trustworthy paradigm of dramatic interpretation.

To entertain this problem, I will turn first to the convention of sight shared by the Florentine Duke and the French King in *All's Well*. This is the standard of single-point perspective that late Renaissance and baroque princes so often manipulated to their political advantage. At separate moments in the play, both the Duke of Florence and the King of France express their confidence that reason and authority rest on their ability to perceive important matters "from point to point." Sovereignty requires that the prince trace all problems, stories, and persons to the point of clear perspective. It almost goes without saying that Shakespeare here puns on the perspectival conventions of the royal theatre, as analyzed in Stephen Orgel's *The Illusion of Power* (1975) and my *Theatrical Legitimation* (1987). In this system, the sovereign occupied the space of ideal perspective allowing those positioned around him to imagine the perspectival setting from his ideal point of view. Just as in *All's Well*, it is not so much the reality of perfect vision as the allegory of perspective – its representation as a simulacrum of optical potency – that fueled the theatrical power of the prince.

As if acknowledging the potency of the allegory of perfect vision, Moshinsky supplements *All's Well*'s references to perspective by designing his set around allusions to the perspectival symmetry of Dutch painting and the French palace at Versailles (Moshinsky 1986: 125). Versailles was designed, like the royal theatres of Richelieu and Louis XIV, to project the vision of the king. With the king's apartment occupying the central position of the Versailles Palace and gardens, he is, to cite Louis Marin's subtle semiotic analysis of the palace and its grounds,

at once everywhere and nowhere. He is not in space or rather he is present in it only as dominant gaze which "develops" its classic place. It is indeed the world in its entirety that finds itself architectured in the place of the King and transubstantiated into a monarchic body in the optical forms of his portrait, that is to say of his all-seeing gaze.

(Marin 1991: 180)

Such a public gaze finds its artistic corollary in the domestic interiorization of Dutch painting. Seeking to produce the Dutch "sense of interior exploration" (Moshinsky 1986: 126), Moshinsky puns throughout the videotape on the spatial interiorization that television shares with the likes of Vermeer:

> TV is a square space; there's no sense of depth, you are actually watching a piece of glass as opposed to a stage where actors are standing. There's a curious correspondence between the space created by the painter and the space created on TV, even more so than on film . . . many shots have to do with pictures behind pictures. That was an attempt to create an illusion of depth. The use of successive zones gives a greater sense of mystery.
>
> (Moshinksy 1986: 126)

Especially in the many scenes at Rossillion, the videotape depicts a visual world tightly ordered in matter and structure to enhance depth and movement. Moshinsky stages much of *All's Well* in familiar Dutch interiors and exteriors where space and pattern are geometrically ordered in what Herbert Read, a traditional reader of Vermeer, describes as "a stable structure, a configuration that allows the spectator's vision to rest meditatively on the scene or subject presented" (Read 1979: 65). In doubling the conventions of Dutch painting's geometrical order and video's close and tight shots, Miller depicts Shakespeare's characters as single figures or carefully composed groups whose geometrical pose allows for a pictorial fixation of dizzying emotional and social comings and goings.

"TRUTH IN PLEASURE FLOW"

The spatial perspective of the Dutch baroque, its pictorial world of visual self-consciousness, is what frames the ideology of ordered vision underlying the video performance of *All's Well*. The symbolic impact of this strategy is exemplified by the tape's art-historical reference to popular metaphysical paintings like Vermeer's *Allegory of the New Testament*. Here a talismanic hanging ball, much like yesterday's princely eye and today's video lens, maintains the symbolic attraction of the viewer inside and outside of the frame. It is through the subject's transfixed gaze on the crystal

ball that the viewer has been understood to share in the allegorical solace of metaphysical rapture. To feel this play is to act, then, as if a painter, as if a cameraman, as if a king, as if a metaphysical (even Shakespearean) fetishist: to feel is to see . . . from point to point.

I introduce the notion of fetishism so abruptly here to stress how rapture, whether religious, political, or cinematic, remains contingent on procedures of blockage that bolster an otherwise weakened subject. While Moshinsky entrusts his directorial potency to one camera to diminish the fissures of three, the fetishist denies the fracture of difference through the potent phantasm of the gaze. That such fetishism is understood psychoanalytically to be inscribed in the disavowal of threatening sexual difference is particularly germane to the visual codes of *All's Well That Ends Well*. For it situates the equation of controlled sight and soothing sentiment within the complicated domain of sexual politics. As discussed in Chapter Two in terms of *King Lear*, Shakespeare's plays frequently conflate male sight and judgment with hallucinations of sexual feeling and anxiety. Consider the layered example of the King's final lines in *All's Well That Ends Well*.

> Let us from point to point this story know,
> To make the even truth in pleasure flow.
> If thou beest yet a fresh uncropped flower,
> Choose thou thy husband, and I'll pay thy dower,
> For I can guess that by thy honest aid
> Thou kept'st a wife herself, thyself a maid.
> Of that and all the progress, more and less,
> Resolvedly more leisure shall express.
> All yet seems well, and if it end so meet,
> The bitter past, more welcome is the sweet.
> (V.iii.325–34)

The King positions himself as a benevolent listener who will determine the veracity of the tale that "yet seems well." His alliteration of the play's conditional ending, "if thou beest yet an uncropped flower," "if it end so meet," foregrounds his authority over all conditions of reception, from who tells the story to who adjudicates its truth. The King summarizes his judgmental dilemma by equating its "truth in pleasure flow," the delight of historical narration, with the epistemological conditions of its presentation, "from point to point this story know." These conditions thus place the listener of the tale in a position analogous to that of a focused viewer of a Renaissance perspective painting. Suggested here is the empirical equation of narration with the visibility of geometric perspective, the precise mapping of "point to point" which was understood in Renaissance art theory to facilitate the rationalization of perception and the objectification of an aesthetic artifact.

All the while, the force of perspective depends on the verisimilitude of aesthetic illusion, the blockage of hidden sights and perspectives. In the case of *All's Well That Ends Well*, moreover, the promise of the King is not to expose the actual sight of Diana's uncropped flower, the material evidence of virginity itself, but to verify the *conditions* of its representation, "to make the even truth in pleasure flow." These conditions, I might add, firmly inscribe the King's judgment in the realm of desire. By the conclusion of *All's Well That Ends Well*, viewers have come to appreciate this King's pleasure in hearing the tales of sexual exploit that lie behind the juridical facts he needs to know. The representation of Diana's virtue is clearly contingent, here, on the enactment of a sort of counter-transference. Proof of her virginity, the representation of her hymen, depends on the satisfactory penetration of the King's gazing eyes, the "stones," that can so readily read her from point to point. Exposed by this problematic ending are the shifting relations of epistemology and ideology (phantasms of power through gender) underlying historical narration throughout Shakespeare's plays.

The *All's Well* tape panders as well to this controlled representation of male pleasure in its depiction of Act III, scene five, when Helena, disguised as a pilgrim, joins the women on the Widow's balcony to view the passing of the troops. Moshinsky's citation of Vermeer's painting, *The Procuress* (Figure 9.2), provides the model for both the blocking and setting of this scene. It might be recalled that in the play, as in *The Procuress*, the women's mere presence on the balcony displays them as ring-carriers or bawds and provokes flirtation from the men below. In the video, moreover, this projection of male sexuality on to the sight (site) of women is set up by a previous shot that depicts Helena sharing wine with the Widow and her women. This image also has baroque corollaries from Le Nain to Vermeer. If read in terms of Louis Le Nain's depiction of the peasant table at which the principals share glasses of wine, this scene is notable for the gender switch of its participants. While Le Nain documents the drinking rituals of male bonding, Moshinsky cites the Dutch baroque's more blatant linkage of such bonding to the hom(m)o-sexual "trading" of women.[9] As stressed by the art historian Madelyn Milner Kahr, "in Vermeer's pictorial world, it is generally only the women who drink wine. The role of the men is to urge them to do it" (Kahr 1978: 281). Paintings like Vermeer's *The Glass of Wine* and *The Girl with the Wine Glass* thus double the sexual conventions of *The Procuress*.[10] In the language of *All's Well That Ends Well*, the women of Vermeer are represented as ring-carriers being warmed up by their suitors for the passionate transfer of their jewels.

It should be noted, moreover, that Moshinsky follows Shakespeare in eliminating the male suitors from his early scenes in the Widow's house, thus seemingly creating an absorptive space of purely female pleasure.

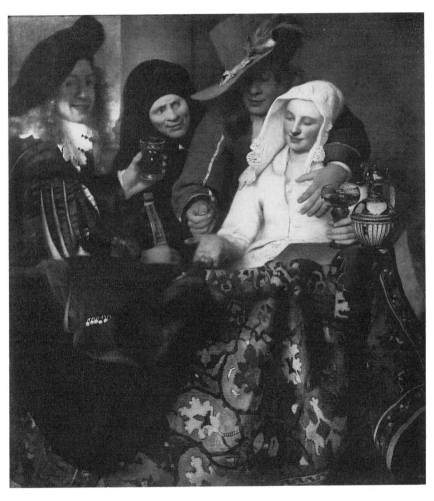

Figure 9.2 Johannes Vermeer, *The Procuress*, Staatliche Kunstsammlungen, Dresden, Gemäldegalerie Alte Meister (courtesy: Alinari / Art Resource, New York)

Such a strategy could be understood as consistent with Vermeer whose women, so Svetlana Alpers maintains, are "for all their presence . . . a world apart, inviolate, self-contained, but, more significantly, self-possessed (Alpers 1983: 224). Yet the lines spoken during the initial kitchen scene prepare the viewer for a later moment in Shakespeare's play when Helena shares wine and then much more with her horny suitor, Bertram. As Mariana warns her female comrade: "Beware of them, Diana; their promises, enticements, oaths, tokens, and all these engines of lust, are not the things they go under" (III.v.18–20).

These mixed artistic and dramatic conventions of the entrapment of women in representations of the visible, not to mention the concomitant female parody of these conventions, illustrate how visual thought and order in *All's Well* provide a precedent for the Dutch pictorial convention of seduction through mediated objectification. By mediated visual objectification, I mean that, at almost every crucial moment in the play, human interaction takes place less through the immediacy of dramatic speech and demystified verbal confrontation than through mediated private and public reflections on visible signs of character, social position, and communication. Like Vermeer's *Young Girl Reading a Letter* (Figure 9.3), the characters of *All's Well* speak to themselves and to each other through their meditation on mediating objects and commodities: rings, letters, portraits, and garments. They learn to know themselves and each other as visual objects, easily known and appropriated as the cultural relics of exchange. Even Helena is first presented to Moshinsky's viewer as a shadowy cut-out whose blacked-out silhouette presents her as but a two-dimensional object (Figure 9.4). This occurs in the opening moments of the tape when a darkened Helena sits juxtaposed in profile against a brightly lit, latticed window. Being much more than a visual gimmick of Moshinsky's citation of Vermeer, this image sharply dramatizes the codes of material objectification sustaining Shakespeare's play. Indeed, *All's Well*'s resemblance to the visual conventions of Vermeer is so uncanny that its characters sometimes speak to each other as if they were in Delft paintings: "So, my good window of lattice," says Lefew to Parolles, "Thy casement I need not open, for I look through thee" (II.iii.213–15). In such a world of objective vision constructed with the grids of perspective, or by extension, with the lens of the telescope or even the video camera, characters and their thoughts are shown to be self-sufficient and narrowly focused. They very much resemble Harry Berger's description of the women of Vermeer: "they approach the condition of objects, solidly filled with and in the present, giving off no sense of other worlds or missing contexts" (Berger 1979: 95). It is thus sufficient, in Act V, for Diana to present her evidence in the guise of unequivocal ocular objectification: "O, behold this ring, / Whose high respect and rich validity / Did lack a parallel" (V.iii.191–93).

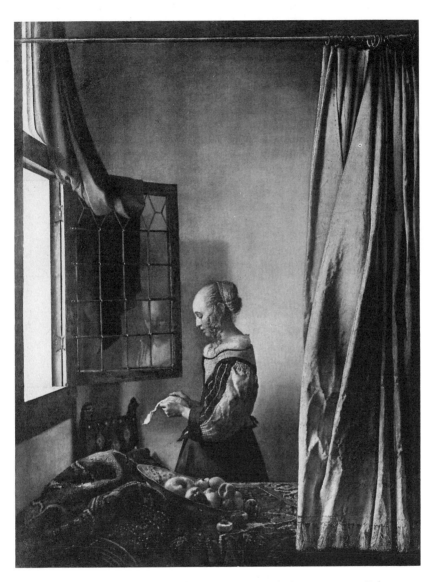

Figure 9.3 Johannes Vermeer, *Young Girl Reading a Letter*, Staatliche Kunstsammlungen, Dresden, Gemäldegalerie Alte Meister (courtesy: Alinari/Art Resource, New York)

Figure 9.4 Elijah Moshinsky, Angela Down as Helena in Elijah Moshinsky's *All's Well That Ends Well* (courtesy: British Broadcasting Corporation)

One pedagogical lesson from Miller's videotape might be the realization that the ability to behold objects in *All's Well* allows the spectator, as Diana suggests, now to "behold the meaning." The value and pleasure of reading Shakespeare through video derives partially from our acknowledgment of the mixture of disciplinary conventions. When the citations from Dutch painting enhance our vision of *All's Well*, they do so because they are recognizable, because they address themselves, in the words of Lyotard, "to the memory of the eye, to the synchronizing signs of fixating identification, known in the sense of the 'well known,' the conventional" (Lyotard 1986: 210). It might be said, especially in the context of the contemporary pedagogy of video, that the viewers' appreciation of and debt to Moshinky's project is related to their accomplishment in remembering Vermeer, de Hooch, de Witte, to their sensitivity to the importance of visual objectification in the world of Shakespeare, and to their ability to recognize how the mixed conventions of text, painting, and video coalesce in reading and performance.

CAMERA OBSCURA

Those spectators in search of a scientific model of such memory may recall the features of the camera obscura used to frame images by Dutch

painters, especially Vermeer.[11] The camera obscura is a darkened box having an aperture, fitted with a lens, through which light enters to form reversed images of external objects on the opposite surface. Dutch artists sometimes modeled their pictures after the abnormal photographic image acquired through the refraction of the lens, one sometimes supplemented by an angled mirror inside the box. This dark device of monocular perspective provided a painter like Vermeer with a third eye enabling him to achieve the weak fiction of stable perspective in his paintings. "Rather than serving as an access to a constructed image of the visible world," the camera obscura, argues Svetlana Alpers, "supplies the visible world direct empirical evidence, as it were, which the artist then uses in his art . . . Instead of finding a direct confrontation with nature, we find a trust to devices, to intermediaries that represent nature to us. The major example is the lens" (Alpers 1983: 32). By enhancing such a trust in the (single) lens, the camera obscura brings with it, of course, significant ideological baggage. As Jonathan Crary maintains, "it was an apparatus that guaranteed access to an objective truth about the world. It assumed importance as a model both for the observer of empirical phenomenon and for reflective introspection and self-observation" (Crary 1988: 31). Much like the televisual box of today, the camera obscura, in Crary's words,

> is a figure for the observer who is nominally a free sovereign individual but who is also a privatized isolated subject enclosed in a quasi-domestic space separated from a public exterior world. It defined an observer who was subjected to an inflexible set of positions and divisions. The visual world could be appropriated by an autonomous subject but only as a private unitary consciousness detached from any active relation with an exterior. The monadic viewpoint of the individual is legitimized by the camera obscura, but his or her sensory experience is subordinated to an external and pre-given world of objective truth.
>
> (Crary 1988: 33)

While Elijah Moshinsky turned from camera obscura to camera videa, this model of self-observation grounded in empirical evidence provides his audience with precisely the sort of introspective relation that motivates his artistic references: "the reason why I quote has to do with wanting to build up a mythology. There should be a double feeling, one, that it is beautiful, two, that it is something recognized, something you have either dreamed or seen before" (Moshinsky 1986: 126).

The haunting nature of such a double feeling is what should not be overlooked. For isn't it precisely the "look back" of retrospection, dream, and fantasy that so readily dispels the fetishistic comfort of the beautiful? Does not the memory of the joys of the figural lay bare the doubleness of

feeling so denied by the ideology of the visible: that in gazing on the blackened silhouette of the beautiful Helena, viewers note the representational fissures of the shadow of a wife or the figure of a French withered pear or the re-presentation of a virgin, "the name and not the thing?" Such a double, uncanny feeling has itself been attributed to the camera obscura by Sarah Kofman. In *Camera obscura: de l'idéologie*, Kofman emphasizes just such a mythological effect of the apparatus. Referring to Marx's use of the camera obscura as a metaphor of ideology,[12] Kofman notes that

> Ideology, the dark chamber, is charged with all the connotations that count in the unconscious and mythological thought. Ideology represents real relations which are veiled, enveloped. Rather than serving as a transparent copy obedient to the laws of perspective, it functions as a simulacrum: it disguises, masks, and clouds real relations. Marx opposes the camera obscura to the values of clarity, light, transparence, truth, and rationality. The camera obscura functions not as a fixed technical object whose effect is the inverse presentation of real relations, but rather as an apparatus of occultation that immerses consciousness in obscurity, evil, and error, that gives it vertigo, that makes it lose its equilibrium; an apparatus that makes real relations enigmatic and secret.
>
> (Kofman 1973: 28)[13]

While noting how much Kofman's 1973 notion of ideology remains caught up in the delimiting discourse of "false consciousness" (in sharp contrast, say, to Žižek's insistence that ideology offers "social reality itself as an escape from some traumatic, real kernel" 1989a: 45), I am interested in how the enigmatic effect of her camera obscura positions it, perhaps, less as a conventionally "ideological" one and more a fluid "uncanny" one. In this latter context of doubleness and uncanniness, Kofman's emphasis on the trope of the camera obscura maintains an energetic alliance with the psychic machinery of Laplanche's "enigmatic signifier" and Žižek's "traumatic, real kernel."

Just such a disarming, uncanny interpellation can be said to haunt the viewers of Moshinsky's tape who are confronted with specters they seem to have seen before. As they crack open the lattice windows of mnemonic vision, of camera obscura fantasy, they surely will be haunted by something, to quote Bertram, "greater than shows itself at the first view" (II.v.68). Underlying the satisfying aesthetic mixture of convention in Miller's *All's Well* is a paradox of doubled feeling that demystifies the ideology of the visible, a paradox deriving almost equally from the play of Shakespeare, the art of Vermeer, and the mechanics of video. While Vermeer affirms the powers of perspective in a painting like *Young Girl Reading a Letter* (Figure 9.3), he also includes the grotesque corollary of

her blurred vision in the window which is not recuperable by subject, artist, or spectator. Moshinsky creates a similar effect when he captures Helena in an illusive mirror reflection (Figure 9.1) designed to evoke Emmanuel de Witte's *Interior with a Harpsichord*. This is the shot following her speech of the memorable words denoting the condition of her visual entrapment:

> 'Twas pretty, though a plague,
> To see him every hour, to sit and draw
> His arched brows, his hawking eye, his curls,
> In our heart's table – heart too capable
> Of every line and trick of his sweet favor.
> But now he's gone, and my idolatrous fancy
> Must sanctify his relics.
>
> <div align="right">(I.i.92–98)</div>

It is by the eye, then, that idolatrous fancy wounds both lovers and viewers of *All's Well That Ends Well*. Seen in the image of desire is not only the elusive figure of Vermeer's anamorphic woman reading *in* the window, but something like the doubled features of the mythological Medusa, the eye and curls, whose prophylactic wounds Helena shares with her viewers. I stress prophylactic, here, in the sense developed by Ann Lecercle in her exceptional reading of the play's "fistuline logic:"

> If she has been wounded in the eye, and suffers in the eye, it is by the eye she will heal ... In Greek, such a remedy went by the name of *baskanion*, in Latin *fascinus* ... The phallus [as figure of an ejaculation or irradiation of the eye] is both *apotropaion* and that against which it is turned: repetition (the same representation) and reversal (direction of its influences).
>
> <div align="right">(Lecercle 1986: 111)[14]</div>

Is it not just such a "double feeling" of desire's representations and reversals that motivates idolatrous fancy in *All's Well That Ends Well*? The double feeling of desire, "the fascination of the picture," literally calls the spectators into the mirrorical[15] image and represents them there as caught in the identificatory states of captivation and loss – very much as Lacan describes the anamorphic stain disturbing the viewers of Holbein's *The Ambassadors* who, being satisfied by the fetishistic disavowal of comfort and mastery, turn away from the deceiving mythology of the painting's beauty only to be surprised by the arresting vision of the anamorphic skull.[16]

"A MOST HIDEOUS OBJECT"

What else, then, is figured by the video's first distorted images of Helena than a perspective gone awry? From the moment of its opening capture

of Helena in the distortion of the mirror, this tape suggests that conventional figuration and trust in the visible involve a sickness of the eye, a displacement of vision through which, as Bertram explains,

> Contempt his scornful perspective did lend me,
> Which warp'd the line of every other favor,
> Scorn'd a fair color or express'd it stol'n,
> Extended or contracted all proportions
> To a most hideous object.

<div align="right">(V.iii.48–52)</div>

All's Well never clearly shows us whether Bertram finally accepts the hideous object after he acknowledges its presence in Act V. Instead the text and video emphasize the frailty of the ideology of the visible. In one of the more memorable moments of both, for example, the ill King musters up his final reserves to warn his young lords against the menace of the invisible, the unanswerable, the free speech of the warped girls of dark Italy: "take heed of them. / They say our French lack language to deny / if they demand. / Beware of being captives / Before you serve" (II.i.19–22). Latent in this advice is the acknowledgment of a threat to the visible by what is seductively silencing, opaque, forceful as the Other, by what is figured as Woman and as irremediably enigmatic to the dull codes of monocular perspective. Ironically, Bertram seeks the dark fields of Italy to flee a similar threat from what he terms, in the accepted Rowe edition, "the dark house and the detested wife" of Rossillion (II.iii.292), or what the First Folio would have him describe as "the dark house and the *detected* wife" (my emphasis). This apparent slip of the Folio text functions in Freudian fashion to highlight the script's play on the detection of the detested body, that of difference otherwise veiled in enigmatic darkness. The line's indirect repetition of Parolles's prior warning, "He wears his honor in a box unseen, / That hugs his kicky-wicky here at home" (II.iii.279–80), illustrates the phantasmic depth of the Folio's slip. Suggesting widespread cultural as well as individual anxiety, such sexual objectification of ocular difference reveals the courtier's semiconsciousness of the allusiveness of the specular Other. It highlights the psychological and ideological links of the visible to the unseen spaces of birth and sexual virility.

In Moshinsky's video, a deep kiss between the weakened King and the traitorous Helena performs this suggestion that the strength of patriarchal perspective depends on its supplementation "in a box unseen, / That hugs its kicky-wicky here at home." I want to recall this sexual moment in the King's death chamber because of the daring interpretative liberty which Moshinsky took in staging it. When asked at a Montpellier conference on *All's Well That Ends Well* whether the kiss might not be too explicit, Moshinsky fudged by deferring to the dramatic liberty of his

actors: "The actors, through rehearsal, started to find the situation very sexy" (Moshinksy 1986: 132). Moshinsky just as easily, and more persuasively, could have cited historical grounds to justify the critical import of the kiss. First, such sexual slippage between barriers of age and class are in keeping with the bawdy tradition of the play's sources, Boccaccio's *Decameron* and Painter's *The Palace of Pleasure*. I do not suppose that Moshinsky would claim that the particular tale of Giletta and Beltramo puts Helena into the bed of the ailing King. But this literary tradition of sexually assertive females may well linger behind the second possible justification for the kiss. Now I am thinking of Shakespeare's text in which Helena claims that there is something in her cure "More than my father's skill, which was the great'st / Of his profession" (I.iii.242–44). This something "more," this "je ne sais quoi," relates metonymically to Helena's visual presence, on which Lafew focuses when encouraging the King to "see" her:

> I have seen a medicine
> That's able to breathe life into a stone,
> Quicken a rock, and make you dance canary
> With spritely fire and motion, whose simple touch
> Is powerful to araise King Pippen.
>
> (II.i.72–76)

Compounded by Lafew's other remark, "I am Cressid's uncle / That dare leave two together" (II.i.97–98), this scene has been read by Barbara Hodgdon to have all the trappings of an illicit encounter: "the exchange of vows, sealed with a handclasp, and the absence of a 'love scene' so far in a play concerned with romance invite reading at least an implicit current of sexual attraction between Helena and the King" (Hodgdon 1987: 53).

It would not be unreasonable, however, for some readers to challenge this passage's allowance for medication of a sexual kind, especially between the King and the daughter of his respected friend. Add to this the unseemly breach of courtly trust to be committed by the King were he later to pass off to his courtiers such a spritely young woman as a virgin worthy of marriage. But the dependability of the dramatic grounds of such reservations, courtly decorum and patriarchal loyalty, are rendered unstable by an additional source with canonical links to Shakespeare studies, although an eighteenth-century one. In his *Life of Samuel Johnson*, Boswell relates how he and Johnson discussed the following case:

> Suppose a man has a daughter, who he knows has been seduced, but her misfortune is concealed from the world: should he keep her in his house? Would he not, by doing so, be accessory to

imposition? And, perhaps, a worthy, unsuspecting man might come and marry this woman, unless the father inform him of the truth.

(Boswell 1948: 357)

To which Johnson responds:

Sir, he is accessory to no imposition. His daughter is in his house; and if a man courts her, he takes his chance . . . we are to judge of one another's characters as well as we can; and a man is not bound, in honesty or honour, to tell us the faults of his daughter or of himself. A man who has debauched his friend's daughter is not obliged to say to every body – "Take care of me; don't let me enter your house without suspicion. I once debauched a friend's daughter. I may debauch yours."

(Boswell 1948: 357)

In providing twentieth-century readers with such a revealing, historical example of the scope of the imaginative norms of male bonding, Boswell's eighteenth-century account of female exchange supplements earlier fictional anecdotes from the likes of Boccaccio and Painter. These and other examples from literary history, its fictions and its fables, provide notable, critical indexes for consideration of Shakespeare's more veiled references to patriarchal fantasies of "exchange" with the daughters of dramatic literature. They illustrate the extent to which Helena's touch might be credibly understood to be as literal as it is figural.

KINSEY-WINSEY FANTASY

But even in view of such contextual evidence in support of Moshinsky's staging of Helena's bedroom physic, some readers would be justified in saying that this melodramatic scene succumbs to the phallocratic ideology of the visible. This is suggested by Moshinsky's need to objectify Helena's pharmakon, her "third eye," in the figure of a kiss. After all, Shakespeare relied on his rhetorical prowess to frame this moment in something like a box unseen that obscures our view of exactly what act of medicine leads to the exchange of a ring in this case. I would counter that by presenting only one teasingly abbreviated shot of the King embracing his medicinal kicky-wicky, that is to say, by showing only the kiss and leaving open the ambiguous possibility of something more climactic than a kiss, the video transforms a moment of visual objectification into one of specular distortion. To envision exactly how the King's ring both "'Twas mine, 'twas Helen's" (V.iii.104), the viewers themselves must supplement through fantasy the enigma of exchange that here surpasses the realism of video verité.

210

It is not inconsequential that the need for such supplementation is inherent in the vision of a kicky-wicky. The Oxford English Dictionary tells us that a kicky-wicky is comparable to a "kinsey-winsey" as a sort of humorous linguistic formation. The particular function of kicky-wicky is to signify "a jocular or ludicrous term for a wife" (OED). Kicky-wicky, then, is less a wife than a term for the wife-as-supplement, a demeaning representation of the post-virginal female as but a matrimonial "left-over." Of course, Freud would caution viewers to be attentive to the jocular status of this term. As a trope of humor, it reveals more about the anxious agent of the joke, the man who "has" the left-overs, than it does about the butt of the joke, the woman who "is" the left-over.[17] In *All's Well That Ends Well*, kicky-wicky is clearly one of those telling signifiers of the sexual anxiety displayed by men like Bertram who quickly lose interest in the virgins they readily despoil. Adelman links this anxiety to male sexuality itself: "the fantasied act of despoiling virginity seems to be the only source of sexual desire . . . [which] underscores the deep incompatibility that separates sexuality from marriage" (Adelman 1992: 78). Even when marriage takes place in *All's Well That Ends Well*, she adds, the scars of anxiety (over "rapacious woman"?) remain deeply etched in the bridal bed. Shifting to the Lacanian terms of Susan Snyder's reading of the play, I am inclined to add that such deep incompatibility is inscribed in the sexual rhythms of deferral itself, that it figures, like a kicky-wicky, "a kind of 'reference back' to the woman who isn't there, highlighting the lack that propels desire" (Snyder 1992: 26).

The OED's reference to the synonym of kicky-wicky, "kinsey-winsey," aligns the supplemental nature of the representation of desire with the ocular strategies of Moshinsky's video production. The "kinsey-winsey," "a fantastic device; whim or erratic fancy" (OED), is rendered visible in Moshinsky's sequence of the effects of Helena's memorable kiss, a sequence that puns not only on Helena's "idolatrous fancy" but on the fantastic representational device underlying both Moshinsky's video technique and the Dutch pictorial conventions of "readily intelligible perspective" so valued by Miller. As a representation of the effects of the kiss, the camera tracks the couple's libidinal dancing through the palace hall, and then rests with a wide shot of the coranto performance before the assembled young lords. This bizarre tableau of baroque *jouissance* is supplemented by two equally fantastic devices that work to disrupt the spectators' passive relation to the action. The camera's tracking of the coranto is disrupted by a series of silent interruptions of the soundtrack that transform the loud and happy dance into an eery dumb show. This strategy of silence is extremely unusual for a mainstream television production whose display of imagery is conventionally subordinate to the use of sound that summons the domestic viewer back to the screen for an added look at what has just occurred.[18] In Moshinsky's *All's Well*

That Ends Well, the converse of "empty sound" confronts the viewers with the melancholic silence of a full screen. These linguistic gaps, so noticeable in a televisual adaptation of dramatic poetry, are then accompanied by a camera angle which is equally erratic in a video production of such relatively conservative technique. The spectators are suddenly confronted with a disorienting shot whose point of view shifts from wide angle at ground level to a sharp angle looking down through the frame of an *oeil de boeuf* above the hall – both the aperture of the *oeil de boeuf* and its frame are shown to the viewers (Figure 9.5). Very much unlike Vermeer's method of realist painting in a box unseen, this fantastic change of camera position and the carefully framed *oeil de boeuf* remind viewers that the final move of Helena's plot is but the visual finale of a carefully designed project of illusionary effects.

By so reading the text, the videotape demystifies its own technological complicity in the ideology of the visible. In showing the viewer its method of capturing the hall in a monocular gaze whose transcendence is tenuous at best (indeed, before the viewers are confronted with the shot through the glass, there is an initial moment when the vision seems to be reflected, as if shot through the glaze of a decorative mirror), the videotape suggests its kinship to another Dutch technique of mixing the illusions of painting

Figure 9.5 Elijah Moshinsky, crane shot reveals window frame showing Helena (Angela Down) dancing with France (Donald Sinden) in Elijah Moshinksy's *All's Well That Ends Well* (courtesy: British Broadcasting Corporation)

with the demystifying mechanics of perspectival representation. I am now thinking of Samuel Van Hoogstraten's *Perspective Box* in the National Gallery, London. The incomplete, disproportional, extended, and contracted objects inside the box are made to seem perfect only by their vision through the hole of an aperture on an outside wall of the box. At issue in the Dutch peep-box is the foregrounding of sight as the representation of vision's numerous distortions.[19] Vision, that is, functions as the concave screen joining the doubled feelings of need and desire, of the demand for corporeal contact and the lack of its sustenance. Through the technological displacement of perspectival play from peep show to video production, Moshinsky's camera provides the viewers with a moment of silent gaze at the medicinal powers of Helena, her representational mysteries, and their own visual incertitudes. Moshinsky's surprising re-figuration of the visual conventions of *All's Well* – text, video, and artistic corollary – ends up providing a sophisticated view of the disfiguring nature of the monocular apparatus. Belying the ideology of the visible, only the supplemental rings of empiric's triple eye, of virginal exchange, and of video technique sustain any hope for perspectival constancy in *All's Well That Ends Well*.

Add to Moshinsky's technique the closing scene of Shakespeare's play. Helena's final manipulation of visible proof in Act V leaves the viewer of the monocular videotape with a strong sense of the text's own disfiguration of the politics of visual constancy. The text makes clear that it only appears "all well" that Helena conquers her lover not with one ring exemplifying monocular perspective (and Moshinsky's single camera) but with two rings. The first is won by Helena at the bed of the sick King. The second is won by Diana, not Helena, through her seductive manipulation of the gullible Bertram. Like Moshinsky's doubled feelings, the double rings embody the hollowness of the admission of Helena's closing testimony: "If it appear not plain and prove untrue" (V.iii.317). Truth, in *All's Well That Ends Well*, is a matter of duplicitous appearance – just as Helena's unconventional response to the letter of Bertram's conditions is a matter of figural interpretation. What rings true in *All's Well* is neither visual mimesis nor narrative reconstruction "from point to point," which is to say, objective knowledge of the rings themselves. Rather, the performative acts of Moshinsky's ring-carriers – Helena, Diana, and the camera holder – lead the King, Bertram, and the audience of Shakespeare on video to supplement the weak truth of conventional perspective with the libidinal delight of kicksey-winsied fancy.

STAINED JUDGMENT?

But where, in conclusion, do the deconstructive delights of my reading of the Moshinsky videotape stand in relation to the more lasting conventions

of Shakespearean pedagogy? Faced with the dizzying technologies of the video and digital revolution, Shakespeare scholars might be tempted to join those characters of *All's Well That Ends Well* who have been trained to respond to crisis by multiplying the prescriptive presence of the letter. "Write, write," pleads Helena to the Countess who then repeats this prescription to her steward, "Write, write, Rinaldo." Theatre's academicians made nervous by the electronic pulsations of the new media might even speak the language of the King in their defense against the malady of video:

> The congregated college have concluded
> That laboring art can never ransom nature
> From her inaidable estate. I say we must not
> So stain our judgment, or corrupt our hope,
> To prostitute our past-cure malady
> To empirics, or to dissever so
> Our great self and our credit, to esteem
> A senseless help, when help past sense we deem.
>
> (II.i.117–24)

Still, the King joins the Widow in the stain of prostitution for the purpose of reviving his senses dulled by the conventional treatments of the College. So it is, I would like to suggest in conclusion, that scholars of Shakespeare are now faced with a similar, albeit anxious, opportunity. Perhaps we can contribute anew to the visual strength of the Shakespearean text by lustily embracing the idolatrous fancies of video . . . in all of its "fistuline logic."

NOTES

1 I discuss this mode of Renaissance theatre advertising in *Theatrical Legitimation* (1987: 34–38).

2 Readers familiar with television theory will recognize that Altman (1986) here dialogues with a point made earlier by John Ellis that television's regime of vision is one of the glance instead of the gaze:

> The gaze implies a concentration of the spectator's activity into that of looking, the glance implies that no extraordinary effort is being invested in the activity of looking. The very terms we habitually use to designate the person who watches TV or the cinema screen tend to indicate this difference. The cinema-looker is a spectator: caught by the projection yet separate from its illusion. The TV-looker is a viewer, casting a lazy eye over proceedings, keeping an eye on events, or, as the slightly archaic designation had it, "looking in." In psychoanalytic terms, when compared to cinema, TV demonstrates a displacement from the invocatory drive of scopophilia (looking) to the closest related of the invocatory drives, that of hearing.
>
> (Ellis 1982: 137)

214

3 See also Kristeva's analysis of the psychoanalytical significance of marriage in *Romeo and Juliet* which I summarize in Chapter Four.

4 This adaptation took place in *Moonlighting*'s 1986–87 episode, "Atomic Shakespeare." Radner (1990) reads this episode in terms of its representation of feminine identity.

5 Doane (1991:17–43) has developed the most helpful arguments linking Riviere's theories to the feminist analysis of film.

6 See the discussion of Miller's controversial *Antony and Cleopatra* by Bulman (1988: 54).

7 See my discussion of "the ideology of the visible" in Chapter Seven. In "Answering the Question: What is Postmodernism?," the Appendix to *The Postmodern Condition*, Lyotard (1984a: 74) compares the art-historical concerns with perspectival painting with the impact of photography and cinema on perspectival thought and thereby provides a helpful overview of the ideology of the visible: "to stabilize the referent, to arrange it according to a point of view which endows it with a recognizable meaning, to reproduce the syntax and vocabulary which enable the addressee to decipher images and sequences quickly, and so to arrive easily at the consciousness of his own identity as well as the approval which he thereby receives from others – since such structures of images and sequences constitute a communication code among all of them." Baudry (1978, 1986a, 1986b) provides a thorough analysis of the philosophical and psychoanalytical conventions of visibility in the cinema.

8 See the concise discussion of the TV apparatus in Flitterman-Lewis (1987: 189–91).

9 I refer her to Luce Irigaray's well-known thesis (1985b: 170–71) that the chivalric code veils the triangular trading of women on which Occidental culture is based. Also refer to Rubin (1975) and Sedgwick (1985: 21–27).

10 See the excellent discussion of sexuality in *The Procuress* by Snow (1994: 66–81).

11 For an overview of Vermeer's use of the camera obscura, see Heinrich Schwarz (1966) and Bryson (1983: 87–131).

12 Kofman grounds her reading on remarks made by Marx and Engels in *The German Ideology* (1970: 47) concerning the camera obscura: "Consciousness can never be anything else than conscious existence, and the existence of men is their actual life-process. If in all ideology men and their circumstances appear upside-down as in a *camera obscura*, this phenomenon arises just as much from their historical life-process as the inversion of objects on the retina does from their physical life-process."

13 While noting how much Kofman's 1973 definition of ideology remains caught up in the discourse of "false consciousness" (in sharp contrast, say, to Žižek's insistence that ideology offers "social reality itself as an escape from some traumatic, real kernel" (1989a: 45)), I am interested in how the enigmatic effect of her camera obscura positions it, perhaps, less as an "ideological" one and more akin to something like Laplanche's "enigmatic signifier."

14 Kofman (1973: 69) relies on the same metaphor to describe the camera obscura: "the camera obscura is this magical apparatus that appeases horror: it functions as *apotropaion*."

15 I use the term "mirrorical" in reference to Duchamp who coined it to refer to his experiments, as described by Lyotard (1990: 96), with "metamorphoses of the forms recognizable by means of an operator of dissimulation, that of the Dedekindian 'cut' . . . in the infinity of mirrors that correspond to as many adjuncts of a break, *the series of other objects that this object also is*."

16 See my discussion of Lacan and *The Ambassadors* in Chapter Two.

17 In Chapter Five, I discussed Freud's understanding that jokes function as a release mechanism for the aggression of the joke teller as well for the willingness of the listener to enter into collusion with the teller at the expense of the listener. See Freud, *Jokes and their Relation to the Unconscious* (1953–74: VIII).

18 Many TV theoreticians argue that sound is the dominant structural agent of TV since only sound maintains contact with the distracted TV viewer at all times; this is because the TV viewer tends to be, as I mention above, a distracted looker, and not an attentive gazer. For significant analyses of TV sound, refer to Ellis (1982: 145–59); Altman (1987); Fiske and Hartley (1987); and Heath (1990).

19 For helpful theoretical discussions of the dynamics of the peep box and similar perspectival devices, see Alpers (1983: 26–71); Bryson (1983: 87–131); Damisch (1987: 343–407); Crary (1990: 25–66).

10

THE CONTRAST HURTS
Censoring the Ladies Liberty
in performance

> Then I remembered my constitutional right to the pursuit of
> happiness, which says: even if there is no such thing as happiness,
> I got a right to pursue it.
>> Lethal Weapon, in *The Lady Dick* by Holly Hughes

Two corollary binary oppositions have dominated artistic responses to
recent debates over National Endowment for the Arts (NEA) funding and
creative liberty: freedom versus censorship; individual expression versus
governmental prohibition. There is little doubt that such binaries reflect
the American habit of relying on the discourse of constitutional liberty
to make the case for artistic license. Some of America's most politicized
artists have adopted this universalistic strategy in response to repressive
charges made against them. Many activist art producers have relied
on claims of freedom of expression rather than analyzing the attack on
the critical imperatives of their work – even when the rhetorical thrust of
their art produces a blatantly political or theoretical message. Adoption
of this strategy responds primarily to the chilling reality that censorship,
but not misogyny, homophobia or racism, is what the sympathetic politi-
cians, journalists, and patrons seem to accept as an identifiable and
unacceptable threat to the arts. Nevertheless, it is precisely this equation
of liberty and anti-censorship that I would like to challenge here by
focusing on a few highly publicized attempts to regulate aesthetics over
the past two decades.

Since this chapter dwells more on conceptual tensions than on historical
details, permit me to open with some brief introductory remarks on the
paradox of censorship that guide my reflections. Even in the wake of
recent governmental attempts to banish formidable feminist and gay
projects in the arts, I wish to emphasize the paradox of the structural
necessity of censorship in any administration of aesthetics, be it public
or personal, political or psychoanalytical. For the economy of choice,
whether in practice or theory, always entails the articulation of critical
positions themselves governed by epistemological principles of selection
and regulation. At issue in the administration of aesthetics, I suggest,

is not so much the principle of artistic regulation itself as the aesthetic principles governing regulation, many of which can have exceptionally productive social effects.[1]

Of course, censorship's negative psycho-political effects are what fuel the anticensorial prejudice. Even the most fundamental aspect of censorship, that is, its constitutional role in psychic administration, can easily render the subject paranoid of its ever present pressures and powers. While censorship has been recognized since Freud as a fundamental attribute of productive libidinal communication (permitting preconscious communication between different ideational contents (Freud 1953–74: XVI, 593)), it is also understood in the same psychoanalytical context to serve as the core representational fabric of both repression and sublimation, of psychic regulation and intellectual productivity. In Freudian terms, censorship is what provides the agency of the super-ego's regulation of psychic waste "in keeping a watch over the actions and intentions of the ego and judging them" (Freud 1953–74: XVI, 765).[2] And one would have no difficulty, following Foucault, to relate the modernist psychoanalytical notions of internal, sadomasochistic surveillance to early modern social formations that relied on the same nexus of perfidious observation and judgment to maintain a paranoid economy of social harmony and cultural productivity. Stated succinctly: paranoia of censorship and its effects are constitutional attributes of the human psyche and its cultural manifestations.

Paradoxically, Freud himself fell prey to the same anti-censorial prejudice, which he theorized so well, by wishing to remove the receptive analyst from the troubling divisions of censorship. He recommends that the analyst maintain an "open line:"

> The doctor must put himself in a position to make use of everything he is told for the purposes of interpretation and of recognizing the concealed unconscious material without substituting a censorship of his own for the selection that the patient has foregone. To put it in a formula: he must turn his own unconscious like a receptive organ towards the transmitting unconscious of the patient. He must adjust himself to the patient as a telephone receiver is adjusted to the transmitting microphone. Just as the receiver converts back into sound-waves the electric oscillations in the telephone line which were set-up by sound waves, so the doctor's unconscious is able, from the derivates of the unconscious which are communicated to him, to reconstruct that unconscious, which has determined the patient's free associations.

> (Freud 1953-74: XII, 359–60)

Wishing to deny the steadfastness of the interpreter's censorial prejudice, which Lacan has since identified as a function of "counter-transference"

(Lacan 1991: 199–232), Freud equates the ideal analytical interaction with a transnarcissistic model of unmediated telecommunications. Freud's uncharacteristic trust in the freedom of expression belies, in much the same way as recent condemnations of artistic censorship, acknowledgment of the epistemological frames mediating any technological model of reception. This paradoxical tendency to link free and open reception to the disavowal of the censorial structures framing all communication is typical of the anti-censorial prejudice and its frequent blindness to the hegemonic discourse of liberty containing it. Just such a trust in the freedom and liberty of expression, whether the medium be telecommunications, transnarcissism, or artistic performance, is precisely what blinds the analyst, artist, and critic to the structural censors of power and surveillance on which they have been led all too passively to depend.[3]

CONSUMING LADY LIBERTY

If Freud had been writing in the more contemporary environment of postmodernism, he might have turned to a different kind of sensory device for his seductive model of open analytical reception. I am thinking of the temporary sound and light machine designed by Iannis Xenakis for the opening of the Paris Pompidou Center in the mid-seventies. This was a geodesic dome filled with hundreds of light bulbs and eight (I recall) laser beams bouncing off some forty tiny mirrors, all shifting and pulsating to the computer-controlled beat, to the gestus, of Xenakis's synthetic music. Inside this rhythmically blinding amoeba, the human spectators-as-performers became mesmerized by the "electric oscillations" of uncensored, phenomenological overkill, the postmodern victims of Artaudian assault. Much like Freud's infatuation with the open telephone line, Xenakis's interiorized spectacle may be representative of a bygone era in which the self-creating and self-consuming artistic machine was enough to wow its beholders into assuming the revolutionary importance of transnarcissistic engagement.[4] Under the veil of "uncensored" absorption, the novel glaze of laser-computer technology (perhaps like Freud's telephone) mystifies the ideological referents of the performative mechanics of reception, from the restricted use rights of international news satellites to the censorial power relations endorsed by seemingly benign technological celebrations.

These are the referents that framed the excessive restaging of an earlier technological artifact from France, one whose lights still point to the stars but in a way more vividly reinscribing technology in the realm of the Symbolic, in the name of the forefathers, in the hands of the protectors of cultural extravagance and its capitalistic simulacra. I refer to the unveiling of the American teen idol of the 1980s, not the young lady Madonna, but the older one with the face-lift, the Lady Liberty.

For one seemingly endless Fourth of July weekend in 1986, the American media mustered its best forces to transmit the electronic oscillations of the Liberty Weekend Celebration that commemorated the restored statue and the liberty for which it stands. At the time, I was particularly struck by the ease with which the Liberty Weekend Celebration was represented both as immediately visible to the entire world and as a necessarily enviable spectacle of capitalism's ideological freedoms and technological achievements. Attesting to Webster's definition of "technology" as "the totality of the means employed by a people to provide itself with the objects of material culture," corporate America continued to capitalize on the event for weeks after that "very special day" (to recall *The New York Times* headline of 5 July). Bloomingdales Department Store, for one, turned pride to capital with "our Liberty Shops for an un-ending variety of souvenirs," and, returning to the media concern of this chapter, "our Photo Essay and Video Tapes; documentation of the fabulous 4th. The magic is far from over. New York only." These alluring promises of unending delight appeared in fine print at the bottom of Bloomies' full-page newspaper advertisement on Sunday 13 July. Framed under the watchful eyes of "Miss Liberty," the ad copy exudes patriotic confidence: "Last weekend was for everyone. No exceptions. No one excluded. The city, the country, the world was invited, and all experienced a warm and positive celebration: a re-affirmation of our values and beliefs. It was a privilege for us to have contributed to this historic event." This remembrance humbly echoed earlier boasts by the ABC television commentators – you know the progressive ones like Ted Koppel and Barbara Walters – who just could not resist making claims that the celebrational weekend was staged "for the whole world to watch." From coast to coast, continent to continent, proud corporate sponsors, from ABC, AT&T, and Chrysler to the upbeat subsidiaries of Procter & Gamble (Joy, Bounce, Ivory, Always, Bounty, Pampers, Sure) pooled their resources in admiration and nostalgia to celebrate liberty, that singular product of American material culture. It took but a metonymic slide for the sponsors of the popular soap operas *Another World*, *As the World Turns*, *Guiding Light*, and *Search for Tomorrow*, to shift their endorsement from one televisual "star" to another.[5] Although capitalistic enterprises have been known to join television in making centralizing claims just as brash, the mere possibility that the "whole" world could be imagined to be tuned to the same picture for four days (as it *was* during the Gulf War) suggests the extent to which video technology has widened the potential of the limitless performance of political "freedom" as combined ideology/commodity.[6]

This is the performance of *techne* which Heidegger discussed in the fledgling years of video as something different from the neoclassical concept of theatre as a mirrorical picture of the world, as something fundamentally different from Aristotelian mimesis.

220

World picture, when understood essentially, does not mean a picture of the world but the world conceived and grasped as picture. What is, in its entirety, is now taken in such a way that it first is in being and only is in being to the extent that it is set up by man, who represents and sets forth.

(Heidegger 1977: 129–30)

Thus we have the reshaping of Lady Liberty from an oversized artistic gift that more or less haphazardly found itself poised opposite Ellis Island to a carefully crafted media event apparently giving the entire world no choice but to watch; for Liberty itself has become the "world picture." Liberty Weekend was uncanny in its embodiment of Heidegger's 1955 discussion which maintains that "the fundamental event of the modern age [is] the conquest of the world as picture . . . For the sake of this struggle of world views and in keeping with its meaning, man brings into play his unlimited power for the calculating, planning, and molding of all things" (Heidegger 1977: 134).[7] Heidegger's comments work in retrospect as a particularly accurate summary of the calculated staging of an American political spectacle, yet another instance of man locking his horns on to the politically feasible vision of the Virgin Mother (the "Lady"-"Miss").

The four-day birthday party was calculated to transmit a maternal image of an America politically unified by its commitment to liberty regardless of the deep divisions of race, gender, and class better signified by the statue's corrosion than by the revitalized Lady's debut. While the Campbell Soup Company strategically cut against the grain by advertising how "even in the shadow of her torch – homeless Americans go hungry," the opening night audience paid $5,000 a person to witness flag-waving testimonials by nostalgic Cold War entertainers and their buddy, President Ronald Reagan. The staged event of the statue's unveiling even glorified the form of technology then pushing the confrontation of world views to a breaking point. From a command post on Governor's Island, and in front of the same French President Mitterrand who had most recently refused to grant air rights to American bombers headed for Libya, Ronny Ray-gun relit the statue by pushing a button activating the laser beams of his Strategic Defense Initiative (the same nostalgic initiative with which the Republicans misguidedly hoped to fuel their 1996 presidential campaign). Here the unstable technology of war presented itself as a dependable and efficient agent of political spectacle – indeed, the theatrical delight of watching the technological wizardry of the former Hollywood cowboy no doubt won adherents to the Star Wars concept of nuclear war as universal video game (the conjoined military/political value of this popular medium is attested not only by the most recent "light shows" in the Persian Gulf but by the laser spectacle that delighted the

delegates and television viewers of the 1996 Democratic Convention in Chicago).[8]

Very much unlike the overly sensual production of Iannis Xenakis, the extravaganza of Liberty Weekend relied on the devices of technology to fortify through mechanical reproduction a sublimated and recognizable image of Liberty, standing forth for the whole world to admire. Even during the more subliminal moments of the celebration, its theatrical producers worked to maintain control of the image and its projection. I was struck, for example, by a moment during the popular culture extravaganza of the final evening when, just for a moment, the agency of the human body became one with the technological picture. Reminiscent of football card stunts, the exuberant crowd filling New Jersey's Giants Stadium held aloft colored flashlights to create a preconceived pattern of patriotic imagery (by now a trite stunt which seems to have been repeated during every Olympic ceremony since). Far more striking than the pictures themselves was the huge crowd's impromptu gasp at its own unrealized, representational potential. The public momentarily acknowledged its possession of the power and aura of the entertainer. And yet, before the spectators could usurp the liberty of performance either by replacing flashlight with flashbulb,[9] thus diminishing focus on the image of Liberty, or by deviating from the set agenda by bringing their own oscillating bodies into visual play, the dimmed stadium lights returned almost immediately to full force in order to illuminate the primary entertainment event. The television cameras followed suit by focusing on a moving platform whose dazzling lights eclipsed the human musicians performing on it.

Always in this careful televisual negotiation between ocular focus and blinding light rests what Lyotard calls the acinematic stuff of diversion and libidinal ruin, that which lays waste to the ordered economy of performance. Lyotard bases his analysis on a simple pyrotechnic example of the misspending of energy, a diversion ("*détournement*"), enjoyed by the child who lights a match:

> He produces, in his own movement, a simulacrum of pleasure in its so-called "death instinct" component. Thus if he is assuredly an artist by producing a simulacrum, he is one most of all because this simulacrum is not an object or worth valued for another object. It is not composed with these other objects, compensated for by them, enclosed in a whole ordered by constitutive laws (in a structured group, for example). On the contrary, it is essential that the entire erotic force invested in the simulacrum be promoted, raised, displayed, and burned in vain. It is thus that Adorno said the only truly great art is the making of fireworks: pyrotechnics would simulate perfectly the sterile consumption of energies in *jouissance*.
>
> (Lyotard 1986: 351)

Just such a marvelous consumption of energies captivated Liberty Weekend participants on the night of 4 July when New York Harbor was bombarded by a fireworks display of such unprecedented proportions that it has not been matched ever since. As a technological event deriving its energy from the wonder of the simulacrum, its brilliant defiance of complete visual recuperation forced the television networks to intercut still shots of the forgotten Lady, reminding the home viewer that the pyrotechnic bacchanal should be taken to symbolize a return to the principles of Liberty, not merely the coming of *jouissance*. From the viewpoint of a vicarious participant from upstate New York, I absorbed the electric oscillations of the cameras and mixing machines while wanting to resist their strategic attempts to fix my gaze on the look of the Lady and, thus, to capture, transmit, and maintain the world's picture of Liberty.

TELE-VISIONS

It is on this performative role of the apparatus and its inconstant attempts to stabilize the fluid and changeable referents of performance that we might focus as the ultimate paradox of Liberty Weekend. The technological process is what beckoned the majority of American spectators, those of us lacking the resources to join Ron and Nancy for $5,000, to approximate what Lyotard describes as mediated "consciousness of [our] own identity as well as the approval which [we] thereby receive from others – since such structures of images and sequences constitute a communication code among all of them" (Lyotard 1984a: 74). As I discussed in more detail in Chapter Seven, the camera as relay device and communication code is laden with a long history of increasingly complex ideological formations of technological and philosophical structures that position the development of the camera within the colonial history of Occidental humanism. Mimi White argues that the ocular project of American (commercial) television is to "engage in practices that assert unity and address the spectator-as-ideal-subject across temporal, spatial, and narrative diversity" (White 1987: 191). White here aligns the ideological theory of the film apparatus with that of the television camera. Her argument situates television in the legacy of the camera's relation to the colonial history of Occidental humanism. Although the visual aims of television do subscribe more to the "look" than to the "gaze," thus differing from the scopophiliac concentration of the cinema theorized by Pleynet, Baudry, and Comolli,[10] television can be said to embrace, even more fiercely than cinema ever has, the ideological function of the camera which is most significant to Pleynet: "the film camera is an ideological instrument in its own right, it expresses bourgeois ideology before expressing anything else . . . What needs to be shown is the meticulous way in which the construction of the camera is geared to 'rectify' any anomalies in perspective

in order to reproduce in all its authority the visual code laid down by renaissant humanism" (cited by Comolli 1977: 129).[11] As Bloomingdales might say, this system wants to leave room for "no exceptions. No one excluded."

It remains true, as stressed by feminist and revisionist film theoreticians, that such a model is flawed by its failure to account for historical alternatives to monocularity,[12] but television continues to produce new methods of addiction to the bourgeois ideology. Most significant is the displacement of divergent political representation which Stephen Heath argues to be endemic to television's

> recasting of the social into "the everyday," the culturalization of everyday life by and as television. Socio-political representation is turned into the commodification of a public that is television's economic representation of itself (its market existence); identities are levelled to that standard, the "other people" of the public (for the individual this is the serial consciousness that television gives: viewers are not me but all the others, and this is the same for everybody), and redeemed in the valuation of the everyday, constructed and presented as the truly real (television accounts for daily life: prime activity, taking up my time, and prime mode of its being, taking over reality in a constant domestic recycling in which the terms of my world are made and approved).
>
> (Heath 1990: 275)

The administration of such a world view operates according to the principle of consensus that we can agree on cognitive boundaries allowing us to recognize what lies inside or outside reality. Heath adds that such consensus departs from its liberal democratic model by being "determined." Determined, that is, in a way that shifts "pluralism and consensus from old notions of representation to the new conditions of multiplication and indifference: the maximum number of heterogeneous images in the maximum homogenization, the saturation of signs and messages, which is the reduction – the neutralization – of meaning, of representation (Heath 1990: 283).[13] Or put similarly in view of my attentiveness here to Liberty Weekend, television's commodification of a public permits the construction of an American "us," a united public of Americans reveling in their common liberty. Sustaining the celebration of freedom, then, are the well-established ideologies of consensus and visibility re-played by the media celebration of Liberty's spectacle: "All experienced a warm and positive celebration: a re-affirmation of our values and beliefs."

Suggested by the ease with which the television sponsors of the Liberty Weekend proclaimed its reaffirmation of liberty a teary-eyed success, not to mention the recent ready embrace of the discourse of "liberty" by

alternative artists faced with the prospects of censorship, the complicated marriage of spectacle, telecommunications, and censorship would benefit clearly from re-vision. Of necessity is a clearer articulation of the radical differential of power relations structuring the censorial scenes of the spectacle of consensus, from Freud's electric oscillations to Liberty's positive celebrations. This will require clarification of the censorial affect underlying all regulation of social discourse, something similar to what readers of this book may now recognize as being similar to Lyotard's differend: "a case of differend between two parties takes place when the 'regulation' of the conflict that opposes them is done in the idiom of one of the parties while the wrong suffered by the other is not signified in that idiom" (Lyotard 1988: 9). What remains to be a critical imperative of performance, politics, even psychoanalysis, suggests Lyotard, is the acknowledgment of differends by "finding idioms for them" (Lyotard 1988: 13).

Some theoreticians of performance, the most vocal being Richard Schechner and his academic theatre colleagues in "performance studies," would recommend turning our sights toward more primitive idioms of performance, in which spectacle is primarily a matter of the soul – whose manifestation is made corporeally immediate and fragile by the presence of participatory spectators. The hope here would be that anthropological absorption of non-Western performance would free theatre from the death of the absorptive gaze which Schechner thinks has been enhanced by contemporary theatrical experiments with the proscenium arch (say by Robert Wilson and Richard Foreman) or by performance art's flirtation with the technology of video representation.[14] I am reluctant, however, to place too much confidence in the promise of (not to mention the urgent need for) the immediate transcultural germination of performance studies. Being mindful, as a former student of comparative religion, of how the discourse on the primitive is framed by the Occidental epistemologies underlying academic study *per se*, I am more inclined to recommend facing head-on the censorious, Occidental ideology of the visible.[15]

This might entail further consideration of what I call "the theatricality of the van-guard."[16] Reworking the Utopian notion of the *avant-garde*, I choose to emphasize the paradoxical and censorial senses of the term suggested by the OED: *van*, "the fore or front part of a thing;" *guard*, "to find out or ascertain by watching," "to keep in check, control (thoughts, utterances)." In the context of the technology of performance, attentiveness to the theatricality of the van-guard would concentrate on two differend, although related, zones of material and conceptual phenomena: the hegemonic myth of unmediated reception and the attendant absorptive eye of the controlling world-picture; and, the continuous variations and disruptions of re-presentation and the concomitant demystification of the world-picture as an uncensored image of the imaginary relationship of individuals to the psycho-political conditions of their existence.[17]

225

In the pages that follow, I would like to sketch out a prolegomena to a future analysis of the theatricality of the van-guard, one that acknowledges the fine censorious fibers distinguishing the overlapping televisual constructs of omniscient sight and deconstructive performance.

In somewhat of a paradoxical move, I now turn directly to television for a theoretical model of the technological oscillations now dispelling the reality of the camera-subject match. While it is not difficult to note television's drive to control the world-picture, it is just as important to acknowledge how the apparatus of television actually disrupts the ocular model from which it descends. In her astute essay on "Psychoanalysis, Film, and Television," for instance, Sandy Flitterman-Lewis stresses television's swerve away from the cinematic model of identification. While noting that cinema's primary identification is based on the association of the spectator's gaze with that of the camera, she argues convincingly that television breaks down the voyeuristic structure of primary identification. As also theorized by Ellis, Fiske, and others, television differs from film by catering to a distracted home viewer with a variety of "looks," machineries, and transmissions. The "telespectator" never receives the kinds of sutured transmission which Hollywood film conventionalized and which Freud expected. Instead, "television's fractured viewing situation explodes this coherent entity, offering in the place of the 'transcendental subject' of cinematic viewing, numerous partial identifications, not with characters but with 'views'" (Flitterman-Lewis 1987: 190).[18] In this sense, then, we can expect the tele-visions of the Liberty Weekend Celebration to have been partial, if not "differend" and incommensurable with the aims of its political and corporate sponsors. While television exchange is not always up-front, I would argue that the theatricality of the van-guard, the performative watching over and judging of the fore and front part of the cultural thing, is inherent in the televisual.

This deconstructive potential to produce competing "censorious" views (what Freud calls communication between different ideational contents) is what the televisual apparatus shares with recent efforts in the field of experimental performance. With the aim of re-presenting Occidental humanism in the context of its colonializing systems of pictorialization, broad collaborative projects in performance and theory have been probing the differential relations of the technological to gender, race, and representation. Exemplary of such efforts are substantial performance pieces by Ntozake Shange, Robbie McCauley, Ping Chong, Guillermo Gómez-Peña, David Wojnarowicz, Carmelita Tropicana (Figure 10.1), and Susan Foster that situate the interrelated histories of spectacle and camera in relation to the politics of sexuality and colonialism (I would also include Foreman's departure from formalist aesthetics in *Africanus Instructus*).[19]

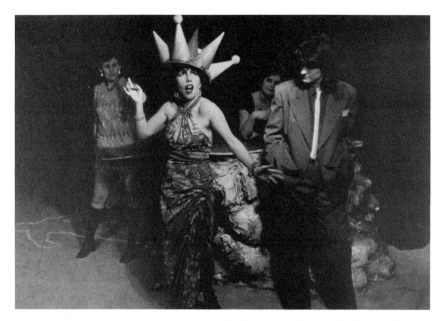

Figure 10.1 Carmelita Tropicana in Holly Hughes's *The Lady Dick*, WOW Cafe
(photo: Dona Ann McAdams; courtesy: The Aperture Foundation:
Caught in the Act: A Look at Contemporary Multimedia Performance, 1996)

In the mixed arena of text and performance, experiments with the theoretical frames of narrative also result in a better understanding of the role of Occidental technology as a hegemonic device of the world picture. Herbert Blau's performative essays on "Theatre at the Vanishing Point" extend his earlier work with the group KRAKEN into written enactments of the terror of theatre and its invisibilities. Just as significant is the continual influence of 1970s, feminist theoretical experiments with the inconstant look of female identity in psychoanalysis, for example, *Dora* by Hélène Cixous, *The Singular Life of Albert Nobbs* by Simone Benmussa, and *India Song* by Marguerite Duras.[20] These and similar pieces set the stage for the look's current reinscription in lesbian and gay performance, film, and video, as recently theorized, in *How Do I Look? Queer Film and Video*, by the activist reading group, Bad Object Choices (1991).

On the more specialized front of performance itself, feminist practitioners and theoreticians have embraced the "live act" as a strategy of further distancing female representation from the voyeuristic framings of male subjectivity and vision. Such distancing has been understood to occur both on conceptual and materialist grounds. It ranges from impromptu live performances in comedy clubs to elaborate scenarios by artists such as Linda Montano, Martha Rosler, Marina Abramovic (Figure

10.2), and Orlan which are designed to be complicated by the continuous variation of their performance on and for video. To Judith Butler, such "acts" of performance demand "a revision of the individualistic assumptions underlying the more restricted view of constituting acts within phenomenological discourse. As a given temporal duration within the entire performance, 'acts' are a shared experience and 'collective action'" (Butler 1990b: 276). Taking somewhat of a different view, Holly Hughes attributes this collectivity less to the theoretical conditions framing it than to the diversity of the performers themselves: "performance art is accessible to disenfranchised persons to express themselves – that's why it's under attack" (Hughes 1991b: 22). Finally, in an essay that aims to dwell on the conceptual interrelation of actress and "act," Jeannie Forte argues that the strong emphasis that performers like Hughes, McCauley, Rachel Rosenthal, and Karen Finley place on the female body and its many ethnic and erotic acts affords "the performance artist the possibility for frustrating fetishistic practices and asserting an alternative viewing practice" (Forte 1990: 261).[21]

Just such a frustration of fetishistic practices may well account for the NEA's 1990 refusal of the recommendation made by its peer-review committee to fund a piece by lesbian writer and performer Hughes, who

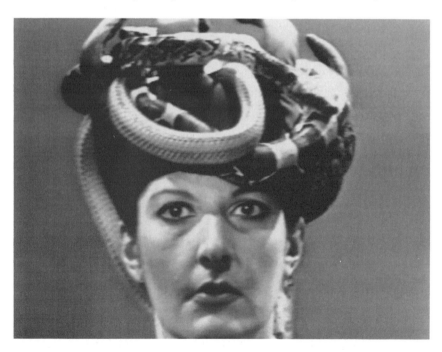

Figure 10.2 Marina Abramovic, *Becoming Visible*, World Wide Video Centre, The Hague

is especially well known for her work with the Split Britches Company of the WOW Cafe[22] (Hughes's piece was "defunded" along with three others by Finley, John Fleck, and Tim Miller that addressed issues of social oppression, sexual politics, AIDS, and homosexuality). The censorship of Hughes's performance piece, *The Lady Dick*, is especially pertinent to this discussion since it restages many of the feminist differends silenced by the idiom of the Lady Liberty Weekend Celebration. In this script, the character Garnet McClit, the Lady Dick, stands forth not as the beautified affirmation of phallocentric aesthetics but as the butch possessor of its vulnerable psycho-sexual authority, "a dick and lady at the same time" (Hughes 1991a: 297). If understood to speak on behalf of other silenced ladies, such as Liberty, the narratives performed by the butch's many femmes demystify the very conditions of oppressive sexual and social administration symbolized by the Lady Liberty Weekend. Angel, the true diva, laments that there will be no happy ending for her midwestern mother – "just clean sheets and boredom in a nice neighborhood" (while her dad was out "foolin' with cherries") (Hughes 1991a: 206). The femme tending a different sort of neighborhood is Con Carne who sports a colossal imitation of Lady Liberty's spiked tiara (see Figure 10.1). Played by Carmelita Tropicana, she is "the hot stuff with the meat," who owns The Pit, the club where lesbian seduction happily takes place. She stands in for the many women of color earlier forgotten by the American celebration of the European symbol of Liberty. As a disenfranchised Latina islander who was dragged unwillingly into the American way by colonialist economic enslavement, she recounts how her survival entailed numerous transformations of identity. Her autobiography spans from the lesbian innocence of her Latin paradise ("The rivers they run with rum. In the trees, the fruit. In the bushes, the girls. Everybody gay! Then one day your people come" (Hughes 1991a: 213)) to her current position as a bourgeois, bisexual entrepreneur ("'bi-sexual?' Is American way, no?" (Hughes 1991a: 213)). Only she possesses the tenuous authority to remind her butch Dick of her marginal place in the televisual scene: "Outside Con Carne's bar and grill you are a dirty joke. They see you and they think you runaway from freak show. When there is nothing buena on the TV you are what they watch for laughs" (Hughes 1991a: 213). Ultimately, *The Lady Dick* is a performance piece highly reflective of the irony of American freedom. Lethal Weapon, who makes the performers "feel as though they are being taken hostage," openly mimics the bland principles of Liberty adopted in 1990 by the American arts coalition, The National Campaign for Freedom of Expression: "Then I remembered my constitutional right to the pursuit of happiness, which says: even if there is no such thing as happiness, I got a right to pursue it" (Hughes 1991a: 212). Not coincidentally, Lethal Weapon is the character performed by Holly Hughes.

THE CONTRAST HURTS

The political friction of her lines is echoed by Hughes in her interview with Charles M. Wilmoth:

> The anticensorship movement has not made a case for validating controversial work, nor have they stated that these four defundings [of Hughes, Finley, Miller, and Fleck] are about sexual politics – and homophobia. They made this generalized appeal, talking about freedom of expression.
>
> Another failure was that, in the effort to save the NEA, there wasn't enough acknowledgment that the NEA was flawed. A whitewash was done on the NEA that it was this wonderful, perfect institution. But number one, it's way too small. There's not enough money, even in the best of circumstances, for it to do what it was chartered to do, which was to fund the cultural diversity of America.
>
> The second thing is that it can't do that because it's riddled with as much bigotry as the rest of the world. There's what Lynn Schuette of Sushi calls "structural discrimination." Most individuals and organizations that are coming from disenfranchised communities – because of class, race, geographical location, or whatever other factors make you an outsider, like being a queer artist – are unlikely to achieve enough visibility and legitimacy in the eyes of the NEA to get funded in the first place.
>
> (Hughes 1991b: 219–20)

An additional factor in the NEA equation is its sponsorship and control not only of live performance but of its cultural administration – its curatorial preservation, textual documentation, and critical evaluation. For Hughes and the other three artists who were refused funding, the representational fallout was enormous. Although the script of *The Lady Dick* was published by *TDR*, along with scripts by Fleck and Miller, even *The Lady Dick*'s inclusion in the journal's "Special NEA Supplement: Offensive Plays" carried the marks of broader cultural censorship. Its editors, Barbara Harrington and M. Elizabeth Hess, note their failure to publish a monograph of the artists' "obscene" texts which would have aimed to counter the reduction of media coverage of these artists to sensational sound bites: "Finley smears herself with chocolate; Miller wants Helms's porky pig face out of his asshole; Hughes' mother taught her to masturbate; and Fleck pees onstage" (Harrington and Hess 1991: 128). But their attempts to publish such a book "proved impossible for countless reasons, most of which stemmed from the nature of controversy and what exactly it does to people and art, and people in art" (Harrington and Hess 1991: 128). In terms of the mediated conditions of reception, then, these performative examples of the theatricality of the

van-guard challenge the broader cultural and political program of the regulation of performance as art – when it is appropriated as a cultural artifact for television broadcast, museum exhibition, academic analysis, and even department store display, all traditionally aiming to rigidify the attentive, unmediated gaze, the absorptive eye of the world-picture.[23]

At issue is how curators, critics, and teachers might turn to the exhibition, documentation, and academic re-presentation of performance art for the demystification of the world-picture, for the re-vision of per-formances framed by (un)familiar aesthetic environments and products. This matter, I feel, lies behind my initial reflections on the showing of Lady Liberty and any possible van-guard benefit we might derive from her unveiling. The problems raised by documentation do not merely revolve around matters of inclusion, *what* to document, but, more signifi-cantly, around questions of method, *how to document*, and, even more importantly, around the veiled issues of ideology, *document to what purpose, to what end, to what audience*. To repeat my introductory assertion, at issue in the administration of aesthetics is not so much the principle of artistic regulation itself as the oscillating aesthetic principles governing regulation.

I would like to elaborate on this point by rehearsing one more protracted clash between live performance and the administration of high culture. This one is from Paris, 1978. I begin with a story told by Derek Jarman about his trip to the Cannes Film Festival to screen *Jubilee* along with its star, the punker Jordan, known in fashion circles for her Lady Liberty-style hairdo (Figure 10.3).

> Jordan is at the height of her media fame as "punk princess," with her ripped Venus T-Shirt, Bunsen-burner hair and extrovert make-up . . . We stop in Paris and I take her to the Louvre to see Caravaggio's *Death of the Virgin*. As she walks through the gloom of the great galleries whole parties of soporific tourists switch their attention from the Poussins and Rembrandts and illuminate her with a thousand flashbulbs. All this reaches its climax in a momentous confrontation with the *Mona Lisa*. For the first time in her 470 or so years of existence the *Mona* is utterly upstaged; for a fleeting moment life triumphs over art. Then the walls open, guards rush out and bundle us into a secret lift; and we descend into a basement office where an embarrassed lady expels us from the gallery for "disturbing the aesthetic environment."
>
> (Jarman 1984: 11)

This is only part of the story. What Jarman apparently did not realize was that theirs was a performance waiting to happen. This was because their chance encounter with the *Mona Lisa* took place soon after the performance artist, Jean Dupuy, extended his invitation to forty artists to

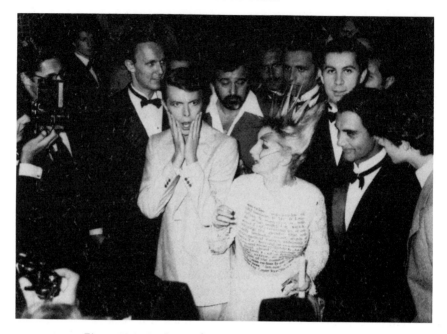

Figure 10.3 Jordan with David Bowie at Cannes, 1978,
Reprinted from Derek Jarman, *Dancing Ledge* (courtesy: Derek Jarman)

perform individual pieces in the Louvre on a Sunday, the day of free admission to the museum. While news of Jordan's visit to the Louvre seems to have eluded Dupuy, the specter of her illumination with a thousand flashbulbs may well have contributed to the museum's resistance to Dupuy's idea of "collective action," which developed into a performance piece of its own. First, the museum agreed to take only fifteen "actions" and only, in Dupuy's words, "on the condition that these performances be held according to the rules imposed on tourists, which means no permission to bring along any objects, no disturbing noise, no action which might hold up the flow of visitors or which might prove morally shocking, etc." (Dupuy 1980: 84). The show could go forward only on the condition that it contribute to the smooth administration of the aesthetics of the museum, to the moral conditions of quiet, privatized voyeurism. Second, after an initial agreement to allow a limited number of performers to invade the museum space on a Sunday afternoon, the only day of free admission, the Louvre attempted to coerce Dupuy into scheduling the performance on a Monday (the only day the museum is closed to the public). The result was a compromise, then violated by Dupuy, who invited more artists than agreed and who blocked the public passages of the Louvre by inviting spectators to sit on the floor and witness the subsequent unveiling of hidden contraband that desecrated the museum

space. The majority of the performances commented on the ideological and cultural codes of the museum, its art and moral assumptions. The group "Untel" wore pants, shirts, and jackets clearly marked with the sign of the limitations imposed on them, "*touriste.*" A more combative comment on the Louvre's contradictory moral code was made by a top-less Jacqueline Dauriac who, standing adjacent to the topless *Gabrielle d'Estrées and Sister*, held the exposed breast of her female partner to restage the painting's infamous nipple touch. Further commenting on painting's capitalization on the display of the female nude was Orlan's painting of her own crotch in front of a group of Rubenesque nudes – this was before she began altering her visage through cosmetic surgery to resemble and compete with the "Mona Lisa" (see Figure 10.4). What is more, these unwelcome "tourists" contributed to the subliminal threat of performance when someone set off three small smoke bombs, interrupt-ing – or rather, extending – the scope of artistic *jouissance*. Although this provoked the museum to close the Salle des Etats, the performances continued under tremendous tension only to be extended in the street where the artists were met by waiting police.

This charged example suggests the implications of regulating and documenting performative art according to museum codes of consensual visibility. Regulation here comes perilously close to the aesthetic and moral cleansing of an unpredictable event, and ends finally in a state of police surveillance of legitimate, institutionally sponsored aesthetics. In generating resistance through surveillance, Dupuy's performance event played out what he calls the gallery/museum/grants network: "We are not controlled by the classical structure of artist–gallery–collector–museum. In that structure, when you reach the museum, you are finished – you don't make anything new anymore" (Dupuy 1980: 84). Ironically, this is the same negative effect recounted by Hughes as the result of adminis-trative censorship: "It's been impossible for me to write anything creative since this happened" (Hughes 1991b: 220). The museum and its defensive economic network clearly stand counter to the creative oscillations of collective performance.

I cite this example, however, only to contrast it with an earlier, historical example of the necessary breakdown of documentation and its traditional inscription in patriarchal forms of power and gaze. Holbein's *The Ambassadors* (see Figure 2.1) provides a perfect example of the early aims of documentation. This is, of course, the well-known sixteenth-century portrait whose two ambassadors pose among the products of their cultural and imperial activities. What is clearly of value here is less the art of portraiture than the desire for wealth and power represented by the portrayal of accumulation and patronage. This portrait is made even more fascinating by the curious anamorphic image competing with the ambassadors in the low, frontal plane of the picture. If viewed from

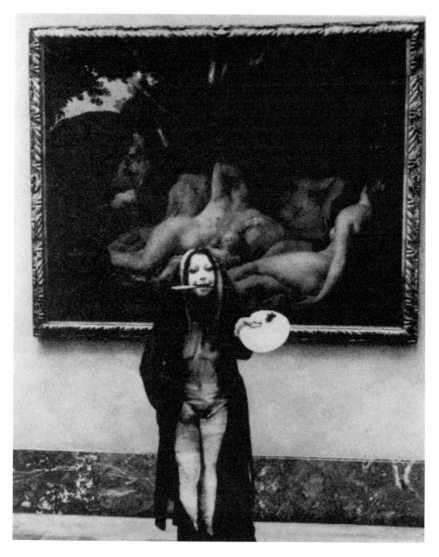

Figure 10.4 Orlan in Jean Dupuy's *Art Performance/One Minute*, Louvre, Paris, October 1978 (photo by and courtesy of André Morain)

the side, it appears to be an uncanny representation of a skull. To repeat a question I posed at the outset of this volume, might this not suggest that any representation of power, accumulation, or wealth inscribes itself in a drive toward death, toward fragmentation, or even toward deconstructive, split-vision?[24] What this picture provides is documentation of a different sort of libidinal enterprise, the fateful performance of the body

in continuous variation which performance art reminds us underlies all aesthetics. Such alternative vision of de-composition is reminiscent of the conditions of documentation that too often repress the subliminal energies and texts underlying their own aesthetic regulations.[25]

Performance art, I want to suggest, re-presents a similar double-edged reversal of the van-guard that underlies traditional forms of aesthetic documentation. This is the documentation drive to release rather than repress the subliminal energies of the body, a drive not merely to make present and visible but more essentially to activate through representational absence and Otherness the sights and scenes which performances always face, but never face, through psychic voyeurism. In many ways, performance is haunted by the paradox of the documentation drive: that for it TO BE means for it also NOT TO BE. What drives both performance and documentation is the irreversibility of the differend, of the incompletions and vanishings of cultural administration.

In acknowledging the tension between the material restrictions of art documentation and the always incomplete subliminality of bodily and psychological performance, I wish to conclude by repeating the critical issue at stake: not the matter of artistic content, *what to document*, but the interrelation of method and ideology, *how to document* and *document to what end*. The consensual end of celebrating the Statue of Liberty points us in one clearly recognizable direction. AT&T's ad in *The New York Times*, 3 July 1986, is clear about its line:

> "Hello, AT&T? Could you give the Statue of Liberty a perm?" What John [Franey, a corrosion scientist] was worried about, as he perched high in the air above New York Harbor, was how he was going to help patch up the Statue of Liberty without it showing. Four hundred square feet of the old lady – including her curls and a nasty spot under her nose – were badly corroded . . . When you see Miss Liberty this weekend, we hope you'll admire her curls (and how nice her upper lip looks).

AT&T's aim is to reinscribe the Hollywood aesthetics of the female "look" into the zone of the gaze, thus patching up "the dreadful things that the environment does to materials" without it "showing." The lead taken most recently by performance art, however, has been to suggest that the aim of documenting performance art should result in the "end" of this notion of giving the Statue of Liberty an aesthetic *perm*anence, one recoupable only by the voyeuristic gaze and commodification of artifacts and artistic knowledge.

In fact, *The Ambassadors* can be cited again for pre-facing the transformation of the old lady into the attractive young miss, for it suggests that the ultimate strength of performance lies in the play of perspectives sensitizing spectators to the choices framing their own libidinal and

ideological re-presentation of aesthetic objects. In moving their bodies to enact the perspectival options of *The Ambassadors*, the viewers transfer art from canvas to spectatorial and performative space, thus *realizing* the side- and split-visions of aesthetic oscillation. The end here is not to present a sanitized image of the art of colonialization, but rather to provide memory traces of the differences enacted by visual immigration and its supplementary libidinal and material vanishings.

Enacting a corollary side-vision of how the Liberty Weekend Celebration might be documented as something other than a universally "warm and positive celebration," I close by citing, against the hopeful grain of Campbell Soup's corporate interests, a fragment from its ad on the repressed death drive of the American dream.

> At a birthday party, everybody should eat. For 100 years, the Statue of Liberty has welcomed the poor of other nations to a wealthier life in America. Yet today, on her nation's birthday – even in the shadow of her torch – homeless Americans go hungry. To the people who work at Campbell Soup Company, and to working people everywhere, their plight is especially painful. Because for so many of us, both as individuals and as corporations, the American dream *has* come true. The contrast hurts. And it should.

What else need be said to Campbell, AT&T, ABC, Bloomingdales, and let's not forget the Hollywood cowboy and his invited guests, but that electric oscillation and media-tion constitute the disfiguring death drive of Liberty's representation. No exceptions? No one excluded? The contrast hurts. And it should.

NOTES

1 This is the perceptive thesis developed by Kuhn (1988) in *Cinema, Censorship, and Sexuality 1909–1925*. For a broadly political, although not very nuanced, analysis of the history of censorship, see Jansen (1991). Burt (1994) provides an unusually broad historical and theoretical overview of literary and artistic censorship.

2 In "Freud and the Scene of Censorship," Levine (1994: 168–91) provides a subtle discussion of the paradox of censorship in Freud's theory of identification.

3 I do not mean to suggest, however, that acknowledgment of cultural power should necessarily mean resisting it at all costs. I strongly differ, for example, with the censorial position adopted by the feminist anti-pornographer, Catherine MacKinnon, who aligns all pornography with the sexuality of male supremacy that fuses "the erotization of dominance and submission with the social construction of male and female" (MacKinnon 1987: 172). This view condemns any sociosexual practice or representation that explores the fine fibers inscribing power in pleasure. For a welcome contrast to this position, see, among many others, Linda Williams, *Hard Core* (1989) as well as the contributions of Mandy Merck (1992) and Beverly Brown (1992) to the special issue of *Critical Quarterly* 34, 2 on "The Pornography Debate." These writers argue for

the potential sociopolitical value of heterogeneous sexual practice, especially in the realms of female and homosexual sexuality. Williams, Merck, and Brown develop positions made earlier by The Feminist Anti-Censorship Task-force (FACT) in its collection of textual responses to the anti-pornographers, along with hard-core imagery, *Caught Looking: Feminism, Pornography & Censorship* (1992).

4 On the vicissitudes of "the nerve-wracking immediacy" of the performative event, see Blau's wide-ranging chapter, "Repression, Pain, and the Participation Mystique" in *The Audience* (1990: 144–209). André Green argues (1997), in "The Psycho-analytic Reading of Tragedy", that "transnarcissism" is the essential psychoanalytic feature of aesthetics.

5 Complex analyses of the oscillation between product and soap opera are provided by Allen (1987), "The Guiding Light: Soap Opera as Economic Product and Cultural Development;" Joyrich (1988), "All That Television Allows: TV Melodrama, Postmodernism and Consumer Culture;" and Modleski (1982: 85–109), *Loving with a Vengeance: Mass-produced Fantasies for Women*. In contrast, see two analyses of how the soaps actually belie the patriarchal commodification of femininity on which their corporate sponsors depend, Flitterman-Lewis (1988), "All's Well That Doesn't End: Soap Operas and the Marriage Motif;" William Galperin (1988), "Sliding off the Stereotype: Gender Difference in the Future of Television."

6 In "Representing Television," Stephen Heath (1990: 267–302) credits television for refinement of "the supreme commodity-reality:" "the full alignment of representation with commodification and the solicitation of consumer desire." Also see Feuer's seminal essay (1983), "The Concept of Live Television: Ontology as Ideology;" and Gitlin (1987), "Prime Time Ideology: The Hegemonic Process in Television Entertainment."

7 Gregory Ulmer (1983: 83–110) provides a "grammatological" analysis of this text.

8 In *War and Cinema: The Logistics of Perception*, Virilio (1989) dwells productively on the seductive flow between the technologies of war and light "where technology finally exposes the whole world."

9 As if to attest to the ongoing media attempt to fortify through mechanical reproduction the ideology of the visible, the designers of the closing ceremonies of the Atlanta Olympic Games replaced the less spectacular flashlight show by issuing disposable cameras to all spectators for the purpose of staging a carefully staged "wave" of camera flash-bulbs – thus guaranteeing that the spectators' flashbulbs would not usurp the American televisual spectacle as had almost happened ten years earlier.

10 I refer again to Ellis's point (1982: 137) that "the cinema-looker is a spectator: caught by the projection yet separate from its illusion. The TV-looker is a viewer, casting a lazy eye over proceedings, keeping an eye on events, or, as slightly archaic designation had it, 'looking in'."

11 For elaborations on film's relation to perspectival theory, see Cha (1980), *Apparatus: Cinematographic Apparatus* and de Lauretis and Heath (1980), *The Cinematic Apparatus*.

12 Refer to Rose (1986); Penley (1989: 57–80); Doane (1991); Copjec (1982); de Lauretis (1987: 1–30), Trinh (1991: 81–105); Rodowick (1994: 67–110).

13 Below, I will develop a more optimistic reading of the inscription of heterogeneity in the "tele-visual."

14 See Schechner (1982; 1988); Schechner and Appel (1990); and Conquergood (1992).

15 See Foster (1985: 181–208); Spivak (1989b); and Trinh's discussion (1991: 185–99) of cultural alterity in the context of television. In the Introduction to *Like a Film* (Murray 1993: 1–21), I voice a similar caution about the casual dismissal of Occidental epistemology by many American multicultural critics.

16 I introduce and develop this concept in relation to theories of the avant-garde by Bürger (1984) and Hadjinicolaou (1982) in "Theatricality of the Van-guard: Ideology and Contemporary American Theatre" (Murray 1984).

17 I refer here to Gilles Deleuze's notion of "continuous variation" which he presents in a succinct fashion in his essay on Carmelo Bene (1997) and in more complicated detail in *Difference and Repetition* (1994) and in his book with Félix Guattari, *A Thousand Plateaus* (1987).

18 As a televiewer less convinced than Heath about the total neutralization of difference effected by television's heterogeneity, Flitterman-Lewis (1987: 203) stresses "the creation of a momentary *experience* in which time, memory, and fantasy converge . . . in keeping with television's fragmented subjectivity and its dispersion of viewing." For extensive discussions of the heterogeneity of televisual culture and response, see Fiske, *Television Culture* (1987) and Cubitt, *Timeshift* (1991). Although a similar model of video heterogeneity underlies Ulmer's (1989) call for "teletheory," a new critical practice and pedagogy, its efficicacy is questioned by Brunette and Wills (1993).

19 In addition to two excellent catalogues documenting this intersection, Herskowitz (1985), *New Performances on Film and Video*, and the Museum of Contemporary Hispanic Art, The New Museum of Contemporary Art, The Studio Museum in Harlem (1990), *The Decade Show*, see Sims (1988); Rivchin (1990); Murray (1990b).

20 For feminist theorizations of specular identifications in these texts, see Diamond (1985, 1992); Willis (1987); Case (1989b).

21 Also see de Lauretis "Sexual Indifference and Lesbian Representation" (1990).

22 On Holly Hughes and the WOW Cafe, see Solomon (1986); Case (1989b); Davy (1989); and Dolan (1988).

23 Margaret Morse's excellent essay, "An Ontology of Everyday Distraction" (1990) pursues the linkage of display shared by television, the mall, and the freeway. Crimp (1984: 49–81 and 1993) provides a history of the museum as an institution of regulatory practices; Pointon (1994) analyzes art institutions and ideology in America and England. Perhaps the greatest practice of artistic regulation, which I do not detail below, is the exclusion of broad classes of artists and their objects from consideration for exhibition. Eloquent discussions of the exclusion of women, women of color, and homosexuals by the museum/gallery nexus of art are provided by Piper (1990); Crimp and Rolston (1990: 12–25); Trinh (1991: 225–35); Schor (1990); and Berger (1990). Although Berger's critique of the 1989 New Museum of Contemporary Art exhibit, "Strange Attractors: Signs of Chaos," displays an impatience with the show's promising dialogue with "chaos theory," it opens by singling out the marginality of what I agree to have been the exhibition's most intriguing piece – David Hammons's mixed-media video installation in which a white mannequin head blankly watches a sixties television interview with Malcolm X.

24 It is in relation to a reading of *The Ambassadors* that Lacan (1978: 67–119) theorizes how the subject stands split between the competing constructions of the scopic field: the look and the gaze. Countering similar rejections by feminists wishing for a subject grounded more firmly in the Symbolic, Rose (1989: 25–39) dwells on the import of the death drive for a theory of female subjectivity.

25 In an argument directly related to the electronic oscillations of this chapter, Cubitt (1991: 180) argues that "a major function of new video will be to negotiate the mourning which we have never been able to conclude, to create forms in which the relation to death can be expressed, in which we can face the founding loss on which our [Anglo-European] culture and society [are] based." In acknowledgment of the dismissal of European psycho-philosophical reflections on death, mourning, and melancholy by American multicultural critics, I turn at different moments in *Like a Film* to AIDS discourse and to Julie Dash's African-American film, *Daughters of the Dust*, for politicized reflections on the cultural value of melancholic incorporation and its confusions.

11

TELEVISUAL FEARS
AND WARRIOR MYTHS
Mary Kelly meets Dawn DeDeaux

I preface this analysis of televisual masculinity and racial incorporation with an anecdote regarding recent debates over analytical method. I sat down to complete this text soon after chatting with the film and humanities editor of an influential university press. In response to my enthusiastic remarks about recent work on visuality in French psychoanalysis, the editor playfully voiced her suspicion that I would disagree with the spin cast by a midwest colleague whose historical and feminist work on cinema I strongly value. This materialist colleague was reported to insist that psychoanalytic film theory had spent all of its limited resources and met its death drive – her point being, no doubt, that this editor should shy away from publishing such deadly work.

My hunch is that the aggression behind this colleague's materialist spin reflects a well-meaning anxiety that desire has gone awry in visual studies, that psychoanalysis favors phantasmic generality over historical particularity, and that psychoanalytic formulations of language, spectatorial identification, voyeurism, masochism, and so on have left significant identity positions out of the game, especially those with racial, feminist, queer, and postcolonial inflections. (Laura Mulvey's chapter, "Visual Pleasure and Narrative Cinema" (1989: 14–26), is almost always naively singled out as the breeding ground of the problem.)[1] A typical instance of this complaint can be found in an anthologized essay by Jane Gaines, "White Privilege and Looking Relations: Race and Gender in Feminist Film Theory," that categorically dismisses psychoanalysis for its myopic consideration of influences of race and economics: "historical materialism cannot enter the space theorized by discourse analysis drawing on psychoanalytic concepts" (1990a: 210). Yet, recent work by feminist, African-American, and postcolonial theorists, from bell hooks and Diana Fuss to Kobena Mercer and Homi K. Bhabha, presents a much more balanced perspective of the potential value of psychoanalytic concepts for an understanding of contemporary culture. Calling for a new theorization of the black male body, Mercer insists that "it is in the domain of race, whose violent and sexy fantasia haunts America daily, that our need for

an understanding of the psychic reality of phantasm, and its effect in the body politic, is greatest" (Mercer 1994: 122). In only slight contrast, bell hooks provides a more circumspect overview of her investment in psychoanalysis:

> Individual black women doing feminist theory often found it difficult to constructively use psychoanalytical frameworks to discuss blackness because we felt work could not be done effectively without an initial interrogation or deconstruction of the ways in which racial and/or racist biases have informed psychoanalytic thinking, scholarship, and the academic field as well as the realm of clinical practice, in ways that devalue and exclude race. Despite these barriers, courageous individual critical thinkers are increasingly using psychoanalysis in discussions of race. It remains abundantly clear that it is useful for black critical thinkers (and our allies in struggle) to engage feminist theory and psychoanalysis as ways of knowing that broaden and illuminate our understanding of black subjectivity – of the black body.
>
> (hooks 1994: 129–29)

Even while promoting psychoanalysis, however, this passage frames its embrace of such an approach to subjectivity in ambivalence. It is important to acknowledge in making a case for psychoanalysis that recent claims of its usefulness are frequently tempered by acknowledgment of the discipline's historical leveling of distinctions of race, class, and sexuality. As hooks suggests, the pervasiveness of this leveling is precisely what lends an aura of credibility to the dismissal of psychoanalysis as a useful means of approaching black and feminist subjectivity.

The terms of this anxiety over the sociohistorical "leveling" of psychoanalysis correspond in an interesting way to Joan Copjec's summary of what she calls the "televisual fear" of Lacanian psychoanalysis. In her preface to the English translation of Lacan's dossier, *Television: A Challenge to the Psychoanalytic Establishment*, Copjec argues that attentiveness to the specificities of Lacanian analysis may help calm the "'televisual fear' that psychoanalysis addresses all in general in order to say nothing in particular" (Copjec 1990: 49). This fear is described by Copjec as "televisual" because of the means by which information about psychoanalysis has been disseminated in America. Copjec reflects on the fact that

> it is principally through [Lacan's] contributions to cultural theory – to theories of film, television, literature, and art – that his reputation has been established in this country [USA] . . . But while the expansion of this audience beyond simply the clinical community has sparked the vigorous and enthusiastic retheorization of disparate disciplines, it has also occasioned a global fear: that each

individual discipline is thereby reduced to some supposed lowest common denominator – language – and submitted to a master discourse – psychoanalysis. That which is feared to be lost is not only the specificity of disciplines, but also . . . the political force of analysis.

(Copjec 1990: 49)

Curiously, this concern about psychoanalytic loss of specificity and political force, "televisual fear," also fuels the dominant dismissal of its frightful carrier, television. Like psychoanalysis, television has been critiqued by a wide variety of hostile media theorists as a source of social "implosion" because it "absorbs all critical content and renders the medium impervious to critique" (Best and Kellner 1987: 103).[2] What remains, argues Mark Crispin Miller, are TV's addictive style and numbing habits of spectatorship that flatten out history, purpose, and value: "TV negates the very 'choices' that it now promotes with rising desperation . . . TV begins by offering us a beautiful hallucination of diversity, but it is finally like a drug whose high is only the conviction that its user is too cool to be addicted" (Miller 1986: 228).[3] It is strange, if not downright uncanny, that television and psychoanalysis have been summarily dismissed by many anxious critics with the same unwavering, materialist logic: either when desire goes awry or when flow annihilates depth, the political force of televisual analysis is said to suffer. But rather than disable the apparatuses of televisual fear, whether the magic writing pad or the home entertainment center, these enigmatic equations of the fearful cultures of psychoanalysis and television seem to have had just the opposite impact. My sense is that the discourse of televisual fear has enlivened recent cultural theory and artistic representations in ways so curious that they promise to catalyze critical productivity from generations of readers to come.

THE ARCHEOLOGY OF MATERIAL AFFECT

Consider the implications of two contrasting projects created around 1991 by the political artists, Mary Kelly and Dawn DeDeaux, who both fantasized about the probable results of future archeological digs in and around the urban areas of their studios in New York and New Orleans. Their projections of archeological finds of their own artistic materials place the flattening and implosive terms of televisual fear in high cultural relief. First, in "Magiciens de la Mer(d): Musée d'art subaltérranéen," a project solicited by *Artforum*, the conceptual, feminist artist Mary Kelly reported what archeologists excavating the Hudson River discovered from the late twentieth century, the period immediately preceding the Great Earthquake of 2001. Their most decisive find was a unique

collection of cans from the postmodern, Cult of Dejecta art movement. Of particular interest was "La Hudson Boîte en fer blanc #6" bearing the label "Pecunia non olet" (Figure 11.1). The precise attribution of La Boîte was left in doubt after carbon analysis identified it as a can of soup from Heinz, not Campbell, thus ruling out the craftsmanship of "the proto-postmoderne master of the soup can, Andrew (known as Handy) Warhol" (Kelly 1991: 91). Kelly recounts the subsequent speculations of museum specialists. I cite some of the more probable ones:

> The Cult of Dejecta can be traced to an earlier era and to the Italian innovator of container art, Cannzoni, who, it is claimed, preserved his own feces in this manner. The socio-psycho-symbolic significance of such actions has been the subject of a major controversy. Some take the view of Apter and Les Anciens, who portray it as a symptomatic consequence of a repression, namely l'érotisme anal. Within the sphere of global finance, argent sec replaced not only barter but the stickiness of coins. Thus capital no longer "smells;" yet once it is demystified, for instance by suppression of the "non," we realize that money (or pecunia) still stinks. All the same, this does not explain the meaning of the coprophilic trace that haunts La Boîte. Alternatively, Weiss et al. describe this inclination toward perversité as an inversion of the concept of the Kantian sublime. The countersublime, he says, marks our disgust with base materiality and thus entails a rediscovery of the body's waste.
>
> (Kelly 1991: 91)

What is fascinating about these archeological methods is their relation to the historical methodologies of the philosophy of the sublime and the economy of psychoanalysis, the procedures most frequently utilized by late twentieth-century theoreticians of poststructuralism to trace both affect and difference. Rather than understanding the enigmatic label, "Pecunia non olet," as a signifier of base material contents or the particular taste of soup, the psychoanalytic methods adopted by these archeologists focus on how "La Hudson Boîte en fer blanc #6" provides a conceptual container of economy: money doesn't smell. In her account of the dig, Kelly adds that the label also aligns this find with an infamous piece of Dejecta art which remains lost, one entitled "Pecunia Olet," from the series *Interim* by an unknown feminist artist "rumored to have had a penchant for both Latin and Dejecta." Thanks to this link, Kelly's archeologists of the future should eventually be able to relate the tin can as a container of the psychoanalytic economies of masquerade, repression, eroticism, and disgust recognized as being so important to the unknown artist's work. Thinking perhaps of its catalytic effect of televisual fear, Kelly adds, by the way, that the Cult of Dejecta was also known as "l'art pervers."

Figure 11.1 Mary Kelly "La Hudson Boîte en fer blanc #6," *Magiciens de la Mer(d),*
Artforum, January 1991 (photo: Ray Barrie)

The seeming perversity of this artwork becomes even more apparent when the postmodern findings made by Mary Kelly's Musée Sub-altéranéen are displayed alongside the postcolonial artifacts reproduced by Dawn DeDeaux, archeological treasures which are more likely to be housed in the Musée Subalterne. DeDeaux, a multimedia video artist from New Orleans, has crafted a "Civilization Series" around the results of similar digs in her Delta City which had been buried in volcanic ash. While her artifacts also suggest the harshness of late twentieth-century repression, their metal reflects a different crisis of bodily waste. Instead of a Warholesque can of tin, DeDeaux's archeologists found three mysterious items of compelling beauty which they catalogued as "Solid Gold Gun with 96 Diamonds" (Figure 11.2), "Solid Gold Rolex Watch," and "Word: Mouth with Four Gold Teeth, Thirteen Diamonds, and a Ten Inch Speaker." In pondering their likely significance to future archeologists, DeDeaux turns not to the economy of psychoanalysis but to the materiality of economy and its relation to the archeology of power. DeDeaux places her money on the possibility that the "Solid Gold Gun with 96 Diamonds" would point not to the psychoanalytical theorist, the TV critic, the art patron, the artist, the Mayor or the Senator, but to the young, urban warrior of color as the misunderstood subject of televisual fear and the indirect shaper of cultural policy way back when. She senses that archeologists would draw parallels between the gold teeth and gun medallions of today's urban youth and the golden booty of Tutankhamen, El Dorado, or the gilded treasures of temples and cathedrals. In DeDeaux's museum, the "Solid Gold Gun" would signify the quest for empowerment and the rites of power that so strongly bind the ages while remnants of ungilded iron, and not tin, would create historical links to young black bodies wasted by their bondage to shackles, bars, and bullets. Hers is a reflection not so much on the challenge to psychoanalytic theory posed by artistic waste and remnants of the sublime as on the palpable, material links of bondage, death, and survival to artistic production, corruption, and reception. Yet, what seems clear to this analyst is that DeDeaux's archeologists would have profited from an understanding of the psychic reality of racial and masculinist fantasy just as much as Kelly's would have benefited from greater sensitivity to the social rites of power signified by the American icon of the soup can and its selective dissemination in cultural circles.[4]

I begin with this comparison of art from futuristic museums not so much to favor one art project over the other as to establish a dialogue between the work of two significant political artists whose innovative experiments in installation derive from their backgrounds in film and video and their interests in the discourses of televisual fear. While Kelly's conceptual concern with sequence, visualization, fetishism, and the sublime reflects her training and involvement in the theoretical endeavors of

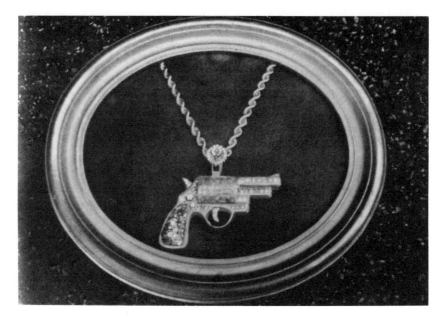

Figure 11.2 Dawn DeDeaux "Solid Gold Gun with 96 Diamonds,"
Civilization Series

avant-garde film, especially those politicized practices concerned with psychoanalysis and the representation of gender difference, DeDeaux's focus on materials of power and oppression stems from her interactive work in documentary video that emphasizes sociological issues and the impact of the "mass language" of the media on contemporary culture. It is just as notable, moreover, that the uncanny commonalities of their work also could be said to erode the unproductive political split now too often plaguing performance, film, video, art, and cultural studies between adherents of theoretical and psychoanalytical approaches to representation and proponents of material, social analyses of culture and power.

It is no mere coincidence that recent sociopolitical events compelled both artists to produce installation pieces that ponder the media's coverage of violent warfare and the pathological discourse of masculinity subtending it. I refer to Kelly's 1992 project, *Gloria Patri*, and DeDeaux's 1992–93 installation, *Soul Shadows: Urban Warrior Myths*.[5] While Kelly departs from media representations of the Gulf War, DeDeaux reflects on video accounts of b-boy style and adolescent urban warfare. Of special interest to me is how both artists appropriate various techniques of video and film for the performative ends of installation which so frequently contrast with those of cinema. While the use of real time and montage in

246

the political films of Straub and Huillet serve as the model of Kelly's project, the strategies of *video verité* and digital editing provide the technological backdrop for DeDeaux's installation. Both projects displace the visitors from cinema's darkened spaces of spectatorial identification to installation's interactive labyrinths of critical performance. By stressing the formal likenesses and differences of their appropriations and spectatorial situations, I also hope to emphasize the ideological cost of creating artistic and political barriers between materiality and affect. Consider, for example, the likely kinship of Kelly's psychoanalytical demystification of the televisual machineries of the Gulf War with DeDeaux's appropriation of the many sides of televisual media to highlight the culture of urban warfare that sustains and victimizes a young generation of color consumed by the everyday challenges of survival. When positioned in adjoining critical spaces, these installations of masculinity and race clarify the need to represent and understand the fantasy of the levelings of televisual fear. Fueled by the recent writings of theorists of race and postcoloniality, my readings will address the need of both installations to take into account the differing psycho-materialist sensibilities of each of these provocative and controversial artists. Put simply, Mary Kelly meets Dawn DeDeaux.

DISPLAYING THE SKIN OF THE SHIELD

Mary Kelly's *Gloria Patri* provides a polished reflection on the media blitz that subjected all telespectators, willing or not, to the censored image and soundbites of the Gulf War. Kelly created her installation in response to watching news commentators on television who were "watching the troops watch the spectacle of annihilation" (Kelly 1994). Catching her attention were both the commentator's inability to witness death and destruction without the mediations of the war's laser and video apparatuses, as well as what she calls "the gleam of the shield; that is, the façade of American militarism and what it revealed about the pathological structuring of masculinity" (Kelly 1994).

Spectators of *Gloria Patri* find themselves in a clean white space sparsely hung on three walls with multiple sequences of gleaming objects in polished steel (Figure 11.3). As installed at Cornell University's Herbert F. Johnson Museum of Art, each sequence is hung on a separate level, from eye level to ceiling height (at about sixteen feet). Close to the ceiling hangs a series of polished semaphores above a sequence of six equally spaced trophies attached by brackets to stand free of the wall. Situated lowest at eye level are five polished shields, each bearing a separate engraved narrative. Upon entering the room, viewers of *Gloria Patri* are struck by the visual impression of Kelly's orderly sequencing of design and layout, military hardware, textual narrative, and the brightly lit shine of polished steel. The bare display of the installation provides the

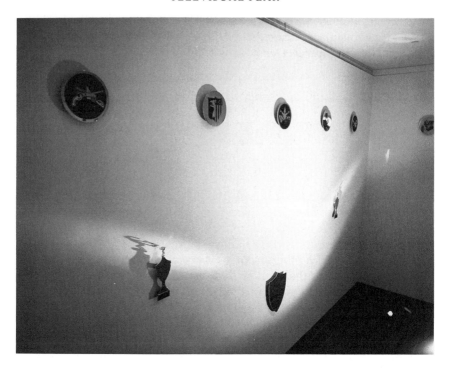

Figure 11.3 Mary Kelly, *Gloria Patri*, installation view, Herbert F. Johnson
Museum of Art, Cornell University, Ithaca, New York, 1992
(photo: Kelly Barrie)

setting for an attentive encounter with Kelly's allegorical reflection on the
cult of the warrior.

Kelly's installation takes up the theme of the shield to convey its
symbolic relation to the pathology of masculinity. In interviews and
essays written about *Gloria Patri*, Kelly situates this pathology in a twofold
theoretical context. One departs from Jacques Lacan's theory of masculine
display in *The Four Fundamental Concepts of Psychoanalysis*. Kelly cites the
following passage from Lacan:

> In the case of display, usually on the part of the male animal, or in
> the case of grimacing swelling by which the animal enters the play
> of combat in the form of intimidation, the being gives of himself, or
> receives from the other, something that is like a mask, a double, an
> envelope, a thrown-off skin, thrown off in order to cover the frame
> of a shield.

<div align="right">(Lacan 1978: 107)</div>

I will say more about the shield in a moment, especially how it frames the
other theoretical context of Kelly's show, the masculinist discourse of

machine technology. Referring to Klaus Theweleit's book, *Male Fantasies*, Kelly discusses this additional conceptual framework in her essay, "On Display: Not Enough Gees and Gollies to Describe It:"

> Theweleit fleshes out this psychic disposition in his analysis of the troop as so many polished components in a totality machine. This machine, he says, expresses a certain type of masculinity, a code between men that consolidates other totalities such as the nation. But unlike the proto-fascist Freikorps of the 1930s, the American military machine of the 1990s has a curious flatness. The display of technology, the shiny surface of the shield, is so replete in itself that it produces the individual soldiers as so many *un*polished components, unable to camouflage their human frailty, made vulnerable, ambivalent in relation to their role of mastery.[6]
>
> (Kelly 1994)

To represent the gleaming shield's ambivalent relation to psychic and mechanistic mastery, *Gloria Patri* thus presents its three concentric registers of combined visuals and texts on the pristine surfaces of polished aluminum. Although all three registers are hung in common dialogue, they each provide different analytic leads.

The set of twenty discs screenprinted on polished aluminum (Figure 11.4) represents the fantasy of the shiny surface of the fraternal insignia. Resembling military semaphores, the discs include insignia or semaphores from military fraternities, such as the Air Training Command, the Chemical Corps, and the Artillery Army Infantry. Rather than merely appropriating these coda, however, Kelly distorts them into monstrous montages by combining half of one emblem with half of another. Although civilian viewers uninitiated in military lore remain unsure of the precise coda presented by the artist, they easily notice the awkward visual distortions of the many insignia. Viewers familiar with Kelly's work sense that she is once again up to the tricks of her *art pervers* and its spectacle of semiotic enigma. In contrast, spectators belonging to the military brethren of hallowed warriors are confronted with the visual assault of misshapen hybridity against which their rigid semiotic systems are poised for defense. Imagine their disgust at the miscegenous conjointment of the semaphores of the Adjutant General Corps and the 101st Airmobile Division or the US Army Engineers and the Army Infantry. Whether horror or humor, the affect aroused by military montage sets the engaging tone of *Gloria Patri*.

A second register includes six polished aluminum trophies (Figure 11.5) that sport etched plaques returning the viewer to the monuments of the Gulf War's soundbites which Kelly recorded from TV: "Not Enough Gees and Gollies to Describe It," "Letting Loose and Hitting 'Em With All We Got," "Busting Our Butts To Get It Right," "Kick Ass," and one

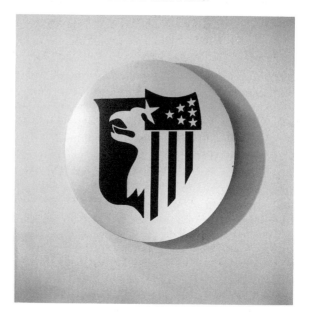

Figure 11.4 Mary Kelly, "Semaphore," *Gloria Patri*, 1992
(courtesy: Postmasters Gallery; photo: Kelly Barrie)

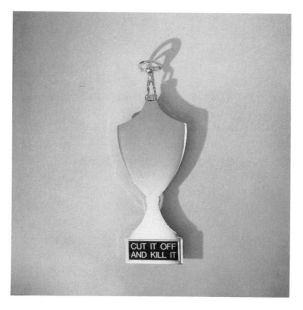

Figure 11.5 Mary Kelly, "Trophy," *Gloria Patri*, 1992
(courtesy: Postmasters Gallery; photo Kelly Barrie)

of Kelly's favorites, "Cut It Off And Kill It." In addition, each trophy sports an athletic figure who bears the weight of the alphabet on his back. Each figure carries a letter proportionally larger than itself. When taken together in sequence, they spell: GLORIA. Although Kelly clearly means for these trophies to align the glory of war with the frail pathology of masculinity, inscribed as it is in fantasies of voyeurism, castration, and fetishism, their semiotics also project the broader masculine fantasy of attraction and seduction fraught in the interpellation of G-L-O-R-I-A. It was through the mediating agency of Van Morrison's screaming chant of these letters, after all, that an entire generation of male and female rockers internalized the masculine ideal of attraction while simultaneously opposing militarization, violence, death, racism, and the Vietnam War.

That the installation means to confront the viewer with his and, indeed, even her own internalization of display is made most apparent by the series of five highly polished shields, hung at eye level, that display engraved fictional narratives of situations of mastery which are set up to be undone (Figure 11.6). Kelly's fluid stories recount a male fishing trip, a middle-aged male softball game, a male witnessing of childbirth, a tense breakfast with mother and son, a gym workout, this one written in a female voice – all of which seem to go somewhat awry.[7] The observant father-to-be is confronted with his ambivalent reaction to the abject messiness of birth. The fisherman's confident tracking of prey is arrested by his acknowledgment that he himself is caught in the gaze of a nearby heron (and not a tin can, *pace* Lacan). The moves of the softball player are rendered less fluid and confident by the aging process mirroring the working-class reality of rising middle-aged unemployment. In keeping with the theme of bodily control, the machineries of physical training encourage the female exerciser to despise the woman thing, the soft thing, in favor of the projection of hardened power. Kelly emphasizes how all of these narratives share in topic and tone the historical contingency of the pathological gestures of virility.

Ultimately, it is the spectator who feels the pinch of this installation's historical contingency. Somewhat like the fisherman and spectating birth-father, the viewer's distant, confident gaze is rendered split in his or her mirrored image which is reflected back to the spectator as misshapen by the polish of the shield. Displayed as the figural stain of the text, the taint of the shield, this mirrorical image places the viewer in the si(gh)te of the installation while thus disrupting the visual flow and intelligibility of Kelly's text.[8] Perhaps even more significant than the symbolic content of its aluminum semaphores, trophies, and shields is how *Gloria Patria* so deflects and interrupts the reading process and disempowers the viewer's visual and linguistic mastery with the stain of the anamorphic mirror. The dilemma of reading anamorphically (see Figure 11.6) is captured brilliantly by Kelly Barry, the artist's son, whose attempt to photograph

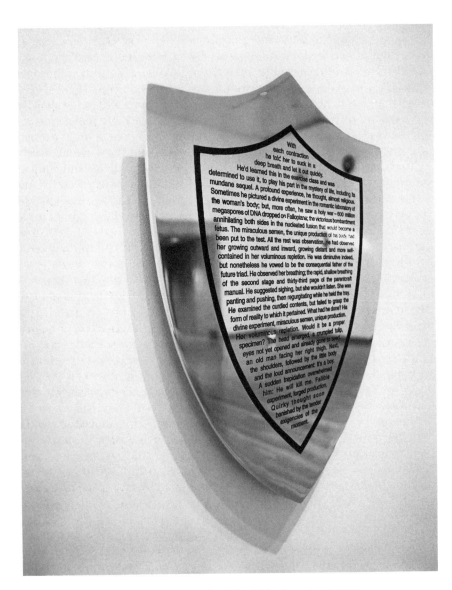

Figure 11.6 Mary Kelly, "Shield," *Gloria Patri*, 1992
(courtesy: Postmasters Gallery; photo Kelly Barrie)

the shields prompted him to position his camera far outside the plane of reflection, thus leaving the text in shadow and out of focus (as well as, I might add, freeing himself from the reflection of his m(O)ther's mirroring image with which he has been identified ever since Kelly's project on the mother–child relationship, *Post-Partum Document*). While here situating the eye within the scene of language, Barry's irresolute capture of the text with the anamorphic mechanisms of the phallic camera exhibits the stain of loss signifying the vicissitudes of the symbolic order.[9] Isn't this dis-play of reading what most successfully arrests and fractures the misleading homogeneity of the pathological machineries of masculinity? The visual sight of reading, caught in the mirrorical return of its own gaze, is what here points, in Kelly's words, "to a psychic excess that threatens to break the seal of the protective envelope, to puncture the shield by returning to the subject an image of his/her own abjection" (Kelly 1994).

Yet, the representation of something like this protective envelope rendered frail through interactive display is precisely what seems to be somewhat understated and repressed in the materiality of the installation itself. Aside from the show's provocative distortions of light and reflection (which I mean not to dismiss), where might we locate the seams or sutures of the shiny fabrics of *Gloria Patri*? Does the installation itself perform Kelly's theoretical point, to return to an earlier citation, "that the display of technology, the shiny surface of the shield, is so replete in itself that it produces the individual soldiers as so many *un*polished components, unable to camouflage their human frailty, made vulnerable, ambivalent in relation to their role of mastery?" Certainly *Gloria Patri* projects a technical splendor that is hard to miss, but what can we locate that remains behind it soft, unpolished, and ambivalent in relation to Mary Kelly's admirable role of artistic mastery?

The answer may well rest outside the parameters of the exhibition in the production of readings that follow. Mary Kelly's own texts and inter-views regarding the theoretical skin of this armor foreground the specter of a conceptual supplement always already compounding the reception, indeed, the material of *Gloria Patri*. I have relied on two supplemental narratives by Kelly and one personal interview to unpack the installa-tion's theoretical fabric (in addition to the narrative texts printed in the shape of shields in *Camera Obscura*). Having been written by Kelly as if her retrospective analysis of the exhibition, these perceptive and helpful commentaries compound and multiply the installation as text. They clarify, for instance, "the way the installation could set up a scene of mastery and undo it blatantly through mimicry," and that "something critical is revealed about the character of masculinity when it is staged by women" (Kelly 1994). Equally challenging are her additional remarks about how *Gloria Patri* addresses "the extent to which women have internalized the masculine ideal" (Kelly 1994), especially when they are read in the

context of Kelly's earlier reference to her relation to psychoanalysis as being rather ambivalently "mercenary" (Foster 1990: 56). Kelly's supplemental texts thus present *Gloria Patri* as somewhat of a mercenary representation always already in production, in process, and always exemplary of its own pathological incompletion, frailty, vulnerability, and ambivalence in relation to mastery.

Perhaps it is precisely the lack of this display of theoretical supplementarity that accounts for my (own pathological?) uneasiness with the installation, *Gloria Patri*. For there remains to be something equally mercenary about the unavailability of Kelly's supplemental texts to the viewers at Cornell's Johnson Museum who found themselves completely inside or outside the Lacanian joke. So, to return to the baffling question, what can be said about the materiality and textuality of the installation itself that might constitute *Gloria Patri* as being somehow different from, resistant to, the axis of virile identification it mercenarily deconstructs? How is the display of *Gloria Patri*, citing Kelly, different from "a form of intimidation, a defense," and not "located within the axis of identification rather than desire?" What makes it other than what Kelly critiques as "this armor, this skeletal thing which doubles, the whole process of doubling [which] is more about homogenization than difference?" Does difference here reside solely in the anamorphic stain of text and reflected image leaving relatives, friends, and viewers uneasily distorted in its admirable presence? Or might there be a further conceptual, even ideological roughness behind all of that polished metal that so denies us the comfort of entry?

The ambivalence I experience in writing about *Gloria Patri* stems from my sense that Kelly's carefully wrought theoretical discourse and the superbly crafted materials shield the installation, and perhaps even its writer/maker, from the frailties of just such a response. While the installation's fictional narratives recount how the display of working-class sportsmen and youths who don't eat their collard greens "will always be a botched affair," it remains unclear how far the confident voice, eye, and hand of the analyst, whether artist, author, or theoretician, is carried into this destabilizing, interactive arena. Where in this display, I suppose I want to ask, can the spectator locate the markers and implications of its staging by women which were so explicitly evident in Kelly's earlier projects, *Post-Partum Document* and *Interim*? Does *Gloria Patri* display the signs of risk, of material and conceptual hybridity, so notable in the mixed apparel of Kelly's previous installations? Finally, where do we locate the modulated grain of the voices of the writers, artists, television viewers for whom perspective is so significantly the matter?

One could respond that in posing these questions I am dodging the depth of the encounter with Kelly's previous installation, *Interim*, which Parveen Adams alertly compares to psychoanalytic transference: "If the

discourse of *Interim* is like that of the analyst, we should be able to locate the spectator as barred subject and the artist as object in those places" (Adams 1991: 87). In this sequence, the Lacanian analyst abdicates the position of mastery and responds with silence to the transferential love of the analysand who must come to terms with the insufficient presence of the desired object (in this case, the artist). While such a reading does account for the rather spooky silence of those gleaming shields of *Gloria Patri*, not to mention the spectator's desire to see himself replete as reflected in and by them, it skirts the issue of the analytic contingencies of counter-transference, which Lacan so rightly identified as the passions, prejudices, and difficulties experienced by the analyst in the face of trans-ference. Were *Gloria Patri* to sport the guise of what Adams terms the "textuality" of the analyst, then it too would carry the grain of affect, the turmoil and the *jouissance* of counter-transference. Might not we be compelled by deconstructive, if not psychoanalytical, motives to wonder how *Gloria Patri* displays or shields the destabilizing affects of itself as not only the site but the source of transference?

A possible clue might lie in the materiality of the installation itself. Materially, for instance, what happens to the televisual set so crucial to the conceptualization of *Gloria Patri*? Just as this installation mimics the cinematic use of real time and montage, it seems to avoid the oppor-tunity to dialogue actively with the messy video apparatus and its vicis-situdes which was partially responsible for displaying the historically contingent ethnographic material, the castrating threats, adorning the trophies of G-L-O-R-I-A. Even a passing mention of the televisual screen and its soundbites might have provided a layered representation of how *Gloria Patri*'s own display remains contingent on all kinds of static, on the specific institutional means, codes, and histories of its own transmissions. Although media theory is not exactly Mary Kelly's domain, her project misses an excellent opportunity to discount the naive theories of tele-visual "leveling" by equating the frailty of masculine display with the fragility of televisual consensus and the fluidity of pixellation.

One provocative retort to such a challenge for a greater material acknowledgment of video-in-its-differences might come from Copjec's essay on televisual fear. Copjec argues, as I mention above, that atten-tiveness to the specificities of Lacanian analysis, such as Kelly's stress on the pathology of display, may help to calm what she calls the "'televisual fear' that psychoanalysis addresses all in general in order to say nothing in particular" (Copjec 1990: 49). Recall how Copjec reflects on the fact that the equation of Lacanian theory with a broader nonclinical, televisual audience has occasioned a global fear "that each individual discipline is thereby reduced to some supposed lowest common denominator – language – and submitted to a master discourse – psychoanalysis. That which is feared to be lost is not only the specificity of disciplines, but also

... the political force of analysis" (Copjec 1990: 49). It may well be that, in response to something like "televisual fear," Kelly chooses, almost insistently, to separate her installation from the display of the televisual apparatus whose material presence might distract the telespectator from dwelling on the specifics of display. But might not just such a tactic prevent *Gloria Patri* from posing the sort of disjointed questions about the hybridity of communication and display to which the master discourse itself has indeed lacked the confidence of response?

Recall the conceptual context of *Gloria Patri*: Lacan's notion of the skin thrown off from the Other to cover the intimidating frame of display's shield. Multicultural theorists of psychoanalysis would be quick to pressure *Gloria Patri* to account for the hybrid psycho-social contingencies of skin. This might mean saying more about the specifically *Persian* tint of the historically contingent skin of the Gulf War. A more specific and forceful analysis of cultural and racial difference would place *Gloria Patri* in a much stronger position to comment on "the problem of masculinity and its imbrication with whiteness and power" (Kelly 1994) to which the artist rapidly alludes in one of her essays.

Although these may appear to be the kinds of analytical desire made in defensive response to the strategic silence of the analyst, *Gloria Patri*,[10] they could well impact on the ideological range of materials and objects the analyst privileges in the analytic sessions of its installation. A more performative display of the mixtures of race might do more to tarnish the glossy narrative of the young lover of rap who equates eating his mother's collard greens with sissiness and pacifism. There might well be interesting performative strategies the narrative could otherwise adopt to address the historical differend disjoining the seam of this loud racialized character and its calm authorial voice. Similar questions can be posed about the critique of the female exerciser who could be read by some viewers as experiencing an empowering *jouissance* from her incorporation of masterful techniques of sports and exercise. Does *Gloria Patri* mean to suggest that power and force can be so easily separated from desire? Where in this feminist installation with a cinematic bent do we read the signs of the revisionist lessons of recent feminist, psychoanalytic justifications of alternative, pornographic cinema and its insistent blend of power and *jouissance*?[11] What makes the female exerciser so different from the mercenary artist and theoretician who knows and benefits from the pleasure of artistic and intellectual mastery?

Indeed, *Gloria Patri* may be paradoxically complicitous with the spread of televisual fear, with an unfortunate homogenization of display that remains indifferent to the added layers of disciplinary specificity and institutional politics to which it alludes. A rather telling example can be found in the narrative that focuses on the aging softball player who had suffered the humiliation of being cut as a youth from VFW baseball.

Especially curious is how the narrative emphasizes the psychological dilemma of the player who finds no solace in the codes of warrior baseball rather than placing more focus on the institutional context of the middle-aged man's oppression by the midwest meat-packing plant that just laid off him and his buddies, a social context on which Kelly elaborates in her essays and interviews but condenses to the personal dilemma of castration in her gleaming narrative: "Yes, age had affected his reaction time, he thought, that's how it happened. Cleaning ham bones and the knife went right through his glove; right through the steel mesh, the company armor, his protective clothing. Then, the lethal wound benignly infected; he was laid off."[12] The narrative then ends up placing more critical stress on the beleaguered worker's unfulfilled desire to soothe himself with leisure than on the pathology of corporate America that so easily displaces the worker for machine, the soldier for laser, the Brechtian reporter for real-time TV anchorman.

The point here is not so much that Mary Kelly need address the specificity and institutional context of every single social pathology to which *Gloria Patri* alludes. But by being slightly more circumspect about the layers of tough skin she exposes, the artist would place herself and her materials more squarely in the vulnerable scene of ambivalent display, identification, trauma, and pathology. Put otherwise, in Kelly's words, "what's problematic about this masculine identification is the pathology of how it is produced, which is always contingent on history" (Kelly 1992b: 8).

INTERACTIVE VIDEOMATICS

In striking contrast to *Gloria Patri*, Dawn DeDeaux's expansive installation, *Soul Shadows: Urban Warrior Myths*, enters into dialogue with the many shady sides of televisual media to present a much more ambivalent story about the urban warrior interpellated by the fantasy of mastery. In highlighting the culture of urban warfare both sustaining and victimizing a young generation of color consumed by the everyday challenges of survival, the artist also more openly displays her own pathology, her attempt to exercise her own racial fears. While *Soul Shadows* would benefit significantly from the psychoanalytic insight, precision, and complexity of *Gloria Patri*, its conceptual messiness displays it as art, installation, and public discourse at the core of the cultural ambivalence surrounding the hybridity of masculinist pathology.

It would take the length of this chapter simply to describe the material complexity of *Soul Shadows* (Figure 11.7) which is constructed to evince both the lamentable glory of the young urban warrior confronted with cataclysmic changes in industry and technology and the neurotic white flight away from the urban economic core of home-boy turf. Filling the

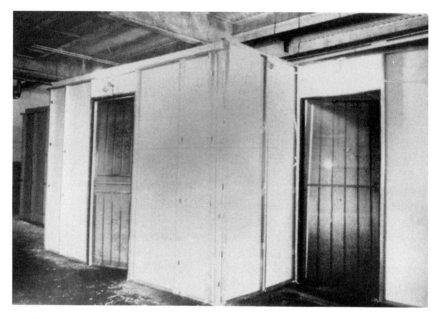

Figure 11.7 Dawn DeDeaux, installation view, *Soul Shadows: Urban Warrior Myths*, Montage 93: International Festival of the Image, Rochester, New York, 1993

entirety of a cavernous space, the noisy multi-media exhibition features two corridors of plywood and sheet rocked video rooms (Figure 11.8) roughly built to simulate the conditions of substandard housing. At the exhibition's entrance, the spectator is confronted by the historical weight of a massive installation of large iron chains wrapped around a suspended industrial scale attesting to "the 'original sin of slavery'" and its consequences for contemporary American life. The viewer then strolls through parallel corridors housing separate cells or video viewing rooms which are divided in the middle by a long passageway, the "Hall of Judgment," leading into the hidden core of the installation, "Ante-chamber: Tomb of the Warrior." Featuring the show's gradual condensation of the four-dimensionality of video hyperspace into two-dimensional icons of a masculinist heritage, the "Hall" and "Tomb" display life-size, hand-colored photographs of the male protagonist featured on many of the videotapes. Such play between hyper- and photo-reality is introduced from the outset of the installation where motion detector lights are poised over the thresholds of each viewing cell to blur the divisions between the jailed and the free. The intimately dark screening spaces also contrast with the open and sometimes brightly lit passages to confront the viewer with the televisual disequilibriums of stasis and movement, private and public, home and unknown. *Soul Shadows* concludes with a "Community

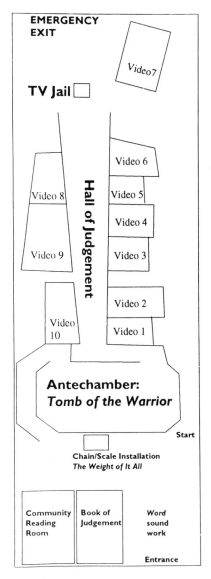

Figure 11.8 Dawn DeDeaux, installation diagram,
Soul Shadows, 1993

Reading Room" where psychically disjointed visitors can attempt to
gather their thoughts, leave their comments, and read texts from the
"Book of Judgments," a limited-edition artist book, hardbound in iron,
which was a collaboration between DeDeaux and the inmates of Orleans
Parish Prison. From its entrance soundtrack, which mixes the tales of

juvenile offenders with the tuneful recitations of Tibetan and Benedictine monks, to the concluding "Tomb of the Warrior," the installation aims "to symbolize a collective lament."[13]

The exhibition's display of invasive televisuality is lent a poignant industrial casing by the grimy sites of its installation. In Baltimore and Rochester, *Soul Shadows* was housed in the cavernous and dingy hallows of the gritty garages of deserted car dealerships – little gleam there. These temporarily transformed spaces position the materiality of artistic site as an institutional framework at the heart of any consideration of the perspective of display. They connote both the blight of urban decay and the dilemma of how best to reclaim abandoned remnants of an earlier age of industrial prosperity. Should such sites be transformed into jails and prisons for warriors still not dead, as the new(t) Republican administration wants, or into the community and job training centers the Republicans most frequently mock? Evoking both the trauma of despair and the language of hope, *Soul Shadows* combines memorable elements of both environments to provoke spectators into pondering the institutional specificities of discipline and punishment, mourning and renewal.

In view of DeDeaux's mixed-media experimentations of warrior lament, perhaps the mental flipside of Kelly's display of military force, I would now like to focus my remarks on *Soul Shadows*' development of a layered, interactive, urban videomatic. What is especially compelling about this installation, I will argue, is how its format belies its strong materialist sensibilities in weaving together the remnants of two kinds of cultural, televisual fabric, the psychic and the social.

There is no doubt that DeDeaux puts all of her money on the social. Her expansive installation of video rooms, sculpture, book art, and photography generated from video responds to the fact that over 1 per cent of the population of New Orleans, as in many American cities, is incarcerated, thus making the prison complex the single largest residential community in the country. "The rest of us," she adds, "incarcerate ourselves by choice in our own home behind security bars, motion detectors and fear." To bring home this point, the exhibition's many video viewing cells are framed by "The Door Series: Who's in Jail?" The entrances to the viewing rooms display life-size photographs of doors whose decorative security bars reflect the pitifully futile attempts of suburban-urban culture to shield and disguise its racist phobia. It is this traumatic combination of socius and psyche, not to mention this white artist's care to identify herself as a member of the traumatized suburban class, having undertaken her project in defensive response to her mugging by a black youth, that inscribes DeDeaux's work in the trenchant divisions of an American society under televisual revision.

DeDeaux dwells on how "the laws of nature have found a strange partner in the culture of television and the Hollywood world of cowboys

and Chicago-style gangsters – and its matinee John Wayne and Rambo idols. Somehow this strange mutation has created the urban warrior." To display such a "mutation," *Soul Shadows* features a series of video installations deriving from DeDeaux's interactive workshops with inmates in the Orleans Parish Prison, projects which were funded as a New Orleans "Percent for Art" project. Her experimentation with interactive video is in direct response, she says in a wall text introducing the show, to how

> the very access to mass communications has helped define the culture and ritualism of today's underclass youth ... A coast to coast simultaneous eruption revealed the new mythology, one that demanded of its followers a form of genocidal suicide, giving us the term Vanishing Black Male. Accompanying the mythology are the rituals exactly duplicated in cities as disparate as New Orleans and Rochester: a fashion of weaponry (one month it's "packing my nine," the next month "Uzis") and costume, battle signs, battle hymns, and battle tactics (Drive-by Shooting, Car-Jacking). Says one of the exhibition's video subjects, "Well we saw it on the news one night about the drive-by shootings in L.A. . . . and well, if they can do it, we can do it, and two weeks later."

In a troubling way, DeDeaux here leaves herself open to serious critique by not challenging what Tricia Rose calls the media "demonization of young black males . . . who have participated in drug-related gang shoot-outs and other acts of violence for no apparent reason" (T. Rose 1994: 152–53). Here televisual fear rears its ugly head in DeDeaux's leveling demonization of "today's underclass youth." By not questioning from the outset the fundamental myth of black cultural "mutation," DeDeaux undercuts her serious efforts to extend the parameters of the media by offering video to its urban victims as a creative tool of self-reflection.

Yet, an appealing aspect of this flawed installation is how DeDeaux's appropriation of the televisual media works to rupture its captivating flow on two levels. From inside the medium, it links the video camera to the infelicities of identification and the sociopolitical blends of subject positions. It combines the documentary practice of controlled interview, the *video verité* of police camcorder evidence, and the crude camera technique and autobiographical messiness of the urban warrior's home movies. From outside the medium, through the virtual space of installation, the spectators are positioned as selective, roving cameras turned away from, as well as always already in on themselves, phantasmically as well as critically. Upon entering the installation's individual video cells, viewers trip motion detectors triggering monitors that display various styles of videotape portraying the related life stories of black imprisoned mothers and youthful male gang members. At other times,

viewers are themselves subject to the surveillance of overhead cameras, thus accentuating their varying sociocultural identifications with, and/or alienation from, the scenes of video incarceration. The critical result is bound up in an interactive mixture of conceptual adaptations molded, as Stuart Hall (1992: 28) would say, "to the mixed, contradictory, hybrid spaces" of black and white popular culture. Just how this installation works against the grain of its artist's frequently Utopian assumptions can be appreciated through closer attention to its videomatics.

Soul Shadows' video experimentations combine hopeful tapes of cultural empowerment from the genre of autobiography that all the while underline the infelicities of sociological, artistic work lacking a psychoanalytic hermeneutics of suspicion. Monitors in two cells screen unedited tapes of the artist's interviews with prisoners and gang leaders on the outside as well as dialogues between incarcerated youths and adults. Viewers are confronted in the first cell, for instance, by "Family Tradition: Mother and Son," a taped exchange between a mother and son who are housed in separate facilities of Orleans Parish Prison and are reunited via video after not having seen each other in over two years. The son initially denies that it is his mother on tape who admits regret for her drug habit and, especially, for allowing him to sell drugs. Another cell, "The Dope Rope," features a tape in which four female inmates discuss the economic and social pressures that led them into drug addiction, as well as the linkage of addiction to their crime and arrest. These tapes end up contesting demonization by exploring, as Rose demands, "the vast and interdependent social forces and structures that have produced and transformed the face of street crime and destabilized the most fragile communities" (T. Rose 1994: 151). I should add that DeDeaux is careful not to edit these tapes, as if needing to allow their subjects fractured by the traumas of drugs, violence, and prison to benefit from the ideology of presence associated with *video verité*.

That the dialogue activated by video tends to enhance the authority of its subjects is born out by the impact of another tape, "The Hardy Boys and Nancy Drew," which records the artist's interview of two infamous, New Orleans gang leaders, Paul and Wayne Hardy, neither of whom were in custody. This exchange documents the Hardys' perceptions of the cult of the urban warrior: that force and strength result in cultural legitimation; that the machineries of violence and intoxication provide ready means of social empowerment; that black gang violence follows the (misunderstood) legacy of Black Panther political protest; and that violence is the noble path to a hero's death. The tape concludes, moreover, with a plea from the reformed brothers for peaceful, community activism. Their hopeful message echoes the artist's Utopian belief that spiritual transformation can occur even in bondage to economic tyranny.[14]

The video display of such cultural transformation may well account

for the enthusiastic sponsorship of this expensive show by influential urban sponsors in Baltimore, Los Angeles, New Orleans, and Rochester. So suggests the script of Fleet Bank's self-promotion for underwriting the installation in Rochester: "Fleet Bank's sponsorship of *Soul Shadows: Urban Warrior Myths* is consistent with our tradition of supporting youth and educational initiatives and anti-drug programs not only with financial contributions but also with our time and concern." While the footage of *Soul Shadows* is often raw, its message of the power of personal transformation is utopically hopeful, if not profoundly unrealistic about the divisions of the cultures it attempts to portray. This Utopian sentiment is what prompts me to question the materialist grounds on which DeDeaux bases her hope in the transformation of the young urban warrior.

In a wall text introducing the exhibition, a volatile claim aggresses the visitor with the white artist's revisions of racism:

> What is certain, but so often misunderstood, is that the face of today's predominantly black urban warrior is not a face belonging to race. It is the face of isolated economic class. The role has remained constant in the human drama. It's just that occasionally the players change. And in the media age, in this age of replication, in this age still shackled by the cobweb of slavery's chains, in this age of political correctness where new chains strangle our ability to broach the urgent subject across and beyond racial lines, it is in this age that our children are dying faster than we can count. It is in this age that fear and misunderstanding have given rise to a new strain of racism before we have been able to eradicate its predecessor.

Particularly baffling is DeDeaux's dismissal of racism as a misdirected construct of political correctness and televisual fear, "in the media age, in this age of replication." Equally startling is the artist's assertion that the face of economic isolation is or ever was raceless in an America still shackled, as she so blatantly states, "by the cobwebs of slavery's chains."[15] But, in direct counter-relation to such a defensive negation of the mobilizing force of race, "it's just that the players change," I propose that *Soul Shadows* is ultimately productive as a videomatic text for the way it actually confronts and haunts the visualizations of a multiracial culture (always already) in peril. Such an appreciation depends, of course, on the signifying relations through which any cinematic installation speaks aside from the purposeful voice of its maker while also necessarily reflecting the maker's critical position. For just as *Soul Shadows* disrupts the commodity flow of television, it is strongly over-determined by the artist's feeble disavowal of race that relies on a kind of commodity panic to screen out her constitutive logic of fetishism: "yes racial difference, but nevertheless class hegemony."

That I here insist on the overdetermination of racial representation in *Soul Shadows* is strategic. For I want to suggest that, regardless of the artist's aspirations and cultural background, the installation is "over-determined" in the two-directional sense said by Stuart Hall to impinge on the hybrid repertoires of black popular culture. Hall writes that these repertoires

> were partly determined from their inheritances; but they were also critically determined by the diasporic conditions in which the connections were forged. Selective appropriation, incorporation, and rearticulation of European ideologies, cultures, and institutions, alongside an African heritage . . . led to linguistic innovations in rhetorical stylization of the body, forms of occupying an alien social space, heightened expressions, hairstyles, ways of walking, standing, and talking, and a means of constituting and sustaining camaraderie and community.
>
> <div align="right">(Hall 1992: 27–28)</div>

Regarding *Soul Shadows*, I want to argue for a similar but reverse over-determination. This time it reflects the critical result of Euro-American incorporations of African-American ideologies, cultures, and institutions that stalk, talk, walk over the heritage of European display. What some might justifiably dismiss as a failed, hegemonic attempt by a Caucasian artist to represent African-American culture as "a hotbed of socio-pathology,"[16] I recommend as a notable example, flaws and all, of the contradictory, hybrid forms and spaces of contemporary culture and the uncertain effect of video feedback from one alien culture on to another. *Soul Shadows* exemplifies how all art and video is critically determined by the diasporic conditions in which their legacies of incorporated fantasy were forged.

Paradoxically, the almost blind hopefulness of this technological experiment is what foregrounds the extent to which DeDeaux is herself interrogated by the hybrid forms and virtual spaces she creates. While these tapes clearly suggest a certain level of empowerment available to their maker through the medium of video, they reflect just as readily the mediating terms of cultural subjection and subjugation constitutive of all subject and gender positions, empowered or not. The promise of this installation is not so much economic transformation as the consistency of its representation of how media culture always already leaves its viewers on the inside as well as the outside of alien social spaces. Two circumstances underline, for instance, DeDeaux's own subjugation to the cultural conditions of her tapes. The first involves the second. Only her screening of the tape, "The Hardy Boys and Nancy Drew," in the Orleans Parish Prison gained her access to the trust, or perhaps camouflaged fear, of the teenage inmates who had been reluctant to participate in her

artistic experiments. Put bluntly, they responded not to the peaceful call of DeDeaux but to the forceful interpellations of the Hardy brothers.[17] The tape reflects, as well, the hybridity of cultural reception which, this time, leaves the artist both in and out of the game. When DeDeaux interviewed the Hardy brothers about why the press dubbed them "The Hardy Boys," they thought it referred to a wild west gang, not to the adventurous, we might now say, sub-urban, adolescents who grew up with Nancy Drew. She suggested in turn that they dub her "Nancy Drew." This is the handle they then adopted to signify the eager investigator living the fantasy life of *video verité* on the brink of, but always free from, the painful display of bondage and oppression.

Consider the role of mimicry in two related tracks, "Urban Jungle Opera" and "Soul Shadows," that celebrate the creative potential of the artist's art therapy class of ninety-six violent juvenile offenders. Different videotapes document the male youths' performance of shadow dances and their celebratory parade of the masks they created in DeDeaux's prison workshop. While these tapes convey DeDeaux's uplifting hope in social transformation as the Utopian result of collective lament, their emphases on the creative joys of arts and crafts fail to account for the psychic instabilities of display and masquerade so crucial to Mary Kelly's *Gloria Patri*. It could be said that the imprisoned warrior, to turn again to Kelly's citation of Lacan, here "gives of himself, or receives from the other, something that is like a mask, a double, an envelope, a thrown-off skin, thrown off in order to cover the frame of a shield." This same shield, Kelly would add, is unable to camouflage "human frailty, made vulnerable, ambivalent in relation to mastery." Whether the prisoners masquerade as the free souls of movement or wield their masks as virile emblems of warrior confidence, they remain ensconced in the psycho-social machineries of identity leaving them in the prisonhouse *vide*, on the wrong side of the video divide. Instead of working to change the structural conditions of their oppression, DeDeaux seems to bank on the curative powers of her cultural therapy. And, still, might not these very procedures of masquerade provide these incarcerated warriors with the parodic means, again citing Kelly, for their "imitation or mimicry of the master" (cited in Egger and Murray 1992: 8). Kelly refers, of course, to Homi Bhabha's theory of the colonized subject's "ambivalence of mimicry:"

> Under the cover of camouflage, mimicry, like the fetish, is a part-object that radically revalues the normative knowledges of the priority of race, writing, history. For the fetish mimes the forms of authority at the point at which it deauthorizes them. Similarly, mimicry rearticulates presence in terms of its "otherness," that which it disavows.
>
> (Bhabha 1994: 91)[18]

DeDeaux comes close to displaying the vulnerability of her intrusive craft in a two-track tape, "Drive By Shooting: Inside, Outside." Here she combines two unrelated videos "to examine," she writes, "the ritualistic glory *inside* the 'hood' in contrast to the stark reality of the death that remains *outside*." The first fourteen minutes record the camera's travels by car through the Hardy Boys' neighborhood while its perspective masquerades as the deadly sight of a drive-by gun. Resembling the disembodied "traveling shot" of laser warfare,[19] this shot registers its targets, instead of destroying them. It captures the mixed reaction of people on the street to the approaching war chariot that blares NWA's rap, from their adornful respect to their respectful fear of its virile display. The segment is followed by four contrasting minutes of *verité* footage obtained by the New Orleans Police Department. This tape documents the frightful chaos immediately following an actual drive-by shooting that left a fifteen-year-old boy dying on the street. What is telling about this two-channel segment, perhaps the most inventive video piece in the show, is how the two tapes document different perspectives inside the "hood" while always leaving the definition of stark reality to the camera that always seems to remain on the outside, in the surveying hands of the police or in the altruistic hands of the white artist as social worker. As it happens in *Gloria Patri*, it is left up to the viewer to screen the more fluid, psychic region of the in-between.

TELEVISUAL INCORPORATIONS, OR GOLDEN FLEECINGS

I wish to suggest, in conclusion, that the show's large-scale digital-photo installations, "Hall of Judgment" and "AnteChamber: Tomb of the Warrior," bring home to American multiculture the depth of its incorporation of the diasporic conditions of racial difference which its producer so desperately wishes to deny. These incorporations, moreover, follow the enigmatic structural logic of the processes of mourning and melancholy which take in loss of the self-same in order to replenish the mysterious attraction of narcissism as Other. Thematically, these stunning visual sequences confront the visitor with phantom specters of loss and death whose presentations work to reshape the reception of their conventionally symbolic figures. The sixty-five-foot-long "Hall of Judgment" is lined with a two-tiered montage of figures whose frozen silhouettes of shadow dancers are burned into paper as if remnants of the apocalypse (Figure 11.9). Their intended reference to Dante's Purgatory, with "the flame-like images . . . stacked two-up to suggest tormented souls imprisoned in holding cells," surely implodes into the ambiguous, almost atomic glow of the environment. Viewers wandering through this long hall find themselves caught in the eerie cast of its red and yellow fluorescent tubes and

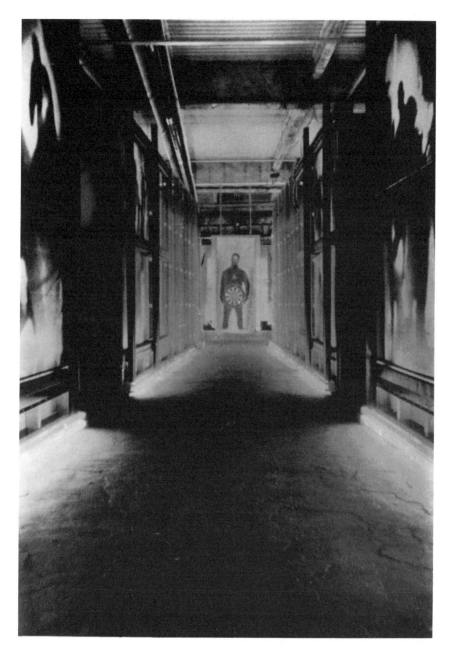

Figure 11.9 Dawn DeDeaux, "Hall of Judgment,"
Soul Shadows, 1993

broken up in the pixel visions of overhead surveillance cameras. In striking contrast to the clearly defined videotapes of previous sections, this sequence of visual hallucination psychically prompts the viewer to confront the representation of the loss of precisely who knows what (Dante? culture? freedom? faith? judgment? display? bondage?). This inability to determine exactly *what* has been lost doubles as the psychic confusion that distinguishes, for Freud, the masochistic disorderings of melancholy from the conventional working-throughs of mourning. As I elaborate in *Like a Film*, the disfigured incorporations of melancholy can function to contain and recirculate cultural constructs which remain out of sync with the dominant social symbols of working-through. So suggests Nana Peazant, the matriarch of Julie Dash's *Daughters of the Dust*: "never forget who we are and how we've come – we carry these memories inside of us; we don't even know where the recollections come from."

Also fascinating about the "Hall of Judgment" is how its melancholic confusion is enhanced by the procedures of video incorporation whose narrative clarity it so uncannily resists. DeDeaux generated these shadow figures by transferring video images from her video sequence, "Soul Shadows," through a computer into a black box, where the film was exposed by laser light. This procedure brings teleconstruction back into alignment with the primitive perspectives of the camera obscura while projecting out, through its introjective taking in, the violent results of video technology at the cutting edge. Here DeDeaux seems to offer her subjects of video autobiography the technological means to extend beyond the limits of their autobiographical entrapment in the photographic procedures of *video verité*. In reflecting on the combined techno-psychoanalytic implications of this impressive process, I hear the haunting words of Antonioni who spoke of video's ability to "arrive at a degree of physical and psychic materiality that aligns itself simultaneously within and beyond the contour of reality imposed by the photographic arrest" (cited by Bellour 1990: 190). DeDeaux's technical process seems to bring to life Antonioni's 1970 prediction of video's "possibility of producing a different impact on matter, the possibility of being more violent than even the matter one treats" (cited by Bellour 1990: 190). This promise of a psycho-physical revolution of hyper-violence confronts the maker and her viewers with the excess of rage and the recycled mixture of unknown loss characteristic of this hybrid, televisual age.

This may be born out by the "Antechamber: Tomb of the Warrior," where life-colored life-size gilded photographs represent Wayne Hardy as the evolving image, returning to Stuart Hall, of "mythological, spiritual, and ideological warriors drawn from European and non-European cultures, matinee idol warriors of Hollywood and television, as well as the urban warrior of today." Here Wayne Hardy masquerades as "Black Christ: The Sacrifice" (Figure 11.10) and "John Wayne," the Hollywood

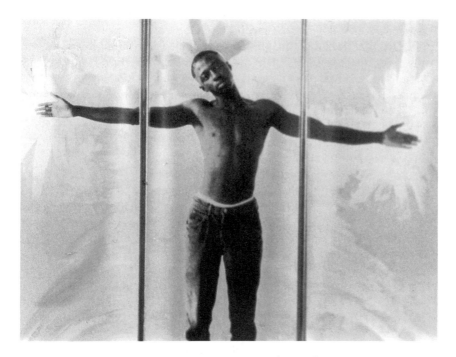

Figure 11.10 Dawn DeDeaux, "Black Christ: The Sacrifice,"
Soul Shadows, 1993

matinee idol (Figure 11.11). In this stunning visualization of the multi-cultural warrior, DeDeaux seems to inflect her art in the incorporation, as Stuart Hall would say, of Wayne Hardy's innovative forms of occupying an alien social space with heightened expressions, hairstyles, ways of walking, standing, and talking, and a means of constituting and sustaining a differend ambivalent blend of camaraderie and community. Guarding the entrance to the "Tomb" is "P'an Ku: Chinese God of Fate and Chaos." But P'an Ku's shiny shield is here displaced by Hardy's parodic display of a target, at once foregrounding the young black male's vulnerability to violence and displaying masculinity's ambivalent relation to its role of mastery. Similarly, the Matador holds up to Poseidon (Figure 11.12), the charging warrior of Occidental mythology, the parodic display of Malcolm's X, a symbol which has since become the enigmatic sign of the entire generation of multicultural hybridity and televisual incorporation. This is the Generation X of urban warriors, dancing in the politicized shadows of its sixties predecessors, always already confronted with the televisual fear, the generational loss of it knows not what.

As for the cast of Hardy's shadows in excessive hues of elaborate gold, I suggest, returning to Kelly's psychoanalytic stress on the enigmatic

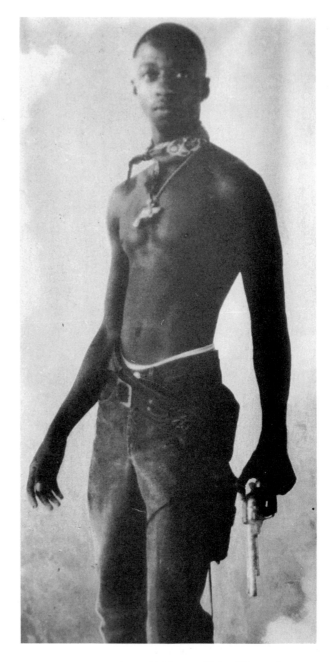

Figure 11.11 Dawn DeDeaux, "John Wayne,"
Soul Shadows, 1993

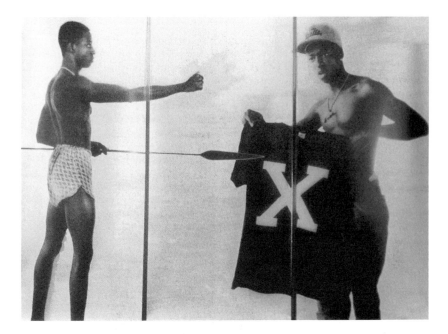

Figure 11.12 Dawn DeDeaux, "Poseidon Intersection with Matador X,"
Soul Shadows, 1993

materials of display, that it be valued as the tint of incorporated colors that will continue to baffle generations to come. Just as the archeologists of the Museé Subalterne may recognize DeDeaux's Utopian reference to the golden quest for empowerment of Tutankhamen and El Dorado, they might just as readily relate the gold to the colonial mythology of economic bondage denoted by the danger of the mimic's reinforcement, rather than erosion, of conventional power relations.[20] Such a reading would benefit from the lesson of the golden fleecing, demystified by another video discovered in their exploration of late twentieth-century postmodern ruins. Perhaps they would read the remnants of *Soul Shadows* alongside the soundtrack of *Sari Red*, the videotape by Pratibha Parmar that laments the racist British murder of a young female Anglo-Indian. The Anglo-Indian narrator of Parmar's tape voices the televisual fear that generalized lament, the British working-through of universal mourning, may dull the interiorized shine of her complex cultural hybridity. Speaking over images of workers enslaved by the machineries of the garment district, she says, rather matter of factly: "her parents came looking for gold, streets paved with gold they were told."

NOTES

1 Consider Lizzie Borden's assertion that "I try to shift the point of reference so an audience has to identify with female subjects through stories told from a woman's point of view. This is why I completely disagree with Laura Mulvey's idea that the apparatus is inherently male. It's all about identification" (cited by Lucia (1992–93: 7)).

2 I stress that Best and Kellner (1987: 103) go on to critique the widespread assumption of televisual implosion and recommend, instead, a more nuanced political reading of TV's "sites of contradiction and struggle."

3 Contrast the generally dismissive tone of this collection with the more critically alert and discriminating approaches to TV in Mellencamp (1990) *Logics of Television: Essays in Cultural Criticism.*

4 I am thinking, for instance, of the psycho-social implications of Andy Warhol's pursuit of patronage by the soup mogul, Heinz, addressed in forthcoming work by Klaus Theweleit, not to mention the attempt of Campbell's to represent itself as the empathetic provider of food for America's homeless, which I discussed in the previous chapter.

5 Mary Kelly's *Gloria Patri* was displayed at Cornell University's Herbert F. Johnson Museum of Art and at Wesleyan University's Ezra and Cecile Zilkha Gallery. Dawn DeDeaux's 1992–93 installation, *Soul Shadows: Urban Warrior Myths,* was displayed at the New Orleans Contemporary Art Center, at the William Reigh Los Angeles Photography Center, and installed in deserted car dealerships by the Baltimore Museum for Contemporary Arts and the Rochester, New York, Montage 93: International Festival of the Image (DeDeaux tells me that she has also produced a work addressing the Gulf War, *Super Convergence*). Pieces from Kelly's and DeDeaux's installations have been included in two significant 1995 exhibitions that investigate the many layers of masculinity. While parts of *Soul Shadows* are included in the Whitney Museum show, *Black Male: Representations of Masculinity in Contemporary Art,* a smaller version of *Gloria Patri* is included in *Masculine Masquerade,* opening in Boston before traveling to the Alternative Museum in New York.

6 Kelly here refers to Theweleit's two volumes of *Male Fantasies* (1987, 1989).

7 These narratives are reprinted as "Stories by Mary Kelly" (1992a).

8 See my discussion of "mirrorical" in Chapter Nine, note 14.

9 See Lacan, *The Four Fundamental Concepts of Psychoanalysis* (1978: 79–90). I provide more extensive discussions of anamorphosis in Chapters Two and Eleven.

10 It is fair to add that Kelly's response to this criticism may well be that it stems from my response, as a masculine critic, to a project whose feminism is too close to home. As she made clear to me in our interview, "the popularization of feminism has produced in women something that's making men find new ways of reasserting difference, of saying, 'this monstrosity is not us'" (Egger and Murray 1992: 8).

11 It is hard to imagine that Kelly would intentionally align herself with the anti-pornography position of MacKinnon which denies the validity of a feminist display of power in sexuality (see Chapter Ten, note 9). To cite Williams's (1989: 217–18) excellent summary of the positive effects of fantasies of power in pleasure for and by women, they offer "one important way in which groups and individuals whose desires patriarchy has not recognized as legitimate can explore the mysterious conjunction of power and pleasure in intersubjective sexual relations."

12 In our interview (Egger and Murray 1992: 8), Kelly clarifies that "my reference

272

here was meat-packing plants in the Midwest like Hormel, which have either closed or cut back because agriculture is in decline. One of the things unemployed workers do to give meaning to their lives is to form softball teams." I should add that this last comment regarding softball may suggest a larger cultural naiveté stemming, most likely, from Kelly's British background – there can be little doubt that those softball leagues were in existence long before those workers lost their jobs.

13 All quotations of DeDeaux are from the wall text of *Soul Shadows*, reprinted in a pamphlet for Rochester viewers sponsored by Fleet Bank.

14 In a phone interview, DeDeaux has since communicated to me that her trust in the brothers' transformation was violated by the revelation that Paul Hardy had been acting as the triggerman for corrupt New Orleans police. As for Wayne Hardy, he was killed in a drive-by shooting in February 1997.

15 DeDeaux wishes me to clarify that she meant here to critique the anthropological stereotype of the "black being beast related to slavery."

16 Vetrocq (1993: 110) reports this to be the charge voiced by African-American critics in New Orleans, while Cynthia Wiggins's exceptionally dismissive article about the show, "Jail Sell" (1994: 11) refers to a charged moment at the LA opening when DeDeaux stood nose to nose with a young black man objecting to her referencing of negative stereotypes.

17 It is almost as if these teenage inmates responded as well to the "liveness" of the tape which lends to it the kind of "amateur" allure discussed by Zimmerman in *Reel Families* (1995).

18 See also Diana Fuss's excellent reading of Bhabha (1994: 25); her cautionary note could just as well be applied to my own reading of these tapes: "If the mimicry of subjugation can provide unexpected opportunities for resistance and disruption, the mimicry of subversion can find itself reinforcing conventional power relations rather than eroding them."

19 In the sense employed by Virilio in *War and Cinema* (1989).

20 Refer to Fuss's lucid discussion of this danger (1994: 25).

BIBLIOGRAPHY

Abraham, Nicolas (1979) "The Shell and the Kernel," trans. Nicolas Rand, *diacritics* 9, 1 (Spring): 16–28.

—— (1988) "The Phantom of Hamlet or The Sixth Act: Preceded by The Intermission of 'Truth,'" trans. Nicolas Rand, *diacritics* 18, 4 (Winter): 2–19.

Abraham, Nicolas, and Torok, Maria (1987) *L'Ecorce et le noyau*, Paris: Flammarion.

Adams, Parveen (1991) "The Art of Analysis: Mary Kelly's *Interim* and the Discourse of the Analyst," *October* 58 (Fall): 81–96.

Adelman, Janet (1992) *Suffocating Mothers: Fantasies of Maternal Origin in Shakespeare's Plays, "Hamlet" to "The Tempest"*, New York and London: Routledge.

Allen, Robert C. (1987) "The Guiding Light: Soap Opera as Economic Product and Cultural Development," in Horace Newcomb (ed.) *Television: The Critical View*, New York and Oxford: Oxford University Press.

Alpers, Svetlana (1983) *The Art of Describing: Dutch Art in the Seventeenth Century*, Chicago: University of Chicago Press.

Althusser, Louis (1971) *Lenin and Philosophy*, trans. Ben Brewster, New York: Monthly Review Press.

—— (1977) *For Marx*, trans. Ben Brewster, London: New Left Books.

Altman, Janet Gurkin (1984) *Epistolarity: Approaches to a Form*, Columbus: Ohio State University Press.

Altman, Rick (1986) "Television/Sound," in Tania Modleski (ed.) *Studies in Entertainment: Critical Approaches to Mass Culture*, Bloomington: Indiana University Press.

—— (1987) "Television Sound," in Horace Newcomb (ed.) *Television: The Critical View*, New York and Oxford: Oxford University Press.

Andrew, Dudley (1987) *Breathless: Jean-Luc Godard, Director*, New Brunswick and London: Rutgers University Press.

Anon. (1643) *The Actor's Remonstrance or Complaint for the Silencing of Their Profession and Banishment from Their Several Play Houses*, London.

Appiah, Anthony (1985) "The Uncompleted Argument: Du Bois and the Illusion of Race," *Critical Inquiry* 12, 1 (Autumn): 21–37.

Apter, Emily (1991) *Feminizing the Fetish: Psychoanalysis and Narrative Obsession in Turn-of-the-century France*, Ithaca: Cornell University Press.

Aristotle (1940) *The Art of Poetry*, intro. W. Hamilton Frye, Oxford: Oxford University Press.

Bad Object Choices, ed. (1991) *How Do I Look? Queer Film and Video*, Seattle: Bay Press.

Baker, Huston A., Jr. (1987) *Modernism and the Harlem Renaissance*, Chicago: Chicago University Press.

Baltrusaitis, Jurgis (1969) *Anamorphose ou magie artificielle des effets merveilleux*, Paris: Olivier Perrin.

Baraka, Amiri (1978a) *The Motion of History*, New York: William Morrow.

—— (1978b) "On Black Theater," *Theater* 9, 2 (Spring): 59–61.

Barish, Jonas (1981) *The Antitheatrical Prejudice*, Berkeley: University of California Press.

Barthes, Roland (1978) *A Lover's Discourse: Fragments*, trans. Richard Howard, New York: Hill & Wang.

—— (1981) *Camera Lucida: Reflections on Photography*, trans. Richard Howard, New York: Hill & Wang.

—— (1985) *The Responsibility of Forms*, trans. Richard Howard, New York: Hill & Wang.

Baudrillard, Jean (1972) *Pour une critique de l'économie politique du signe*, Paris: Editions Gallimard.

Baudry, Jean-Louis (1978) *L'Effet cinéma*, Paris: Editions Albatros.

—— (1986a) "Ideological Effects of the Basic Cinematographic Apparatus," trans. Alan Williams, in Philip Rosen (ed.) *Narrative, Apparatus, Ideology*, New York: Columbia University Press.

—— (1986b) "The Apparatus: Metapsychological Approaches to the Impression of Reality in Cinema," trans. Jean Andrews and Bertrand Augst, in Philip Rosen (ed.) *Narrative, Apparatus, Ideology*, New York: Columbia University Press.

Beaujour, Michel (1980) "Genus Universum," *Glyph* 7: 15–31.

Bellamy, Elizabeth J. (1995) "Othello's Lost Handkerchief: Where Psychoanalysis Finds Itself," in Richard Felstein and Willy Apollon (eds.) *Lacan: Politics and Aesthetic Representation*, Albany: SUNY Press.

Bellour, Raymond (1990) *L'Entre-images: photo, cinéma, vidéo*, Paris: La Différence.

Belsey, Catherine (1985) *The Subject of Tragedy: Identity and Difference in Renaissance Drama*, London and New York: Methuen.

—— (1993) "The Name of the Rose in *Romeo and Juliet*," *The Yearbook of English Studies* 23: 126–42.

Benjamin, Walter (1969) "The Work of Art in the Age of Mechanical Reproduction," in Hannah Arendt (ed.) *Illuminations*, trans. Harry Zohn, New York: Schocken Books.

—— (1977) *The Origin of German Tragic Drama*, trans, John Osborne, London: NLB.

Benston, Kimberly W. (1992) "Introduction. Being-There: Performance as Mise-en-Scène, Abscene, Obscene, and Other Scene," *PMLA* 107, 3 (May): 434–49.

Berg, Elizabeth L. (1983) "Recognizing Differences: Perrault's Modernist Esthetic in *Parallèle des anciens et des modernes*," *Papers on French Seventeenth Century Literature*.

Berger, Harry, Jr. (1979) "Conspicuous Exclusion," *Salmagundi* 44–45 (Spring–Summer): 89–112.

—— (1989) "What Did the King Know and When Did He Know It? Shakespearean Discourses and Psychoanalysis," *The South Atlantic Quarterly Review* 88, 4 (Fall): 813.

Berger, Maurice (1990) "Are Art Museums Racist?," *Art in America* (September): 68–77.

Bersani, Leo (1976) *A Future for Astyanax: Character and Desire in Literature*, Boston: Little, Brown and Company.

—— (1990) *The Culture of Redemption*, Cambridge, Mass.: Harvard University Press.

Best, Steven and Kellner, Douglas (1987) "(Re)watching Television: Notes toward a Political Criticism," *diacritics* 17, 2 (Summer): 97–113.

Bhabha, Homi K. (1989) "Remembering Fanon: Self, Psyche, and the Colonial Condition," in Barbara Kruger and Phil Mariana (eds.) *Remaking History*, Dia Art Foundation Discussions in Contemporary Culture, 4, Seattle: Bay Press, 131–48.

—— (1990) "DissemiNation: Time, Narrative, and the Margins of the Modern Nation," in Homi K. Bhabha (ed.) *Nation and Narration*, London and New York: Routledge, 291–322.

—— (1994) *The Location of Culture*, London and New York: Routledge.

Blau, Herbert (1982a) *Take up the Bodies: Theatre at the Vanishing Point*, Urbana: University of Illinois Press.

—— (1982b) *Blooded Thought: Occasions of Theatre*, New York: Performing Arts Journal Publications.

—— (1983) "Ideology and Performance," *Theatre Journal* 35, 4: 441–60.

—— (1987) *The Eye of Prey: Subversions of the Postmodern*, Bloomington: Indiana University Press.

—— (1990) *The Audience*, Baltimore: The Johns Hopkins University Press.

—— (1992) *To All Appearances: Ideology and Performance*, London and New York: Routledge.

Booth, Stephen (1983) *King Lear, Macbeth, Indefinition, and Tragedy*, New Haven: Yale University Press.

Borch-Jacobsen, Mikkel (1988) *The Freudian Subject*, trans. Catherine Porter, Stanford, Calif.: Stanford University Press.

Borch-Jacobsen, Mikkel, Michaud, Eric, and Nancy, Jean-Luc (1984) *Hypnoses*, Paris: Galilée.

Boswell, James (1948) *The Life of Samuel Johnson*, Garden City, NY: Garden City Publishing.

Brettle, Jane and Rice, Sally (1994) *Public Bodies – Private States: New Views on Photography, Representation and Gender*, Manchester and New York: Manchester University Press.

Brewer, Maria Minich (1984) "A Loosening of Tongues: From Narrative Economy to Women Writing," *MLN* 99, 5 (December): 1141–61.

—— (1985) "Performing Theory," *Theatre Journal* 37, 1 (March): 13–30.

Brooks, Peter (1984) *Reading for the Plot: Design and Intention in Narrative*, New York: Random House.

Brown, Beverly (1992) "Pornography and Feminism: Is Law the Answer?," *Critical Quarterly* 34, 2 (Summer): 72–82.

Brunette, Peter and Wills, David (1993) "Images Off: Ulmer's Teletheory," *diacritics* 23, 2 (Summer): 36–46.

Bryson, Norman (1983) *Vision and Painting: The Logic of the Gaze*, New Haven, Conn.: Yale University Press.

Bulman, J. C. (1988) "The BBC Shakespeare and 'House Style'" in J. C. Bulman and H. R. Coursen (eds.) *Shakespeare on Television*, Hanover and London: University Press of New England.

Bulman, J. C. and Coursen, H. R., eds. (1988) *Shakespeare on Television*, Hanover and London: University Press of New England.

Bürger, Peter (1984) *Theory of the Avant-Garde*, trans. Michael Shaw, Minneapolis: University of Minnesota Press.

Burgin, Victor, ed. (1982) *Thinking Photography*, London: Macmillan.

—— (1986) *The End of Art Theory: Criticism and Postmodernity*, Atlantic Highlands, NJ: Humanities Press International.

Burgin, Victor, Donald, James, and Kaplan, Cora, eds. (1986) *Formations of Fantasy*, London: Methuen.

Burke, Kenneth (1964) *"Othello*: An Essay to Illustrate a Method," in Stanley Edgar Hymen (ed.) *Perspectives by Incongruity*, Bloomington: Indiana Univ. Press, 152–95.

—— (1969) *A Grammar of Motives*, Berkeley: University of California Press.

—— (1973) *The Philosophy of Literary Form*, Berkeley: University of California Press.

Burt, Richard, ed. (1994) *The Administration of Aesthetics: Censorship, Political Criticism, and the Public Sphere*, Minneapolis: University of Minnesota Press.

Butler, Judith (1990a) *Gender Trouble: Feminism and the Subversion of Identity*, New York and London: Routledge.

—— (1990b) "Performative Acts and Gender Constitution: An Essay in Phenomenology and Feminist Theory," in Sue-Ellen Case, (ed.) *Performing Feminisms: Feminist Critical Theory and Theatre*, Baltimore: The Johns Hopkins University Press, 270–82.

—— (1993) *Bodies That Matter: On the Discursive Limits of "Sex"*, New York and London: Routledge.

Calderwood, James L. (1991) *"A Midsummer Night's Dream*: Anamorphism and Theseus' Dream," *Shakespeare Quarterly* 42, 4 (Winter): 409–30.

Callaghan, Dympna C. (1994) "The Ideology of Romantic Love: The Case of *Romeo and Juliet*," in Dympna C. Callaghan, Lorraine Helms, and Jyotsna Singh, *The Weyward Sisters: Shakespeare and Feminist Politics*, Oxford and Cambridge, Mass.: Blackwell.

Carby, Hazel V. (1985) "'On the Threshold of Woman's Era:' Lynching, Empire, and Sexuality in Black Feminist Theory," *Critical Inquiry* 12, 1 (Autumn): 262–77.

Caruth, Cathy, ed. (1991) *Psychoanalysis, Culture, and Trauma*, American Imago 48, 1 (Spring).

—— ed. (1995) *Trauma: Explorations in Memory*, Baltimore: The Johns Hopkins University Press.

Case, Sue-Ellen (1989a) "Toward a Butch-femme Aesthetic," in Lynda Hart (ed.) *Making a Spectacle: Feminist Essays on Contemporary Women's Theatre*, Ann Arbor: University of Michigan Press.

—— (1989b) "From split subject to split britches," in Enoch Brater (ed.) *Feminine Focus: The New Women Playwrights*, New York and Oxford: Oxford University Press.

—— ed. (1990) *Performing Feminisms: Feminist Critical Theory and Theatre*, Baltimore: The Johns Hopkins University Press.

Cavell, Stanley (1979) *The Claim of Reason: Wittgenstein, Skepticism, Morality, and Tragedy*, Oxford: Clarendon Press; New York: Oxford University Press.

—— (1987) *Disowning Knowledge in Six Plays of Shakespeare*, Cambridge: Cambridge University Press.

Cha, Theresa Hak, ed. (1980) *Apparatus: Cinematographic Apparatus: Selected Writings*, New York: Tanam Press.

Chambers, E. K. (1923) *The Elizabethan Stage*, Oxford: The Clarendon Press.

Chambers, Ross (1984) *Story and Situation: Narrative Seduction and the Power of Fiction*, Minneapolis: University of Minnesota Press.

Chapman and Shirley (1639) *The Tragedy of Chabot*.

Chase, Cynthia (1986) "Anecdote for Fathers: The Scene of Interpretation in Freud and Wordsworth," in Mary Ann Caws (ed.) *Textual Analysis: Some Readers Reading*, New York: Modern Language Association of America, 182–206.

Cheng, Anne Annlin (1997) "The Melancholy of Race," *The Kenyon Review* 23, 1 (Winter): 49–61.

Cheyfitz, Eric (1981) *The Poetics of Imperialism: Translation and Colonization from "The Tempest" to "Tarzan"*, New York and Oxford: Oxford University Press.

Chin, Daryl (1989) "Interculturalism, Postmodernism, Pluralism," *Performing Arts Journal* 33/34: 163–75.

Cixous, Hélène (1981) "The Laugh of the Medusa," trans. Keith Cohen and Paula Cohen, in Elaine Marks and Isabelle de Courtivron (eds.) *New French Feminisms: An Anthology*, New York: Schocken Books.

—— (1997) *"Hois Cadre*: Interview," trans. Verena Andermatt Conley, in Timothy Murray (ed.) *Mimesis, Masochism, and Mime: The Politics of Theatricality in Contemporary French Thought*, Ann Arbor: University of Michigan Press.

Cixous, Hélène and Clément, Catherine (1986) *The Newly Born Woman*, trans. Betsy Wing, Minneapolis: University of Minnesota Press.

Colie, Rosalie (1973) *The Resources of Kind: Genre-theory in the Renaissance*, ed. Barbara K. Lewalski, Berkeley: University of California Press.

Comolli, Jean-Louis (1977) "Technique and Ideology: Camera, Perspective, Depth of Field," *Film Reader* 2.

—— (1980) "Machines of the Visible," in Teresa de Lauretis and Stephen Heath (eds.) *The Cinematic Apparatus*, London: Macmillan; New York: St. Martin's Press.

Conley, Tom (1991) *Film Hieroglyphs: Ruptures in Classical Cinema*, Minneapolis: University of Minnesota Press.

Conley, Verena Andermatt ed. (1993) *Rethinking Technologies*, Minneapolis and London: University of Minnesota Press.

Conquergood, Dwight (1992) "Performance Theory, Hmong Shamans, and Cultural Politics," in Janelle G. Reinelt and Joseph R. Roach (eds.) *Critical Theory and Performance*, Ann Arbor: The University of Michigan Press.

Copjec, Joan (1982) "The Anxiety of the Influencing Machine," *October* 23 (Winter): 43–59.

—— (1990) "Document on the Institutional Debate: An Introduction," in Jacques Lacan, *Television: A Challenge to the Psychoanalytic Establishment*, trans. Denis Hollier, Rosalind Krauss, and Annette Michelson, New York: W. W. Norton.

Crary, Jonathan (1988) "Modernizing Vision," in Hal Foster (ed.) *Vision and Visuality*, Seattle: Bay Press.

—— (1990) *Techniques of the Observer: On Vision and Modernity in the Nineteenth Century*, Cambridge, Mass., and London: MIT Press.

Crimp, Douglas (1984) "The Art of Exhibition," *October* 30: 49–81.

—— (1993) *On the Museum's Ruins*, Cambridge, Mass.: MIT Press.

Crimp, Douglas, and Rolston, Adam (1990) *AIDSDEMOGRAPHICS*, Seattle: Bay Press.

Cronacher, Karen (1992) "Unmasking the Minstrel Mask's Black Magic in Ntozake Shange's Spell no.7," *Theatre Journal* 44, 2: 177–93.

Cubitt, Sean (1991) *Timeshift: On Video Culture*, London and New York: Routledge.

Damisch, Hubert (1994) *L'Origine de la perspective*, Paris: Flammarion.

Daney, Serge (1970) "Sur Salador," *Cahiers du cinéma* 222 (July): 39.

Dash, Julie (1991) *Daughters of the Dust*, 35mm.

d'Aubignac, Abbé (1927) *La Pratique du théâtre*, ed. Pierre Martino, Alger: Jules Carbonel.

Davis, Natalie Zemon (1975) "Gender and Genre: Women as Historical Writers, 1400–1820," in Patricia H. Labalme (ed.) *Beyond Their Sex: Learned Women of the European Past*, New York: New York University Press.

Davy, Kate (1989) "Reading Past the Heterosexual Imperative: *Dress Suits to Hire*," *The Drama Review* 33, 1: 153–70.

de Certeau, Michel (1986) *Heterologies: Discourse on the Other*, trans. Brian Massumi, Minneapolis: University of Minnesota Press.

de Lauretis, Teresa (1984) *Alice Doesn't: Feminism, Semiotics, Cinema*, Bloomington: Indiana University Press.

—— (1987) *Technologies of Gender: Essays on Theory, Film, and Fiction*, Bloomington: Indiana University Press.

—— (1990) "Sexual Indifference and Lesbian Representation," in Sue-Ellen Case (ed.) *Performing Feminisms: Feminist Critical Theory and Theatre*, Baltimore: The Johns Hopkins University Press.

de Lauretis, Teresa, and Heath, Stephen, eds. (1980) *The Cinematic Apparatus*, London: Macmillan; New York: St Martin's Press.

Deleuze, Gilles (1986) *Cinema 1: The Movement-Image*, trans. Hugh Tomlinson and Barbara Habberjam, Minneapolis: University of Minnesota Press.

—— (1989) *Cinema 2: The Time-Image*, trans. Hugh Tomlinson and Robert Galeta, Minneapolis: University of Minnesota Press.

—— (1993) *The Fold*, trans. Tom Conley, Minneapolis and London: University of Minnesota Press.

—— (1994) *Difference and Repetition*, trans. Paul Patton, New York: Columbia University Press.

—— (1997) "One Less Manifesto," trans. Eliane dal Molin and Timothy Murray, in Timothy Murray (ed.) *Mimesis, Masochism, and Mime: The Politics of Theatricality in Contemporary French Thought*, Ann Arbor: University of Michigan Press.

Deleuze, Gilles and Guattari, Félix (1987) *A Thousand Plateaus: Capitalism and Schizophrenia*, trans. Brian Massumi, Minneapolis: University of Minnesota Press.

de Man, Paul (1984) *The Rhetoric of Romanticism*, New York: Columbia University Press.

Dent, Gina, ed. (1992) *Black Popular Culture, a Project by Michele Wallace*, Seattle: Bay Press.

Derrida, Jacques (1979a) "Scribble (writing-power)," *Yale French Studies* 58: 116–47.

—— (1979b) "Me – Psychoanalysis: An Introduction to the Translation of 'The Shell and the Kernel' by Nicolas Abraham," trans. Richard Klein, *diacritics* 9, 1 (March): 4–12.

—— (1980) *La Carte postale: de Socrate à Freud et au-dela*, Paris: Aubier-Flammarion.

—— (1981) *Dissemination*, trans. Barbara Johnson, Chicago: University of Chicago Press.

—— (1987) *Psyche: inventions de l'autre*, Paris: Galilée.

—— (1992) *Acts of Literature*, ed. Derek Attridge, New York and London: Routledge.

—— (1994) *Specters of Marx: The State of the Debt, the Work of Mourning, and the New International*, trans. Peggy Kamuf, New York and London: Routledge.

—— (1997) "The Theater of Cruelty and the Closure of Representation," trans. Alan Bass, in Timothy Murray (ed.) *Mimesis, Masochism, and Mime: The Politics of Theatricality in Contemporary French Thought*, Ann Arbor: University of Michigan Press.

Diamond, Elin (1985) "Refusing the Romanticism of Identity: Narrative Interventions in Churchill, Benmussa, Duras," *Theatre Journal* 37, 3 (October): 273–86.

—— (1988) "Brechtian Theory/Feminist Theory: Toward a Gestic Feminist Criticism," *The Drama Review* (Spring): 82–94.

—— (1992) "The Violence of 'We:' Politicizing Identification," in Janelle G. Reinelt and Joseph R. Roach (eds.) *Critical Theory and Performance*, Ann Arbor: The University of Michigan Press.

—— (1997) *Unmasking Mimesis: Essays on Feminism and Theater*, London: Routledge.

Doane, Mary Ann (1987) *The Desire to Desire: The Woman's Film of the 1940s*, Bloomington: Indiana University Press.

—— (1991) *Femmes Fatales: Feminism, Film Theory, Psychoanalysis*, New York: Routledge.

Dolan, Jill (1988) *The Feminist Spectator as Critic*, Ann Arbor: UMI Research Press.

—— (1990) "'Lesbian' Subjectivity in Realism: Dragging at the Margins of Structure and Ideology," in Sue-Ellen Case (ed.) *Performing Feminisms: Feminist Critical Theory and Theatre*, Baltimore: The Johns Hopkins University Press.

Dupuy, Jean, ed. (1980) *Collective Consciousness: Art Performances in the Seventies*, New York: Performing Arts Journal Publications.

Dusinberre, Juliet (1975) *Shakespeare and the Nature of Women*, London: Macmillan.

Edelman, Lee (1991) "Seeing Things: Representation, the Scene of Surveillance, and the Spectacle of Gay Male Sex," in Diana Fuss (ed.) *Inside/Out: Lesbian Theories, Gay Theories*, New York: Routledge.

Egger, Rebecca and Murray, Tim (1992) "Montage, Mastery, and Masquerade: An Interview with Mary Kelly," *The Bookpress* 2, 3 (April): 8, 14.

Ellis, John (1982) *Visible Fictions, Cinema: Television: Video*, London and New York: Routledge.

Enzensberger, Hans Magnus (1986) "Constituents of a Theory of the Media," in John G. Hanhardt (ed.) *Video Culture: An Investigation*, Rochester, NY: Visual Studies Workshop Press.

Erickson, Peter (1985) *Patriarchal Structures in Shakespeare's Drama*, Berkeley: University of California Press.

Ettinger, Bracha Lichtenberg (1996) "The With-In-Visible Screen," in Catherine de Zegher (ed.) *Inside the Visible in, of, and from the Feminine: An Elliptical Traverse of 20th Century Art*, Cambridge, Mass.: MIT Press.

Fanon, Frantz (1967) *Black Skin, White Masks*, trans. Charles Lam Markmann, New York: Grove Press.

—— (1997) "Algeria Unveiled," in Timothy Murray (ed.) *Mimesis, Masochism, and Mime: The Politics of Theatricality in Contemporary French Thought*, Ann Arbor: University of Michigan Press.

Feminist Anti-Censorship Task-force (1992) *Caught Looking: Feminism, Pornography & Censorship*, East Haven, Conn.: LongRiver Books.

Féral, Josette (1997) "Performance and Theatricality: The Subject Demystified," in Timothy Murray (ed.) *Mimesis, Masochism, and Mime: The Politics of Theatricality in Contemporary French Thought*, Ann Arbor: University of Michigan Press.

Ferguson, Russell, Gever, Martha, Trinh T. Minh-ha, and West, Cornel, eds. (1990) *Out There: Marginalization and Contemporary Cultures*, New York: The New Museum of Contemporary Art; Cambridge, Mass.: MIT Press.

Feuer, Jane (1983) "The Concept of Live Television: Ontology as Ideology," in E. Ann Kaplan (ed.) *Regarding Television: Critical Approaches – An Anthology*, Frederick, Md.: University Publications of America and the American Film Institute.

Fiedler, Leslie (1972) *The Stranger in Shakespeare*, New York: Stein and Day.

Fineman, Joel (1991) *The Subjectivity Effect in Western Literary Tradition: Essays Toward the Release of Shakespeare's Will*, Cambridge, Mass.: MIT Press.

Fische-Lichte, Erika (1989) "Theatre and the Civilizing Process: An Approach to the History of Acting," in Thomas Postlewait and Bruce A. McConachie (eds.) *Interpreting the Theatrical Past: Essays in the Historiography of Performance*, Iowa City: University of Iowa Press.

Fiske, John (1987) *Television Culture*, London and New York: Methuen.

Fiske, John and Hartley, John (1987) "Bardic Television," in Horace Newcomb (ed.) *Television: The Critical View*, New York and Oxford: Oxford University Press.

Fletcher, John (1992) "The Letter in the Unconscious: The Enigmatic Signifier in the work of Jean Laplanche," in John Fletcher and Martin Stanton (eds.) *Jean Laplanche: Seduction, Translation, Drives*, London: Institute of Contemporary Arts.

Flitterman-Lewis, Sandy (1987) "Psychoanalysis, Film, and Television," in Robert C. Allen, *Channels of Discourse: Television and Contemporary Criticism*, Chapel Hill and London: The University of North Carolina Press.

—— (1988) "All's Well That Doesn't End: Soap Operas and the Marriage Motif," *Camera Obscura* 16: 119–28.

Forte, Jeanne K. (1990) "Women's Performance Art: Feminism and Postmodernism," in Sue-Ellen Case (ed.) *Performing Feminisms: Feminist Critical Theory and Theatre*, Baltimore: The Johns Hopkins University Press.

Foster, Hal (1985) *Recodings: Art, Spectacle, Cultural Politics*, Port Townsend: Bay Press.

—— (1990) "That Obscure Subject of Desire: An Interview with Mary Kelly," in Mary Kelly, *Interim*, New York: The New Museum of Contemporary Art.

—— (1991) "Convulsive Identity," *October* 57 (Summer): 19–54.

—— (1993) *Compulsive Beauty*, Cambridge, Mass., and London: MIT.

—— ed. (1988) *Vision and Visuality*, Seattle: Bay Press.

Foucault, Michel (1970) *The Order of Things: An Archeology of the Human Sciences*, New York: Vintage Books.

—— (1977) *Discipline and Punish: The Birth of the Prison*, trans. Alan Sheridan, New York: Pantheon Books.

—— (1997) "Theatrum Philosophicum," in Timothy Murray (ed.) *Mimesis, Masochism, and Mime: The Politics of Theatricality in Contemporary French Thought*, Ann Arbor: University of Michigan Press.

Freud, Sigmund (1953–74) *The Standard Edition of the Complete Psychological Works of Sigmund Freud*, 24 vols, ed. and trans. James Strachey, London: Hogarth Press and the Institute of Psychoanalysis.

Fusco, Coco (1995) "Performance and the Power of the Popular," in Catherine Ugwu (ed.) *Let's Get It On: The Politics of Black Performance*, London: Institute of Contemporary Arts; Seattle: Bay Press.

Fuss, Diana (1994) "Interior Colonies: Frantz Fanon and the Politics of Identification," *diacritics* 24, 2–3 (Summer): 20–42.

Gaines, Jane (1990a) "White Privilege and Looking Relations: Race and Gender in Feminist Film Theory," in Patricia Erens (ed.) *Issues in Feminist Film Criticism*, Bloomington: Indiana University Press.

—— (1990b) "Competing Glances: Reading Robert Mapplethorpe's *Black Book*," Cornell University Library, audiotape, 6 December.

Galperin, William (1988) "Sliding off the Stereotype: Gender Difference in the Future of Television," in E. Ann Kaplan (ed.) *Postmodernism and its Discontents*, London and New York: Verso.

Gammon, Lorraine and Marshment, Margaret, eds. (1989) *The Female Gaze: Women as Viewers of Popular Culture*, Seattle: The Real Comet Press.

Gantheret, Francois (1987) "Du Coin de l'oeil," *Nouvelle Revue de Psychanalyse* 35 (Spring): 107–25.

Gasche, Rodolphe (1986) *The Tain of the Mirror: Derrida and the Philosophy of Reflection*, Cambridge, Mass.: Harvard University Press.

Gates, Henry Louis, Jr. (1985) "Writing 'Race' and the Difference it Makes," *Critical Inquiry* 12, 1 (Autumn): 1–20.

—— (1988) *The Signifying Monkey: A Theory of Afro-American Literary Criticism*, New York and Oxford: Oxford University Press.

—— (1992a) "The Black Man's Burden," in Gina Dent (ed.) *Black Popular Culture: A Project by Michele Wallace*, Seattle: Bay Press.

—— (1992b) "Must Buppiehood Cost Homeboy His Soul?," *The New York Times*, 1 March: 111–13.

Geis, Deborah R. (1989) "Distraught Laughter: Monologue in Ntozake Shange's Theater Pieces," in Enoch Brater (ed.) *Feminine Focus: The New Women Playwrights*, New York and Oxford: Oxford University Press.

Genette, Gérard (1980) *Narrative Discourse: An Essay in Method*, trans. Jane E. Lewin, Ithaca: Cornell University Press.

Gilman, Ernest P. (1978) *The Curious Perspective: Literary and Pictorial Wit in the Seventeenth Century*, New Haven: Yale University Press.

Gilroy, Paul (1992) "It's a Family Affair," in Gina Dent (ed.) *Black Popular Culture: A Project by Michele Wallace*, Seattle: Bay Press, 303–16.

—— (1995) "'. . . To Be Real:' The Dissident Forms of Black Expressive Culture," in Catherine Ugwu (ed.) *Let's Get It On: The Politics of Black Performance*, London: Institute of Contemporary Arts; Seattle: Bay Press.

Girard, René (1977) *Violence and the Sacred*, trans. Patrick Gregory, Baltimore: The Johns Hopkins University Press.

—— (1997) "From Mimetic Desire to the Monstrous Double," in Timothy Murray (ed.) *Mimesis, Masochism, and Mime: The Politics of Theatricality in Contemporary French Thought*, Ann Arbor: University of Michigan Press.

Gitlin, Todd (1987) "Prime Time Ideology: The Hegemonic Process in Television Entertainment," in Horace Newcomb (ed.) *Television: The Critical View*, New York and Oxford: Oxford University Press.

Gohlke, Madelon (1980), "'I wooed thee with my sword:' Shakespeare's Tragic Paradigms," in Murray M. Schwarz and Coppélia Kahn (eds.) *Representing Shakespeare*, Baltimore: The Johns Hopkins University Press.

Goldberg, Jonathan (1988) "Perspectives: Dover Cliff and the Conditions of Representation," in G. Douglas Atkins and David M. Bergeron (eds) *Shakespeare and Deconstruction*, New York and Bern: Peter Lang.

—— (1994) "Romeo and Juliet's *Open Rs*," in Jonathan Goldberg (ed.) *Queering the Renaissance*, Durham and London: Duke University Press.

Golden, Thelma, ed. (1994) *Black Male: Representations of Masculinity in Contemporary American Art*, New York: Whitney Museum of Art.

Goldsby, Jackie (1993) "Queens of Language: *Paris is Burning*," in Martha Gever, Pratibha Parmar, and John Greyson (eds.) *Queer Looks: Perspectives on Lesbian and Gay Film and Video*, New York and London: Routledge.

Gosson, Stephen (1974) "Playes Confuted in Five Actions," in Arthur F. Kinney, *Markets of Bawdrie: The Dramatic Criticism of Stephen Gosson*, Salzburg: Institut für Englische Sprache und Literatur, Universität Salzburg.

Green, André (1979) *The Tragic Effect: The Oedipus Conflict in Tragedy*, trans. Alan Sheridan, Cambridge: Cambridge University Press.

—— (1997) "The Psycho-analytic Reading of Tragedy," in Timothy Murray (ed.) *Mimesis, Masochism, and Mime: The Politics of Theatricality in Contemporary French Thought*, Ann Arbor: University of Michigan Press.

Greenaway, Peter (1991) *Prospero's Books: A Film of Shakespeare's The Tempest*, New York: Four Walls Eight Windows.

Greenberg, Mitchell (1992) *Subjectivity and Subjugation in Seventeenth-century Drama and Prose: The Family Romance of French Classicism*, Cambridge: Cambridge University Press.

—— (1994) *Canonical States, Canonical Stages: Oedipus, Othering, and Seventeenth-century Drama*, Minneapolis and London: University of Minnesota Press.

—— (1997) "Absolutism and Androgyny: The Abbé de Choisy and the Erotics of Trompe-l'oeil," in Timothy Murray and Alan Smith (eds.) *Repossessions: Psychoanalysis and the Phantoms of Early Modern Culture*, Minneapolis: University of Minnesota Press.

Greenblatt, Stephen (1980a) *Renaissance Self-Fashioning: From More to Shakespeare*, Chicago: University of Chicago Press.

—— (1980b) "The Improvisation of Power," in Edward W. Said (ed.) *Literature and Society, Selected Papers from The English Institute 1978*, Baltimore: The Johns Hopkins University Press, 57–99.

——(1988) *Shakespearean Negotiations: The Circulation of Social Energy in Renaissance England*, Berkeley: University of California Press.

Habermas, Jürgen (1975) *Legitimation Crisis*, Boston: Beacon Press.

Hadjinicolaou, Nicos (1982) "On the Ideology of Avant-gardism," trans. Diane Belle James, *Praxis* 6: 39–70.

Hall, Stuart (1992) "What is this 'Black' in Black Popular Culture?" in Gina Dent (ed.) *Black Popular Culture: A Project by Michele Wallace*, Seattle: Bay Press.

Hallinan, Tim (1981) "Interview: Jonathan Miller on the Shakespeare Plays," *Shakespeare Quarterly* 32, 2 (Summer): 134–45.

Harper, Brian Phillip (1994) "'The Subversive Edge:' *Paris is Burning*, Social Critique, and the Limits of Subjective Agency," *diacritics* 24, 2–3 (Summer–Fall): 90–103.

Harrington, Barbara and Hess, M. Elizabeth (1991) "Editors' Introduction," *The Drama Review* 35, 3 (Fall): 128–30.

Hatch, James V. (1989) "Here Comes Everybody: Scholarship and Black Theatre History," in Thomas Postlewait and Bruce A. McConachie (eds.) *Interpreting the Theatrical Past: Essays in the Historiography of Performance*, Iowa City: University of Iowa Press.

Heath, Stephen (1974) "Lessons from Brecht," *Screen* 15, 2 (Summer): 103–28.

—— (1981) *Questions of Cinema*, Bloomington: Indiana University Press.

—— (1986) "Joan Riviere and the Masquerade," in Victor Burgin, James Donald, and Cora Kaplan (eds.) *Formations of Fantasy*, London: Methuen.

—— (1990) "Representing Television," in Patricia Mellencamp (ed.) *Logics of Television: Essays in Cultural Criticism*, London: BFI Publishing; Bloomington: Indiana University Press.

Heidegger, Martin (1977) *The Question Concerning Technology and Other Essays*, trans. William Lovitt, New York: Harper & Row.

Herskowitz, Richard, ed. (1985) *New Performances on Film and Video*, Ithaca: Herbert F. Johnson Museum of Art, Cornell University.

Hobson, Louis B. (1996) "The Original Fatal Attraction," *Calgary Sun*: http://www.conoe.ca/JamMoviesArtistsA2D/danes_clare.html.

Hodgdon, Barbara (1987) "The Making of Virgins and Mothers: Sexual Signs,

Substitute Scenes and Doubled Presences in *All's Well That Ends Well*," *Philological Quarterly* 66, 1 (Winter): 47–71.

hooks, bell (1994) "Feminism Inside: Toward a Black Body Politic," in Thelma Golden (ed.) *Black Male: Representations of Masculinity in Contemporary American Art*, New York: Whitney Museum of American Art.

—— (1995) "Performance Practice as a Site of Opposition," in Catherine Ugwu (ed.) *Let's Get It On: The Politics of Black Performance*, London: Institute of Contemporary Arts; Seattle: Bay Press.

Hope, Trevor (1994) "Sexual Indifference and the Homosexual Male Imaginary," *diacritics* 24, 2–3 (Summer–Fall): 169–83.

Horkheimer, Max and Adorno, Theodor W. (1972) *Dialectic of Enlightenment*, New York: Continuum.

Howell, John (1988) "Robbie McCauley, Indian Blood," *Artforum* 25, 5 (January): 120–21.

Hughes, Holly (1991a) *"The Lady Dick,"* *The Drama Review* 35, 3 (Fall): 199–215.

—— (1991b) "The Archeology of Muff Diving: An Interview by Charles M. Wilmoth," *The Drama Review* 35, 3 (Fall): 199–215.

Huston, Hollis W. (1984) "The Gest of the Breath," *Theatre Journal* 36, 2: 199–211.

Irigaray, Luce (1985a) *Speculum of the Other Woman*, trans. Gillian G. Gill, Ithaca: Cornell University Press.

—— (1985b) *This Sex Which Is Not One*, trans. Catherine Porter and Caroline Burke, Ithaca: Cornell University Press.

Jackson, Elaine (1971) *"Toe Jam,"* in Woodie King and Ron Milner (eds.) *Black Drama Anthology*, New York: New American Library.

Jacobus, Mary (1986) *Reading Woman: Essays in Feminist Criticism*, London: Methuen.

Jameson, Fredric (1988) "Postmodernism and Consumer Society," in E. Ann Kaplan (ed.) *Postmodernism and its Discontents: Theories, Practices*, London: Verso.

Jansen, Sue Curry (1991) *Censorship: The Knot That Binds Power and Knowledge*, New York and Oxford: Oxford University Press.

Jardine, Lisa (1987) "Cultural Confusion and Shakespeare's Learned Heroines: 'These Are Old Paradoxes'," *Shakespeare Quarterly* 38, 1 (Spring): 1–18.

Jarman, Derek (1984) *Dancing Ledge*, London: Quartet Books.

Jeyifo, Biodun (1985) *The Truthful Lie: Essays in a Sociology of African Drama*, London: New Beacon Books.

Johnson, Barbara (1982a) "The Frame of Reference: Poe, Lacan, Derrida," in Shoshana Felman (ed.) *Literature and Psychoanalysis, the Question of Reading: Otherwise*, Baltimore: The Johns Hopkins University Press.

—— (1982b) "My Monster/My Self," *diacritics* 12, 2 (Summer): 2–10.

Joyrich, Lynne (1988) "All That Television Allows: TV Melodrama, Postmodernism and Consumer Culture," *Camera Obscura* 16 (January): 129–53.

Kahn, Coppélia (1981) *Man's Estate: Masculine Identity in Shakespeare*, Berkeley: University of California Press.

—— (1982) "Excavating 'Those Dim Minoan Regions:' Maternal Subtexts in Patriarchal Literature," *diacritics* 12, 2 (Summer): 32–41.

Kahr, Madelyn Milner (1978) *Dutch Paintings in the Seventeenth Century*, New York: Harper & Row.

Kauffman, Linda S. (1986) *Discourses of Desires: Gender, Genre, and Epistolary Fiction*, Ithaca: Cornell University Press.

Kelly, Mary (1983) *Post-Partum Document*, London: Routledge & Kegan Paul.

—— (1990) *Interim*, New York: The New Museum of Contemporary Art.

—— (1991) "Magiciens de la mer(d): Un projet pour *Artforum*," *Artforum* 24, 5 (January): 90–94.

——(1992a) "Stories by Mary Kelly," *Camera Obscura* 30 (May): 51–56.

——(1992b) *Gloria Patri*, Wesleyan: Wesleyan University.

——(1994) "On Display: Not Enough Gees and Gollies to Describe It," *Whitewalls* 33/34.

Kennedy, Adrienne (1977) "A Growth of Images," *The Drama Review* 9, 2 (Spring): 71.

—— (1978) *"An Evening with Dead Essex,"* *Theater* 9, 2 (Spring): 66–78.

Kermode, Frank (1974) "Introduction to *Hamlet, Prince of Denmark*," in William Shakespeare, *The Riverside Shakespeare*, ed. G. Blakemore Evans, Boston, Mass: Houghton Mifflin, 1135–40.

King, Woodie and Milner, Ron (1971) *Black Drama Anthology*, New York: New American Library.

Klemesrud, Judy (1979) "She Had Her Own 'Getting Out' To Do," *The New York Times*, 27 May.

Kluge, Alexander (1981–82) "Film and the Public Sphere," trans. Thomas Y. Levin and Miriam B. Hansen, *New German Critique* 24–25 (Fall/Winter): 206–20.

Kofman, Sarah (1973) *Camera obscura: de l'idéologie*, Paris: Galilée.

Kolbowski, Silvia, ed. (1984) "Sexuality: Re/Positions," *Wedge* 6 (Winter).

Krauss, Rosalind (1990) *Le Photographique: pour une théorie des écarts*, Paris: Macula.

——(1993) *The Optical Unconscious*, Cambridge, Mass., and London: MIT.

Kristeva, Julia (1982) *Powers of Horror: An Essay on Abjection*, trans. Leon S. Roudiez, New York: Columbia University Press.

—— (1983) *Histoires d'amour*, Paris: Denoël.

—— (1987) *Tales of Love*, trans. Leon S. Roudiez, New York: Columbia University Press.

Krysinksi, Wladimir (1982) "Signes et sens du corps dans le théâtre," *Parachute* 27: 28–35.

Kubiak, Anthony (1991) *Stages of Terror: Terrorism, Ideology, and Coercion as Theatre History*, Bloomington: Indiana University Press.

Kuhn, Annette (1988) *Cinema, Censorship, and Sexuality 1909–1925*, London and New York: Routledge.

Lacan, Jacques (1966) *Ecrits*, Paris: Seuil.

—— (1977) *Ecrits: A Selection*, trans. Alan Sheridan, New York: W. W. Norton.

—— (1978) *The Four Fundamental Concepts of Psychoanalysis*, trans. Alan Sheridan, ed. Jacques-Alain Miller, New York: W. W. Norton.

—— (1985) *Feminine Sexuality: Jacques Lacan and the École Freudienne*, ed. Juliet Mitchell and Jacqueline Rose, trans. Jacqueline Rose, New York: W. W. Norton.

—— (1990) *Television: A Challenge to the Psychoanalytic Establishment*, trans. Denis Hollier, Rosalind Krauss, and Annette Michelson, ed. Joan Copjec, New York: W. W. Norton.

—— (1991) *Le Séminaire VIII: Le transfert*, Paris: Seuil.

LaCapra, Dominick (1985) *History and Criticism*, Ithaca: Cornell University Press.

Laclau, Ernesto, and Mouffe, Chantal (1985) *Hegemony and Socialist Strategy: Towards a Radical Democratic Politics*, London: Verso.

Lacoue-Labarthe, Philippe (1978) "The Caesura of the Speculative," trans. Robert Eisenhower, *Glyph* 4, Baltimore: The Johns Hopkins University Press.

—— (1997) "Theatrum Analyticum," trans. Robert Vollrath and Samuel Weber, in Timothy Murray (ed.) *Mimesis, Masochism, and Mime: The Politics of Theatricality in Contemporary French Thought*, Ann Arbor: University of Michigan Press.

Laplanche, Jean (1980) *Problématiques III: la sublimation*, Paris: Presses Universitaires de France.

—— (1989) *New Foundations for Psychoanalysis*, trans. David Macey, Oxford: Basil Blackwell.

—— (1992a) "Interview: Jean Laplanche Talks to Martin Stanton," in John Fletcher and Martin Stanton (eds.) *Jean Laplanche: Seduction, Translation, Drives*, London: Institute of Contemporary Arts.

—— (1992b) "The Kent Seminar," in John Fletcher and Martin Stanton (eds.) *Jean Laplanche: Seduction, Translation, Drives*, London: Institute of Contemporary Arts.

—— (1992c) "The Freud Museum Seminar," in John Fletcher and Martin Stanton (eds.) *Jean Laplanche: Seduction, Translation, Drives*, London: Institute of Contemporary Arts.

Laplanche, Jean, and Pontalis, J. B. (1986) "Fantasy and the Origins of Sexuality," in Victor Burgin, James Donald, and Cora Kaplan (eds.) *Formations of Fantasy*, London: Methuen.

Lecercle, Ann (1986) "Anatomy of a Fistula, Anomaly of a Drama," in Jean Fuzier and François Laroque (eds.) *All's Well That Ends Well: Nouvelles perspectives critiques*, Montpellier: Publications de l'Université Paul Valéry.

Leeman, Fred, Elfers, Joost, and Shuyt, Michael (1976) *Anamorphoses: Games of Perception and Illusion in Art*, New York: Harry N. Abrams.

Lenz, Carol Ruth Swift, Green, Gayle and Neely, Carol Thomas, eds. (1980) *The Woman's Part: Feminist Criticism of Shakespeare*, Urbana: University of Illinois Press.

Leverenz, David (1980) *The Language of Puritan Feeling: An Exploration in Literature, Psychology and Social History*, New Brunswick: Rutgers University Press.

Levine, Michael G. (1994) "Freud and the Scene of Censorship," in Richard Burt (ed.) *The Administration of Aesthetics: Censorship, Political Criticism, and the Public Sphere*, Minneapolis and London: University of Minnesota Press.

Linker, Kate (1984a) "Representation and Sexuality," in Brian Wallis (ed.) *Art after Modernism: Rethinking Representation*, New York: The New Museum of Contemporary Art; Boston, Mass.: David R. Godine.

—— ed. (1984b) *Difference: On Representation and Sexuality*, New York: The New Museum of Contemporary Art.

Lionnet, Françoise (1989) *Autobiographical Voices: Race, Gender, Self-Portraiture*, Ithaca and London: Cornell University Press.

Lucia, Cynthia (1992–93) "Redefining Female Sexuality in the Cinema: An Interview with Lizzie Borden," *Cineaste* 19, 2–3: 6–10.

Lukacher, Ned (1986) *Primal Scenes: Literature, Philosophy, Psychoanalysis*, Ithaca: Cornell University Press.

—— (1989) "Anamorphic Stuff: Shakespeare, Catharsis, Lacan," *South Atlantic Quarterly* 88, 4 (Fall): 863–98.

—— (1994) *Daemonic Figures: Shakespeare and the Question of Conscience*, Ithaca and London: Cornell University Press.

Lupton, Julia Reinhard, and Reinhard, Kenneth (1993) *After Oedipus: Shakespeare in Psychoanalysis*, Ithaca and London: Cornell University Press.

Lyotard, Jean-Francois (1971) *Discours, figure*, Paris: Editions Klincksieck.

—— (1973) "Contribution des tableaux de Jacques Monory," *Figurations 1960/73*, Paris: 10/18.

—— (1977) *Rudiments païens*, Paris: 10/18.

—— (1984a) *The Postmodern Condition: A Report on Knowledge*, trans. Geoff Bennington and Brian Massumi, Minneapolis: University of Minnesota Press.

—— (1984b) *Driftworks*, New York: Semiotext(e).

—— (1985) "Les immateriaux," dossier prepared by the Centre de Creation Industrielle, Paris: Centre Georges Pompidou.

—— (1986) "Acinema," trans. Paisley N. Livingston, in Philip Rosen (ed.) *Narrative, Apparatus, Ideology*, New York: Columbia University Press.

—— (1988) *The Differend: Phrases in Dispute*, trans. Georges Van Den Abbeele, Minneapolis: University of Minnesota Press.

—— (1989) "The Sublime and the Avant-garde," in Andrew Benjamin (ed.) *The Lyotard Reader*, Oxford: Basil Blackwell.

—— (1990) *Duchamp's TRANS/formers*, trans. Ian McLeod, Venice, Calif.: The Lapis Press.

—— (1993) *Libidinal Economy*, trans. Iain Hamilton Grant, Bloomington: Indiana University Press.

—— (1997a) "The Tooth, The Palm," in Timothy Murray (ed.) *Mimesis, Masochism, and Mime: The Politics of Theatricality in Contemporary French Thought*, Ann Arbor: University of Michigan Press.

—— (1997b) "The Unconscious as Mise-en-scene," trans. Anne Knab and Michael Benamou, in Timothy Murray (ed.) *Mimesis, Masochism, and Mime: The Politics of Theatricality in Contemporary French Thought*, Ann Arbor: University of Michigan Press.

MacDonald, Erik (1993) *Theater at the Margins: Text and the Post-structured Stage*, Ann Arbor: University of Michigan Press.

MacKinnon, Catherine (1987) *Feminism Unmodified: Discourses on Life and Law*, Cambridge, Mass.: Harvard University Press.

Mapplethorpe, Robert (1986) *Black Book*, New York: St. Martin's Press.

Marin, Louis (1978) *Le Récit est un piège*, Paris: Editions de Minuit.

—— (1988) *Portrait of the King*, trans. Martha M. Houle, Minneapolis: University of Minnesota Press.

—— (1991) "Classical, Baroque: Versailles, or the Architecture of the Prince," *Yale French Studies* 80: 167–82.

—— (1995) *To Destroy Painting*, trans. Mette Hjort, Chicago and London: University of Chicago Press.

Martin, Biddy (1994) "Sexualities without Genders and Other Queer Utopias," *diacritics* 24, 2–3 (Summer–Fall): 104–21.

Marx, Karl and Engels, Frederick (1970) *The German Ideology, Part One*, New York: International Publishers.

McKewin, Carole (1980) "Counsels of Gall and Grace: Intimate Conversations between Women in Shakespeare's Plays," in Carol Ruth Swift Lenz, Gayle Greene, and Carol Thomas Neely (eds.) *The Woman's Part: Feminist Criticism of Shakespeare*, Urbana: University of Illinois Press.

McMillan, Michael (1995) "Fishing for a New Religion (for Lynford French)," in Catherine Ugwu (ed.) *Let's Get It On: The Politics of Black Performance*, London: Institute of Contemporary Arts; Seattle: Bay Press.

McMillin, Scott (1984) "*Richard II*: Eyes of Sorrow, Eyes of Desire," *Shakespeare Quarterly* 35: 40–52.

Mehlman, Jeffrey (1975) "How to Read Freud on Jokes: The Critic as Schadchen," *New Literary History* 4: 439–61.

Mellencamp, Patricia, ed. (1990) *Logics of Television: Essays in Cultural Criticism*, Bloomington: Indiana University Press; London: BFI Books.

Mercer, Kobena (1991) "Skin Head Sex Thing: Radical Difference and Homoerotic Imagery," in Bad Object Choices (ed.) *How Do I Look? Queer Film and Video*, Seattle: Bay Press.

—— (1992) "Endangered Species," *Artforum* 30, 10 (Summer): 74–77.

—— (1994) "Fear of a Black Penis," *Artforum* 32 (April).

Mercer, Kobena and Julien, Isaac (1994) "True Confessions," in Thelma Golden (ed.) *Black Male: Representations of Masculinity in Contemporary American Art*, New York: Whitney Museum of Art.

Merck, Mandy (1992) "From Minneapolis to Westminster," *Critical Quarterly* 34, 2 (Summer): 32–42.

Merleau-Ponty, Maurice (1964) *Le Visible et l'invisible*, Paris: Gallimard.

Metz, Christian (1977) *Le Signifiant imaginaire: psychanalyse et cinema*, Paris: 10/18.

—— (1986) "Problems of Denotation in the Fiction Film," in Philip Rosen (ed.) *Narrative, Apparatus, Ideology*, New York: Columbia University Press.

Miller, Mark Crispin (1986) "Deride and Conquer," in Todd Gitlin (ed.) *Watching Television: A Pantheon Guide of Popular Culture*, New York: Pantheon Books.

Modleski, Tania (1982) *Loving with a Vengeance: Mass-produced Fantasies for Women*, New York and London: Methuen.

—— ed. (1986) *Studies in Entertainment: Critical Approaches to Mass Culture*, Bloomington: Indiana University Press.

Montaigne, Michel de (1893) *The Essayes of Michael Lord of Montaigne*, trans. John Florio, London: George Routledge.

Morse, Margaret (1990) "An Ontology of Everyday Distraction: The Freeway, the Mall, and Television," in Patricia Mellencamp (ed.) *Logics of Television: Essays in Cultural Criticism*, London: BFI Publishing; Bloomington: Indiana University Press.

Moshinsky, Elijah (1980) *All's Well That Ends Well*, BBC/Time-Life, video.

—— (1986) "Table ronde avec Elijah Moshinsky," in Jean Fuzier and François Laroque (eds.) *All's Well That Ends Well: Nouvelles perspectives critiques*, Montpellier: Publications de l'Université Paul Valéry.

Mullen, Harryette (1994) "Optic White: Blackness and the Production of Whiteness," *diacritics* 24, 2–3 (Summer–Fall): 71–89.

Muller, John P. and Richardson, William J., eds. (1988) *The Purloined Poe: Lacan, Derrida, and Psychoanalytic Reading*, Baltimore: The Johns Hopkins University Press.

Mulvey, Laura (1989) *Visual and Other Pleasures*, Bloomington: Indiana University Press.

—— (1996) *Fetishism and Curiosity*, London: British Film Institute; Bloomington: Indiana University Press.

Murray, Timothy (1976) "A Marvelous Guide to Anamorphosis: *Cendrillon ou la petite pantoufle de verre*," *Modern Language Notes* 91, 6 (December): 1276–95.

—— (1977) "Kenneth Burke's Logology: A Mock Logomachy," in *Glyph 2*, Baltimore: The Johns Hopkins University Press.

—— (1984) "The Theatricality of the Van-guard: Ideology and Contemporary American Theatre," *Performing Arts Journal* 24 (Fall): 93–99.

—— (1987) *Theatrical Legitimation: Allegories of Genius in Seventeenth-century England and France*, New York and Oxford: Oxford University Press.

—— (1990a) "Review of Stanley Cavell, *Disowning Knowledge*," *MLN* 105, 5 (December): 1080–85.

—— (1990b) "Duck and Cover? 'Radioactive, Inactives Portraits' by Nagatani and Tracey," *Q: A Journal of Art* (May): 31–33.

—— (1991) "Translating Montaigne's Crypts: Melancholic Relations and the Sites of Altarbiography," in Jonathan Crewe (ed.) *Reconfiguring the Renaissance: Essays in Critical Materialism, Bucknell Review*, 35, 2: 121–49.

—— (1993) *Like a Film: Ideological Fantasy on Screen, Camera, and Canvas*, London and New York: Routledge.

—— (1997a) "You Are How You Read: Baroque Chao-errancy in Greenaway and Deleuze," *Iris* 23 (Spring).

—— ed. (1997b) *Mimesis, Masochism, and Mime: The Politics of Theatricality in Contemporary French Thought*, Ann Arbor: University of Michigan Press.

—— (1997c) "Et in Arcadia Ego: Poussin, the Image of Culture with Marin and Kuntzel," *MLN* 112 (Spring): 431–53.

Murray, Timothy and Smith, Alan K., eds. (1997) *Repossessions: Psychoanalysis and the Phantoms of Early Modern Culture*, Minneapolis: University of Minnesota Press.

Museum of Contemporary Hispanic Art, The New Museum of Contemporary Art, The Studio Museum in Harlem (1990) *The Decade Show*, New York: Museum of Contemporary Hispanic Art, The New Museum of Contemporary Art, The Studio Museum in Harlem.

Neely, Carol Thomas (1980) "Women and Men in *Othello*: 'What Should Such a Fool / Do With So Good a Woman?'," in Carol Ruth Swift Lenz, Gayle Greene, and Carol Thomas Neely (eds.) *The Woman's Part: Feminist Criticism of Shakespeare*, Urbana: University of Illinois Press.

—— (1985) *Broken Nuptials in Shakespeare's Plays*, New Haven: Yale University Press.

Negt, Oscar, and Kluge, Alexander (1988) "The Public Sphere and Experience: Selections," trans. Peter Labanyi, *October* 46: 60–82.

Newman, Karen (1987a) "'And Wash the Ethiop White:' Femininity and the Monstrous in *Othello*," in Jean E. Howard and Mario F. O'Connor (eds.) *Shakespeare Reproduced: The Text in History and Ideology*, New York: Methuen.

—— (1987b) "Portia's Ring: Unruly Women and Structures of Exchange in *The Merchant of Venice*," *Shakespeare Quarterly* 38, 1 (Spring): 19–33.

Norman, Marsha (1980) *Getting Out*, New York: Avon Books.

Novy, Marianne (1980) "Shakespeare's Female Characters as Actors and Audience," in Carol Ruth Swift Lenz, Gayle Greene, and Carol Thomas Neely (eds.) *The Woman's Part: Feminist Criticism of Shakespeare*, Urbana: University of Illinois Press.

Olaniyan, Tejumola (1995) *Scars of Conquest/Masks of Resistance: The Invention of Cultural Identities in African, African-American, and Caribbean Drama*, New York and Oxford: Oxford University Press.

Olivier, Christiane (1980) *Les Enfants de Jocaste*, Paris: Denoël.

Omi, Michael (1989) "In Living Color: Race and American Culture," in Ian Angus and Sut Jhally, *Cultural Politics in Contemporary America*, New York and London: Routledge.

Orgel, Stephen (1975) *The Illusion of Power: Political Theater in the English Renaissance*, Berkeley: University of California Press.

—— (1979) "Shakespeare and the Kinds of Drama," *Critical Inquiry* 6: 107–33.

Owens, Rochelle (1982) "*Chucky's Hunch*," in Bonnie Marranca and Gautum Dasgupta, *Word Plays 2*, New York: Performing Arts Journal Publications.

Panofsky, Erwin (1991) *Perspective as Symbolic Form*, New York: Zone Books.

Parker, Patricia (1985) "Shakespeare and Rhetoric: 'Dilation' and 'Deletion' in *Othello*," in Patricia Parker and Geoffrey Hartman (eds.) *Shakespeare and the Question of Theory*, New York: Methuen.

—— (1996) *Shakespeare from the Margins: Language, Culture, Context*, Chicago and London: University of Chicago Press.

Parker, Rozsika, and Pollock, Griselda (1987) *Framing Feminism: Art and the Women's Movement 1970–85*, London: Pandora.

Parmar, Pratibha (1988) *Sari Red*, video.

Pellegrini, Anne (1996) *Performance Anxieties: Staging Psychoanalysis, Staging Race*, New York and London: Routledge.

Penley, Constance (1989) *The Future of an Illusion: Film, Feminism, and Psychoanalysis*, Minneapolis: University of Minnesota Press.

Phelan, Peggy (1991) "Money Talks, Again," *TDR* 35, 3 (Fall): 131–41.

—— (1993) *Unmarked: The Politics of Performance*, London and New York: Routledge.

Piper, Adrian (1990) "The Triple Negation of Colored Women Artists," in Southeastern Center for Contemporary Art, *Next Generation: Southern Black Aesthetic*, Winston-Salem, NC: Southeastern Center for Contemporary Art.

Pointon, Marcia (1994) *Art Apart: Art Institutions and Ideology across England and North America*, Manchester and New York: University of Manchester Press.

Pollock, Griselda (1988) *Vision & Difference: Femininity, Feminism and the Histories of Art*, London and New York: Routledge.

Pontalis, J.-B. (1988) *Perdre de vue*, Paris: Editions Gallimard.

—— (1990) *La Force d'attraction*, Paris: Seuil.

Prynne, William Prynne (n.d.) *Histriomastix*, London.

Pryse, Marjorie (1976) "Lust for Audience: An Interpretation of *Othello*," *ELH* 43: 461–78.

Pye, Christopher (1990) *The Regal Phantasm: Shakespeare and the Politics of Spectacle*, London: Routledge.

—— (1997) "Froth in the Mirror: Demonism, Sexuality, and the Early Modern Subject," in Timothy Murray and Alan K. Smith (eds.) *Repossessions: Psychoanalysis and the Phantoms of Early Modern Culture*, Minneapolis: University of Minnesota Press.

Radner, Hilary (1990) "Quality Television and Feminine Narcissism: The Shrew and the Covergirl," *Genders* 8 (Summer): 110–28.

Rankins, William (1587) *A Mirror of Monsters*, London.

Read, Herbert (1979) "His Serene Art," *Salmagundi* 44–45 (Spring–Summer): 63–69.

Reinelt, Janelle (1994) *After Brecht: British Epic Theatre*, Ann Arbor: The University of Michigan Press.

Richards, Sandra L. (1983) "Conflicting Impulses in the Plays of Ntozake Shange," *Black American Literature Forum* 17, 2 (Summer): 73–78.

Riggs, Marlon T. (1991) *Color Adjustments*, video.

Riley, Bob (1986) "Notes on Media Theater," The Institute of Contemporary Art, Boston (ed.) *Endgame: Reference and Simulation in Recent Painting and Sculpture*, Cambridge, Mass.: MIT Press.

Rivchin, Marilyn (1990) "Robbie McCauley: Performance Artist / History Artist," *Q: A Journal of Art*, Department of Art, Cornell University (May): 58–61.

Riviere, Joan (1986) "Womanliness as a Masquerade," in Victor Burgin, James Donald, and Cora Kaplan (eds.) *Formations of Fantasy*, London: Methuen.

Roach, Jacqui and Felix, Petal (1989) "Black Looks," in Lorraine Gammon and Margaret Marshment (eds.) *The Female Gaze: Women as Viewers of Popular Culture*, Seattle: The Real Comet Press.

Roach, Joseph R. (1989) "Power's Body: The Inscription of Morality as Style," in Thomas Postlewait and Bruce A. McConachie (eds.) *Interpreting the Theatrical Past: Essays in the Historiography of Performance*, Iowa City: University of Iowa Press.

Rodowick, D. N. (1985) "The Figure and the Text," *diacritics* 15, 1 (Spring): 34–50.

—— (1994) *The Crisis of Political Modernism: Criticism and Ideology in Contemporary Film Theory*, Berkeley: University of California Press.

Ropars-Wuilleumier, Marie-Claire (1981) *Le Texte divisé: essai sur l'écriture filmique*, Paris: Presses Universitaires de France.

Rose, Jacqueline (1986) *Sexuality in the Field of Vision*, London: Verso.

—— (1989) "Where Does the Misery Come from? Psychoanalysis, Feminism, and the Event," in Richard Feldstein and Judith Roof (eds.) *Feminism and Psychoanalysis*, Ithaca: Cornell University Press.

—— (1996) *States of Fantasy*, Oxford: Clarendon Press.

Rose, Tricia (1994) "Rap Music and the Demonization of Young Black Males," in Thelma Golden (ed.) *Black Male: Representations of Masculinity in Contemporary American Art*, New York: Whitney Museum of American Art.

Rosenblatt, Roger (1980) "Black Autobiography: Life as the Death Weapon," in James Olney (ed.) *Autobiography: Essays Theoretical and Critical*, Princeton: Princeton University Press.

Rosolato, Guy (1985) *Éléments de l'interprétation*, Paris: Gallimard.

—— (1990) *La Force d'attraction*, Paris: Seuil.

—— (1993) *Pour une Psychanalyse exploratrice dans la culture*, Paris: Presses Universitaires de France.

Rubin, Gayle (1975) "The Traffic in Women: Notes toward a Political Economy of Sex," in Rayna Reiter (ed.) *Toward an Anthropology of Women*, New York: Monthly Review Press.

Rymer, Thomas (1693) *A Short View of Tragedy; Its Original Excellency and Corruption with Some Reflections on Shakespeare and Other Practitioners for the Stage*, London.

Schechner, Richard (1982) *The End of Humanism*, New York: Performing Arts Journal Publications.

—— (1988) *Performance Theory*, New York: Routledge.

Schechner, Richard and Appel, Willa (1990) *By Means of Performance: Intercultural Studies of Theatre and Ritual*, Cambridge, Mass.: Harvard University Press.

Schiesari, Juliana (1992) *The Gendering of Melancholia: Feminism, Psychoanalysis, and the Symbolics of Loss in Renaissance Literature*, Ithaca: Cornell University Press.

Schor, Mira (1990) "Girls Will Be Girls," *Artforum* 19, 1 (September): 121–27.

Schwartz, Murray M., and Kahn, Coppélia, eds. (1980) *Representing Shakespeare: New Psychoanalytic Essays*, Baltimore: The Johns Hopkins University Press.

Schwarz, Heinrich (1966) "Vermeer and the Camera Obscura," *Pantheon* 24: 170–80.

Sedgwick, Eve Kosofsky (1985) *Between Men: English Literature and Male Homosocial Desire*, New York: Columbia University Press.

Shakespeare, William (1963) *Othello*, ed. Alvin Kernan, New York: Signet.

—— (1974) *The Riverside Shakespeare*, ed. G. Blakemore Evans, Boston, Mass.: Houghton Mifflin.

Shange, Ntozake (1981) *Three Pieces*, New York: Penguin.

—— (1982) *Sassafrass, Cypress & Indigo*, New York: St. Martin's Press.

—— (1984) *SeeNoEvil: Prefaces, Essays & Accounts 1976–1983*, San Francisco: Momo's Press.

—— (1986) "Foreword," in Robert Mapplethorpe, *Black Book*, New York: St. Martin's Press.

Showalter, Elaine (1985) "Representing Ophelia: Women, Madness, and the Responsibilities of Feminist Criticism," in Patricia Parker and Geoffrey Hartman (eds.) *Shakespeare and the Question of Theory*, New York: Methuen.

Sibony, Daniel (1977) "*Hamlet*: A Writing-effect," in Shoshana Felman (ed.) *Literature and Psychoanalysis, the Question of Reading: Otherwise*, Baltimore: The Johns Hopkins University Press.

Silverman, Kaja (1983) *The Subject of Semiotics*, New York and Oxford: Oxford University Press.

—— (1988) *The Acoustic Mirror: The Female Voice in Psychoanalysis*, Bloomington: Indiana University Press.

—— (1992) *Male Subjectivity at the Margins*, New York and London: Routledge.

Simon, John (1972) "Pearl Throwing Free Style," in Charles W. Eckert (ed.) *Focus on Shakespearean Films*, Englewood Cliffs, NJ: Prentice Hall.

——(1978) "Free, Bright, and 31," *New York*, 13 November: 152.

Sims, Lowery Stokes (1988) "Aspects of Performance in the Work of Black American Women Artists," in Arlene Raven, Cassandra L. Langer, Joanna Frueh (eds.) *Feminist Art Criticism: An Anthology*, Ann Arbor and London: UMI Research Press, 207–25.

Slotek, Jim (1996) "Love, American Style: What Light through Yonder Tradition Breaks?," *Toronto Sun*, http://www.conoe.ca/JamMoviesArtistsA2D/danes_clare.html.

Smith, Valerie (1994) "Reading the Intersection of Race and Gender in Narratives of Passing," *diacritics* 24, 2–3 (Summer–Fall): 43–57.

Snow, Edward (1994) *A Study of Vermeer*, Berkeley: University of California Press.

Snow, Edward A. (1980) "Sexual Anxiety and the Male Order of Things in *Othello*," *English Literary Renaissance* 10, 2 (Autumn): 384–412.

—— (1985) "Language and Sexual Difference in *Romeo and Juliet*," in Peter Erickson and Coppélia Kahn (eds.) *Shakespeare's "Rough Magic:" Renaissance Essays in Honor of C. L. Barber*, Newark: University of Delaware Press; London and Toronto: Associated University Presses.

Snyder, Susan (1992) "'The King's Not Here:' Displacement and Deferral in *All's Well That Ends Well*," *Shakespeare Quarterly* 20 (Spring): 20–32.

Solomon, Alisa (1986) "The WOW Cafe," in Brooks McNamara and Jill Dolan (eds.) *The Drama Review: Thirty Years of Commentary on the Avant-garde*, Ann Arbor: UMI Research Press.

Spillers, Hortense (1987) "Mama's Baby, Papa's Maybe: An American Grammar Book," *diacritics* 17, 2 (Summer): 65–81.

—— (1996) "'All the Things You Could Be by Now, if Sigmund Freud's Wife Was Your Mother:" Psychoanalyis and Race," *Critical Inquiry* 22, 4 (Summer): .

Spivak, Gayatri Chakravorty (1979) "Explanation and Culture: Marginalia," *Humanities in Society* 2 (Summer): 201–21.

——(1989a) "In a Word: Interview with Ellen Rooney," *differences* 1, 2 (Summer): 124–54.

—— (1989b) "Who Claims Alterity?," in Barbara Kruger and Phil Mariani (eds.) *Remaking History*, Seattle: Bay Press.

Squiers, Carol (1990) *The Critical Image: Essays on Contemporary Photography*, Seattle: Bay Press.

Steinberg, Leo (1983) *The Sexuality of Christ in Renaissance Art and in Modern Oblivion*, New York: Pantheon/October.

Tagg, John (1988) *The Burden of Representation: Essays on Photographies and Histories*, Amherst: University of Massachusetts Press.

Theweleit, Klaus (1987) *Male Fantasies: Volume 1: Women, Floods, Bodies, Histories*, trans. Stephen Conway, Minneapolis: University of Minnesota Press.

—— (1989) *Male Fantasies. Volume 2: Male Bodies: Psychoanalyzing the White Terror*, trans. Stephen Conway, Minneapolis: University of Minnesota Press.

Trinh T. Minh-ha (1989) *Woman, Native, Other: Writing, Postcoloniality and Feminism*, Bloomington: Indiana University Press.

—— (1991) *When the Moon Waxes Red: Representation, Gender, and Cultural Politics*, New York: Routledge.

Turim, Maureen (1980) "The Place of Visual Illusions," in Teresa de Lauretis and Stephen Heath (eds.) *The Cinematic Apparatus*, London: Macmillan; New York: St. Martin's Press.

—— (1984) "Desire in Art and Politics: The Theories of Jean-François Lyotard," *Camera Obscura* 12 (Summer): 91–106.

Ugwu, Catherine, ed. (1995) *Let's Get It On: The Politics of Black Performance*, London: Institute of Contemporary Arts; Seattle: Bay Press.

Ulmer, Gregory (1983) "The Object of Post-criticism," in Hal Foster (ed.) *The Anti-aesthetic: Essays on Postmodern Culture*, Port Townsend, Washington: Bay Press.

—— (1989) *Teletheory: Grammatology in the Age of Video*, New York and London: Routledge.

Vetrocq, Marcia E. (1993) "Dawn DeDeaux at the Contemporary Arts Center," *Art in America* 81, 6 (June): 110.

Villarejo, Amy (1996) "Retrospective Hallucinations: Postcolonial Video as Cultural Critique," in Gita Rajan and Radhika Mohanran (eds.) *Postcolonial Discourse and Changing Cultural Contexts: Theory and Criticism*, New York: Greenwood Press.

Virilio, Paul (1989) *War and Cinema: The Logistics of Perception*, trans. Patrick Camiller, London: Verso.

Wallace, Michele (1990) "Modernism, Postmodernism, and the Problem of the Visual in Afro-American Culture," in Russell Ferguson, Martha Gever, Trinh T. Minh-ha, and Cornel West (eds.) *Out There: Marginalization and Contemporary Cultures*, New York: The New Museum of Contemporary Art; Cambridge, Mass.: MIT Press.

—— (1992) "Afterword: 'Why Are THERE NO GREAT BLACK ARTISTS?' The Problem of Visuality in African-American Culture," in Gina Dent (ed.) *Black Popular Culture: A Project by Michele Wallace*, Seattle: Bay Press.

Wallis, Brian, ed. (1984) *Art after Modernism: Rethinking Representation*, New York: The New Museum of Contemporary Art; Boston: David R. Godine.

Warner, William Beatty (1986) *Chance and the Text of Experience: Freud, Nietzsche, and Shakespeare's Hamlet*, Ithaca: Cornell University Press.

Watney, Simon (1989) *Policing Desire: Pornography, AIDS, and the Media*, Minneapolis: University of Minnesota Press.

Weber, Samuel (1977) "The Divaricator: Remarks on Freud's *Witz*," in *Glyph 1*, Baltimore: The Johns Hopkins University Press.

—— (1982) *The Legend of Freud*, Minneapolis: University of Minnesota Press.

Wees, William C. (1980) "The Cinematic Image: As a Visualization of Sight," *Wide Angle* 4, 3: 28–37.

Weimann, Robert (1992) "Representation and Performance: The Uses of Authority in Shakespeare's Theater," *PMLA* 107, 3 (May): 497–510.

—— (1996) "Thresholds to Memory and Commodity in Shakespeare's Endings," *Representations* 53 (Winter): 1–20.

West, Cornel (1989) "Black Culture and Postmodernism," in Barbara Kruger and Phil Mariani (eds.) *Remaking History*, Seattle: Bay Press.

White, Mimi (1987) "Ideological Analysis and Television," in Robert C. Allen (ed.) *Channels of Discourse: Television and Contemporary Criticism*, Chapel Hill and London: The University of North Carolina Press.

Wiggins, Cynthia (1994) "Jail Sell," *Afterimage* 22, 3 (October): 10–11.

Willbern, David (1980) "Shakespeare's Nothing," in Murray M. Schwarz and Coppélia Kahn (eds.) *Representing Shakespeare: New Psychoanalytic Essays*, Baltimore: The Johns Hopkins University Press.

Williams, Linda (1989) *Hard Core: Power, Pleasure, and the "Frenzy of the Visible"*, Berkeley: University of California Press.

Williams, Raymond (1975) *Television: Technology and Cultural Form*, New York: Schocken.

Willis, Sharon (1987) *Marguerite Duras: Writing on the Body*, Urbana: University of Illinois Press.

—— (1993) "The Fathers Watch the Boys' Room," *Camera Obscura* 32: 41–73.

Winston, Michael R. (1982) "Racial Consciousness and the Evolution of Mass Communications in the United States," *Daedalus*, "Print and Video Culture," 111, 4 (Fall): 171–82.

Yingling, Thomas (1990) "How the Eye is Caste: Robert Mapplethorpe and the Limits of Controversy," *Discourse* 12, 2 (Spring–Summer): 3–28.

Zimmerman, Patricia R. (1995) *Reel Families: A Social History of Amateur Film*, Bloomington: Indiana University Press.

Žižek, Slavoj (1989a) *The Sublime Object of Ideology*, London: Verso.

—— (1989b) "Looking Awry," *October* 50 (Fall): 29–55.

INDEX